Francis Alÿs//Vladimir Arkh
Banes//Maurice Blanchot//1
Brouwn//Sophie Calle//Gregory Crewdson//Rebecca
J. DeRoo//Marcel Duchamp//Geoff Dyer//Patrick Frey//
Ben Highmore//Susan Hiller//Ilya & Emilia Kabakov//
Vincent Kaufmann//Stephen Koch//Joseph Kosuth//
Henri Lefebvre//Jean-Jacques Lévêque//Lettrist
International//Lucy R. Lippard//Tom McDonough//
Michel Maffesoli//Alison Marchant//Ivone Margulies//
Jonas Mekas//Annette Messager//Aleksandra Mir//
Helen Molesworth//Roman Ondák//Yoko Ono//Gabriel
Orozco//Nikos Papastergiadis//Georges Perec//John
Roberts//Martha Rosler//David A. Ross//Kristin Ross//
Allen Ruppersberg//Nicholas Serota//Michael
Sheringham//Stephen Shore//Alison and Peter
Smithson//Abigail Solomon-Godeau//Daniel Spoerri//
Helena Tatay//Paul Virilio//Jeff Wall//Jonathan
Watkins//Richard Wentworth//Stephen Willats

WITHDRAWN

The Everyday

Whitechapel
London
The MIT Press
Cambridge, Massachusetts

Edited by Stephen Johnstone

THE EVERYDAY

Documents of Contemporary Art

Co-published by Whitechapel and The MIT Press

First published 2008
© 2008 Whitechapel Ventures Limited
All texts © the authors or the estates of the authors,
unless otherwise stated

Whitechapel is the imprint of Whitechapel
Ventures Limited

ISBN 978-0-85488-159-8 (Whitechapel)
ISBN 978-0-262-60074-3 (The MIT Press)

A catalogue record for this book is available from
the British Library

Library of Congress Cataloging-in-Publication Data

The everyday / edited by Stephen Johnstone.
 p. cm. – (Documents of contemporary art)
Includes bibliographical references and index.
ISBN 978-0-262-60074-3 (pbk. : alk. paper)
1. Art and society. 2. Art, Modern – 20th century.
3. Art, Modern – 21st century.
I. Johnstone, Stephen.
N72.S6E94 2008
701'.03
 2007041006

10 9 8 7 6 5 4 3 2 1

Series Editor: Iwona Blazwick
Commissioning Editor: Ian Farr
Project Editor: Hannah Vaughan
Designed by SMITH
Printed in Slovenia

Cover: Gabriel Orozco, *Pelota en agua* (*Ball
on Water*), 1994. Cibachrome print. Collection
Solomon R. Guggenheim Museum, New York.
© Gabriel Orozco. Courtesy of the Solomon
R. Guggenheim Museum.

Whitechapel Ventures Limited
80-82 Whitechapel High Street
London E1 7QX
www.whitechapel.org
To order (UK and Europe) call +44 (0)207 522 7888
or email MailOrder@whitechapel.org
Distributed to the book trade (UK and Europe only)
by Art Books International
Tel +44 (0) 23 9220 0080
www.art-bks.com

The MIT Press
55 Hayward Street
Cambridge, MA 02142
MIT Press books may be purchased at special
quantity discounts for business or sales
promotional use. For information, please email
special_sales@mitpress.mit.edu or write to Special
Sales Department, The MIT Press, 55 Hayward
Street, Cambridge, MA 02142

Documents of Contemporary Art

In recent decades artists have progressively expanded the boundaries of art as they have sought to engage with an increasingly pluralistic environment. Teaching, curating and understanding of art and visual culture are likewise no longer grounded in traditional aesthetics but centred on significant ideas, topics and themes ranging from the everyday to the uncanny, the psychoanalytical to the political.

The Documents of Contemporary Art series emerges from this context. Each volume focuses on a specific subject or body of writing that has been of key influence in contemporary art internationally. Edited and introduced by a scholar, artist, critic or curator, each of these source books provides access to a plurality of voices and perspectives defining a significant theme or tendency.

For over a century the Whitechapel Gallery has offered a public platform for art and ideas. In the same spirit, each guest editor represents a distinct yet diverse approach – rather than one institutional position or school of thought – and has conceived each volume to address not only a professional audience but all interested readers.

Series editor: Iwona Blazwick; Commissioning editor: Ian Farr
Editorial Advisory Board: Roger Conover, Neil Cummings, Mark Francis,
David Jenkins, Gilane Tawadros

Only

minutes of every day are interesting.

I
want
to show
the rest.

Hans-Peter Feldmann, in conversation with Helena Tatay, 2002

I GREW UP IN A WORLD HELD TOGETHER WITH STRING AND BROWN PAPER AND SEALING WAX, AND
THAT'S HOW IT WAS. I SLOWLY REALIZED THAT THIS IS THE UNDERLYING CONDITION OF THE WORLD, AND

THERE'S NOTHING
I LIKE MORE THAN
WHEN, FOR EXAMPLE, THERE'S BEEN A

NEAR
DISASTER AT
NASA
AND THEY SAY: 'IF IT HADN'T BEEN FOR THE CHEWING GUM ...'

Richard Wentworth, Statement, 2007

Stephen Johnstone
Introduction//Recent Art and the Everyday

Mostly, I believe an artist doesn't create something, but is there to sort through, to show, to point out what already exists, to put it into form and sometimes reformulate it. That's the spirit in which I gathered all the press clippings and photos of women, their postures, their gestures – their hands stirring sauce or putting on a bandage. It's a language in itself, which is why we don't pay any attention to it. I didn't invent anything, I indicated ...
– Annette Messager, *Word for Word*, 2006

The banal, the quotidian, the obvious, the common, the ordinary, the infra-ordinary, the background noise, the habitual? [...] How are we to speak of these common things, how to track them down, how to flush them out, wrest them from the dross in which they are mired, how to give them meaning, a tongue, to let them, finally, speak of what it is, who we are.
– Georges Perec, *Species of Spaces*, 1974

Contemporary art is saturated with references to the everyday. Since the mid-1990s numerous international biennales, site-specific projects, historical overviews of modernism and themed group exhibitions have attested to the widespread appeal of the quotidian to curators and artists alike.[1] Coupled with this is the persistent presence of the term and its affiliates in reviews, articles and essays, in which everyday life attains the status of a global art-world touchstone.

Drawing on the vast reservoir of normally unnoticed, trivial and repetitive actions comprising the common ground of daily life, as well as finding impetus in the realms of the popular and the demotic, the rise of the everyday in contemporary art is usually understood in terms of a desire to bring these uneventful and overlooked aspects of lived experience into visibility.

For some, this turn to the ordinary leads to a recognition of the dignity of ordinary behaviour, or the act of stating simply, 'here is value'.[2] For others, it may result in an unveiling of the 'accidentally miraculous', or the desire to make art with the unassuming ease of the amateur photographer.[3] For others still, an art that focuses on the everyday might construct 'a vaguely ethnographic aesthetic',[4] or be nothing more than the record of simply venturing out and happening across something interesting.[5] Elsewhere, the everyday sparks a distrust of the heroic and the spectacular; its oppositional and dissident connotations are foregrounded as it is deployed in a confrontation with 'the bureaucracy of controlled

consumption'.[6] From another position, interest in the everyday signals a loss of guilt before popular culture and its pleasures,[7] while elsewhere again, the investigation of everydayness asks us to consider the deceptively simple question: What happens when nothing happens?[8]

From another perspective, however, a commitment to the quotidian has a profoundly political tenor: accessed through the use in art of ordinary found materials, the everyday might be the common ground of experience that allows museum visitors to 'understand the effects of history on the private lives of those who were usually overlooked'.[9] Commitment to the everyday can also indicate the desire to give a voice to those silenced by dominant discourses and ideologies – a commitment coupled with the responsibility to engage with the everyday's transformative potential; for in this dialogue to notice the taken-for-granted conversation of others is the first step in irrevocably changing everyday life.[10]

Connecting these various and sometimes contradictory approaches to the everyday are a number of common assumptions. First is the sense that the everyday, as in Georges Perec's epigraph above, exists below the threshold of the noticed and is everywhere and nowhere at the same time. Secondly, there is a desire to confront things in the world at large rather than in the art world (i.e., the critique of other art or of art institutions). Linked to this is the assumption that the everyday is both authentic and democratic; it is the place where ordinary people creatively use and transform the world they encounter from one day to another. Thirdly, when artists and curators allude to the everyday it is almost always to suggest that what is at stake in such a gesture is the extent to which an artist is able to get close to things, to be immersed in the world, as opposed to observing and judging from afar. And finally, running through many of these examples is the sometimes unstated but always implicit notion that a turn to the everyday will bring art and life closer together.

But why the everyday now? Possibly, as John Roberts suggests, it has something to do with the lure of the ordinary[11] and, in this regard, the final point above is germane here; in the reconciliation of art and life lies perhaps the potential to undermine what has appeared to many as a misconceived view of art's destiny: to be no more than an autonomous and rarefied sphere of production and consumption.

If the everyday is the realm of the unnoticed and the overlooked, however, it might be asked just how we can attend to it? How do we drag the everyday into view? And if we manage to do so, is there a form or style appropriate to representing what has been identified as the 'inherent indeterminacy' of the everyday? Which in turn begs the question: why should we wish to investigate the everyday in the first place? Is it simply to see what remains hidden in our lives, to identify what we take for granted? Or do works about the everyday in

some way show us how to look more critically and in so doing 'train attention on our own experience, so that discourse on the everyday is ultimately pragmatic or performative in character?'[12] And finally, what of the injunction that to bring the everyday into view is to change it?

, The diverse texts collected here address these questions, while not answering them in any simple way. This anthology documents the various different ways that artists have engaged with the everyday since 1945. The focus is on contemporary practice since the 1980s and the antecedents that most often inform this work, from the Situationist International and Fluxus to conceptualism and feminist art of the 1970s. In recent years publications on the everyday have surveyed aspects of the Soviet avant-garde, Dada and Surrealism, documentary photography in Weimar Germany and the Mass Observation movement in Britain; identified the aesthetic character of everyday life; and introduced figures such as Henri Lefebvre, Michel de Certeau and Georg Simmel to a new audience. Even more recently we have seen a polemic that attempts to reinvigorate the revolutionary potential of the everyday and in so doing counter the perceived 'contraction' and 'philosophical foreshortening' of the idea into a theory of creative consumption.[13]

However, very little exists on the everyday in recent art. In gathering this material together it is possible to begin mapping the singularity and specific character of art's recent encounter with everydayness. A number of the texts gathered here make it explicit that the everyday is one of the few critical concepts in which the agency of art is acknowledged – it is in the speculative, unsystematic and ambiguous work of writers and artists, dramatists and poets that we see the pre-history of an analysis of the everyday. Thus, while a key theorist of the everyday such as Henri Lefebvre may at times be extremely critical of the specialized knowledge art produces and the professional identity of artists, he readily acknowledges that the imprecise and ambiguous realms of art, literature and drama have played a fundamental role in bringing everyday life into view. While it may be the case that for Lefebvre art still remains an alienated activity and a sphere of limited freedom, artworks can offer illuminating and revealing routes into the everyday. For example, in volume II of the *Critique of Everyday Life* he suggests that art is fundamentally linked to play and, like play, is 'transfunctional' (that is, it has many uses and at the same time it is not useful at all). In fact, Lefebvre claims, the work of art acts as a kind of 'play-generating yeast' in the everyday; an action that suggests both the splitting down into simpler substances and the process of fermentation, agitation and disruption.[14] Developing this theme in the well known opening section of *Everyday Life in the Modern World* some seven years later in 1968 Lefebvre emphasizes the crucial role of James Joyce's novel *Ulysses* in establishing the revelatory character of art's

experimental engagement with the everyday. For Lefebvre, Joyce's 'profoundly boring' book is the first time a piece of creative fiction had dared to exploit language 'to the farthest limits of its resources, including its purely musical potentialities' in order to convey the dailyness of daily life. In so doing, Joyce 'rescues, one after the other, each facet of the quotidian from anonymity'.[15]

For Lefebvre the aim of any investigation of the everyday is 'to grasp a certain quality', to 'get inside' it. But what is there to get inside? For the everyday, as Lefebvre goes on to tell us, is what is 'left over' when specialized knowledge has been exhausted. In the essay that opens this collection Maurice Blanchot goes so far as to suggest that the everyday exhibits an 'absence of qualities', that it cannot be approached cognitively, and 'displays an energizing capacity to subvert intellectual and institutional authority'. It is 'inexhaustible, unimpeachable, always open ended and always eluding forms or structures'. Moreover, the everyday is the site of a fundamental ambiguity: it is both where we become alienated and where we can realize our creativity. Here Blanchot closely follows Lefebvre, who argues that the everyday is the place 'where repetition and creativity confront each other': it is both 'humble and sordid' and 'simultaneously the time and place where the human either fulfils itself or fails'.[16]

Lefebvre not only suggests how difficult it is to answer the question 'what is the everyday?' but also indicates that any attempt to do so using a 'one-way critique' or a single body of existing knowledge may well immobilize the qualities that define the very thing we are concerned to locate. There is no either/or position in the study of the everyday, for to adopt such a stance would miss the complex, contradictory overlapping of alienation and creativity at its heart. Thus the everyday is said to demand an interdisciplinary openness, a willingness to blur creatively the traditional research methods and protocols of disciplines such as philosophy, anthropology and sociology. Perhaps these contradictions and qualifications that characterize the everyday make it seductive territory for those artists who intuitively value the qualities of ambiguity and indeterminacy as ends in their own right (Annette Messager, Susan Hiller, Fischli and Weiss, for example). Most of the art presented or discussed here may aspire to directness and immersion but it does not approach the everyday in any straightforward documentary way. Much of it uses ruses and subterfuge to find ways of representing or engaging with the quotidian (Annette Messager as a trickster and 'word thief'; Stanley Brouwn as someone lost in need of directions; Sophie Calle as a chambermaid rifling through the belongings of hotel guests). Or it adopts a childlike attitude (Yoko Ono's instruction to jump in every puddle; Francis Alÿs playing nursery rhymes with a drumstick on street railings). It trades in a kind of willed naïveté (Gillian Wearing) or nostalgic passivity (Allen Ruppersberg's loving recreation of a café, 'sumptuously filled with romantic detail'). It adopts strategies

associated with schooling and socialization such as copying out lists of instructions – how to cook properly or make a shelf for your kitchen (Annette Messager). It questions the need to make choices when noticing the ordinary (we are going on a journey so we must take our camera and film everything we see – Fischli and Weiss). It takes advantage of chance (the overheard fragments of conversation collected by Ian Breakwell; Gabriel Orozco's films of interesting chance configurations found in the urban landscape; Richard Wentworth's street photos of objects evidencing makeshift solutions to everyday problems). It stages barely noticeable events (Roman Ondák's *SK Parking* – Slovakian Skoda cars parked behind the Secession building in Vienna for two months; or Hans-Peter Feldmann's 'actions' in which he paints the exterior of his family car in different ways, as if he belonged in turn to a rock group, a circus, a striptease club). It deploys poetic devices such as slow motion and the over-extended take (Andy Warhol, Chantal Akerman), or literally shooting from the hip when something captivating comes into sight (Jonas Mekas – who frequently films without looking through the viewfinder). All of which alerts us to another important point about the relation between art and theories of the everyday: most artists don't read Henri Lefebvre or Michel de Certeau in order to discover the ordinary. When the artists above perform these actions they are not doing so in order to illustrate the central theses of *The Practice of Everyday Life* or *Everyday Life in the Modern World*. What becomes evident in the interplay between the theoretical writings of such theorists and the examples of individual artworks presented here is a dialogue in which all of those interested in the everyday search to find a language or form that can adequately convey its complexity, ambiguity and elusiveness.

In a key contribution to the first section 'Art and the Everyday', Jonathan Watkins, who curated the 1988 Sydney Biennale titled 'Every Day', develops a historical and generational argument to account for the contemporary rise of the everyday. He claims that the desire to look at the ordinary is to reassert 'a non ironic kind of realism' and to 'express what it's like to be in the real world'; a desire to communicate what it really feels like 'to be here, now'. This everyday realism is also linked to 'efficacy and unpreciousness' in the way art looks, and a new concern with 'the power of relatively simple gestures' as art connects with lived experience. Such works are 'unforced artistic statements, incidentally profound observations on our lives as lived everyday'. This art has no particular form – in the sense that no one form or style predominates over any other – but the artists selected for the Biennale (and the number here is large, around 100 or so) are united by a shared concern: 'an aspiration to directness, as opposed to gratuitous mediation or obscurantism'. And so, with no individual style privileged over another, works as various as the process-based paintings of Bernard Frize (frequently produced using commonplace tools such as a roller or ad-hoc painting

devices such as four brushes tied together to produce rhythmic paintings that 'embody the passage of time'); the multi-monitor video work *Visible World* by Fischli and Weiss (nearly 100 hours of video footage that transcribes their many unremarkable journeys in which everything they see appears to demand their attention); Vladimir Arkhipov's *Museum of the Handmade Object* (a collection of makeshift, hand crafted devices, tools and household items made by ordinary Russian people out of discarded and broken materials); and Navin Rawanchaikul's *Navin Gallery, Bangkok* (in which taxi drivers sell comic books in their cabs narrating events from their lives) can all 'communicate the nature of the everyday'. The direct simplicity of these artworks is then positioned as a 'rejoinder to played-out operatic tendencies and an overloaded academic (or pseudo-academic) discourse in the visual arts'.[17]

Watkins' polemical assertion that the everyday may be seen as an antidote to a barren, academicized and theoretically overloaded art was not unique in the latter part of the 1990s and several of the essays reproduced here express variants of this belief, most notably those by John Roberts and Nikos Papastergiadis.[18] But it would be a mistake simply to position art as the experimental research arm of everyday life studies. Art may offer models for revealing what is hidden in the everyday but the question of what actually happens to quotidian phenomena when they are recoded into art is still a thorny issue for many critics. Oppositions and contradictions are not smoothed out in this collection and texts range from the affirmative to those condemning the appropriation and containment of the everyday by art. For some, such as Papastergiadis, the particularity of the engagement that art may have with the everyday must be grounded in an awareness of the materiality of art and the type of counter-intuitive knowledge that art might produce. For others, such as Ben Highmore, the relationship of art to the everyday is entirely problematic: while he may develop an argument to support the claim that art, particularly the early twentieth-century avant-garde, has played a fundamental role in identifying the everyday, he also asserts that 'high culture's propensity towards subjective expressionism in relation to the everyday' must be dislodged if the aesthetic is to become an appropriate tool for registering everyday life's contradictions and inexhaustible ambiguity.[19]

The complexity of art's position in relation to the everyday is thus central to the essays in the first section. In addition to key texts by Lefebvre and Blanchot, and those by the authors mentioned above, are a discussion between the curators David Ross and Nicholas Serota on the role of recent art about the everyday in bringing to light new narrative accounts of modernism; Martha Rosler's polemic for an art of *Verfremdunseffekt* or distanciation in order to subvert the myths of the everyday; Jeff Wall's analysis of the role of fellow artist Dan Graham's 1960s magazine works in fusing a 'journalistic attitude … with a

situationist-conceptualist strategy of interventionism, or détournement' in order to intrude into the everyday sites of the media'; and Allen Ruppersberg's *Fifty Helpful Hints on the Art of the Everyday*, which in stark contrast to Rosler's text is a bright and sunny set of aphorisms that encapsulate Ruppersberg's affectionate embrace of the ordinary, summed up by the artist Allan McCollum as 'a love letter to the ephemeral and to memory, a valorization of the things that are destined to disappear'.[20]

These essays and statements help to frame what follows in the subsequent sections on looking and noticing, and on ethnographic and documentary approaches, but it's important to note that they don't in any way contain what comes next. Texts such as Sally Banes' historical overview of the recuperation of the ordinary in the New York art world of the early 1960s; Helen Moleworth's essay on Mary Kelly, Mierle Laderman Ukeles, Judy Chicago and her collaborators, and Martha Rosler; and Lucy Lippard's account of the participation of women in conceptualism; all demonstrate that the everyday was the focus of a wide range of investigations long before the current use of the concept.

The second section, 'The Poetics of Noticing', features a number of shorter texts – works by Yoko Ono, Daniel Spoerri, Ian Breakwell; statements by Marcel Duchamp, the Lettrists, Alison and Peter Smithson; interviews with Stephen Shore, Francis Alÿs and Roman Ondák – all of which highlight strategies to represent that which is apparently untellable or below the threshold of the understood and the seen. This theme of noticing, or attending to, is the fundamental concern of Perec's experimental writings from the early 1970s and the extract included here centres on his attempts to find a model of notation appropriate to the task of simply looking at the everyday and describing an ordinary street scene. The importance of Perec's work to the emergence of the everyday as a site of interest for artists, writers and theorists alike is emphasized in the extracts from an interview with Paul Virilio, who worked with Perec on the journal *Cause Commune* in the late 1960s. He identifies the notion of the 'infra-ordinary' as central to Perec's concern with everydayness (*infra* here meaning below, beneath or after): 'What do we do when we do nothing, what do we do hear when we hear nothing, what happens when nothing happens?' This concern is also explored in the text by Ivone Margulies on the influential early films of Chantal Akerman, who employs extended takes, no camera movement and a lack of any kind of dramatic action as she trains her camera on the repetitions of ordinary life – a woman doing domestic chores, a pension hotel, a New York street scene. Margulies places Akerman's work in the context of neo-realism and the films of Andy Warhol to discuss the representation and experience of boredom as a central concern in any attempt to mine the everyday.

Vincent Kaufmann's text on Guy Debord views the influential situationist idea

WHAT HAPPENS WHEN NOTHING HAPPENS
?

Paul Virilio, Interview on Georges Perec, 2001

of the dérive, the activity of the 'drifter' in the city, as a principle of 'pure mobility' that presages an art with no works. Three texts by critics, on Hans-Peter Feldmann, Fischli and Weiss and Richard Wentworth, and a statement by the artist Gabriel Orozco, focus on art that explores the idea of looking and noticing.

Concluding this section and, at the same time, constructing a bridge to the discussion of ethnography in the next, is Michael Sheringham's text 'Configuring the Everyday', focused on 'projects of attention'. Sheringham takes us directly to the question 'Should we pay attention to the everyday, and if so how should we do it?'. Recognizing that '*quotidienneté* dissolves (into statistics, properties, data) when the everyday is made an object of scrutiny' he proposes that what connects the most redolent and suggestive attempts to acknowledge the everyday is their project-like status. Drawing on examples from French everyday ethnography, such as Cortázar and Dunlop's *Les Autonautes de la cosmoroute, ou Un Voyage intemporel*, a journey from Paris to Marseilles in a camper van during which they never left the immediate confines of the autoroute; Jean Rolin's attempt to walk the line of the Paris meridian; and examples from contemporary art, such as Sophie Calle's *L'Hôtel*, Sheringham details the 'characteristic myopia' of these projects and the attendant 'preoccupation with the domain of practice' as self-imposed rules, tasks and constraints force the authors into an 'interrogative rather than assertive' mode of looking.

The final section, 'Documentary Style and Ethnography', focuses on the idea of 'getting inside' the everyday and the methods that artists have adopted to register the quotidian from a position of being *plongé dans* (plunged into) dailyness and triviality. Of key interest here is the way that various artists appropriate and transform the conventions of documentary filmmaking and photography and the protocols of ethnography as they search for a way to find a form of practice that stays immersed in the everyday. This possibility is explored in the essays by John Roberts, Abigail Solomon-Godeau and Tom McDonough in relation to transgressive forms of popular pleasure in the British art of the 1990s; the intimate 'insider' photographs of Nan Goldin; and the experimental documentary filmmaking of Edgar Morin, Jean Rouch and Guy Debord in the early 1960s. Also included in this section are Joseph Kosuth's call for artists to cultivate cultural fluency as a way of ensuring an anthropological art of engagement and praxis, Susan Hiller's informal lecture about her work *Monument* (1980–81) that reflects on a collaborative form of noticing in order to produce new meanings, and Stephen Willats' statement describing his work *The Lurky Place* (1978), in which he investigates how 'counter consciousness' might be produced by the users of everyday objects and places.

Among the other significant works by artists in this section, Annette Messager's short text pieces from the 1970s are included here as examples of an

art of the everyday that endlessly plays with the conventions of documentary and ethnography to forge a poetics of the social forces, influences and desires that have shaped femininity in post-1945 France. Moving between the twin poles of ethnographer and fantasist, her work shines an ambiguous half-light on the hidden language that underpins the most quotidian of activities, those of washing the dishes, opening the post, finding an appropriate type of signature, sewing, cleaning and cooking. In the resulting notebooks and personal albums, pages from magazines and household instruction manuals are copied, redrawn and collaged together, and then in turn combined with poetic personal maxims, proverbs and omens, repetitive observations about men she sees on the street or photographed in magazines, lists of phrases culled from romance novels and comic books, and photographs of household gestures. All of this is then presented in hundreds of school-type writing books or cheap albums that are almost impossible to classify, in that they both intimately resemble and at the same time distance themselves from the kind of instructional notebooks promoted in women's magazines and schools. Contextualizing her work, Rebecca DeRoo describes how 'by preserving women's work through ethnographic methods that presented it as a form of subculture, Messager not only engaged in a task of preservation and celebration, but also displayed an awareness of limitation'.

Messager's work is emphasized here as it draws together many of the themes presented across this collection. Her projects suggest the active transformation of what she 'points' at, while simultaneously retaining a profound intimacy with it. At the same time, it becomes entirely unclear what her position is in regard to the political potential of this work. Is she simply pointing and saying here is value? Is she advocating a form of historical recovery and a celebration of traditional house-making skills that have been all but obliterated by the educational manuals and popular journals she draws on? Is she simply drawing attention to the overlap of fiction and reality in the everyday? Or is she suggesting that a creative impulse remains buried deep in the activities she documents?

Perhaps this is where Lefebvre's notion of art as play-generating yeast is useful. Artworks that attend to the everyday are not arguments; they do not offer resolutions or indeed even rational observations. As Messager herself suggested in 1976, an art of the everyday might be nothing more than a modest and highly ambiguous form of paying attention and tinkering:

'Annette Messager the Practical Woman, and Annette Messager the Collector "pay attention". They do not want to lose anything: they recuperate whatever winds up in their home, file it and appropriate it. It must be able to be used again (while Annette Messager the Artist dares to be much more extravagant …)

In the end my work is nothing but a very large patchwork, just like our culture is cobbled together, a bric-à-brac of different elements, of heterogeneous

recollections juxtaposed like a patchwork quilt that constitutes our identity: that's why I am so interested in the notion of tinkering. Annette Messager the Artist "tinkers with media" by mixing together photography and drawing in the same image, by altering their functions. So the drawing seems more objective than the photo; it may even become photography's evidence.'[21]

1 'Everyday', 11th Biennale of Sydney (1998); 'The Quiet in the Land: Everyday Life, Contemporary
 Art and The Shakers' (Project with Shaker communities of Maine and an international selection
 of contemporary artists, 1995–98; exhibited at Institute of Contemporary Art, Portland Maine,
 1997; Institute of Contemporary Art, Boston, 1998); 'Quotidiana: The Continuity of the Everyday
 in Twentieth-Century Art', Castello di Rivoli, Museo d'Arte Contemporanea, Turin (2000);
 'American Standard: (Para)normality and the Everyday', Barbara Gladstone Gallery, New York
 (2001); 'Micropolitics: Art and Everyday Life 2001–1968', Espai d'Art Contemporain de Castello,
 Valencia (2003); 'The Everyday Altered', (curated by Gabriel Orozco) 50th Venice Biennale (2003).
 Other exhibitions include: 'The Epic and the Everyday', Hayward Gallery, London (1994); 'Radical
 Scavengers: The Conceptual Vernacular in Recent American Art', Museum of Contemporary Art,
 Chicago (1994); 'The Art of the Everyday: France in the Nineties', Grey Art Gallery and Study
 Center, New York (1997); 'Snapshots: The Photography of Everyday Life 1888 – Present'; San
 Francisco Museum of Modern Art (1998); 'Experiments in the Everyday: Allan Kaprow and Robert
 Watts: Events, Objects, Documents', Wallach Art Gallery, Columbia University, New York (1999);
 'Definition of Everyday', 2nd Prague Biennial (2003); 'Days Like These', Tate Britain (2003);
 'Everyday: Contemporary Art from Japan China, Korea and Thailand' Kunstforeningen,
 Copenhagen (2003); 'The Interventionists: User's Manual for the Creative Disruption of Everyday
 Life', Massachusetts Museum of Contemporary Art, North Adams, Massachusetts (2004); 'Art,
 Design and Everything Else'. 6th Shanghai Biennale (2005); 'An Image Bank for Everyday
 Revolutionary Life', Roy and Edna Disney CalArts Theater, Los Angeles (2006); 'Spinnwebzeit: Die
 ebay-Vernetzung' ('Spinning the Web: The e-bay Connection'), Museum für Moderne Kunst,
 Frankfurt am Main (2006); 'Homework', Gagosian Gallery, Berlin, 4th Berlin Biennale for
 Contemporary Art (2006); 'Everyday Laughter' section, 'All About Laughter: Humour in
 Contemporary Art', The Mori Art Museum, Tokyo (2007); 'Everyday People, Twentieth-Century
 Photographs from the Menil Collection', Menil Collection, Houston, Texas (2007).
2 David Ross and Nicholas Serota, 'Quotidiana', in this collection.
3 Geoff Dyer on Richard Wentworth, in this collection.
4 Kristin Ross, 'French Quotidian', in The Art of the Everyday (1997, see bibliography) 28.
5 Boris Groys, in Peter Fischli and David Weiss, Swiss Pavilion, XLVI Venice Biennale (1995).
6 Steven Harris and Deborah Berke, The Architecture of the Everyday (Princeton, New Jersey:
 Princeton Architectural Press, 1997) 3.
7 John Roberts, 'Mad For It', in this collection.
8 Ivone Margulies, 'Nothing Happens', in this collection.
9 Rebecca J. DeRoo, The Museum Establishment and Contemporary Art: The Politics of Artistic

Display in France after 1968 (Cambridge, England: Cambridge University Press, 2006) 2.

10　Jose Miguel G. Cortes, Introduction, in Juan Vincente Aliaga, et al., *Micropolitics: Art and Everyday Life 2001–1968* (Valencia: Espai d'Art Contemporani de Castello, 2003).

11　See John Roberts, *Philosophizing the Everyday: Revolutionary Praxis and the Fate of Cultural Theory* (London: Pluto Press, 2006) 1.

12　Michael Sheringham, *Everyday Life: Theories and Practices from Surrealism to the Present* (Oxford: Oxford University Press, 2006).

13　See Roberts, *Philosophizing the Everyday*, op. cit., 1. On the centrality of the everyday to Russian avant-garde, Surrealist and German photographic culture see John Roberts, *The Art of Interruption. Realism, Photography and the Everyday* (1998). On Surrealism see Michael Sheringham, op. cit., Michael Gardner, *Critiques of Everyday Life* (2000); and Roberts, op. cit. On Mass-Observation see Ben Highmore, *Everyday Life and Cultural Theory* (20020; On Lefebvre see Stuart Elden, *Understanding Henri Lefebvre* (2004); Rob Shields, *Lefebvre, Love and Struggle* (1999). On design see Andrew Blauvelt, *Strangely Familiar: Design and Everyday Life* (2003). On cultural studies see Elizabeth B. Silva and Tony Bennett, *Contemporary Culture and Everyday Life* (2004). And on aesthetics see Andrew Light and John M. Smith, *The Aesthetics of Everyday Life* (2005).

14　*Critique of Everyday Life* (1961) vol. 2 (London: Verso, 2002) 3.

15　Lefebvre, *Everyday Life in the Modern World* (New York: Harper & Row, 1971) 2–3.

16　Lefebvre, 'Clearing The Ground' in *Critique of Everyday Life* (1961), vol 2 (London: Verso, 2002) 47; reprinted in this collection.

17　Watkins, in this collection.

18　Harris and Berke use an almost identical language in the introduction to *The Architecture of the Everyday* (op. cit.): 'the hegemony of structuralism and its derivatives' they assert, coincided with the 'virtual abandonment of architecture's social and political ambitions and the estrangement of direct experience from architectural discourse'. Clearly, the rise of the everyday in contemporary art is part of a much larger picture and connects not just with architectural discourse, but also with wider changes and transformations in the social sciences and humanities over the past thirty years. In his recent book about the centrality of the idea of everyday life in postwar French culture, Michael Sheringham goes so far as to suggests that in the 'new cross-disciplinary academic world, the everyday becomes the litmus test of viability' (Sheringham, op. cit., 295). This arises because, firstly 'the end of the structuralist embargo on subjectivity and reference' emphasizes lived experience, and secondly a turn to 'new ways of looking at the concrete human subject at grips with experience' brings with it 'a desire to escape from disciplinary pigeonholes' (Ibid., 300).

19　See also Highmore, Introduction, *The Everyday Life Reader* (2002) and 'Rough Poetry: *Patio and Pavilion* Revisited', *Oxford Art Journal*, vol. 29, no. 2 (Spring 2006) 269–73.

20　Allan McCollum, 'Allen Ruppersberg: What One Loves about Life are the Things that Fade', in *Allen Ruppersberg* (Limousin: Fonds regional d'art contemporain de Limousin, 2001) 20.

21　Annette Messager, 'Patchwork' (1976) in *Word for Word* (2006, see bibliography).

I HAVE LEARNED

A
LOT
BY

PUTTING MY WORK IN TEMPLES,
STREETS AND TAXI CABS

Navin Rawanchaikul, *Out of the Gallery and into the Taxi Cab*, 2005

ART AND THE EVERYDAY

Henri Lefebvre
Clearing the Ground//1961

Common-sense objections [to the critique of everyday life]:
To begin with, everyday life does not exist as a generality. There are as many everyday lives as there are places, people and ways of life. Everyday life is not the same in Timbuktu, in Paris, in Teheran, in New York, in Buenos Aires, in Moscow, in 1900, in 1960. In fact, what do the words mean? Whatever is repeated on a daily basis? The action of opening or shutting doors, of eating and drinking? Only organic functions correspond to your definition. Utterly without interest.

Everyday life in art? In politics? That must mean the everyday life of the artist, of the politician, what they eat, what they drink, how good or bad their digestion is. As far as art or politics is concerned, utterly unimportant. You are just a vulgar materialist ...

Reply
Do you really think you have understood what the words *critique of everyday life* actually mean? Is it a question of describing, comparing and discovering what might be identical or analogous in Teheran, in Paris, in Timbuktu or in Moscow? Such an aim would indeed be restricted to the basic and the physiological. The aim of a critique of everyday life is quite different. It is a question of discovering what must and can change and be transformed in people's lives, in Timbuktu, in Paris, in New York or in Moscow. It is a question of stating critically how people live or how badly they live, or how they do not live at all. Would you go so far as to say that everyday life cannot change? If so, you destroy your own argument, because you have already admitted that it can. Critique implies possibilities, and possibilities as yet unfulfilled. It is the task of critique to demonstrate what these possibilities and this lack of fulfilment are. Do you think that basic physiological demands – organic functions, as you call them – are external to social life, to culture, to civilization, and are thus unchangeable, or relatively so? Such a postulate would be highly debatable and highly dangerous. Moreover, the term 'everyday' has misled you. You take it literally rather than seeing its deeper meaning. Do you think that the repetitions which take place each week and each season are not part of everyday life? Frequently, and not for the last time, we have taken rhythms and cyclic time scales to be one of the contents of the everyday, with all that they organize and command, even when they are broken and fragmented by linear time scales. This is something which supersedes 'the everyday' in its strictest sense. And

another thing: do you think that art is external and superior to real life, and that what the artist creates is on a transcendental plane? Similarly, do you think that politics and the state are above everyday life and external to society? Critique of everyday life encompasses a critique of art by the everyday and a critique of the everyday by art. It encompasses a critique of the political realms by everyday social practice and vice versa. In a similar sense, it includes a critique of sleep and dreams by wakefulness (and vice versa), and a critique of the real by the imaginary and by what is possible, and vice versa. This is to say that it begins by establishing dialectical links, reciprocities and implications rather than an unrelated hierarchy, as you do. Finally, please note that what you say about the diversity of everyday lives is less and less true. Technological or industrial civilization tends to narrow the gaps between lifestyles (we are not talking about living standards) in the world as a whole. Having said that, your argument has a point and raises a question. Would everyday life be merely the humble and sordid side of life in general, and of social practice? To repeat the answer we have already given: *yes* and *no*. Yes, it is the humble and sordid side, but not only that. Simultaneously it is also the time and the place where the human either fulfils itself or fails, since it is a place and a time which fragmented, specialized and divided activity cannot completely grasp, no matter how great and worthy that activity may be ...

Objections from historians

Everyday life is an aspect of history, an interesting one, maybe, but minor. To study it in itself and for itself entails certain dangers. Like it or not, aren't you falling back on the anecdotal, on something external to events and their deep-seated reasons and causes? Over the last few years there have been volumes and even entire series dedicated to everyday life in such and such a society, at such and such an epoch. Sometimes these are the work of serious historians. But do you honestly believe that they do not bypass history, that they are not merely marginal or anecdotal? Except when they deal with archaic societies, and are written by ethnographers, they add nothing to what we already know ...

Reply

Agreed on one major point: history is a fundamental science. The human being is historical and its historicity is inherent to it: it produces and is produced, it creates its world and creates itself. Having said that, let us not simplify the process of historical becoming, and let us avoid historicism. Everything is historical, agreed, but not equally so. History as a science does not exhaust the human. It neither eliminates nor absorbs political economy, sociology or psychology. Remember what we sometimes refer to as historical drift, in other words the gap between

intentions, actions and results. There can be no history without a critique of history itself. Above all remember the issue of uneven development. In the links between mankind (human groups) and nature, is that not a significant factor? And there is not only history, but culture too, and civilization ... [...] For us, here, the question is the modern everyday. We observe that history has had the following result: the separation from what is historical *per se* of that other aspect of history and of the human which we call the everyday. Today, in our society, everyday life and culture, everyday life and historical event, are dissociated (but without losing their solidarity completely). Marx was the first to perceive this characteristic of the period. Read the *Critique of Hegel's Philosophy of the State* again, where Marx points out the modern rift between private and public life which did not exist in antiquity or in the Middle Ages:

> The abstraction of the state as such was not born until the modern world because the abstraction of private life was not created until modern times ... The abstract reflected antithesis of this is to be found only in the modern world. The Middle Ages were an age of real dualism; the modern world is the age of abstract dualism.[1]

We could study literary history, and in particular the history of the novel, in this light. We would see how the narrative of the novel distances itself from the epic and the tragic, just as the everyday it describes becomes distant from historical action and cultural totality. In fact it is true that at certain moments institutions, culture, ideologies and the most important results of history are forcefully brought into the everyday life over which they formerly towered; there they find themselves accused, judged and condemned: grouped together, people declare that these institutions, these ideas, these forms of state and culture, these 'representations' are no longer acceptable and no longer represent them. Then, united in groups, in classes, in peoples, men are no longer prepared to live as before, and are no longer able to do so. They reject whatever 'represented', maintained and chained them to their previous everyday life. These are the great moments of history: the stirrings of revolution. At this point, the everyday and the historical come together and even coincide, but in the active and violently negative critique which history makes of the everyday. After which, the wave subsides and spreads out in a backward surge. What other moments are there when the distance between what history makes possible and what it has achieved becomes so great, like the distance between what men have wanted, what has resulted, and what they have lived? History is necessary, but by itself it is inadequate. According to Marx, this historicity is nothing more than a summary of the prehistory of mankind, and indeed the men it tries to define

become aware of alternative forms of knowledge and critique. To sum up, the historian wishes to challenge the critique of everyday life in the name of science: but critique of everyday life will in turn challenge and accuse history in so far as it is a mere series of *faits accomplis*, in so far as it is history which has reduced the everyday to the state in which we find it! [...]

VIII

How can everyday life be defined? It surrounds us, it besieges us, on all sides and from all directions. We are inside it and outside it. No so-called 'elevated' activity can be reduced to it, nor can it be separated from it. Its activities are born, they grow and emerge; once they have left the nourishing earth of their native land, not one of them can be formed and fulfilled on its own account. In this earth they are born. If they emerge, it is because they have grown and prospered. It is at the heart of the everyday that projects become works of creativity.

Knowledge, science and scientific discovery sometimes consist of brief instants of discovery. Yet science has its everyday life: training, teaching, the climate in scientific circles, administrative questions, the way institutions operate, etc.

The professional soldier dedicates himself to heroism. The army prepares itself for war; that is its aim and its purpose. And yet moments of combat and opportunities to be heroic are thin on the ground. The army has its everyday life: life in barracks and more precisely life among the troops (otherwise known as the 'contingent'; lexical familiarity may veil what is ironic and dialectical about this, but here, as elsewhere, the 'contingent' is the 'necessary'!). This everyday life is not without its importance in relation to dreams of heroism and the fine moral ideal of the professional soldier. It is the springboard for sublime actions. Questions of rank, promotion and military honours are part of it. There is a saying that army life is made up of a lot of boredom and a couple of dangerous moments.

Let us consider the state and the practical operation of its managerial spheres. There is an everyday life of the state. It is not the same thing as the everyday (private) lives of public figures. It has a well-known name: bureaucracy. There is a political everyday, the everyday of parties, apparatus, relations between these bodies and the masses who elect them and whom they administer. To study the everyday life of the state would thus be to study *in vivo* and *in concreto* the functions and the functioning of bureaucratic apparatuses and their relation to social praxis. Emerging above this everyday life are important decisions and dramatic moments of decisive action.

Factories, trades unions, work and the relations between workers all have their own everyday life. And from that everyday life come strikes, or the introduction of new technologies, etc.

IX

Should we define the everyday as the petty side of life, its humble and sordid element? As we already said, yes and no. Yes, this small, humble and sordid side of all human existence has been part of the everyday since time began, and until there is a project, a policy to restore technical possibilities to the everyday in order to overturn it from top to bottom, it may well be so for a long time to come.

> Every day thousands upon thousands of women sweep up the dust which has gathered imperceptibly since the previous day. After every meal, too numerous to count, they wash the dishes and saucepans. For times too numerous to count, by hand or in the machine, they remove the dirt which has built up bit by bit on sheets and clothes; they stop up the holes the gentle rubbing of heels inevitably makes; they fill emptied cupboards and refrigerators with packets of pasta and kilos of fruit and vegetables … [*which explains the following definition of everyday life*:] The ensemble of activities which of necessity result from the general processes of development: evolution, growth and ageing, of biological or social protection or change, those processes which escape immediate notice and which are only perceptible in their consequences.[2]

This attempt at a definition, with the vivid description which accompanies it, sheds a remarkable light on one aspect of the everyday: the reverse side of all praxis. However, it prompts several reservations and criticisms. Like all definitions, it tends to immobilize what it is trying to define, presenting it as timeless and unchangeable. And as definitions frequently do, it takes one aspect or one part as the whole.

If things were like this, the study of everyday life would be easy and critique of it would be effortless. It would suffice to note down and emphasize trivial details from one day to the next, the daily gestures with their inevitable repetitions. And after that a simple project: work, family life, immediate relations (block of flats, neighbourhood or village, town), leisure. The impoverished eloquence of tape-recorded interviews would reveal the poverty and misfortunes of the everyday. Analysis of the content of these interviews, and in particular of their language, would quickly single out a certain number of themes: loneliness, monotony, insecurity, discussions on solutions and the absence of solutions, on the advantages and disadvantages of marriage, on professional occupations. One could possibly examine these themes using the well-tried methods of sociology or combinative analysis. One might succeed in determining fairly precisely attitudes within or towards the everyday (attitudes of acceptance, but more often of rejection) in certain groups. As well as quantifying in this way, the inquiry would retain a certain number of privileged

pieces of evidence. It could even go so far as to attempt some experiments (similar to the somewhat too successful experiment in which a study group simulated a serious car accident in order to observe the behaviour of the other drivers on the road!).

With the help of a little irony, this path could lead us a long way. One may conceive of a sociology of the reverse images of society and of its duplicates, sacred or cursed. A social group is characterized just as much by what it rejects as by what it consumes and assimilates. The more economically developed a country is, the more gets thrown away, and the faster it gets thrown away. People are wasteful. In New York, in the promised land of free enterprise, the dustbins are enormous, and the more visible they are the more inefficiently public services operate. In underdeveloped countries, nothing is thrown away. The smallest piece of paper or string, the smallest tin is of use, and even excrement is gathered. What we are outlining here is a sociology of the dustbin. [...]

If this were all there was, critique of everyday life would only bring the disappointing aspects of social praxis to the fore. It would emphasize the trivial and the repellant. It would paint a black picture of dissatisfaction. It would tend to concentrate on the sordid side of life, on suffering, on a rather old-fashioned populism. It would use the pseudo-realism of a Bernard Buffet or the stammering, desperate lyricism of a Samuel Beckett as a means of understanding social man. If this were the only path it followed, critique of everyday life would be barely distinguishable from a certain branch of existentialism which took it upon itself – and very skilfully – to underline the marginal elements of existence. To a philosophy like this, all analysis of everyday life would contribute would be scientific jargon and a stodgy sociological pretentiousness.

The hypothesis of our study is rather different. According to this hypothesis, which underpins the programme as a whole, it is in everyday life and starting from everyday life that genuine *creations* are achieved, those creations which produce the human and which men produce as part of the process of becoming human: works of creativity.

These superior activities are born from seeds contained in everyday practice. From the moment groups or individuals are able and obliged to plan ahead, to organize their time and to use whatever means they have at their disposal, reason is formed in social practice. As day follows trivial day, the eye learns how to see, the ear learns how to hear, the body learns how to keep to rhythms. But the essential lies elsewhere. What is most important is to note that feelings, ideas, lifestyles and pleasures are confirmed in the everyday. Even, and above all, when exceptional activities have created them, they have to turn back towards everyday life to verify and confirm the validity of that creation. Whatever is produced or constructed in the superior realms of social practice must

demonstrate its reality in the everyday, whether it be art, philosophy or politics. At this level alone can it be authenticated. What does such and such an idea or creative work tell us? In what way and how far does it change our lives? It is everyday life which measures and embodies the changes which take place 'somewhere else', in the 'higher realms'. The human world is not defined simply by the historical, by culture, by totality or society as a whole, or by ideological and political super-structures. It is defined by this intermediate and mediating *level*: everyday life. In it, the most concrete of dialectical movements can be observed: need and desire, pleasure and absence of pleasure, satisfaction and privation (or frustration), fulfilments and empty spaces, work and non-work. The repetitive part, in the mechanical sense of the term, and the creative part of the everyday become embroiled in a permanently reactivated circuit in a way which only dialectical analysis can perceive.

In short, the everyday is not a synonym for *praxis*. If we look at it in its entirety, praxis is the equivalent of totality in action; it encompasses the base and the superstructures, as well as the interactions between them. This view of praxis may be rather too sweeping, but if we substitute it with something more restricted and determined, it will disintegrate into fragmented practices: technology, politics, etc. We will have to look at the category of *praxis* again. For us, the everyday is a *level*.

Critique of unfulfilment and alienation should not be reduced to a bleak picture of pain and despair. It implies an endless appeal to *what is possible* in order to judge the present and what has been accomplished. It examines the dialectical movements intrinsic to what is concrete in the human, i.e., to the everyday: the possible and the impossible, the random and the certain, the achieved and the potential. The real can only be grasped and appreciated via potentiality, and what has been achieved via what has not been achieved. But it is also a question of *determining* the possible and the potential and of knowing which yardstick to use. Vague images of the future and man's prospects are inadequate. These images allow for too many more-or-less technocratic or humanist interpretations. If we are to know and to judge, we must start with a precise criterion and a centre of reference: the everyday.

It is in this sense that in Volume I of *Critique of Everyday Life* we defined everyday life initially as the region where man appropriates not so much external nature but *his own nature* – as a zone of demarcation and junction between the *uncontrolled sector* and the *controlled sector* of life – and as a region where *goods* come into confrontation with needs which have more or less been transformed into desires.

This definition is not exhaustive, and needs to be more thorough. Let us go back to the definition we suggested previously. It raises several questions

concerning the general processes of growth, development, maturation and decline. To what extent do these general processes (not only individual ones, but social and historical as well) go beyond the boundaries of the everyday? Do they abandon it? To what extent do they return to it? This is a question which will have to be addressed.

X

Let us look at things from another perspective. Let us use our thought and imagination to exclude specialized activities from praxis. If this abstraction is successful, it will rid practical experience of discreet occupations like the use of such and such a technique or implement (but not, of course, in physical terms of effort, time consumed, rhythm or absence of rhythm). What are we left with?

Nothing (or virtually nothing), say the positivists, scientists, technologues and technocrats, structuralists, culturalists, etc.

Everything, say the metaphysicians, who would consider that this abstraction or analytic operation scarcely attains the 'ontic' and is still far removed from the 'ontological', i.e., it fails to grasp the foundation, being (or nothingness).

Something, we will say, which is not easy to define, precisely since this 'something' is not a thing, nor a precise activity with determined outlines. So what is it? A mixture of nature and culture, the historical and the lived, the individual and the social, the real and the unreal, a place of transitions, of meetings, interactions and conflicts, in short a *level* of reality.

In one sense there is nothing more simple and more obvious than everyday life. How do people live? The question may be difficult to answer, but that does not make it any the less clear. In another sense nothing could be more superficial: it is banality, triviality, *repetitiveness*. And in yet another sense nothing could be more profound. It is existence and the 'lived', revealed as they are before speculative thought has transcribed them: what must be changed and what is the hardest of all to change.

This proves the general methodological principle of *double determination*. In our opinion, this is essential to dialectical thought, which is not restricted simply to discovering links (differences, oppositions, polarities and reciprocal implications, conflicts and contradictions, etc.) between determinations. It discovers differences, dualities, oppositions and conflicts within each determination (by conceptualizing it, i.e., thinking of it within a concept). [...]

XII

Having defined in outline everyday life as a level (of social reality) we can consider individuals' and groups' situation in relation to this level. Conversely, it allows us to clarify the ideas of level and of the everyday, as a level of reality.

Thus it is clear that in terms of the everyday, the situation of a housewife and a 'society woman', of a tool-maker and a mathematician, is not the same. The housewife is immersed in everyday life, submerged, swallowed up; she never escapes from it, except on the plane of unreality (dreams: fortune tellers, horoscopes, the romantic press, anecdotes and ceremonies on television, etc.). The 'society woman' gets out of it by artificial means: society life, fashion shows, snobbery, aestheticism or the pursuit of 'pure' pleasure. The mathematician gets out of it by way of an extremely specialized activity in which, as it happens, moments of creativity are few and far between. If he 'is' a mathematician and nothing but a mathematician, how insipid and unbearably obsessive he will be! The more highly qualified and technical an activity becomes, the more remote from everyday life the time it takes up becomes; and the more urgent the need becomes for a return to the everyday. For the housewife, the question is whether she can come to the surface and stay there. For the mathematician, the question is whether he can rediscover an everyday life in order to fulfil himself not only as a scholar (even if he is a genius), but also as a human being. And the 'society woman'? No questions, Your Honour. [...]

1 Karl Marx, Critique of Hegel's Doctrine of the State in *Early Writings* (Harmondsworth: Penguin, 1975) 90.

2 This is from a report sent by Christiane Peyre of the Centre national de la recherche scientifique (CNRS) to the Groupe d'études de sociologie de la vie quotidienne, Centre d'Études Sociologiques (1960–61).

Henri Lefebvre, *Critique de la vie quotidienne II, Fondements d'une sociologie de la quotidienneté* (Paris: L'Arche, 1961); trans. John Moore, *Critique of Everyday Life, vol. 2: Foundations for a Sociology of the Everyday* (London and New York: Verso, 2002) 18-22; 44-47; 51.

Maurice Blanchot
Everyday Speech//1962

The Everyday: What is Most Difficult to Discover

In a first approximation, the everyday is what we are first of all, and most often: at work, at leisure, awake, asleep, in the street, in private existence. The everyday, then, is ourselves, ordinarily. In this first stage, let us consider the everyday as without a truth proper to itself: our move then will be to seek to make it

participate in the diverse figures of the True, in the great historical transformations, in the becoming of what occurs either below (economic and technical change) or above (philosophy, poetry, politics). Accordingly, it will be a question of opening the everyday onto history, or even, of reducing its privileged sector: private life. This is what happens in moments of effervescence – those we call revolution – when existence is public through and through. Commenting upon the law regarding suspects during the French Revolution, Hegel showed that each time the universal is affirmed in its brutal abstract exigency, every particular will, every separate thought falls under suspicion. It is no longer enough to act well. Every individual carries in himself a set of reflections, of intentions, that is to say reticences, that commit him to an oblique existence. To be suspect is more serious than to be guilty (hence the seeking of confession). The guilty party relates to the law to the extent that he manifestly does everything he must in order to be judged, that is, in order to be suppressed, brought back to the void of the empty point his self conceals. The suspect is that fleeting presence that does not allow recognition, and, through the part always held back that he figures forth, tends not only to interfere with, but to bring into accusation, the workings of the State. From such a perspective, each governed is suspect, but each suspect accuses the one who governs and prepares him to be at fault, since he who governs must one day recognize that he does not represent the whole, but a still particular will that only usurps the appearance of the universal. Hence the everyday must be thought of as the suspect (and the oblique) that always escapes the clear decision of the law, even when the law seeks, by suspicion, to track down every indeterminate manner of being: everyday indifference. (The suspect: any and everyone, guilty of not being able to be guilty.)

But, in a new step, the critique (in the sense that Henri Lefebvre, by establishing 'the critique of everyday life', has used this principle of reflection) is no longer content with wanting to change day-to-day life by opening it onto history and political life: it would prepare a radical transformation of *Alltäglichkeit* [commonplacesness]. A remarkable change in point of view. The everyday is no longer the average, statistically established existence of a given society at a given moment; it is a category, a utopia and an Idea, without which one would not know how to get at either the hidden present, or the discoverable future of manifest beings. Man (the individual of today, of our modern societies) is at the same time engulfed within and deprived of the everyday. And – a third definition – the everyday is also the ambiguity of these two movements, the one and the other hardly discernible.

From here, one can better understand the diverse directions in which the study of the everyday might be oriented (bearing now upon sociology, now upon ontology, at another moment upon psychoanalysis, politics, linguistics,

literature). To approach such a movement one must contradict oneself. The everyday is platitude (what lags and falls back, the residual life with which our trash cans and cemeteries are filled: scrap and refuse), but this banality is also what is most important, if it brings us back to existence in its very spontaneity and as it is lived – in the moment when, lived, it escapes every speculative formulation, perhaps all coherence, all regularity. Now we evoke the poetry of Chekhov or even Kafka, and affirm the depth of the superficial, the tragedy of nullity. Always the two sides meet: the daily with its tedious side, painful and sordid (the amorphous, the stagnant), and the inexhaustible, irrecusable, always unfinished daily that always escapes forms or structures (particularly those of political society: bureaucracy, the wheels of government, parties). And that there may be a certain relation of identity between these two opposites is shown by the slight displacement of emphasis that permits passage from one to the other; as when the spontaneous, the informal – that is, what escapes forms – becomes the amorphous and when, perhaps, the stagnant merges with the *current* of life, which is also the very movement of society.

Whatever its other aspects, the everyday has this essential trait: it allows no hold. It escapes. It belongs to insignificance, and the insignificant is without truth, without reality, without secret, but perhaps also the site of all possible signification. The everyday escapes. This makes its strangeness – the familiar showing itself (but already dispersing) in the guise of the astonishing. It is the unperceived, first in the sense that one has always looked past it; nor can it be introduced into a whole or 'reviewed', that is to say, enclosed within a panoramic vision; for, by another trait, the everyday is what we never see for a first time, but only see again, having always already seen it by an illusion that is, as it happens, constitutive of the everyday.

Hence the exigency – apparently laughable, apparently inconsequential, but necessary – that leads us to seek an always more immediate knowledge of the everyday. Henri Lefebvre [in *Everyday Life in the Modern World*, 1962] speaks of this as the Great Pleonasm. We want to be abreast of everything that takes place at the very instant that it passes and comes to pass. The images of events and the words that transmit them are not only inscribed instantaneously on our screens, in our ears, but in the end there is no event other than this movement of universal transmission: 'the reign of an enormous tautology.' The disadvantages of a life so publicly and immediately displayed are henceforth observable. The means of communication – language, culture, imaginative power – by never being taken as more than means, wear out and lose their mediating force. We believe we know things immediately, without images and without words, and in reality we are dealing with no more than an insistent prolixity that says and shows nothing. How many people turn on the radio and leave the room, satisfied with this

distant and sufficient noise? Is this absurd? Not in the least. What is essential is not that one particular person speak and another hear, but that, with no one in particular speaking and no one in particular listening, there should nonetheless be speech, and a kind of undefined promise to communicate, guaranteed by the incessant coming and going of solitary words. One can say that in this attempt to recapture it at its own level, the everyday loses any power to reach us, it is no longer what is lived, but what can be seen or what shows itself, spectacle and description, without any active relation whatsoever. The whole world is offered to us, but by way of a look. We are no longer burdened by events, as soon as we behold their image with an interested, then simply curious, then empty but fascinated look. What good is it taking part in a street demonstration, since at the same moment, secure and at rest, we are at the demonstration itself, thanks to a television set? Here, produced-reproduced, offering itself to our view in its totality, it allows us to believe that it takes place only so that we might be its superior witness. Substituted for practice is the pseudo-acquaintance of an irresponsible gaze; substituted for the movement of the concept – a task and a work – is the diversion of a superficial, uncaring and satisfied contemplation. Man, well protected within the four walls of his familial existence, lets the world come to him without peril, certain of being in no way changed by what he sees and hears. 'Depoliticization' is linked to this movement. And the man of government who fears the street – because the man in the street is always on the verge of becoming political man – is delighted to be no more than an entrepreneur of spectacle, skilled at putting the citizen in us to sleep, the better to keep awake, in the half-light of a half-sleep, only the tireless voyeur of images.

Despite massive development of the means of communication, the everyday escapes. This is its definition. We cannot help but miss it if we seek it through knowledge, for it belongs to a region where there is still nothing to know, just as it is prior to all relation in so far as it has always already been said, even while remaining unformulated, that is to say, not yet information. It is not the implicit (of which phenomenology has made broad use); to be sure, it is always already there, but that it may be there does not guarantee its actualization. On the contrary, the everyday is always unrealized in its very actualization which no event, however important or however insignificant, can ever produce. Nothing happens; this is the everyday. But what is the meaning of this stationary movement? At what level is this 'nothing happens' situated? For whom does 'nothing happen' if, for me, something is necessarily always happening? In other words, what corresponds to the 'who?' of the everyday? And, at the same time, why, in this 'nothing happens', is there the affirmation that something essential might be allowed to happen?

What questions these are! We must at least try to hold onto them. Pascal

gives a first approach, which is taken up again by the young Lukàcs and by certain philosophies of ambiguity. The everyday is life in its equivocal dissimulation, and 'life is an anarchy of *clair-obscur*. ... Nothing is ever completely realized and nothing proceeds to its ultimate possibilities ... Everything interpenetrates, without discretion, in an impure mix, everything is destroyed and broken, nothing blossoms into real life ... It can only be described through negations ...' This is Pascalian diversion, the movement of turning this way and that; it is the perpetual alibi of an ambiguous existence that uses contradictions to escape problems, remaining undecided in a restless quietude. Such is quotidian confusion. Seeming to take up all of life, it is without limit and it strikes all other life with unreality. But there arises here a sudden clarity. 'Something lights up, appears as a flash on the paths of banality ... it is chance, the great instant, the miracle.' And the miracle 'penetrates life in an unforeseeable manner ... without relation to the rest, transforming the whole into a clear and simple account.'[1] By its flash, the miracle separates the indistinct moments of day-to-day life, suspends nuance, interrupts uncertainties, and reveals to us the tragic truth, that absolute and absolutely divided truth, whose parts solicit us without pause, and from each side, each of them requiring everything of us and at every instant.

Against this movement of thought nothing can be said, except that it misses the everyday. For the ordinary of each day is not such by contrast with some extraordinary; this is not the '*nul moment*' that would await the 'splendid moment' so that the latter would give it a meaning, suppress or suspend it. What is proper to the everyday is that it designates for us a region, or a level of speech, where the determinations true and false, like the oppositions yes and no, do not apply – it being always before what affirms it and yet incessantly reconstituting itself beyond all that negates it. An unserious seriousness from which nothing can divert us, even when it is lived in the mode of diversion; so we experience it through the boredom that seems to be indeed the sudden, the insensible apprehension of the quotidian into which one slides in the levelling of a steady slack time, feeling oneself forever sucked in, though feeling at the same time that one has already lost it, and is henceforth incapable of deciding if there is a lack of the everyday, or if one has too much of it. Thus is one maintained in boredom by boredom, which develops, says Friedrich Schlegel, as carbon dioxide accumulates in a closed space when too many people find themselves together there.

Boredom is the everyday become manifest: as a consequence of having lost its essential, constitutive trait of being *unperceived*. Thus the daily always sends us back to that inapparent, nonetheless unhidden part of existence: insignificant because always before what signifies it; silent, but with a silence already dissipated as soon as we keep still in order to hear it, and that we hear better in that unspeaking speech that is the soft human murmuring in us and around us.

The everyday is the movement by which the individual is held, as though without knowing it, in human anonymity. In the everyday we have no name, little personal reality, scarcely a face, just as we have no social determination to sustain or enclose us. To be sure, I work daily, but in the day-to-day I am not a worker belonging to the class of those who work. The everyday of work tends to keep me apart from this belonging to the collectivity of work that founds its truth; the everyday breaks down structures and undoes forms, even while ceaselessly regathering itself behind the form whose ruin it has insensibly brought about.

The everyday is human. The earth, the sea, forest, light, night, do not represent everydayness, which belongs first of all to the dense presence of great urban centres. We need these admirable deserts that are the world's cities for the experience of the everyday to begin to overtake us. The everyday is not at home in our dwelling-places, it is not in offices or churches, any more than in libraries or museums. It is in the street – if it is anywhere. Here I find again one of the beautiful moments of Lefebvre's books. The street, he notes, has the paradoxical character of having more importance than the places it connects, more living reality than the things it reflects. The street renders public. 'The street tears from obscurity what is hidden, publishes what happens elsewhere, in secret; it deforms it, but inserts it in the social text.' And yet what is published in the street is not really divulged; it is said, but this 'is said' is borne by no word ever really pronounced, just as rumours are reported without anyone transmitting them and because the one who transmits them accepts being no one. There results from this a perilous irresponsibility. The everyday, where one lives as though outside the true and the false, is a level of life where what reigns is the refusal to be different, a yet undetermined stir: without responsibility and without authority, without direction and without decision, a storehouse of anarchy, since casting aside all beginning and dismissing all end. This is the everyday. And the man in the street is fundamentally irresponsible; while having always seen everything, he is witness to nothing. He knows all, but cannot answer for it, not through cowardice, but because he takes it all lightly and because he is not really there. Who is there when the man in the street is there? At the most a 'who?', an interrogation that settles upon no one. in the same way indifferent and curious, busy and unoccupied, unstable, immobile. So he is; these opposing but juxtaposed traits do not seek reconciliation, nor do they, on the other hand, counter one another, all the while still not merging; it is the *vicissitude* itself that escapes all dialectical recovery.

To the above it must be added that the irresponsibility of rumour – where everything is said, everything is heard, incessantly and interminably, without anything being affirmed, without there being a response to anything – rapidly grows weighty when it gives rise to 'public opinion', but only to the degree that

what is propagated (and with what ease] becomes the movement of propaganda: that is to say, when in the passage from street to newspaper, from the everyday in perpetual becoming to the everyday transcribed {I do not say inscribed), it becomes informed, stabilized, put forth to advantage. This translation modifies everything. The everyday is without event; in the newspaper this absence of event becomes the drama of the news item. In the everyday, everything is everyday; in the newspaper everything is strange, sublime, abominable. The Street is not ostentatious, passers-by go by unknown, visible-invisible, representing only the anonymous 'beauty' of faces and the anonymous 'truth' of people essentially destined to pass by, without a truth proper to them and without distinctive traits (when we meet someone in the street, it comes always by surprise and as if by mistake, for one does not recognize oneself there; in order to go forth to meet another, one must first tear oneself away from an existence without identity). Now in the newspaper, everything is announced, everything is denounced, everything becomes image. How then does the non-ostentation of the street, once published, become constantly present ostentation? This is not fortuitous. One can certainly invoke a dialectical reversal. One can say that the newspaper, incapable of seizing the insignificance of the everyday, is only able to render its value apprehensible by declaring it sensational; incapable of following the movement of the everyday in so far as it is inapparent, the newspaper seizes upon it in the dramatic form of a trial. Incapable of getting at what does not belong to the historical, but is always on the point of bursting into history, newspapers keep to the anecdotal and hold us with stories – and thus, having replaced the 'nothing happens' of the everyday with the emptiness of the news item, the newspaper presents us with history's 'something is happening' at the level of what it claims to be the day-to-day, and which is no more than anecdote. The newspaper is not history in the guise of the everyday, and, in the compromise it offers us, it doubtless betrays historical reality less than it misses the unqualifiable everyday, this present without particularity, that it contrives in vain to qualify, that is, to affirm and to transcribe.

The everyday escapes. Why does it escape? Because it is without a subject. When I live the everyday, it is anyone, anyone whatsoever, who does so, and this anyone is, properly speaking, neither me, nor, properly speaking, the other; he is neither the one nor the other, and he is the one and the other in their interchangeable presence, their annulled irreciprocity – yet without there being an 'I' and an 'alter ego' able to give rise to a *dialectical recognition*. At the same time, the everyday does not belong to the objective realm. To live it as what might be lived through a series of separate technical acts (represented by the vacuum cleaner, the washing machine, the refrigerator, the radio, the car), is to substitute a number of compartmentalized actions for this indefinite presence, this

connected movement (which is however not a whole) by which we are continually, though in the mode of discontinuity, in relation with the indeterminate totality of human possibilities. Of course the everyday, since it cannot be assumed by a true subject (even putting in question the notion of subject), tends unendingly to weigh down into things. This anyone presents himself as the common man for whom all is appraised in terms of good sense. The everyday is then the medium in which, as Lefebvre notes, alienations, fetishisms, reifications produce their effects. He who, working, has no other life than everyday life, is also he for whom the everyday is the heaviest; but as soon as he complains of this, complains of the burden of the everyday in existence, the response comes back: 'The everyday is the same for everyone' and even adds, like Büchner's Danton: 'There is scarcely any hope that this will ever change.'

There must be no doubt about the dangerous essence of the everyday, nor about this uneasiness that seizes us each time that, by an unforeseeable leap, we stand back from it and, facing it, we discover that precisely nothing faces us: 'What?' 'Is this my everyday life?' Not only must one not doubt it, but one must not dread it; rather one ought to seek to recapture the secret destructive capacity that is in play in it, the corrosive force of human anonymity, the infinite wearing away. The hero, while still a man of courage, is he who fears the everyday; fears it not because he is afraid of living in it with too much ease, but because he dreads meeting in it what is most fearful: a power of dissolution. The everyday challenges heroic values, but even more it impugns all values and the very idea of value, disproving always anew the unjustifiable difference between authenticity and inauthenticity. Day-to-day indifference is situated on a level at which the question of value is not posed; *il y a du quotidien* [there is everydayness], without subject, without object, and while it is there, the 'he' [*il*] of the everyday does not have to be of account, and, if value nevertheless claims to step in, then 'he' is worth 'nothing' and 'nothing' is worth anything through contact with him. To experience everydayness is to be tested by the radical nihilism that is as if its essence, and by which, in the void that animates it, it does not cease to hold the principle of its own critique.

Conclusion in the Form of a Dialogue

Is not the everyday, then, a utopia, the myth of an existence bereft of myth? We no more have access to the everyday than do we touch this moment of history that could, historically, represent the end of history.

That can, in fact, be said, but opens onto another meaning: the everyday is the inaccessible to which we have always already had access; the everyday is inaccessible, but only in so far as every mode of acceding is foreign to it. To live in the way of the quotidian is to hold oneself at a level of life that excludes the

possibility of a beginning, an access. Everyday experience radically questions the initial exigency. The idea of creation is inadmissible, when it is a matter of accounting for existence as it is borne by the everyday.

To put this another way, everyday existence never had to be created. *This is exactly what the expression* il y a du quotidien *[there is the everyday] means. Even if the affirmation of a creating God were to be imposed, the* there is *(there is already when there is not yet being, what there is still when there is nothing) would remain irreducible to the principle of creation; and the* there is *is the human everyday.*

The everyday is our portion of eternity: the *eternullity* of which [the symbolist poet] Jules Laforgue speaks. So that the *Lord's Prayer* would be secretly impious: give us our daily bread, give us to live according to the daily existence that leaves no place for a relation between Creator and creature. Everyday man is the most atheist of men. He is such that no God whatsoever could stand in relation to him. And thus one understands how the man in the street escapes all authority, whether it be political, moral or religious.

For in the everyday we are neither born nor do we die: hence the weight and the enigmatic force of everyday truth.

In whose space, however, there is neither true nor false.

1 [footnote 4 in source] Georg Lukács, *L'Âme et les formes* (Paris: Gallimard, 1974).

Maurice Blanchot, 'L'Homme de la rue', in *Nouvelle revue française*, no. 114 (Paris, June 1962); reprinted as 'La Parole quotidienne', in Blanchot, *L'Entretien infini* (Paris: Gallimard, 1969); trans. Susan Hanson, 'Everyday Speech', in *Yale French Studies*, no. 73 (1987) 12–20.

Kristin Ross
French Quotidian//1997

Sometime in 1946, the French philosopher Henri Lefebvre discovered the quotidian.[1] He discovered it, that is, in the sense that he proclaimed that most insignificant of categories, the everyday, to be worthy of theoretical attention. And he went on to spend the next several decades, until his death in 1991, paying very close attention to that rapidly changing and elusive phenomenon, French everyday life, first on his own and then in the company of countless fellow travellers. The fact that postwar France in a sense 'caught up' with Lefebvre, that

the 1950s and 1960s were awash in a kind of sociological fascination on the part of novelists, sociologists, historians and filmmakers with the transformed rhythms and accoutrements of daily lived experience, should not lessen the audacity of the discovery Lefebvre made right after the war. For here was a serious thinker elevating to the status of a theoretical concept what in the minds of most other thinkers was nothing more than the drudgery of routine, or at the very least that which constituted the *non*-philosophical par excellence. In interviews, much later, Lefebvre placed his groundbreaking work in context. Wasn't it in the nature of theoretical thought to investigate the trivial? Hadn't Marx done the same thing by analysing that most banal of activities – work? And what could be more ordinary than sexuality, which, once raised to the level of a concept by Freud, had generated countless theoretical edifices?

But to see in Lefebvre's work on the everyday nothing more than a neutral philosophical investigation, an exercise in pure thought, would be an error. For from the outset of his project, Lefebvre made it clear that to formulate the quotidian as a concept, to wrench it from the continuum in which it is embedded (or better yet, the continuum that it *is*), to expose it, examine it, give it a history, is already to form a critique of it. And to do so is to wish for and work towards change, transformation, a revolution in the very nature of advanced capitalist society in the second half of the twentieth century.

Seen in this light, the moment of Lefebvre's discovery, 1946, takes on added significance. The Liberation and the end of the war unleashed in France a euphoria and a sense of unlimited possibilities; for a brief time, life was lived differently, and the hope was that it might continue to be so. But the promise of social transformation gave way to a gradual submersion in old, daily patterns and routines. As the trappings of the everyday re-emerged, they appeared for a brief moment as alien, unnatural – not inevitable. Having been disrupted and thrown into question by the utopian optimism of the Liberation, old routines were suddenly all the more palpable and visible – and thus all the more difficult to bear.

From his experience of this turbulent mixture of freedom and inexorability, from a historical moment that combined the Resistance impetus towards national renovation with the cold war strictures that lay just around the corner, Lefebvre derived his emphasis on the inherent ambiguity of the quotidian. Earlier thinkers like Lukács and Heidegger (and Lefebvre himself in the 1930s) had, to very different philosophical purposes, presented the everyday as simply a negative category: dull, ordinary, rote existence, the dreary unfolding of trivial repetition. But Lefebvre, whose little book on dialectical materialism published in 1940 would provide many French youth with their earliest instruction in dialectical thinking, insisted on a more contradictory formulation.[2] Certainly the everyday consisted of that which is taken for granted: the sequence of regular,

unvarying repetition. But in that very triviality and baseness lay its seriousness, in the poverty and tedium of the routine lay the potential for creative energy. After all, people do not make revolutions because of abstract ideological principles; they make them because they want to change their lives. In the words of Michel Trebitsch, writing in the preface to the English edition of Lefebvre's *Critique de la vie quotidienne*, everyday life in the modern world is not simply a residuum, 'it is both a parody of lost plenitude and the last remaining vestige of that plenitude'.[3] Even at its most degraded, in other words, the everyday harbours the possibility of its own transformation.

In France a popular series of books exists which sets out to resurrect and document the lost daily habits of distant ages and civilizations – those of monks in Florence during the Renaissance, for example, or of Corsican shepherds in the thirteenth century. But to read books like these, Lefebvre argued, was to discover how much everyday life was absent from rural, premodern communities. In pre-industrial societies, he maintained, Church and monarch held sway, imparting a distinct imprint or style – and thus significance – to every gesture, utensil or article of clothing. Lefebvre's view of style seemed to allude to an almost poetic effect, a kind of aesthetic unification of the most trivial acts and objects into a meaningful cultural whole. As the power of the Church and the aristocracy declined, that auratic sense of cultural unity disintegrated as well. 'Everyday life', properly speaking, came into being only with the rise of the masses, when European cities began to swell with the arrival of large numbers of newcomers, when the lived experience of those new urban dwellers became organized, channelled and codified into a set of repetitive and hence visible patterns, when markets became common between the provinces and the capital, when everything – money, work hours, miles, calories, minutes – became calculated and calculable, and when objects, people and the relations between them changed under the onslaught of such quantification. Only then, midway through the last century, and only there, in the large Western metropolises, did the world, in Lefebvre's words, 'turn to prose'.

Everyday life, then, was a distinctly modern, a *bourgeois* phenomenon. We might imagine it lurching into being around the time that Baudelaire attempted to capture its vicissitudes in his essay on sketches by Constantin Guys. But if everyday life was a nineteenth-century development, it became an object of theory only during the post-World War II era. In 1961, fourteen years after the publication of the first volume of the *Critique*, in the face of the enormous changes wrought by the state-led modernization effort of the preceding decade, Lefebvre felt the need to return to the subject of the quotidian. In an anecdote he was fond of recounting, he attributed his return to the topic to a banal domestic incident: returning home from shopping one day, his wife held up a box of

laundry soap and announced, '*This* is an excellent product'. Was the peculiar tone of her voice an unconscious imitation of the advertising slogans heard daily on the radio? In the 1950s and 1960s, something that could be called Americanism (or multinational capital, in another formulation) was insinuating itself into France not by means of any heavy-handed ideological takeover but precisely through the quotidian: blue jeans, car culture, cleaning products.

Lefebvre was far from alone in perceiving French society's gradual adoption of American-style consumption practices. Between 1957 and 1969, a fringe group of cultural activists, the Situationists, irregularly published an inspired journal of social critique called *L'Internationale Situationniste* whose subject was primarily the new patterns of consumption that had solidified after the war, as well as the image culture that fuelled that consumption.[4] The Situationists took to interpreting Lefebvre's concept of everyday life in an essentially spatial way; their 'research', conducted as a series of day- or week-long 'drifts' (*dérives*) through the streets of Paris, was designed to map the psychological and political ambiences produced by the material organization of urban space. For the Situationists, changing everyday life meant transforming the space and texture of urban experience; to do so, the city would have to be surveyed for those elements, constructions and interstitial spaces that might be salvaged from the dominant culture, and, once isolated, put to new use in a utopian reconstruction of social space.

Other social theorists and novelists turned their attention to the changes transpiring in postwar French lived experience. In 1957 Lefebvre's friend and neighbour, Roland Barthes, published a collection of the occasional journalistic pieces he had been spurred into writing about such ordinary events as a wrestling match or the arrival of the new Citröen onto the floors of the yearly Salon de l'Automobile.[5] With *Mythologies*, cultural studies *à la française* was born. Much of the source material for Barthes' studies came from women's magazines like *Elle* or *Marie-Claire*, born or reborn to enormous circulation after the war, whose pages provided a veritable roadmap of the quotidian. On those newly glossy pages, the products, appliances and domestic landscapes of daily life were proudly displayed next to informative 'how to' articles, step-by-step prescriptions for acquiring the comportments and gestures necessary for adapting to alien settings of chrome and Formica. (American movies, inundating France after the war, also helped make the new domestic spaces of 'the ideal home' seem more natural, the already sedimented background to neat, realistic film narrative.) Social theorists like Edgar Morin, Barthes and Lefebvre were not alone in plumbing the depths of women's journalism. Simone de Beauvoir and Perec wrote novelistic parodies of the upbeat tone of the emergent advertising discourse: the poetry of modernity.[6]

Behind such widespread immersion in the analysis of the quotidian on the part of sixties thinkers and artists, we might detect at least three critical perceptions still relevant in the France of today: First, that women 'undergo' the everyday – its humiliations and tediums as well as its pleasures – more than men. The housewife, that newly renovated postwar creation, is mired in the quotidian; she cannot escape it. Second, that the 'centre of interest' in French culture had been displaced away from work towards leisure, the family and private life. And third, that the daily existence of the streamlined middle-class couples who played such a starring role in the French modernization effort after the war, as well as in countless film and novelistic representations, transpired in an urban setting, much as they might hanker for (and in some instances acquire) a vacation home in the Dordogne.

By the year 1968, France had reached the summit of its economic miracle, the peak of postwar prosperity. But with the abundance of material goods and the widespread illusion of equal access to those goods, new scarcities that were not precisely reducible to the economic came to the forefront, scarcities like those of space or desire that Lefebvre would locate squarely in the realm of the quotidian. These lacks and dissatisfactions, among others, provided a project for the student activists of May 1968; the critique of everyday life gave them a theoretical perspective that was not turned toward the past or preoccupied with classical historical models. May '68 was a brief moment when, for the first time, and by way of paths that are still now very poorly understood, critical thinking rejoined practice.

The literature devoted to rethinking the notion of the everyday after 1968 reflected a sensibility disabused of what came to be seen as the naïveté of hope for social transformation. As such, it was in line with the generalized retreat, on the part of French intellectuals, from the historical materialism and ideological analysis of the 1960s. Writers like Michel de Certeau, in his *L'Invention du quotidien* (1980), in effect 'reinvented' the quotidian.[7] Their new, more contentedly phenomenological quotidian dispensed with Lefebvre's emphasis on critique or transformation, and instead celebrated the homely practices – cooking, hobbies, strolling – of life as it is lived in the here and now by individuals intent on escaping the rationalist grids of modern administration. Everyday life for Certeau was a 'complex geography of social ruses'[8] played out on the interstices of bureaucratic surveillance by the relatively powerless, a group that had given up any hope for a change in their circumstances. In his work, the everyday coincides with the actual order of things, which is 'precisely what "popular" tactics turn to their own ends, without any illusion that it is about to change'.[9]

Art and social thought do not develop in a lockstep relation to each other.

They follow staggered, semi-autonomous paths, sometimes intersecting and communicating with each other at the same time, sometimes across decades and generations (and sometimes, it must be said, not at all). A case could be made, for example, that it was Henri Lefebvre's close friendship with Tristan Tzara, and his immersion in the Surrealist and Dadaist culture of the 1920s, that provided the groundwork for his articulation of a critique of the quotidian after World War II. In the 1990s artists and intellectuals alike, attuned to the question of the everyday, confront problems that are in one sense new: they are dealing not with a scarcity of theoretical materials or a lack of awareness of the quotidian, but rather with an abundance of such materials – a kind of surplus of knowledge. [...]

1 The first volume of Henri Lefebvre's *Critique de la vie quotidienne* was first published by Grasset in 1947 and republished by Arche with an expanded preface in 1958. Two subsequent volumes were published in 1961 and 1981. *Critique de la vie quotidienne* (Paris: Arche, 1958–81); volume 1 trans. John Moore as *The Critique of Everyday Life* (London: Verso, 1991).

2 See Henri Lefebvre, *Le Matérialisme dialectique* (Paris: Presses Universitaires de France, 1940); trans. John Sturrock, *Dialectical Materialism* (London: Jonathan Cape, 1968).

3 Michel Trebitsch, preface, *The Critique of Everyday Life*, xxiv.

4 *L'Internationale Situationniste: 1958–69* (Paris: Champ Libre, first published by Van Gennep, Amsterdam, 1970). [...] For further study of the relationship between the Situationists and Lefebvre, see Alice Kaplan and Kristin Ross, eds, *Yale French Studies*, 73 (1987).

5 Roland Barthes, *Mythologies* (Paris: Seuil, 1957); English translation by Annette Lavers, *Mythologies* (New York: Noonday Press, 1972).

6 See Simone de Beauvoir, *Les Belles images* (Paris: Gallimard, 1966); trans. Patrick O'Brian, *Les Belles Images* (New York: Putnam, 1968). Georges Perec, *Les Choses* (Paris: Rene Julliard, 1965); trans. David Bellos, *Things* (Boston: Godine, 1990). For an analysis of the culture of postwar French modernization, see my *Fast Cars, Clean Bodies: Decolonization and the Reordering of French Culture* (Cambridge, Massachusetts: The MIT Press, 1995).

7 Michel de Certeau, *L'Invention du quotidien: Arts de faire* (Paris: Gallimard, 1980); trans. Stevan Rendall, *The Practice of Everyday Life* (Berkeley and Los Angeles: University of California Press, 1984).

8 Certeau, *The Practice of Everyday Life*, 22.

9 Ibid., 26.

Kristin Ross, extract from 'French Quotidian', in *The Art of the Everyday: The Quotidian in Postwar French Culture*, ed. Lynn Gumpert (New York: Grey Art Gallery, 1997) 19–30.

Jean-Jacques Lévêque
Occupation of Places//1968

[Christian Boltanski, Jean Le Gac, Michel Journiac, Tetsumi Kudo, Antoni Miralda and Gina Pane] ... will not only be physical presences but an affirmation by acts and objects: what in former times we called a work of art is here a living work. More than aesthetic speculations, they propose as a new philosophy mechanisms of public health. They invite you, through their action, to know yourself better, communicate better, dream better, love better, to be without false pretences and without prevarication. It's not about an exhibition, it's about communication, a collective gesture that doesn't have any reason for being except for participation, the continuity of living. The traditional work of art is an object added to life; here life is modified. The urgency for such a modification of art has been felt by various isolated people. This is a tentative meeting, without distinctions of style or genre, of those who in France have brought the most to this game of exchange, this essential form of communication that will save man from corrosive, anaemic, deadly anonymity, for which the society of consumption prepares him.

Jean-Jacques Lévêque, text from poster for 'Occupation des lieux', American Center for Students and Artists, Paris, December 1968. © Jean-Jacques Lévêque, courtesy of the Archives de la Critique d'Art, Châteaugiron (fonds Pierre Restany).

Lucy R. Lippard
Escape Attempts//1997

[...] I applied the conceptual freedom principle to the organization of a series of exhibitions which began in 1969 at the Seattle Art Museum's World's Fair annexe. They included wall works, earthworks, and sculptural pieces as well as more idea-oriented pieces. Three aspects (or influences) of Conceptual art were incorporated in these shows: the titles ('557,087' in Seattle) were the current populations of the cities; the catalogues were randomly arranged packs of index cards; and with a team of helpers, I executed (or tried to) most of the outdoor works myself, according to the artists' instructions. This was determined as much by economic limitations as by theory; we couldn't afford plane fares for the artists.

When the show went to Vancouver, it acquired a new title ('955,000'), additional cards, a bibliography, and many new works, which were shown in two indoor locations (the Vancouver Art Gallery and the Student Union at the University of British Columbia) and all over the city. My texts in the card catalogues included aphorisms, lists and quotes, and were mixed in, unsequentially, with the artists' cards. The idea was that the reader could discard whatever s/he found uninteresting. Among my cards:

> Deliberately low-keyed art often resembles ruins, like neolithic rather than classical monuments, amalgams of past and future, remains of something 'more', vestiges of some unknown venture. The ghost of content continues to hover over the most obdurately abstract art. The more open, or ambiguous, the experience offered, the more the viewer is forced to depend upon his [sic] own perceptions.

The third version, in 1970, was a more strictly conceptual and portable exhibition that originated at the Centre de Arte y Comunicación in Buenos Aires as '2,972,453'; it included only artists not in the first two versions: among others, Siah Armajani, Stanley Brouwn, Gilbert & George and Victor Burgin. The fourth version, in 1973, was 'c. 7,500' – an international women's Conceptual show that began at the California Institute of the Arts in Valencia, California, and travelled to seven venues, ending in London. It included Renate Altenrath, Laurie Anderson, Eleanor Antin, Jacki Apple, Alice Aycock, Jennifer Bartlett, Hanne Darboven, Agnes Denes, Doree Dunlap, Nancy Holt, Poppy Johnson, Nancy Kitchel, Christine Kozlov, Suzanne Kuffler, Pat Lasch, Bernadette Mayer, Christiane Mobus, Rita Myers, Renee Nahum, N.E. Thing Co., Ulrike Nolden, Adrian Piper, Judith Stein, Athena Tacha, Mierle Laderman Ukeles and Martha Wilson. I list all these names here, as I said on a catalogue card at the time, 'by way of an exasperated reply on my own part to those who say "there are no women making conceptual art". For the record, there are a great many more than could be exhibited here.'

The inexpensive, ephemeral, unintimidating character of the Conceptual mediums themselves (video, performance, photography, narrative, text, actions) encouraged women to participate, to move through this crack in the art world's walls. With the public introduction of younger women artists into Conceptual art, a number of new subjects and approaches appeared: narrative, role-playing, guise and disguise, body and beauty issues; a focus on fragmentation, interrelationships, autobiography, performance, daily life, and, of course, on feminist politics. The role of women artists and critics in the Conceptual art flurry of the mid-sixties was (unbeknownst to us at the time) similar to that of women on the Left. We were slowly emerging from the kitchens and bedrooms,

off the easels, out of the woodwork, whether the men were ready or not – and for the most part they weren't. But even lip service was a welcome change. By 1970, thanks to the liberal-to-left politics assumed by many male artists, a certain (unprecedented) amount of support for the feminist programme was forthcoming. Several men helped us (but knew enough to stay out of the decision-making) when the Ad Hoc Women Artists Committee (an offshoot of the AWC) launched its offensive on the Whitney Annual exhibition. The 'anonymous' core group of women faked a Whitney press release stating that there would be fifty per cent women (and fifty per cent of them 'non-white') in the show, then forged invitations to the opening and set up a generator and projector to show women's slides on the outside walls of the museum while a sit-in was staged inside. The FBI came in search of the culprits.

One of the reasons we were successful in forcing the Whitney to include four times as many women as before in that year's sculpture show was the establishment of the Women's Art Registry, initiated in angry response to the 'There-are-no-women-who …' (make large sculpture, Conceptual art, kinetic art, etc., etc.) syndrome. As a freelance writer I was unaware of personal gender discrimination (it's hard to know what jobs you don't get), but it was easy enough to perceive when it came to women artists, who were virtually invisible in the mid-sixties, with a very few exceptions: Lee Bontecou, Carolee Schneemann, and Jo Baer being practically the only ones around my age; the others were older, second-generation Abstract Expressionists. A brilliant horde was waiting in the wings.

In terms of actual Conceptual art, the major female figure in 1960s New York was Lee Lozano, who had shown her huge industrial/organic paintings at Dick Bellamy's cutting-edge Green Gallery. In the late 1960s she made extraordinary and eccentric art-as-life Conceptual works: a 'general strike piece', an 'I Ching piece', a 'dialogue piece', a 'grass piece', and 'infofictions'. 'Seek the extremes', she said, 'That's where all the action is.' (When the Women's Movement began, Lozano made the equally eccentric decision never to associate with women.)

Yoko Ono, who had participated in Fluxus since the early 1960s, continued her independent proto-Conceptual work. In 1969 Agnes Denes began her Dialectic Triangulation: *A Visual Philosophy*, involving rice, trees, and haiku as well as mathematical diagrams. Martha Wilson, still a student at the Nova Scotia College of Art and Design, began her examinations of gender and role playing that evolved into performance and continue today in her 'impersonations' of Nancy Reagan, Tipper Gore, and other friends of the arts. Christine Kozlov, who was also very young, was Joseph Kosuth's collaborator in the Museum of Normal Art and other enterprises and did her own rigorously 'rejective' work. Yvonne Rainer's drastic alterations of modern dance were also very influential. On the

West Coast, Eleanor Antin pursued the whimsical, narrative vein that was to lead her to neo-theatrical performance and filmmaking, especially with her cinematic *700 Boots* postcards (1971), in which pairs of rubber boots wandered out of the gallery to explore the real world, travelling through the US mails.

By the end of the decade Adrian Piper (also very young then) had made a series of mapping pieces and intellectual actions that explored philosophical/spatial concepts, somewhat reminiscent of LeWitt and Huebler. By 1970 she had launched into her own totally original identity works – the *Catalysis* series, in which she recreated or destroyed her own image/identity in bizarre public activities. Conceptual art has continued to be the basis of much important postmodern feminist work, from Piper, Antin, Martha Rosler (who was making photo-text pieces in Los Angeles in 1970), Suzanne Lacy, Susan Hiller and Mary Kelly to Barbara Kruger, Jenny Holzer and Lorna Simpson, among others. [...]

Lucy R. Lippard, 'Escape Attempts', introduction to revised edition, *Six Years: The Dematerialization of the Art Object from 1966 to 1972* (Berkeley and Los Angeles: University of California Press, 1997) x-xii.

Stephen Koch
Stargazer: The Films of Andy Warhol//1973

[...] It is exactly in the arena of time – of speed, if you will – that *Sleep* (1963) is so radical. The film entirely modifies the very nature of film viewing. Obviously, very few people are able to sit through all the film and give it the kind of attention normally given to a movie. At the early screenings, audiences came forewarned, intending to make an evening of it. People would chat during the screening, leave for a hamburger and return, greet friends and talk over old times. All the while, the film serenely devolved up there on the screen of the Film-Makers' Cinémathèque. The Sleeper breathed, stirred sometimes, on the couch. [...]

The film remains on the screen always. Its time is utterly disassociated from that of the audience: the Image glows up there, stately and independent. Its cinematic isolation on the screen exerts a bizarre fascination beyond its immediate pictorial allure. Even if one only glances at the image from time to time, it plunges one into a cinematic profundity; in a single stroke, that image effects a complete transformation of all the temporal modes ordinarily associated with looking at a movie. The knot of attention is untied, and its strands are laid out before us anew. We've been told that film records literal

time; but the literal time of *Sleep* is undetermined, rendered hallucinatory and other, by the use of silent speed (all Warhol's silents were shot at 24 frames per second, but they should be projected at 16 frames per second; the effect is an unchanging but barely perceptible slow motion).

And yet as the minutes tick on, the work seems to insist upon its hallucinated literal time as few other films ever do. Meanwhile, the audience's participation in the image is never allowed to fall into the slot of that *other* temporal reality – that acceleration and deceleration of the audience's temporal sense created by narrative fantasy or conventionally edited structure, as in almost any other film one can think of. [...]

Stephen Koch, extract from 'Silence', *Stargazer: The Films of Andy Warhol* (New York: Praeger, 1973; London: Marion Boyars 1974) 39.

Martha Rosler
to argue for a video of representation. to argue for a video against the mythology of everyday life//1977

I

Where do ideas come from? All the myths of everyday life stitched together form a seamless envelope of ideology, the false account of everything thinkable. Ideology is a readymade always ready to stand in for a closer understanding of the world and its workings. The myths of ideology cushion us, it is true, from the paranoia that is engendered by mistrust of cultural givens. But they are not nurturant. The interests served by ideology are not human interests properly defined; rather, ideology serves society in shoring up its particular form of social organization. In class society, ideology serves the interests of the class that dominates. Through the channels of mass communication, which it controls, our dominant class holds its own ideology up to our whole society as the real and proper set of attitudes and beliefs. The impetus is then strong for everyone to identify her/himself as a member of the 'middle class', a mystified category standing in for the image of the dominant class. We have all come to aspire to the condition of the petit bourgeoisie: to be, paradigmatically, 'one's own boss'. Thus the legitimate desire for control over one's own life is flattened out, transmuted into a desire to own one's own business – or, failing that, to construct a 'private' life in opposition to the world out there.

The eradication of craft skills, of *economically productive* family activity, has lessened people's chances to gain a sense of accomplishment and worth and has

increased our vulnerability to the blandishments of advertising, the most potent educational institution in our culture. As the opportunities for personal power on a human level diminish for all but a relatively small part of the population, self-confidence, trust and pleasure conceived in straightforward terms are poisoned, and we are increasingly beguiled by an accordion-like succession of mediations between ourselves and the natural and social world, mediations in the form of commodities. We are each promised personal power and fulfilment through consumption; we are as nothing unless clothed in a culture that is conceived of as a congeries of packages, each of which presents us with a bill. In pursuit of meaning and satisfaction we are led to grant the aura of life to things and to drain it from people: *we personify objects and objectify persons*. We experience alienation from ourselves as well as from others. We best comprehend ourselves as social entities in looking at photos of ourselves, assuming the voyeur's role with respect to our own images; we best know ourselves from within in looking through the viewfinder at other people and things. [...]

How does one address these banally profound issues of everyday life? It seems to me appropriate to use the medium of television, which in its most familiar form is one of the primary conduits of ideology – through both its ostensive subject matter and its overtly commercial messages. I am trying to enlist 'video', a different form of television, in the attempt to make explicit the connections between *ideas* and *institutions*, connections whose existence is never alluded to by corporate TV. Nevertheless, video is not a strategy, it is merely a mode of access.

II

Video itself is not 'innocent'. It too is a form of cultural commodity that often stands for a celebration of the self and its powers of invention. Yet video is useful in that it provides me with the opportunity to construct 'decoys', entities that engage in a natural dialectic with TV itself. A woman in a bare-bones kitchen, in black and white, demonstrating some hand tools and replacing their domesticated 'meaning' with a lexicon of rage and frustration is an antipodean Julia Child.[1] A woman in a red and blue Chinese coat, demonstrating a wok in a dining room and trying to speak with the absurd voice of the corporation, is a failed Mrs Pat Boone. An anachronistically young couple, sitting cramped and earnest in their well-appointed living room, attempting to present a coherent narrative and explanation of their daughter's self-starvation, are any respectably middle-class couple visited by misfortune and subjected to a 'human interest' news-show interview. A woman and child in a studio-constructed no-space, being handed can after package after can of food as Christmas charity, are a faded echo of *Queen for a Day*. An operatic presentation of a woman put through

an ordeal of measurement tenuously alludes to a monumentally stretched-out version of *Truth or Consequences*. [...]

In choosing representational strategies I aim for the distancing (*ostranenie*, the *Verfremdungseffekt*), the distantiation occasioned by a refusal of realism, by foiled expectations, by palpably flouted conventions. Tactically I tend to use a wretched pacing and a bent space; the immovable shot or, conversely, the unexpected edit, pointing to the mediating agencies of photography and speech; long shots rather than close ups, to deny psychological intent; contradictory utterances; and, in acting, flattened affect, histrionics or staginess. Although video is simply one medium among several that are effective in confronting real issues of culture, video based on TV has this special virtue; it has little difficulty in lending itself to the kind of 'crude thinking', as Brecht used this phrase, that seems necessary to penetrate the waking daydreams that hold us in thrall. The clarification of vision is a first step towards reasonably and humanely changing the world.

1 [The TV cookery programme presenter.]

Martha Rosler, extracts from 'to argue for a video of representation. to argue for a video against the mythology of everyday life', pamphlet for 'New American Film Makers: Martha Rosler' (New York: Whitney Museum of American Art, 1977); reprinted in Rosler, *Decoys and Disruptions: Selected Writings, 1975–2001* (Cambridge, Massachusetts: The MIT Press, 2004) 366–9.

Allen Ruppersberg
Fifty Helpful Hints on the Art of the Everyday//1985

General
The individual search for the secret of life and death. That is the inspiration and the key.
The reality of impressions and the impression of reality.
The ordinary event leads to the beauty and understanding of the world.
Start out and go in.
Each work is singular, unique and resists any stylistic or linear analysis. Each work is one of a kind.
Personal, eccentric, peculiar, quirky, idiosyncratic, queer.
The presentation of a real thing.

USE EVERYTHING

Allen Ruppersberg, *Fifty Helpful Hints on the Art of the Everyday*, 1985

The ordinary and the rare, their interconnectedness and interchangeability.

There is a quotidian sense of loss and tragedy.

Collect, accumulate, gather, preserve, examine, catalogue, read, look, study, research, change, organize, file, cross-reference, number, assemble, categorize, classify, and conserve the ephemeral.

Art should make use of common methods and materials so there is little difference between the talk and the talked about. [...]

A sort of journalist reporting on the common, observable world.

Suicide is often the subject because it is a representative example of the ultimate moment of mystery. The last private thought.

Look for narrative of any kind. Anti-narrative, non-narrative, para-narrative, semi-narrative, quasi-narrative, post-narrative, bad narrative.

Use everything.

The artist is a mysterious entertainer.

Specific

[...] I want to reveal the quality of a moment in passing. Where something is recognized and acknowledged but remains mysterious and undefined. You continue on your way, but have been subtly changed from that point on.

I try to set up a network of ideas and emotions with only the tip showing. The major portion of the piece continues to whirl and ferment underneath, just as things do in the world at large.

It is constructed to work on you after you have seen it.

The act of copying something allows the use of things as they are, without altering their original nature. They can then be used with ideas about art on a fifty-fifty basis, and create something entirely new.

It operates on a basis of missing parts. The formal structure, a minimalist strategy of viewer completion and involvement, is one of fragment, space, fragment, space, fragment, fragment, space, space, space.

The form of each piece is determined by the nature of its subject. [...]

I'm interested in the translation of life to art because it seems to me that the world is fine just as it is. [...]

Allen Ruppersberg, extracts from 'Fifty Helpful Hints on the Art of the Everyday,' *The Secret of Life and Death* (Los Angeles: The Museum of Contemporary Art/Santa Barbara: Black Sparrow Press, 1985) 111–14.

Jeff Wall
Dan Graham's *Kammerspiel*//1988

[...] Since the mid-1960s, Dan Graham's work has consisted of a critical interrogation of the discourses proposed by Pop and Minimal art, as they emerge in the critique of conceptualism.

By 1966, Graham, in his magazine article piece *Homes for America*, had identified the central dialectic of Minimalism as existing between the reawakened movement to social discourse in its direct implication of the architectural container, and its residual conformity to New York School pure abstraction. By ironically pointing out the 'readymade' representational elements simultaneously evoked *and* repressed in the architectural parallels of Minimalist structures (in the 'Pop' form of a magazine photo-essay), Graham also identified the missing term in the Minimalist evocation of Constructivism – the absent revolutionary teleology. The 'grey humour' of *Homes for America*, with its mockeries of consumer choice in the suburban grid, returns to the Minimalist object that historical dilemma which it is so ambivalent about: the denied social roots of its own signification. Graham's semiotic and historically-constructed exposure of common architectural tropes within the Minimalist formal canon reveals the iron law that, in relinquishing the revolutionary social perspective which animated Constructivism's conflict with the meaning of the built environment, Minimalism's discourse must assume a double emptiness: that of the rigid mimetic eternity of the Readymade, and that of formalism. This synthesis of the most rigorous sense of formalistic introversion of the art object with the idea of scandalous mechanistic proceduralism (suggested by Duchamp) had been established ten years earlier by Jasper Johns. 'Neo-Dada' was one of the first terms used to designate Johns' work. The term was obliterated by the triumphal advance of 'Pop art', but in it is preserved the element of Duchampian *kenosis*, the last-ditch artistic strategy of self-emptying, or ironic self-defeat. Pop art is based upon the gesture of the traditional artist's snuffing-out of the vestiges of his historically-specific distinction from other modes of production. Johns' works, in the decade of 1955–65 or so, retained a sense of sadness and fright about this collapse of distinction, carried out on the rigidly occupied surfaces of his own paintings. Although extremely subdued and even repressed, the gloomy comfort of these surfaces retains an element of historical awareness to which Pop always displayed deep hostility. Pop art in fact marched triumphally over Johnsian melancholy, leaving the 1950s generation behind and drawing up a covert detente with the most institutionalized forms of insignia-

making. In 1966 Graham redesigned Pop in the grim, grey style of 'factography' in order to present an image of the miserable consequence of architectural thought in the postwar era – the barracks-like tract house. Upon this structure his thought dwells consistently over the years. A sense of the social misery congealed across the abstract surfaces of the Pop-Minimal coalescence, is retrieved as Graham marks off the affirmativeness of both types of art. Minimalism is seen through *Homes for America* as a repressed social semiotics which is barred from accepting itself as such by its roots in Idealist abstraction.

Homes for America is indeed a form of Pop art, in that it mimics a certain kind of magazine article the way Lichtenstein copied comic strips. However, it establishes its particular form of mimesis as both Pop and antithetical to Pop (in part by not being a traditional artwork). More importantly, this piece of 'photojournalism' becomes the vehicle by which means the social surfaces of American culture, brightened and celebrated by Pop, are reinvested with the grey, funereal and somewhat distressing atmosphere of the Johnsian mid-fifties, the Cold War era in which corporate emblems still retained vestiges of their then-recent function as war-propaganda. The text of *Homes for America* discusses the development of tract-housing after World War II. The insistent comparison of the new suburb to a barracks or prison is articulated in language combining journalistic concreteness with a sense of the deliriously labyrinthine. Graham's text is as Borgesian as those of Robert Smithson, whose *Monuments of Passaic* is its closest parallel (and who played a part in having *Homes* commissioned as a 'think-piece' for *Arts Magazine*). Graham's intention with this work is to reveal the structural and historical isomorphism of Minimal and Pop art. The consequences for both trends of the repression are not directly linked with any particular attitude towards the political problems of urbanism since the 1920s, but the issue is evoked obliquely in the unveiling of the consequences of those problems both for architecture itself, and for Pop and Minimalism, which appropriate material from the common or popular signifiers put in place by urbanism.

Thus, through a series of assumptions of roles or functions. *Homes for America* arrives at its position as unique within conceptual art. Like much conceptualism, it attempts to breach the dominance of the established art forms and to articulate a critique of them. However, unlike the more academic types of conceptual art (as practised by Art-Language, they could arrive only at a paradoxical state of establishing themselves as works of art *negatively*, by enunciating conditions for art which they had no interest in actually fulfilling) Graham's photojournalistic format demands that his work have a separable, distinguishable subject-matter. Instead of making artistic gestures which were little more than rehearsals of first principles, as Kosuth or Art-Language were to

do, Graham brings into being his analysis of the institutional status of art through the dynamism of a journalistic subject which is implicitly the inner truth of purer forms of art. This is, of course, the antithesis of the formalist abolition of subject-matter. In a single gesture Graham establishes the primacy of social subject-matter as *the* historically essential problem to be posed by conceptualism, and at the same time he identifies the single grand subject which will remain central to the development of the movement's historical self-consciousness: the city. *Homes for America* is the work in which Graham recognizes that the conceptual critique indeed has an inherent subject, which he explicitly begins to investigate – the historical development of the city as site of cultural conflict. This investigation begins on the ground of conceptualism by posing anew the antithesis faced by the more revolutionary artists of the 1920s and 30s: one between the isolated and exalted 'pure' work of art (the highest product of the distraught bourgeois self-consciousness) and the social machine as a whole that reproduces this distraught consciousness in the process of its own reproduction as city.

Homes for America is, however, of its own time and does not pose this historical contradiction in terms of the explicit dynamism of Lissitzky or Tatlin. Although Graham manages to identify the historical consequences of the collapse of the hopes of the utopian artists and planners of the 1920s, he cannot rekindle them. He can go no further than specifying those conditions resulting in the era when this hope appears to have been permanently eclipsed. Graham's reminiscence of the oppressive greyness of the fifties sets off a further reminiscence of the history of earlier planning schemes whose liberating rhetoric has shrunken into the gratuitous structures of the suburban grid, the garden of subjection for a lost proletariat. For Graham, as for many other young artists, in 1966, the key revelation of the city was in the shock of the absolute loss of hope. This loss was as much a stimulant for critical memory as was indignation: the city of Antonioni provoked the memory of de Chirico and Breton, as the city of Godard did that of Heartfield or Meyerhold. Although his response to this shock shares neither Smithson's black indignation nor his black humour, Graham appreciates both, and commits himself to the decipherment of this image of mechanistic domination. When Smithson leads the incensed Romantics into the desert, Graham remains in the city and suburbs.

Homes for America is the finest of the group of magazine pieces of the late sixties, all articulating the theme of the defeat of those ideals of rational, critical language by bureaucratic-commercial forms of communication and enforcement. The magazine pieces are structured as small, ironically insignificant defeats for liberationist ideas, as 'defeatist interventions' in the mechanisms of ideological domination. They are aimed at interrupting the flow

of standardized, falsified representation and language, and inducing a 'mini-crisis' for the reader or viewer by means of the inversions they create. This strategy, carried out most insidiously and brilliantly in *Detumescence* (1966/69), parallels the creation of distancing effects in everyday environments by early conceptualists such as Weiner (particularly in his series of 'removals'). Reflected in the provocations and interventions characteristic of sixties Situationism in which an unexpected and confrontational gesture interrupts the established rhythm of relationships in a specific context, and induces a form of contestation, paradox or crisis, this approach thereby exposes the forms of authority and domination in the situation, which are normally imperceptible or veiled. The most notable artistic image of this is the unexpected 'void' or 'rupture' in the seamlessly designed social surface, and conceptualism's origins are filled with such blanks, erasures, tears and cuts. These gestures interrupt the induced habits of the urban masses, and the interruption theoretically permits social repression (which is the veiled content of habit) to emerge in a kind of hallucination provoked by the work. This liberating hallucination is the objective of the work, and its claim to value. Such Situationist intervention is also related to Pop, but inversely, as is conceptualism; it aggravates Pop irony by means of *humour noir*, and attempts to elicit a recognition of the terroristic aspects of the normalized environment of images, things, spaces and mechanisms.

Graham's magazine pieces fuse the Situationist-inspired strategy of the 'cut', of *détournement*, with that of the mimesis of bureaucratic forms of 'factography'. The interventions designed by him remain primarily concrete, functioning through the dynamics of specific subjects. Conceptualism, in relapsing into 'radical formalism', tended to empty the 'cut' or intervention of its specific character, thereby absolutizing it as an extreme form of emblematic abstraction. Such interventions are reduced to decorativism, as is the case with many later works by Buren, for example.

Graham uses an actual text – an article, an advertisement, a chart – which constitutes its intervention through a structured difference with the norms of the genre in question. Thus, in these works, a specific social genre, existing functionally, is altered in a prescribed direction aimed at bringing out and making perceptible the underlying historical oppression.

Thus, *Homes for America*'s theme, the subjection of the romantic ideal of the harmonious garden suburb to the systems of 'land development', is presented in the pseudo-Readymade form of a 'think-piece' or popular photo-essay. This format is retained, mimetically, as the means by which the subject-matter is altered and made perceptible in a negative sense. Graham's approach accepts the existing formalism of culture – its rigidified generic structure – as a first principle, and applies pseudo-Readymade, pseudo-Pop and authentically Situationist

strategies to it. The result is formalism intensified to the qualitative crisis point. The work makes its intervention in the context of a formalized emptiness of existing genres, but does not create an antithetical emptiness, a purely abstract or emblematic intervention. In fusing the journalistic attitude which accepts the primacy of subject-matter together with the Situationist-conceptualist strategy of interventionism and *détournement*, the work establishes a discourse in which its subject-matter, a critique of Minimalism and Pop via a discussion of the architectural disaster upon which they both depend, can be enlarged to the point of a historical critique of reigning American cultural development.

This approach became identified explicitly with architectural theory and discourse by 1973–74 via a series of video-performance works. These and the environmental 'functional behavioural models' use window, mirror and video control systems to construct dramas of spectatorship and surveillance in the abstracted containers of gallery architecture. Following his ideas about the relation of the work of art to the implicit semiotics of its built environment, its institutionally-designed container, the emphasis shifts through the decade of the seventies from an experimental concentration on enactment or behaviour ('performance'), to work upon the actual institutional settings of these 'dramas'. Graham's work shows new influences, particularly from Daniel Buren, Michael Asher and Gordon Matta-Clark, with the effect that architecture emerges as the determining or decisive art form, because it most wholly reflects institutional structure, and influences behaviour through its definition of positionality. [...]

Jeff Wall, extract from 'Dan Graham's Kammerspiel', in *Real Life Magazine*, no. 15 (Winter 1985/86); reprinted in Jeff Wall, *Selected Essays and Interviews* (New York: The Museum of Modern Art, 2007) 23–33.

Jonathan Watkins
Every Day//1998

There is a growing interest amongst contemporary artists, worldwide, in quotidian phenomena and the power of relatively simple gestures. It constitutes a rejoinder to played-out operatic tendencies and an overloaded academic (often pseudo-academic) discourse in visual arts, engendered by early postmodernism. The imminence of the year 2000 makes this artistic sea change at once paradoxical and timely, a foil for the portentousness of millennial cultural events.

Emphasis here is placed on the significance of every day, and any day, not on the distance between now and arbitrary past and future dates in Western history.

The fundamental proposition of this exhibition arises out of current artistic practice. Selected works are characterized by efficacy and unpreciousness. They are unforced artistic statements, incidentally profound observations on the nature of our lives as lived every day, in contradistinction to supposedly *fin-de-siècle* appropriationist, neo-surrealist or mannerist strategies – all-too-familiar in living memory – and likewise new-age transcendentalist gestures. Their impetus, derived from what is ordinary, is not unlike that which led nineteenth-century French artists to their realist and subsequently impressionist positions. It is more human than spiritual, more empiricist than idealistic, more philosophical than ideological.

Though this project springs from a current Western context, there is significant correspondence with a wide range of cultural traditions increasingly being acknowledged through a new internationalism. As every day occurs everywhere in the world, participating artists hail from each of the five continents. The curatorial challenge arises from the relativism of what is everyday, the differences between what is familiar, common or ordinary within the diversity of cultures represented. The aim is to communicate the nature of every day and to be culturally specific, declaring differences without resorting to exoticism, particularly in the presentation of non-Western art. Whereas a sublime and prescriptive world-view of contemporary art is out of the question, a more balanced and ultimately more constructive global dialogue is certainly feasible. The Biennale presents an opportunity for the telling juxtaposition of work by artists whose distance from one another is normally vast. Here, for example, On Kawara (Japan/USA) meets Georges Adéagbo (Benin), Frédéric Bruly Bouabré (Ivory Coast) and Jean Frédéric Schnyder (Switzerland) in works that all resemble personal journals. The single-image colour photographs by Roy Arden (Canada), Noa Zait (Israel) and Pekka Turunen (Finland), so evocative particularly of the places they depict, can be readily compared. The minimalism of paintings by Katherina Grosse (Germany), Rover Thomas (Australia) and Ding Yi (China) seen in proximity suggest an affinity in spite of the virtually incommensurable thought systems which inform them.

The broad area covered by this exhibition is articulated by various concerns and stances. Pronouncements with respect to style or medium (the dominance of one, the redundancy of another) are deliberately avoided, deemed pointless now, but the artists clearly do share various attitudes. Above all perhaps is an aspiration to directness, as opposed to gratuitous mediation or obscurantism. A break is made with art about art (interrogation of its own artistic identity) and continuity is affirmed between phenomena within and beyond the art world.

Much of the work exhibited embodies or marks the passage of time through traces of the process of production, thereby stressing its place in our material world. Time is measured out in gestures analogous to the coming and going of every day, reminders that all is temporary and mutable. Concomitant with this is the acknowledgement that the everyday is manifest as much in natural phenomena as it is in common man-made or urban subjects.

Carl Andre's work epitomises the directness at the heart of this project, diametrically opposed to theatricality. Its concrete nature, its 'this-is-this-ness', at once conveys the artist's feeling for basic materials and a tough logic which does not distract from the fact that they are simply there. Denise Kum and Ernesto Neto similarly encourage an apprehension of material fact. The latter, who is working in a Brazilian tradition notably developed by Hélio Oiticica and Lygia Clark, seems to encourage a revelry in stuff – ranging from lead shot to powdered spices – and recently his exhibitions have included lycra tent-like structures which can be entered and experienced from the inside. Kum takes raw chemical substances and combines them with extraordinary results, an abstract insistence on the possibility of invention. [...]

The unhindered flow of information from everyday life into the art world was made conscious and deliberate with Marcel Duchamp's introduction of the Readymade, and not surprisingly, readymade objects are found throughout this exhibition. José Resende is a choreographer of cranes and shipping containers, Virginia Ward resurrects discarded machinery, Desmond Kum Chi-Keung works with bamboo bird cages, while Marijke van Warmerdam invites us to gamble on one-armed bandits.

It is a truism that art can be made from anything. Rasheed Araeen's recent works are made from scaffolding, Tadashi Kawamata's from garden sheds. Peter Robinson (3.125% Maori) treads a tightrope stretched between political correctness and heresy as he picks up awful nationalist clichés and racist taunts, as readymades, and then throws them back.

Vladimir Arkhipov's *Post-Folk Archive* puts a further twist to the tale of the Readymade, consisting as it does of home-made gadgets, all ready made, collected from people living around Moscow. The ingenuity of these gadgets, in the face of shortages of the most ordinary manufactured goods, inspired him to stop being a sculptor and start collecting. Now Arkhipov's art practice bridges the gap between the useful lives of these gadgets and their acquired identity as components of an artwork. The twist lies in the fact that these are not manufactured objects, as readymades usually are, but instead unique creations which might be mistaken for folk art, implying a curatorial effort to somehow 'elevate' them. This could not be further from the truth, Arkhipov suggests, because the art world clearly does not occupy elevated ground.

Bangkok has an artistic community, largely orbiting around the About Cafe, which places an extraordinary emphasis on audience participation, asserting not only a democracy of objects through the use of readymades, but also an interdependence between artists and non-artists. In the spirit of Jorge Luis Borges, who argued for the recognition of the crucial role of the reader, many Thai artists are literally making work with their audience. Rirkrit Tiravanija has at different times provided take-away food, a recording studio for passers-by and art workshops for children. Surasi Kusolwong recently organized an exchange of everyday objects with gallery visitors. Chumpon Apisuk, in a long-term project concerned with the plight of local sex-workers, especially with respect to HIV and AIDS, exhibits a continuing correspondence by fax and recorded messages.

Navin Rawanchaikul's work for this exhibition developed out of his Navin Gallery, Bangkok, an ordinary working taxi in Bangkok which is also the venue for an exhibition programme. It is based on recorded conversations with Sydney taxi drivers. These are transformed into a small comic story book, *Another Day in Sydney*, freely available in taxis around town, and a sound installation involving a taxi parked inside the exhibition.

Guy Bar-Amotz, an Israeli artist now based in London and Amsterdam, also derives his work from an identifiable professional group, buskers, and karaoke is the chosen form of audience participation. The gruesome cathartic sing-a-long of the overworked middle classes with underprivileged accompaniment, an increasing phenomenon around the world, is a characteristically edgy mix.

Perhaps as an antidote, the home has come to signify, more than ever, a refuge, as Nikos Papastergiadis observes in his essay here: 'Not only are more and more people living in places which are remote and unfamiliar to them, but even those who have not moved increasingly feel estranged from their own sense of place.' Whether or not this is directly experienced by artists, a preponderance of current art works refer to the nature of the home, often problematically, and reflect a basic need for shelter.

Desmond Kum Chi-Keung's birdcages allude to the overcrowded housing conditions in Hong Kong. Gavin Hipkins' photostrips make up an obsessive unedited analysis of the various rooms he inhabits. Howard Arkley's choice of the suburban Australian home as a subject for his spray paintings could not be more apt. Maria Hedlund's white photographs suggest the corruptible nature of the domestic spaces we create for ourselves.

Absalon's actual-size white prototypes for houses epitomise a very particular daily life and at the same time anticipate his tragic early death. Ostensibly, the *Cellules*, to be built in various cities around the world, were to be small buildings in which the artist lived alone, with room enough for only one visitor at a time.

SOMEWHERE JUST
AS SOME PEOPLE
ARE THINKING,
'I FEEL LIKE HAVING
A CUP OF COFFEE.
IS THERE SOME CAFÉ
AROUND HERE?'
THEY WILL SEE A
CAFÉ COMING TO
THEM UP THE ROAD.

Shimabuku, *The Story of the Travelling Café*, 1996

With interconnected spaces for eating, sleeping, working and toilet activity, the designs betray the formative influences not only of classic modernism but also the artist's native middle-eastern culture. Ideas from Arab architecture and Bedouin life are combined for the accommodation of an endlessly travelling individual.

The appeal of the *Cellules* lies largely in the viewer's identification with Absalon's need to make a place for himself. Henrietta Lehtonen's work *Nest*, (1995), subtitled 'Reconstruction of a nest I built when five years old. At the age of eighteen I started to study architecture', strikes the same chord. Sofas, rugs, blanket, pillows and a coffee table are rearranged in order to create a child-sized refuge, one to keep the adult world at bay.

Other works by Lehtonen have referred directly to childhood and in this too, she is not alone amongst contemporary artists. There is a distinct revival of interest in the world of children. This is not sentimental and more than a simple acknowledgement that children are equally part of everyday life – it springs from an appreciation that children's perception is relatively unhabituated and their expression of thoughts and feelings is refreshingly candid. Furthermore, children are indicative of an imagined future and thus their significant figuring as subjects in contemporary art tends to contradict notions of a washed-up, decadent culture. [...]

On Kawara's work is canonical, direct and economical, marking time as it passes – in the case of his *Date Paintings*, against an unseen backdrop of newspaper pages which reiterate his continuing existence. His famous statement 'I am still alive' (at once too much and not enough, wonderfully funny and deadly serious) is implicit in everything he does. Parts of his *I Met* and *I Went* projects (from 1968), recording everywhere he went and everyone he met on the same days thirty years ago, are also in this exhibition.

The measured continuum of time embodied in On Kawara's work features in many works in this exhibition. Frédéric Bruly Bouabré's postcard-sized pictures are drawn from daily life in his village of Zéprégühé on the Ivory Coast. Hung in long rows they suggest both a spelt-out pictorial language and, as each is dated, the regular diurnal cycle. The dates assert the fact that he was actually there, then.

Jean Frédéric Schnyder exhibits a row of forty paintings, each depicting a sunset over the Zugersee, the lake near his home. Riding his bicycle to the same place every evening during several months last year, he set about painting the same scene *en plein air*, one painting per day, thereby recording the incremental movement of the sun in relation to the horizon and a spectrum of impressions and meteorological effects. Intersecting in Schnyder's work are a number of concerns which exemplify the thesis of this exhibition. They include a response, as direct as possible, to his subject, a subject that is at once familiar and taken as it is, and a concern with the effects of temporality.

In addition, Schnyder is declaring his unabashed interest in landscape and natural phenomena. Many other artists here, such as Roni Horn, Patrick Killoran, Olafur Eliasson, Gereon Lepper, Kim Young-Jin, Dieter Kiessling, Joyce Campbell, Jimmy Wululu and Rover Thomas, are doing the same. This does not signify a sentimental or reactionary tendency, somehow in opposition to an avant-garde; it is rather the artistic expression of what happens every day, as innovative as it is uncontrived.

The serial nature of Schnyder's work, and that of On Kawara and Bouabré, suggests another pattern which can be extended to include those artists in this exhibition whose practice involves small repetitive gestures, a certain orientation towards craft activity. There is reference to the marking of time, and a light touch on the subject of mortality, for example, in the work of Fernanda Gomes and Germaine Koh. The latter's ongoing project, *Knitwork*, is an accumulation of her knitting with wool unravelled from second-hand garments. Its present sixty-metre length has Sisyphean implications and becomes increasingly a heavier burden. Ani O'Neill's crocheted circles have affinities with the project of Katherina Grosse and, at the same time, bear witness to her ancestry in the Cook Islands.

The woven works of Aboriginal artists Margaret Robyn Djunjiny and Elizabeth Djutarra also derive from traditional culture. Ding Yi uses paintstick on tartan fabric, playing off the pattern or mimicking the weave with a technique which clearly betrays the influence of Buddhist philosophy, through calligraphy. Kim Soo-Ja conflates fabric bundles, potent symbols of the role of women in Korean society, with video images of their movement.

The reference to craft is taken to an extreme by those artists who simulate the everyday, not in games of double-take or due to a latter day Pre-Raphaelitism, but because the subject suggests itself as absolutely sufficient. The meticulousness of the process signifies a fascination with the smallest detail, and simulation is the logical conclusion. Fischli and Weiss produce painted polyurethane sculptures of the most humble objects, such as orange peel and cigarette ends, and Yoshihiro Suda makes painted wooden flowers and weeds. Clay Ketter and Joe Scanlan use the actual materials of their chosen subjects – respectively, plasterboard, nails and plaster for sculptures of sections of prepared walls, and timber for a coffin sculpture – and their aspiration to directness could not be clearer.

Ketter and Scanlan operate within the realm of the everyday, and every day, as do Fischli and Weiss, Carl Andre, Lisa Milroy, On Kawara, Virginia Ward, Joyce Campbell, Georges Adéagbo, Rirkrit Tiravanija, and the many other artists included in this exhibition.

Such diversity with respect to media, style and subject matter, such interest

in all areas of life and unpretentiousness, however, does not mean this is an art world where anything goes. Never does anything go. Then again, never before has an art world been so open, and so accessible.

Jonathan Watkins, Introduction, *Every Day. 11th Biennale of Sydney* (Sydney: Biennale of Sydney, 1998) 15-19.

Nikos Papastergiadis
'Everything That Surrounds': Art, Politics and Theories of the Everyday//1998

[...] Bringing art and life as close together as possible can be a healthy antidote to some of the academicist approaches emerging in the late 1980s. However, it can also lead to the idiocies and banalities of life being reproduced under the name of art. The relationship between art and life is never straightforward or transparent. What cannot be denied, however, is the need for the artist to start from the materiality of both art practice and experience. This appreciation of materiality does not preclude language, nor does it imply that the limitations of our specific starting points, by their mere display, should be elevated to marvellous achievements. [...]

In the new art there is both sensuous absorption with the present, a shameless fascination with the abject, and a candid representation of the banalities of everyday life. Neither the pleasures nor the vices expressive of this voluptuous self-presence are embedded within a social history of political solidarity or aesthetic investigation. This practice of acknowledgement is disavowed as being part of the boring politics of correctness. Yet paradoxically, in the assertion of newness there is both rejection of lineage and claim of assimilation. It is assumed that the new British art has already embraced the kernel of the old without hanging onto the academicist crust of history. This dynamic of internalization is supposedly already there in the pulse of popular culture. Can we assume that the history of resistance is already incorporated in popular consciousness, and that, by virtue of its own sensual and material practice, the production of art traces the contours of this silent knowledge and bears witness to all that is knowable and real? To attempt to forget the past is to be condemned to repeat it by other means. [...]

Despite repeated efforts to break the divide between popular culture and high art, the concept of the everyday has remained relatively untheorized within

the contemporary discourse of art. As a theoretical concept, it is clearly opposed to transcendental or ahistorical forces. It does not seek to confine the significance of art within the *a priori* categories of a given political ideology. It does not place its development within the stages of certain psychic states, or seek to elaborate its meaning purely within the terms of pre-existing philosophical models. To consider art from the perspective of the everyday is to stress that the measure of art is not found by borrowing the yardsticks of other discourses, but rather from its articulation and practices within everyday life. Yet this aim, which seeks to take us directly into the lifeworld without the mediation of other discourses, cannot be conducted in pure form. There is never a direct access to life – language, culture and the psyche are always inextricably interwoven in our every effort.

Another benefit of the term everyday is that it recalls a number of philosophical traditions on praxis. From 'art and the everyday' there is but an indistinguishable step to the 'art of living'. The purpose of this essay is not to illustrate how the various artists in this exhibition have grappled with this process or striven to energise the nodal points between art and the everyday, but rather to contextualize this strategy within a number of earlier debates. As Scott McQuire points out: 'While the term 'everyday' has longstanding oppositional connotations, stemming from its usage in Marxist sociology … and passing, by way of phenomenology and the Situationist International … into the doxa of contemporary cultural studies, what it represents has undergone significant mutations in the passage.'[1]

The genealogy of the concept of the everyday can be traced much further back, and the net cast more widely. Mike Featherstone finds echoes of the concept all the way to Antiquity, and draws on phenomenological as well as Marxist traditions.[2] The Ancient Greek philosophers paid meticulous attention, and were in ongoing debate, about what made the 'good life'. In the phenomenological tradition the term 'lifeworld' is central, and when Alfred Schutz first introduced it to sociology he defined it in relation to the heterogeneity of attitudes in action and thinking, in contrast with dominant institutionalized actions and rationalized modes of thinking. Agnes Heller's attempt to synthesize both the phenomenological and Marxist traditions of the everyday leads her to characterize it as 'encompassing different attitudes, including reflective attitudes'. These attitudes are not just those which situate the self and help make sense of the world, but include those imbued with critical force and capable of offering a vision of a 'better world'. In her definition, everyday life is the co-constitution of self and society. It is the aggregate of both the attitudes that shape the self and the processes of shaping the world.[3]

While the concept of the everyday is like an amoeba, its nature and shape

varying according to the content it absorbs and surrounds, it is in no way outside theory or politics. It is clearly opposed to the use of theory as either a prescriptive modelling of the world, or a totalizing abstraction which determines the precise order of causes and consequences. The concept of the everyday is antithetical to such normative and deterministic schemes. However, if we understand theory as operating within, rather than above or beyond, a specific context, then this perspective, which implicates the process of representation within the structures and institutions of belonging, allows a level of critique which registers the flows and tensions within social relations. A theory of the everyday is thus located in the in between spaces, the margins and disjunctive zones of the social.

Given the restless dynamic of modernity, the modality of the everyday is particularly well-suited to grasping the experience of displacement and rupture that are symptomatic of our age. The concept of the everyday in critical theory is closely linked to the tension between freedom and alienation in modernity. Henri Lefebvre emphasized that the concept of everyday life is a supplement to Marx's concept of alienation.[4] In positing that capitalism creates social relations which alienate subjects from their 'species being' and from others, Lefebvre stressed that the concept of everyday life can illuminate the complex ways in which subjects exercise their potential to be emancipatory and critical. Thus, in the Marxist tradition, the significance of the concept of the everyday lies in the way it points to the overcoming of alienation. Communism did not eliminate alienation by political feat. On the contrary, under Stalinism it deepened.

Two flaws in the Marxist theorization of alienation also constrained the conception of the everyday. First, the theory of self, which served as the counter to alienated subjectivity, presupposed the existence of a unified personality. Second, the privileging of the commodification of labour in the definition of alienation overlooked the domain of non-economic work. Alienation was thus confined to forms of non-reciprocal relationships between individuals and their work. According to Marx, as value is concentrated in the object of work, and as the worker is perceived as another commodity in the chain of production, the ensuing process leads to externalization of the value of production, estrangement of the worker from the object of work, undermining of the worker's sense of worth through production, and objectification of all social relationships in the workplace. Ultimately, workers are left feeling alienated from nature, their own identity and consciousness of the totality of all other human relations. Marx thereby argued that the consequence of alienation is the estrangement of workers from their 'species being'.

The other side of the theory of alienation is the everyday. It is in the space of the everyday, Marx claimed, that the worker's genuine sense of self worth is

possible. In this space, the fragments of the social world can be integrated withy the essence of identity. Heller stressed that Marx's theory of self poses the necessary unity between personality and sphere of action that constitutes society. The integrated self is one which perceives the flux and fragmentation of the social world, but is capable of providing a critique through a synthesis between subjectivity and everyday life.

Lefebvre extends this integrative logic in his definition of the concept: everyday life refers to all the spheres and institutions which in their unity and their totality 'determine the concrete individual'.[5] From the choice of leisure to the structure of domesticity, Lefebvre draws our attention to the complex means by which social structures are internalized in daily life. This practice of internalization is neither passive nor neutral. It impacts on the broader dynamics of social change. The reciprocal relationship between part and whole is critical in Lefebvre's theory. He sees 'the humble events of everyday life as having two sides': the arbitrariness of the particular, and the essence of the social.[6] By tracing the reproduction of the whole in the practice of the part, Lefebvre thought he had found a way out of the base-superstructure model that was stultifying Marxist debates on culture.

Michel de Certeau's concept of the everyday goes even further and provides a way of understanding the everyday without reproducing the integrative logic central to Marxist tradition. When Certeau represents an analogy between part and whole, he also suggests a displacement effect. His focus is more attuned to the sly step towards transformation in every act of internalization:

> The presence and circulation of a representation ... tell us nothing about what it is for the users. We must first analyse its manipulation by users who are not its makers. Only then can we gauge the difference or similarity between the production of the image and the secondary production that is hidden in the process of its utilization.[7]

This investigation of the difference between the laws, rituals and representations imposed by the dominant order, and the subversive practices of compliance, adoption and interpretation by the weak, fuels Michel de Certeau's study of social relations. His concern is not with the intended effects of a social system, but the actual uses made of it by the people who are operating within it. The politics of everyday life revolve around two dimensions. First are the ways in which people make ethical responses to the social order, and thereby humanize their relations with each other. Second are the ingenious and devious ways by which the weak, the marginalized majority, make use of the strong. These tactical responses are necessary, he argues, since the individual is

increasingly situated in a position where the social structures are unstable, boundaries are shifting, and the context is too vast and complex either to control or to escape. From this perspective, Certeau's and Lefebvre's concepts of the everyday are significantly different.

Given the social complexity and diversity of the everyday, Certeau does not claim that the part can carry the essence of the whole. Through the shift in forms of production, relocation of central command centres, rapid flows of financial and speculative trading across national borders, increasing interpenetration of local cultures by the media industries, and the new patterns of migration, globalization has heightened the complexity and fragmentation of the social order. The identity of the social whole can no longer be represented according to the neat and discrete boundaries of the national. This re-evaluation of the identity of the whole also complicates the representative status of the part. For instance, can art of the everyday represent the lifeworld of the whole nation? Or do we need to make smaller, more specific claims about the relationship between the particular, which is always a tactical response to a number of conflicting demands, and the whole, which is already too fragmented and complex to appear as a single unit. At the micro level of everyday life, the individual is compelled to utilize intelligence, cunning and ruse in order both to survive and gain pleasure.

'This mutation makes the text habitable, like a rented apartment.'[8] The metaphor of a house is apposite for this exilic epoch. According to Certeau, our mode of being in this world, that is our ability to insert ourselves into the present and to make the meaning of our time memorable and affirmative, is like the practice of renting an apartment. The space is borrowed, the structures are given, and the possibility of dwelling is not infinite. However, the practice of living is neither closed nor predetermined by the architecture of the building. We enter the apartment with our baggage, furnish it with our memories and hopes, and make changes which give form to our needs and desires. The order with which our belongings are arranged is like the fingerprint of our social identity.

The home is always saturated with emotive associations and social meanings, but perhaps unlike other historical periods the contemporary home gains its identity from the oscillation between arrival and departure, integration and fragmentation. Zygmunt Bauman was right when he characterized our relationship to home in late modernity in terms of not displacement but unplacement. Not only are more and more people living in places which are remote and unfamiliar to them, but even those who have not moved increasingly feel estranged from their own sense of place. The concept of home needs to be fused with the practice of belonging. 'Home is no longer a dwelling but the untold story of life being lived.'[9] Home must be seen as a verb, rather than as a

noun which refers to distinct place. For home is no longer a place in the past or a fixed geographical spot, but rather a horizon that recedes in the future. We approach but never fully arrive. To tell the story of the life being lived in the home, we must perform what John Berger calls 'bricolage of the soul'. When Gaston Bachelard picked up the tools of psychoanalysis and applied them to the structure of the house, renaming the garret as super ego, the ground level as ego and the basement as id, thereby providing us with topoanalysis, he gave us a first look into the soul of architecture.[10] Or was it an insight into the architecture of the soul? Through these figurative techniques Bachelard addressed the practice of making meaning through the assemblage of fragments that constitute home.

Psychoanalysis, which was driven in Freud's hands to uncover the hidden meanings of the banal and trivial in everyday habits, was lifted out of its therapeutic context by Bachelard and released into the realm of critical poetics. Psychoanalysis can benefit our understanding of the everyday when its application is not confined to a diagnostic and medical science, but extended to a mode of investigating the constitution of the social. All the messy desires and neurotic habits of the everyday cannot be removed by 'working through' their origin in the primal sexual scenes. The connections between past and present may be even more elliptical than the concept of the unconscious, just as the tensions between self and other may never be reconciled by the acknowledgement of aggression generated by conflicting drives. Psychoanalysis opened the door to understanding the repressed in everyday life, it provided epistemic insight into the orders of the psyche, it exposed the unconscious layers obscured by the commonplace distinction between truth and lies, but it is not clear that its prescribed methods for dealing with either the energies of the unconscious or the 'regressions' into collective practices of identity formation are sufficient models for defining the constitution of the social. The general point that something is always left out, something remains unspoken, even when the speaker expresses their views sincerely, needs to be lifted out of the clinical framework in order to offer a metaphor for the gritty silences in the everyday.

The utilization of psychoanalysis and Marxism by the Frankfurt School took an even more decisive role in tracing the 'itinerary of desire' in everyday life. Conscious of shifts in the political terrain, whereby the role of the proletariat did not resemble a vanguard and the internal dynamics of history did not suggest the inevitable overthrow of the capitalist system, Adorno and Horkheimer sought in psychoanalysis clues for explaining the culture of survival. Their critique against domination and authority was framed by an emphasis on the redemptive potential of memory. The work of memory was not confined to a nostalgic retreat, but knotted into an emancipatory project which involved uncovering the elements of subjectivity and heightening the reflexive attitude

that had been suppressed by the instrumental rationalism of the modern world.

The combination of Marx's theory of alienation and Freud's theory of repression meant that the dynamics of culture and the role of agency could never be reduced merely to a negative or positive expression of material forms of production. If Marx's great contribution to social theory was to position the intellectual within the site of struggle, it could be said that Freud's equally significant insight was the idea that the analyst must offer his or her body, through the act of transference, as the vehicle to uncover the meanings of the past and transform the everyday. After Marx and Freud, the distance between subject and object changed and the possibility of time opened.

The future will be like the past, not in the sense of repetition, but in the sense of having been uncalculated. So one of the aims of analysis is to free people to do nothing to the future but be interested in it.[11]

The theorist, the analyst and the artist could no longer claim an aloofness from the social. The relationship between the abstract and the concrete could no longer be thought of as a one-way street. The culture of the everyday was not a mechanical part that neatly revolved around the pivots of the dominant order. Most significantly, the concept of the everyday was a challenge to the structural determinist tendencies in social theory. Agents could not be represented as being mere 'dupes' of an overarching ideology. By drawing attention to intricate and reciprocal relationships between agency and structure, the theories of the everyday rejected the assumption that change could be imposed from above, or sustained by purely external forces. The everyday became a concept for understanding how the strategies of resistance in the practices of living were not always explicitly oppositional. The heroics and ethics of the everyday did not appear in titanic stature or saintly guise, rather they were enacted through subtle acts of involvement and displacement. The spirit of resistance did not come from beyond or above, but from within. Choice does not always imply freedom, but it opens a space in which the lifeworld can be humanised. The concept of the everyday is thus part of a long tradition in identifying the potential for critical practice, and for offering alternative interpretations on what makes the 'good life'.

Making art by taking what is close at hand. Thinking about the biggest philosophical abstractions from the position of our most intimate experiences. Seeing change as being part of our choices and responses to the inventory of demands and obligations in daily life. From this perspective, where the everyday and the dominant structures are perceived as interconnected, we can also see that art, theory and politics are in a constant dialogue. One cannot proceed without the other. It would be absurd to believe that one discourse has already answered the questions of another. Sociologists such as Fiona Mackie have noted

the process of bracketing and foreclosure that limits comprehension of the legitimate sphere of knowledge and curtails those experiences which are translated back into everyday language.[12] Mackie recognized this blindness, not only in the dominant rationality of the social but also within the mainstream traditions of social theory. The relationship between art, politics and theory can never be of value if the integrity of each position is not acknowledged. Perhaps the concept of the everyday will be seen not as the rejection of earlier debates on the context of art and the responsibility of the artist, but as the grounding of meanings in art. Lyotard, in a rare moment of rapture, caught this beautifully: 'art is the flash that rises from the embers of the everyday'.

Art may be a precursor of changes not yet fully felt, or witness to states either excluded from the frame of hegemonic discourse or still a faint murmur in the heart of everyday life. An art which seeks to heighten our senses to the proximity of the marvellous, to find significance in commonplace signs, to connect one level of subjectivity with another, is a practice which inevitably fans the embers of theory and politics.

1 [footnote 5 in source] Scott McQuire, 'Unofficial Histories', catalogue essay for *Archives and the Everyday*, curated by Trevor Smith (Canberra Art Space, 1997).

2 [6] See Michael Featherstone, 'The Heroic Life and Everyday Life', *Theory, Culture & Society*, vol. 9, no. 1 (1992); Michael Maffesoli, 'The Sociology of Everyday Life', *Current Sociology*, vol. 37, no. 1 (1989).

3 [7] Agnes Heller, *Everyday Life* (London: Routledge, 1984).

4 [8] Henri Lefebvre, *Critique of Everyday Life*, trans. J. Moore (London and New York: Verso, 1991).

5 [9] Ibid., 31.

6 [10] Ibid., 57.

7 [11] Michel de Certeau, *The Practice of Everyday Life*, trans. S. Rendall (Berkeley and Los Angeles: University of California Press, 1988) xiii.

8 [12] Ibid., xxi.

9 [14] John Berger, *And our Faces, My Heart, Brief as Photos* (London: Writers and Readers Press, 1984) 64.

10 [15] Gaston Bachelard, *The Poetics of Space*, trans. M. Jolas (Boston: Beacon Press, 1969).

11 [16] Adam Phillips, *The Beast in the Nursery* (London: Faber & Faber, 1998) 35.

12 [17] Fiona Mackie, *The Status of Everyday Life* (London: Routledge, 1985).

Nikos Papastergiadis, extracts from 'Everything that Surrounds: Art, Politics and Theories of the Everyday', in *Every Day. 11th Biennale of Sydney* (Sydney: Biennale of Sydney, 1998) 21–7.

David A. Ross and Nicholas Serota
The Everyday: A Conversation//2000

David A. Ross [...] The evocation, through metaphor, not of the everyday experience but of a feeling, a psychic experience, of the everyday – more than its simple, literal evocation.

Nicholas Serota I think that is the thread that ties together many of the artists represented in this exhibition. We have not brought together artists who are representing the everyday as such.

Ross We've avoided not only that level of realism but we've also avoided the Surrealists, whose response to the everyday was to move it into a kind of everyday experienced in dream. We've decided to privilege conscious as opposed to unconscious thought, dream and the repressed. [...] I think it may be a bigger task to look at the quotidian and to recognize that in fact it's a reflection of a mind awake and a mind asleep. That the conscious and unconscious minds are both reflections of our quotidian lives. If we frame the reasoning behind our decision to eliminate not only certain artists but certain directions in art and to define the quotidian, I think we would end up by saying we've used contemporary practice to go back and redefine the quotidian throughout this century.

Serota Well, this is a show that is being made in the late 1990s and reflects a view of history which is undoubtedly shaped by what artists are doing today.

Ross It's not just shaped by what we're all doing today in the field of art. When you leave this museum what role does art play in your life? I think one of the things we're talking about is artists who are speaking about changes in the way we are supposed to look at things. It all speaks to a desire towards a reintegration of life, some inherent societal concern about our lives having become so fractured. Not life and art alone because I think that's too simple, but all the elements that one recognizes could produce a more fully lived life. [...]

Serota I think the difficulty for many observers of contemporary art is to understand that the everyday in art is in itself an insight rather than necessarily a representation. The constant media cry in Britain is: 'But is this art?' or 'Why is this art?', when the art appears to be simply the presentation of a slice of life. Of course what those questions do not acknowledge is the degree of selectivity,

of distillation, of isolation that occurs when an artist like Michael Billingham or Tracey Emin takes an element of life and appears to present it verbatim. […]

Serota Is dealing with the everyday essentially an amoral position?

Ross No, quite the contrary. I think it's the reassertion of a real moral position […] This is not art that's easy. This is art that is distinctly staking out a moral position about the way life could and, if you want to get prescriptive, should be lived without getting ham-handed about it. Without saying you have to live my life. It's taking the dictum of Marcel Duchamp and John Cage and bringing it to another moment which is: 'Here is life. You are in it just as I'.

Serota I agree that it's a fundamentally moral position, which of course connects it back to the modernist tradition. I think it is saying: 'Here is value'.

Ross Yes, and perhaps it's also saying that we no longer have to mourn the inability to construct the ideal that seems to lie at the heart of the modernist enterprise; that this longing for an ideal was a false call, and that the modernist enterprise can carry on quite well in relation to a reflection on the ideal that can be found – not necessarily celebrated but acknowledged – in day to day life. […]

Nicholas Serota and David A. Ross, extracts from 'The Everyday: A Conversation', in *Quotidiana: The Continuity of the Everyday in the Twentieth Century* (Turin: Castello di Rivoli/Milan: Museo d'Arte Contemporanea/Charta, 2000) n.p.

Michel Maffesoli
Walking in the Margins//2002

Must quotidian always be associated with humdrum?

Rather, it is perhaps the quotidian – the everyday, the banal – that, in the long run, heroically ensures the survival of the individual and the group as a whole.

In this respect, it is worth recalling the origin of the word 'banal': in mediaeval France, a 'banal' baking day was one when the bread that came from the oven was not owed to the lord of the manor. It was a day of common bread, a day of quiet celebration when life was not owed to the powers that be.

It is precisely these innocuous activities and daily little rituals that constitute

the eternal bedrock of 'being together'. We should remember that when nothing is important, everything assumes importance.

The interlude represented by the 'modern period' is coming to a close. It has been a period of closure – of closed identities, shielded by the walls of private life. A period of the individual as master and owner of self and the world. Of the individual as a powerful yet solitary figure.

The world is now reclaiming its right to centre stage. The street is back in circulation, as is the etymology of 'trade', which once meant to tread the path or road. There's trade in goods, of course, yet also trade in feelings and ideas.

Public pavements serve as a fine metaphor for this commerce, reminding us that what was unduly privatized is now back in collective circulation. Sexuality, for instance, is nothing less than individual, yet is also a subterranean lode of collective eroticism.

Urban theatricality is now demonstrating, in various ways, that the individual is an indeterminate thing. None of us have any worth unless we are an integral part of a social context.

Genius, don't forget, is above all part of a collective 'genius' in the sense of 'a prevailing spirit'. It is part of the spirit of a place, one moment in a whole that transcends it. That is how we should understand [the artist] Hassan Khan's 'I am a hero / You are a hero'.

This equation is reversible, moreover: a fragment of crystal exists thanks only to the heterogeneous rock from which it is extracted.

Indeed, the compact, mundane framework of the quotidian stresses an eternal present, lending meaning to all the intense, brief 'snapshots' so typical of everyday life. Postmodern life, echoing premodern life, reminds us that existence does not become meaningful in some yonder world, but is embodied in the here and now.

Transcendence becomes immanent in a kiss rendered tragic because it is so fleeting, in a 'quick coffee' elevated to a daily ritual at the café, in a tattoo that marks the sharing of bodies. All things remind us, as Nietzsche pointed out, that sometimes depth can hide on the surface of things.

Paths on the fringe are converging into a main path, reminding us that all existence, individual and collective, is one long undertaking. The street is a path with no end other than itself.

Michel Maffesoli, 'Promenades en marges', exhibition statement, *Trottoirs – Sidewalks [Promenades en marges]*. *Nobuyoshi Araki, Ed van der Elsken, Alberto Garcia-Alix, Hassan Khan, Enrique Metinides. An exhibition curated by Galerie Chantal Crousel at the Poste du Louvre* (Paris: Galerie Chantal Crousel, 2002) n.p.

Gregory Crewdson
American Standard: (Para)Normality
and Everyday Life//2002

'American Standard: (Para)Normality and Everyday Life' is a group exhibition that traces an American aesthetic tradition of art that explores the intersection of everyday life and theatricality. The artists in this exhibition combine a realist aesthetic sensibility with heightened lighting and colour, dislocations in scale, and other defamiliarizing effects. This collision between the normal and the paranormal produces a tension that transforms the topology of the American landscape into a place of wonder and anxiety.

In order to express fully the breadth and continuity of this tradition, the exhibition brings together historical and contemporary works of art in a variety of mediums and genres. The exhibition features painting by Robert Bechtle, Vija Celmins, John Currin, Eric Fischl, Maureen Gallace and Edward Hopper; sculpture by Robert Gober, Keith Edmier and Joel Shapiro; photography by Robert Adams, Diane Arbus, Tim Davis, Bill Owens, Charles Ray, Cindy Sherman, Joel Sternfeld, Stephen Shore, Hiroshi Sugimoto and Henry Wessel; and production imagery by filmmakers Todd Haynes and Steven Spielberg. Although the artists assembled in 'American Standard' vary widely in style and practice they share a common aspiration to find unexpected beauty and mystery within the American vernacular. [...]

Gregory Crewdson, curatorial statement for 'American Standard: (Para)Normality and Everyday Life', Barbara Gladstone Gallery, New York, 2002.

Ben Highmore
Everyday Life and Cultural Theory//2002

Aesthetics
[...] Isn't the field of aesthetics concerned with the values and practices of high culture, which if not antithetical to the world of the everyday, tend to be removed from it? Our initial move then will have to be to ignore such insistent associations for the moment. If we swap the world of everyday life for the socio-historical terrain of Western fine art (in which aesthetic questions have taken

root) what then becomes of aesthetics? Aesthetics, I want to argue, allows us to consider two questions simultaneously. On the one hand, by foregrounding the world as both mental *and sensual* experience it problematically expands the range of meaningful elements attributable to the everyday. If, for instance, boredom is seen as a central experience in everyday life, then it is clearly not limited to the realm of thought (which is usually 'where' meaning is located). Boredom can affect the body and mind as a form of existential and physical tiredness. How should this experience (or these experiences) be understood? How should they be described? This takes us directly to the other central aspect of aesthetics: aesthetics insists on examining the way in which experiences are registered and represented. So aesthetics is concerned with experience and the form such experience takes when it is communicated. Such concerns are clearly crucial for theorizing the everyday. It should also be noted that thinking of aesthetics in this way takes us back to a realm of high culture, though not exclusively. After all, the province of poets, painters, novelists and composers has often been to try and register 'ordinary' experience. The relevance of so-called high culture becomes even more vivid when the formal experimentation of avant-garde artists is taken into account. The attempt to locate and apprehend modern everyday life, and to find forms that are capable of articulating it, might be seen as the overriding ambition of many avant-garde artists of the late nineteenth and early twentieth century. The importance of such an avant-gardist ambition will be central to this book [*Everyday Life and Cultural Theory*, 2002]. First though we need to flesh out a notion of aesthetics as it might impact on the theorizing of everyday life.

In his discussion of the term 'everyday life' in his book *Undoing Culture* (1995), Mike Featherstone suggests that 'it appears to be a residual category into which can be jettisoned all the irritating bits and pieces which do not fit into orderly thought'. He goes on to write that 'to venture into this field is to explore an aspect of life whose central features apparently lack methodicalness and are particularly resistant to rational categorization' (*Undoing Culture*, 55). This suggests that the everyday cannot be properly accommodated by rationalist thought and that the everyday is precisely what becomes remaindered after rationalist thought has tried to exhaust the world of meaning. It also implies that the concept of everyday life has much in common with the incipient meaning of aesthetics. When the term aesthetics emerged in the work of the German philosopher Alexander Baumgarten at the end of the eighteenth century, it was going to be the 'science of the senses'[1] – a philosophical and scientific attention to sensory, corporeal experience (perhaps the very stuff of the everyday). As Terry Eagleton writes:

It is as though philosophy suddenly wakes up to find that there is a dense, swarming territory beyond its own mental enclave which threatens to fall utterly outside its sway. That territory is nothing less than the whole of our sensate life together – the business of affections and aversions, of how the world strikes the body on its sensory surfaces, of that which takes root in the gaze and the guts and all that arises from our most banal, biological insertion into the world.
(Eagleton, *The Ideology of the Aesthetic*, 1990, 13)

The history of attempts to attend to these experiences, like the history of attending to the everyday, is fraught with contradiction. Eagleton suggests that rationalist philosophy's approach to sensory experience operates as a form of colonization: 'the colonization of reason' (*The Ideology of the Aesthetic*, 15). What Eagleton points to is the tendency of philosophy to submit sensate experience to the procedures of reason and science without questioning the adequacy of its form of attention. Indeed some philosophers have embraced this colonizing operation with a missionary zeal: 'Science is not to be dragged down to the region of sensibility, but the sensible is to be lifted to the dignity of knowledge' (Baumgarten, quoted in Eagleton, 17).

The example of Baumgarten demonstrates a problematic: to borrow the procedures and materiality of a 'scientific' discourse for attending to everyday life can be seen to remainder precisely that which is the object of study. How often is the particularity of the everyday lost as it is transformed in the process of description and interpretation? As rationalist discourse expands to cover areas of life that are non-rational, that do not follow patterns of logical reasoning, what is lost (as these aspects of life are transformed into suitable objects for attention) is the very 'stuff-ness' that made them urgent problems in the first place. Of course for Baumgarten the intention is precisely to 'rescue' such material from its inchoate state, to transform the material to the point where it transcends its status as 'mere' sensation living in the lowly realms of the everyday. Significantly, much of aesthetics (as a discourse about art) is concerned with the everyday only at the point of such transcendence. Even in the aesthetic discourses that are most concerned with the everyday world of experience, transformation and transcendence are the operative procedures.

At this level of argument the everyday represents an impossibly evasive terrain: to attend to it is to lose it, or as Blanchot writes: 'We cannot help but miss it if we seek it through knowledge, for it belongs to a region where there is still nothing to know' (Maurice Blanchot, 'Everyday Speech' [1962], 1987, 15). But this should not be taken to suggest that the everyday is completely unyielding to forms of representation (description or theory); rather it is to suggest that certain forms of discourse (discourses of 'knowledge' in Blanchot's words) are

not adequate to their objects and at times fail to accommodate them at all. The other side of this is that there might well be forms of representation that are more appropriate, *more* adequate, for attending to the everyday. To suggest that the sensory and the everyday are outside representation, and that they are fundamentally incommensurate with forms of representation, is to miss the fact that sensation and the everyday are already part of a world of representation. To treat everyday life as a realm of experience unavailable for representation or reflection is to condemn it to silence. However, if the sensory and the everyday are seen as already fully colonized by discourse and representation, as if nothing could possibly be outside the forms of representation that are currently in use, then everyday life is neither problematic nor capable of generating counter-discourses. It becomes merely a term used to designate an area already fully represented. An everyday aesthetics would have to negotiate to avoid either one of these endgames.

Tradition might suggest that certain forms of representation are more appropriate for attending to specific aspects of the world. For instance, a poem might be seen as a more fitting form for attending to the world of feelings and emotions than a sociological study; the economic treatise more capable of apprehending capitalism than a novel. Yet in relation to the everyday, all forms of representation are hampered by a similar problem. If, for example, the everyday is seen as a 'flow', then any attempt to arrest it, to apprehend it, to scrutinize it, will be problematic. Simply by extracting some elements from the continuum of the everyday, attention would have transformed the most characteristic aspect of everyday life: its ceaseless-ness. As far as this goes, a good starting point would be to suggest that no form of discourse is ever going to be 'proper' (appropriate) to everyday life. The everyday will necessarily exceed attempts to apprehend it. This would simply mean that the search for the perfect fit between a form of representation and its object (the everyday) needs to be called off. Instead we might say that different forms of representation are going to produce different versions of the everyday. But if what is deemed to be the appropriate form for attending to the everyday (mainstream sociology, say, or novelistic description) has resulted in a lack of attention to certain aspects of the everyday, then the everyday might benefit from the attention of purposefully *inappropriate* forms of representation. Or rather, the everyday might be more productively glimpsed if the propriety of discourses is refused. In the work of Simmel or Benjamin, or in the avant-garde practices of Surrealism or the College of Sociology, or in the 'Anthropology at Home' of Mass-Observation, a form of representation is fashioned that might be seen as *improper*. To use Surrealism to conduct sociological research or to insist on montage as the technique for historical study is to cut across discursive decorum. It is also to test the potential

of different forms of representation to apprehend the experience of everyday life.

One of the main arguments of this book is that *something like* an avant-garde sociology is being fashioned when the everyday is taken as the central problematic. A significant concern for theorizing the everyday is the problem of generating a suitable *form* for registering everyday modernity. In other words, all the projects dealt with here can be seen to contribute to the creation of an aesthetics of and for everyday modernity. That the very form of articulating the everyday is seen as a problem, or that describing the everyday might require formal experimentation, implies not only that the everyday has suffered from inattention, but that the kinds of attention that are available are severely out of step with the actuality of the everyday. There is a historical dimension to this that cannot be ignored. The dramatist Bertolt Brecht once suggested that 'new problems appear and demand new methods. Reality changes; in order to represent it, modes of representation must also change' (Brecht, 'Against Georg Lukács', 1980, 82). The projects I go on to discuss can all be seen to respond to a sense of everyday modernity as described in the previous chapter. It is this sense of modernity as complex, contradictory (both boredom and mystery) and dynamic that makes traditional – forms of representation appear unfit for dealing with modem everyday life. Perhaps the most famous text that deals with the revolutionary aspects of modernization is Marx and Engels' *Manifesto of the Communist Party* (1848). In this, they treat modernization as an assault on all forms of tradition:

> Constant revolutionizing of production, uninterrupted disturbance of all social conditions, everlasting uncertainty and agitation distinguish the bourgeois epoch from all earlier ones. All fixed, fast-frozen relations, with their train of ancient and venerable prejudices and opinions are swept away, all new-formed ones become antiquated before they can ossify. All that is solid melts into air, all that is holy is profaned ... (Marx and Engels, *Selected Works*, 1968: 38)

Marx and Engels insist on the everydayness of modernization. As a form of consciousness ('uncertainty and agitation') modernization is unsettling, as an attack on traditional beliefs ('ancient and venerable prejudices and opinions are swept away') it is disorientating, and as an assault on perception ('all that is solid melts into air') it is unnerving. By connecting technological and social changes with changes in everyday experience the *Communist Manifesto* becomes one of the first texts to posit modernity as a revolutionary experience to be located at the level of everyday life. What then would constitute a suitable aesthetic form for registering daily life in all its newness, uncertainty and lack of tradition? How might such an unsettled form of life register? This might well be the question

that the everyday poses to the avant-garde sociologist. The necessity of fashioning new forms (or tools) for apprehending new kinds of experiences (new- 'realities') might be seen as the general impetus and problematic attendant on theorizing daily life. What is called the artistic avant-garde seems to offer a repertoire of formal devices for registering a world that appears chaotic, disrupted and radically new. The projects discussed in this book might be seen to exist on the boundaries of art and science, borrowing from the artistic avant-garde (or working in sympathy with them) and yet directing their concerns towards other ends. Here I shall only give a very quick synopsis of some of the formal 'aesthetic' devices that might coexist in both an artistic avant-garde and in a more sociological one.

If everyday life, for the most part, goes by unnoticed (even as it is being revolutionized), then the first task for attending to it will be to make it noticeable. The artistic avant-garde's strategy of 'making strange', of rendering what is most familiar unfamiliar, can provide an essential ingredient for fashioning a sociological aesthetic (to use Simmel's term). Aesthetic techniques, such as the surprising juxtapositions supplied by Surrealism, provide a productive resource for rescuing the everyday from conventional habits of mind. Similarly, if the everyday is conventionally perceived as homogeneous, forms of artistic montage work to disturb such 'smooth surfaces'. But this sociological aesthetic isn't simply designed to 'shock' us out of our established forms of attention; its ambition is to attempt to register the everyday in 'all' its complexities and contradictions. For this montage might be seen as an aesthetic form particularly well suited to the complex and contradictory. Yet if 'everyday life theory' is to promote and practise montage, then, unless it is going to simply register the cacophony of the everyday, it has to find some way of ordering, of organizing the everyday. Here the theoretical is precisely the problem of ordering and arranging, of making some kind of sense of the endless empiricism of the everyday.

The theorists and theories explored in this book (Georg Simmel, Walter Benjamin, Surrealism, Mass-Observation, Lefebvre and Certeau) can be seen to begin to fabricate an 'alternative' aesthetic for attending to the experience of modern everyday life. It is an alternative to a range of options in regard to the everyday: it is alternative to the instrumentality of governmental attempts to catalogue the everyday; to high culture's propensity towards expressive subjectivism in relation to the everyday; and to science's dour positivism. Theirs is an aesthetic that in negotiating the experience of everyday life never claims to exhaust it. It is an aesthetic of experimentation that recognizes that actuality always outstrips the procedures for registering it. The work of these everyday life theories can be characterized by a hybrid mode of representation. Never simply 'theory' or 'fiction', philosophy or empirical observation, 'everyday life studies'

exist on the borders and the gaps between these representational categories. It is an aesthetic that questions the suitability of 'system', 'rigour' and 'logic' for attending to the everyday. As such its theoretical resources emerge from a variety of sources, from writers such as Brecht and Joyce as much as from Marx, from daily observations as much as from intellectual encounters. It is an aesthetic struggling to find a place within a field (social and cultural theory) that is often oblivious to its own aesthetic protocols.

Archives

The second cluster of questions concerns the (related) problem of the archive. At one level this might be thought of as a simple practical question: what would an archive of everyday life include? What could it possibly exclude? For instance, if an archive of the everyday (for example, the one Mass-Observation produced) were to include a potentially infinite number of items (diaries, photographs, observations and so on, compiled by anyone who wants to participate), then how could it be organized? The question of what to include in an everyday life archive raises questions about the appropriate form for collating 'everyday life' material. In the case of Mass-Observation the desire to let the_eyervday speak for itself resulted in an archive on an unmanageable scale. Two problems immediately become clear. First, if the everyday is going to be represented 'from within', so to speak, then questions emerge about the organization and limits that might be placed on such a necessarily disordered archive. Will everything and anything be included? Will there be any way of organizing this material? A second and related problem becomes evident in any use of this archive. If the archive is made up of a polyphonic everyday, then how is it to be orchestrated into meaningful themes or readable accounts? How can one construct an intelligible articulation from the archive that doesn't submerge the polyphonic, beneath the editorial voice at work? In other words the possible use of the archive seems to linger between two extremes: on the one hand an unmanaged accumulation of singularities, and on the other a constrictive order that transforms the wildness of the archive into tamed narratives. The history of Mass-Observation is the history of negotiating this problematic.

So even at the level of collecting and organizing data, more fundamental problems intrude, namely the problem of making the everyday meaningful in a way that doesn't imprison it at the level of the particular, or doesn't eradicate the particularity of the particular by taking off into abstract generalities. This problem can be seen as the dilemma of negotiating between the microscopic levels (most frequently classed as everyday) and macroscopic levels of the totality (culture, society and so on). The issue that this articulates is about the privileging accorded to either one of these perspectives. In recent years (in the wake of

certain kinds of arguments associated with accounting for postmodernism) the privilege has tended to fall on the side of the microscopic. Yet, if 'everyday life theory' is a meaningful and historically urgent form of attention, I would want to argue that this is because at some level it simply refuses to remain at the microscopic scale. After all doesn't the notion of the everyday suggest a desire for something more than an endless series of singular 'everydays'? Simply put, *everyday life might be the name for the desire of totality in postmodern times.*

However, if the argument that the desire to attend to the 'totality' must be a 'totalitarian' desire is overblown (which it clearly is), then the tendency of 'grand narratives' to erase and ignore vast terrains of experience can't be so easily dismissed. Indeed, as should be becoming clear by now, much everyday life theory is purposefully addressed to responding to the way in, which conventional discourse has erased and ignored the everyday. So if general accounts of 'society' or 'culture' are seen as oblivious towards the everyday, then before any general account of these can be proffered the absolute priority is going to be to rescue the everyday from oblivion. If this is the case, the initial move for a cultural theory of the everyday will be to bring to recognition this benighted realm of the everyday – to allow it to become visible in all its particularity. But (and this may be the central dilemma of the everyday archive) if this is the case, might it not become impossible (or at least, less likely) to generate new and better accounts of the social totality as the archive literally submerges this possibility in its exponentially increasing textuality? There is of course no recourse to a solution here. For someone committed to Marxism, such as Lefebvre, without a philosophical (abstract and critical) orientation it made no sense to attend to the empirical. Lefebvre provides a useful approach to this problematic in that he treats everyday life as the relationships between different registers of social life. In his *Critique of Everyday Life* he suggests that the singularity of the everyday event (a woman buying sugar, for example) reverberates with social and psychic desire as well as with the structures of national and global exchange (Lefebvre, *Critique*, vol. 1: 57). The question that this poses for the archive is a massive one. Not only does it suggest the endless proliferation of singular events, but also it demands the relating of these events to economic structures of desire and exchange. The methodological problems this poses for Lefebvre are dealt with in a variety of ways, but as the focus of his work shifts from everyday life in general to the urban everyday, the unmanageability of the everyday archive is increasingly managed by spatializing the interrelations of the everyday.

A more epistemological problem exists in relation to the history of archival practices. For Certeau, what united the archival practices that emerged in the West as a corollary to colonial expansion (both at 'home' and 'abroad') was a combined operation that both repressed the culture that was supposed to be

'conserved' by the archive, and inscribed there a desire of its own. For Certeau it is the translation of a lived culture into a *written* culture that marks the taming of the everyday and the inscription of a disciplinary writing. It is clear in Certeau's work that those discourses (at once archival and scriptural) that might at first glance be seen as attending to the everyday (anthropology, 'official' studies of daily life and so on) work to erase the everyday. Yet it also becomes clear that they are never entirely successful. The everyday exists 'between the lines' (so to speak) of archival practices. So for Certeau attending to the everyday will also mean attempting to rescue the traces, the remainders of the overflowing unmanageability of the everyday that erupt within representation, and mark the work of repression.

The question of methodology is raised again by the heterogeneity of the material that could be included in an archive of everyday life. While Cultural Studies has developed sophisticated ways of attending to the semiotic material of the visual and verbal, it is massively underdeveloped in relation to the aural, the olfactory and the haptic. An archive of everyday life based on the writings of Certeau, for instance, might include: walking, talking, cooking, eating, slouching and so on. Both Simmel and Benjamin recognize the everyday of modernity as assaulting the totality of the sensate body. While the theories being considered here don't result in a worked-through approach to the totality of sensory life, they do point to the lack of attention to non-visual and non-scriptural senses. The historicity of everyday sensation might well be a necessary accompaniment to any future theorizing of everyday life. It might also mean that the archive of everyday life includes not only the recording and collection of everyday voices, everyday events, everyday materials and everyday sensations; it should also include a process of everyday-ing archives already in existence. For instance, this might mean attempting to read the haptical (through posture, gait, the sense of a body holding itself) in the negotiated moments of visual description that make up a photographic archive. It might also suggest that the presentation of archival material would benefit from experimental approaches that attempt to articulate the everyday as a sensory realm. [...]

1 See Christine Battersby, 'Situating the Aesthetic: A Feminist Defence', in *Thinking Art: Beyond Traditional Aesthetics*, ed. Andrew Benjamin and Peter Osborne (London: Institute of Contemporary Arts, 1991) 35.

Ben Highmore, extract from 'Arguments', *Everyday Life and Cultural Theory: An Introduction* (London and New York: Routledge, 2002) 17-26.

Step
in
all
the
puddles
in
the
city

Yoko Ono, *City Piece*, Autumn 1963

Marcel Duchamp
Notes on the Infra-Slim//c. 1945

A transformer designed to utilize the slight, wasted energies such as:
the excess of pressure on an electric switch
the exhalation of tobacco smoke
the growth of a head of hair, of other body hair and of the nails
the fall of urine and excrement
movements of fear, astonishment, boredom, anger
laughter
dropping of tears
demonstrative gestures of hands, feet, nervous tics
forbidding glances
falling over with surprise
stretching, yawning, sneezing
ordinary spitting and of blood
vomiting
ejaculation
unruly hair, cowlicks
the sound of nose-blowing, snoring
fainting
whistling, singing
sighs, etc. [...]

View, 5, no. 1 (March 1945). Reproduced in facsimile in *The Complete Works of Marcel Duchamp* and analysed on pages 519–20. In 'Marcel Duchamp, mine de rien', *Preuves* (Paris), XVIII, no. 204 (Feb. 1968), 43–47, Denis de Rougemont quotes Duchamp as saying that he 'chose on purpose the word slim which is a word with human, affective connotations, and is not an exact laboratory measure. The sound or the music which corduroy trousers, like these, make when one moves, is pertinent to infra-slim. The hollow in the paper between the front and back of a thin sheet of paper. ... To be studied! ... it is a category which has occupied me a great deal over the last ten years. I believe that by means of the infra-slim [*infra-mince*] one can pass from the second to the third dimension.'; reprinted in Marcel Duchamp. *Notes*, ed. Paul Matisse (Paris: Éditions du Centre Georges Pompidou, 1980).

THE SOUND OR THE MUSIC WHICH CORDUROY TROUSERS, LIKE THESE, MAKE WHEN ONE MOVES.

Marcel Duchamp, *Notes on the Infra-Slim*, c. 1945

Jonas Mekas
Interview with Jérôme Sans//2000

Jérôme Sans Since 1950 you have always carried your Bolex camera, all day long and everywhere. Why this desire to record everything?

Jonas Mekas I have no real answer. All answers that I have given to this question in the past could be wrong, they are all my inventions. One of the answers, usually, is that as an exile, as a displaced person, I felt that I had lost so much, my country, my family, even my early written diaries, ten years of it, that I developed a need to try to retain everything I was passing through, by means of my Bolex camera. It became an obsession, a passion, a sickness. So now I have these images to cling to ... It's all ridiculous, I think. Because what I have, after all, is already fading, so it's all just like a shadow of the real reality which I do not really understand. When you go through what I went through, the wars, occupations, genocides, forced labour camps, displaced person camps, and lying in a blooming potato field – I'll never forget the whiteness of the blossoms – my face down to earth, after jumping out of the window, while German soldiers held my father against the wall, gun in his back – then you don't understand human beings any more. I have never understood them since then, and I just film, record everything, with no judgement, what I see. Not exactly 'everything', only the brief moments that I feel like filming. And what are those moments, what makes me choose those moments? I don't know. It's my whole past memory that makes me choose the moments that I film ...

Jonas Mekas and Jérôme Sans, Interview, in Mekas, *Just Like a Shadow* (Göttingen: Steidl, 2000) n.p.

Lettrist International
Proposals for Rationally Improving the City of Paris[1]//1955

The Lettrists present at the September 26 meeting jointly proposed the following solutions to the various urbanistic problems that came up in discussion. They stress that no constructive action was considered, since they all agreed that the most urgent task is to clear the ground.

The subways should be opened at night after the trains have stopped running. The corridors and platforms should be poorly lit, with dim lights flickering on and off intermittently.

The rooftops of Paris should be opened to pedestrian traffic by modifying fire-escape ladders and by constructing bridges where necessary. Public gardens should remain open at night, unlit. (In a few cases, a steady dim illumination might be justified on psycho-geographical grounds.)

Street lamps should all be equipped with switches so that people can adjust the lighting as they wish.

With regard to churches, four different solutions were proposed, all of which were considered defensible until appropriate *experimentation* can be undertaken, which should quickly demonstrate which is the best.

G.-E. Debord argued for the total destruction of religious buildings of all denominations, leaving no trace and using the sites for other purposes.

Gil J Wolman proposed that churches be left standing but stripped of all religious content. They should be treated as ordinary buildings, and children should be allowed to play in them.

Michèle Bernstein suggested that churches be partially demolished, so that the remaining ruins give no hint of their original function (the Tour Jacques on Boulevard de Sébastopol being an unintentional example). The ideal solution would be to raze churches to the ground and then build ruins in their place. The first method was proposed purely for reasons of economy. Lastly, Jacques Fillon favoured the idea of transforming churches into *houses of horror* (maintaining their current ambience while accentuating their terrifying effects).

Everyone agreed that aesthetic objections should be rejected, admirers of the portals of Chartres silenced. Beauty, *when it is not a promise of happiness*, must be destroyed. And what could be more repugnant representations of unhappiness than such monuments to everything in the world that remains to be overcome, to the numerous aspects of life that remain inhuman?

Train stations should be left as they are. Their rather poignant ugliness contributes to the feeling of transience that makes these buildings mildly attractive. Gil J Wolman proposed removing or scrambling all information regarding departures (destinations, timetables, etc.) in order to facilitate *dérives*. After a lively debate, those opposing this motion retracted their objections and it was wholeheartedly approved. It was also agreed that background noise in the stations should be intensified by broadcasting recordings from many other stations, as well as from certain harbours.

Cemeteries should be eliminated. All corpses and related memorials should be totally destroyed, leaving no ashes and no remains. (It should be noted that these hideous remnants of an alienated past constitute a subliminal reactionary

propaganda. Is it possible to see a cemetery and not be reminded of Mauriac, Gide or Edgar Faure?)

Museums should be abolished and their masterpieces distributed to bars (Philippe de Champaigne's works in the Arab cafés of rue Xavier-Privas; David's *Sacre* in the Tonneau on Rue Montagne-Geneviève).

Everyone should have free access to the prisons. They should be available as tourist destinations, with no distinction between visitors and inmates. (To spice things up, monthly lotteries might be held to see which visitor would win a real prison sentence. This would cater to those imbeciles who feel an imperative need to undergo uninteresting risks: spelunkers, for example, and everyone else whose craving for play is satisfied by such paltry pseudo-games.)

Buildings whose ugliness cannot be put to any good use (such as the Petit or Grand Palais) should make way for other constructions. Statues that no longer have any meaning, and whose possible aesthetic refurbishings would inevitably be condemned by history, should be removed. Their usefulness could be extended during their final years by changing the inscriptions on their pedestals, either in a political sense (*The Tiger Named Clemenceau* on the Champs Élysées) or for purposes of disorientation (*Dialectical Homage to Fever and Quinine* at the intersection of Boulevard Michel and rue Comte, or *The Great Depths* in the cathedral plaza on the Île de la Cité).

In order to put an end to the cretinizing influence of current street names, names of city councillors, heroes of the Resistance, all the Émiles and Édouards (55 Paris streets), all the Bugeauds and Gallifets,[2] and in general all obscene names (Rue de l'Évangile) should be obliterated.

In this regard, the appeal launched in *Potlatch* #9 for ignoring the word 'saint' in place names is more pertinent than ever.

1 The title echoes 'Proposals for Irrationally Improving a City' (*Le Surrealisme au Service de la Revolution* #6, 1933).

2 Of the various persons disdainfully mentioned in this article, Clemenceau and Edgar Faure were politicians, Gide and Mauriac were writers, and Bugeaud and Gallifet were nineteenth-century generals (the first responsible for the conquest of Algeria, the second for the crushing of the Paris Commune).

Internationale Lettriste, 'Projet d'embellissements rationnels de la ville de Paris', *Potlatch*, no. 23 (Paris, 13 October 1955); trans. Ken Knabb, in *Situationist International Anthology* (Berkeley: Bureau of Public Secrets, 2002).

Vincent Kaufmann
The Poetics of the Dérive//2001

[...] In public, the Lettrists insulted Charlie Chaplin, celebrated the fall of Dien Bien Phu, and later made apologies for the Algerian partisans. In private, they cultivated their most secret gardens; they dreamed of labyrinths in which they could disappear and, when they couldn't build them, tried to transform the city itself into a giant maze. Such were the charms of the dérive, one of the major inventions of the Lettrist and later the Situationist movement, or at least one of its most characteristic practices. It would be wrong to conclude that the phenomenon was entirely new to the avant-garde, regardless of the originality of Ivan Chtcheglov's 1951 'Formulary for a New Urbanism' and the concrete experiences 'programmed' by his essay.

What exactly did the 'Formulary for a New Urbanism' and the psycho-geographic experiments of the Lettrist and Situationist Internationals referred to in so many texts of the period entail? Primarily the desire to introduce poetry into a lived experience of the street, of the city. Psychogeography consisted in experimenting with the affective variants of the urban environment, an immediate aesthetic experience [this is obviously a paradox in terms of the Western philosophical tradition, which associates aesthetic possibility with distance and contemplation) brought about by walking around a city that is systematically explored. This is also the meaning of the dérive – literally, drift – which can be minimally defined as a controlled and, in principle, collective (in small groups) form of movement through several areas of the same city in order to distinguish, as objectively as possible, differences in ambience or atmosphere. Such practices were exercises in the recognition or interpretation of the urban fabric, or urban text, an anticipatory and ironic homage to all those who, ten or twenty years later, chose to drift more comfortably by means of the signifier. The Lettrist or Situationist artist was devoted to the interpretation of the city, the way others examined texts. He took pleasure in the city's streets, markets and cafes rather than its libraries and books. And like any form of interpretation, this involved a certain number of rules. It required a structure. You couldn't wander the city in any old way. Debord was very specific about this, especially in an article titled 'Théorie de la dérive' [Theory of the dérive]:

> Of the various situationist tools, the dérive is a technique for rapidly moving through various environments. The concept of the dérive is inextricably bound with the recognition of effects of a psychogeographic nature and the affirmation

of a ludic-constructive form of behaviour, which contradicts every conventional notion of an excursion or walk.

When one or more individuals are involved in the dérive, they abandon, for a relatively lengthy period of time, the customary rationales for movement and action, their relationships, their work and their own leisure time, to succumb to the enticements of the terrain and the encounters associated with it. The element of chance is less important here than one might suspect: from the point of view of the dérive, there is a psychogeographic contour map associated with cities, with their permanent currents, their fixed points, and whirlpools that make entering or leaving certain zones quite difficult.

But the dérive, as a whole, comprises both this letting-go and its necessary contradiction; the domination of psychogeographic variants through an understanding and calculation of their possibilities. ...

One can drift alone, but everything points to the fact that the most fruitful numerical distribution consists of several small groups of two or three individuals with the same degree of awareness; cross-checking the impressions of these different groups enables us to arrive at objective conclusions.

The dérive is a method of 'rapid movement'. It is impossible not to recall the title of Debord's second film, *On the Passage of a Few Persons through a Rather Brief Unit of Time* (1959), devoted entirely to the lost children of Saint-Germain-des-Prés. They moved from one environment to another, from one part of the city to another, and, most certainly, from one café to another, just as they passed through time. The dérive is the projection onto space of a temporal experience, and vice versa. It is the emblem of lost children, who drift, who abandon themselves to a principle of pure mobility, absent the customary reasons for going places – a directionless mobility, unproductive, serving no purpose, which is open to the 'enticements of the terrain' and to encounters.

Yet those who drift are not passive, and we should not confuse the dérive with the contemplative charms of the conventional, or classically surrealist, promenade. From this point of view, we see that a not inconsiderable part of the 'Theory of the dérive' is devoted to explaining that although the dérive is to some extent a bet against chance, chance is not the key element. On the contrary, the dérive entails a preliminary determination of environments, the possibility of calculating them, of establishing some form of objective understanding. It was important to avoid any confusion or similarity with other forms of urban experience, especially those of the Surrealists, who were always suspected of subjectivity and passivity, of an allegiance to chance. From Debord's perspective, it would be highly unfortunate if the dérive were confused with the Parisian promenades of Breton and Aragon, which it resembles but with the addition of

an 'objective' understanding. The history of the avant-garde is inextricably linked to the notion of the promenade, a phenomenon it is difficult to escape even when it has been rechristened the 'dérive'.

Between the urban experiences described in books such as Breton's *Nadja* and Aragon's *Le paysan de Paris* [*Paris Peasant*] and the way in which Debord presented the dérive, there were a certain number of points in common that trace the outlines of a relationship. Although Surrealism and Situationism have other features in common, it is obvious that at this time Debord was uninterested in them, for rarely have avant-gardes maintained good relations with their predecessors, which they have always struggled to relegate to the past. Neither Breton nor the Aragon of the surrealist period would have disavowed the idea of being open to the enticements of the city or chance, or the rejection of ordinary activities and relationships, in short, everything that made the derive an aimless wandering and the absence of goals the opportunity for an aesthetic or affective experience. Even the group nature of the dérive, which provided the objectivity of the psychogeographic experience, would easily have found favour with Breton. Wasn't his entire urban experience associated with encounters and sharing? The surrealist *trouvaille* [the chance 'find'] so often sought in flea markets or elsewhere, was never individual. It only had meaning and reality if it was the product of at least two individuals; it too was part of a project to objectify desire. The surrealist promenades (at least those of Breton, for it was very different with Aragon) were no less productive of community or communication than those of the Situationists, or at least this was their intent. Similarly, the question of objectifying the aesthetic impression or sensation is already present and, as in the case of international Lettrism or Situationism, this objectification involved immersion in the urban milieu. (The only attempt at a surrealist dérive in the countryside turned out badly; Debord was quick to point this out in the same text, to highlight a difference that may not have been obvious.)

Psychogeography set in motion a surrealist experiment with the city. Many passages in Chtcheglov's 'Formulary for a New Urbanism' also reflect this, in a way that is both conscious and constrained: 'All cities are geological and you can't take three steps without encountering ghosts, armed with the prestige of their legends. We evolve in a closed landscape whose landmarks draw us incessantly towards the past. Shifting angles and receding perspectives enable us to perceive original conceptions of space, but this vision remains fragmentary. It must be sought in the magic lands of folklore and surrealist writings: castles, endless walls, small forgotten bars, prehistoric caves, casino mirrors.' This passage is not without ambiguity. It suggests, as was also the case with the surrealist experiment with the city, that psychogeography is fundamentally an experience of mobility, applied to space as much as to time. The objectification

of urban environments entails a capacity for movement that is both spatial and temporal: the ability to recognize the city in its geological dimension and concentrate on the different temporal strata of which it is composed, as reflected in certain buildings, forgotten bars, and endless walls – one can also drift through a Paris that is in the process of disappearing. This mobility is essential. Chtcheglov confirmed the importance in the conclusion of his 'formulary': 'The principal activity of the inhabitants will be to DRIFT CONTINUOUSLY. The change of scenery on an hourly basis will be responsible for the complete sense of disorientation.' To drift from space to space, temporality to temporality, and, while drifting, to enter a logic of disorientation, the logic of the Paris peasant: even if the lettrist project was more systematic, more constructed, it duplicated that of the surrealists while attempting to distinguish itself from it. Moreover, Chtcheglov notes that the past also encloses us, which impedes mobility and blocks the vanishing lines of the dérive. And if the Surrealists indicated which receding perspectives and shifting angles to follow, they looked too hard to find them in a past they were now a part of. Chtcheglov was interested in a 'new urbanism', characteristic of the utopian strain among the early Situationists. He introduced activism to the field of urbanism, something that was nowhere to be found among the surrealist dreamers, who were too passive, too ready to let themselves go, carried away by chance or the unconscious. To avoid this it was necessary to move beyond the past and passivity, drifting had to be more controlled, more systematic, and new cities and spaces had to be invented that would provide greater scope for the dérive.

I will return later to the utopian element in Situationism, which was especially evident during the first years of its existence, but want to point out that Debord himself never showed much enthusiasm for it. He often seems much closer to the melancholic aspect of the surrealist urban experience (that of Aragon in this case, who was much more Baudelairean than Breton). It was hardly arbitrary that the places he cared about, which served as landmarks for his dérives, are those that have since disappeared: the area around Les Halles, an emblematic crossroads, a meeting place teeming with life, or other areas that were still working-class in the fifties, any number of cafés, one more insalubrious than the next, no trace of which remains today or of their habitués: North African immigrants on Rue Xavier-Privas, Jews who spoke only Yiddish along Rue Vieille-du-Temple, Spanish Republicans in the 'Taverne des Révoltés' in Aubervilliers.

Debord's Paris of legend, the one he drifted through, is a Paris of the foreigner and the foreign, of disorientation, of travellers, of those who are away from home. It is also, on occasion, the subterranean Paris of truants and thieves. But it is especially a Paris marked by transience, condemned to a disappearance later

identified in *In girum imus nocte* ('Paris no longer exists'). It is the city of 'Andromache, I'm thinking of you', through which we can retrace our steps, possibly through Benjamin, to the sources of a perception of the city as both modern and melancholic, that is, to Baudelaire once more. The old Paris is no longer, the shape of a city changes more quickly than the heart of a mortal, and this is why, since Baudelaire, the city has served as a source for poetry. It does so in its temporal-geographic dimension, precisely because of everything that has disappeared, the remains of another time. We can say – appropriating the title of a book that meant a great deal to Debord, one he quoted often – that the psychogeographic investigation of the city was necessary because of what was assassinated by the boulevards of Haussmann's time, and the expressways and ring roads of Debord's: rupture, the abolition of the past and its symbolic efficacy, the interruption of space and communication, through which the society of the spectacle robbed the city without leaving any possibility for the dérive.

In the fifties Debord was a master of the dérive. He was during the sixties as well, according to several reports of the situationist movement (especially in London, but in Brussels and Amsterdam as well). He was a tireless drifter, he could walk across Paris, with friends or lovers, for days and nights at a time (wandering not only through urban space but through time, never as palpable as when life no longer conforms to a regular succession of days and nights). He initiated a number of his companions into the psychogeographic experience, taught them how to see a city. He participated in the riskiest dérives, including, at least since the period of Saint-Germain-des-Prés, a fondness for exploring the catacombs of Paris (preferably the sections off limits to the public), at least one of which came close to ending badly when the lights failed. Obviously, there is considerable risk, when playing with lost children, of losing oneself for good. And even if no one ever really got lost in the catacombs, it would have been a fitting ending for such authentic amateurs.

In later years, Debord and his associates would imagine other labyrinths. The catacombs were replaced by the subway tunnels, which they explored after closing, or by homes in the process of demolition. Gradually, the cities as we know them today got the better of the dérive, which was unable to resist the relative uniformization of environments or the homogenization of life or the functionalization of urban space, its systematic exploitation. Les Halles disappeared, and with it the possibility of deciding what to eat in Paris, food now being shipped in, after being sterilized and packaged. During the sixties, Paris, like the rest of the world, was gradually deprived of the right to taste. Today, who would want to 'drift' down the Rue Saint-André-des-Arts or the Rue Mouffetard, surrounded by tourists from around the world? Certainly not Debord, whose exploration always led him to places and persons on the margins

of society, toward those who struggled to resist the spectacle and the forms of appearance it imposed. Like Baudelaire, he had his little old women, the blind men, the passers-by, and his swan. And, like Baudelaire, he loved them, spoke with them, spoke – and drank – a great deal in fact with the people he met during his dérives. Even hasty walks through changing environments do not stand in the way of authentic contact and dialogue. In fact, the opposite is true, and this is an essential difference with walks and travel in general. The dérive bears no resemblance to a tourist activity, spectacular or even voyeuristic (old Aragon, I salute you) activity. It is not, strictly speaking, an aesthetic experience, recycled, almost before it begins, into a book. On the contrary, it implies an experience 'from within'. Its authenticity requires this. The apparently serious term 'psychogeography' comprises an art of conversation and drunkenness, and everything leads us to believe that Debord excelled in both.

The dérive is a 'technique for moving quickly through varied environments'. It is a technique of transience, devoted to places themselves transient, like the passages that Aragon and Benjamin were once so fond of (and they also provide a clear illustration of what the lettrists called a 'situational' art, which was both temporary and lived). The city entered modern artistic consciousness because of its transformations and disfigurements, the mirror of a vanished fullness or unity that had to be reconstructed. There is nothing surprising, therefore, in the fact that, having been lost from sight after Breton and Aragon, it returned with the lettrists and was well positioned on their poetic agenda, because a new phase of modern urbanism had been established in the fifties, following the years of glaciation resulting from the Occupation and the war. Rarely have cities been transformed as they were during the 1950s and 1960s. They were reconfigured according to the needs of the automobile, and emptied of their inhabitants, who were forced to make room for stores and offices; they became places of separation and solitude. They were bathed in hygiene and light, the last empty and clandestine lots disappeared, and with them the dangerous classes. Fast cars, clean bodies. Everything is functionalized, identified, monitored, culminating in a process that had begun a century earlier under the auspices of Baron Haussmann's 'scientific' urbanism. From this perspective, the practice of the dérive appears as a military, erotic and (therefore) poetic attempt to conquer or reconquer the terrain lost-to-the enemy, a technique of subjective reappropriation of functionalized social space. Which again reveals the similarities with détournement: not only is the dérive an art of the detour, but, like détournement, it also implies an attempt to re-appropriate the urban space, it assumes a contested relation to a space considered to have been occupied by the enemy. As Debord suggests in his *Mémoires*, the drifters were modern Knights of the Round Table who had gone off in search of the Holy Grail. They

had waged war on modern urbanism using their passion, their discipline, their virtue, their courage and their skill. And, like their legendary ancestors, almost to a man they ended up vanishing. [...]

The dérive can be compared to the technique of disorientation. It is not designed to help us understand a comprehensible and eventually presentable ego. Debord [notes] that 'What can be written down serves only as a password in this great game'. In place of surrealist writing, the dérive stepped in, descriptions of which – and they are rare – served as simple passwords for an initiation that took place on another terrain. The adventures of the participants remain clandestine, the players invisible. They literally melt into the landscape, disappear behind the drawings, maps, aerial photographs of cities and images of buildings, which adorn the early issues of *Internationale situationniste* as they do Debord's works, from *Mémoires* to *In girum imus nocte* and beyond. Maps of the heart on which to dream, on which to imagine desires as yet unknown, but which exist in the absence of any dreamer or any image, drawings and stones for experiences that cannot be transmitted. 'The sectors of a city are to some extent decipherable. But the personal meaning they have had for us is incommunicable, as is the secrecy of private life in general, regarding which we possess nothing but pitiful documents'.

Where were these dériveurs? They hid themselves in the sinuous folds of large cities. What they experienced is incommunicable, unrepresentable. It happened and will never return other than as allusions and suggestions, maps and drawings, photos of cities in which to wander. It will also return, but as if in relief, in the form of social criticism, that is, a description and denunciation of the way in which spectacular power dissects the urban landscape for its own profit, a form of criticism found in the pages of *The Society of the Spectacle* devoted to city and regional planning. In its mourning for the world, this book, one of Debord's most important, was not unrelated to his experience of loss, and in this sense it is much less theoretical than has been acknowledged. The pages on regional planning, beneath the veneer of theory, are also based on Debord's and his friends' psychogeographic experience. The theory of 'unitary urbanism', which the Situationists contrasted with the urbanism of power, was developed by drifting, by walking, by evaluating the ambience of the oldest parts of Paris and other European capitals. Debord found theory through the soles of his feet. While he could write in *The Society of the Spectacle* that 'the effort of all established powers, since the experience of the French Revolution, to augment their means of keeping order in the street has eventually culminated in the suppression of the street itself', it was because he worked to delay this suppression, because the dérive consisted, if not in re-creating streets, at least in occupying them for as

long as possible. *The Society of the Spectacle* imitated the absence of life, the raw material of the spectacle; it abolished any reference to the authorial 'I', to a lived singularity. Similarly, Debord's theses on urbanism and regional planning can be read as the exact opposite of the psychogeographic experience of the Lettrists and Situationists. Psychogeography was a conquest, or reconquest, of the reality of space. And the spectacle is what removed reality from space (as from life in general). Debord is quite specific about this: 'The economic management of travel to different places suffices in itself to ensure those places' interchangeability. The same modernization that has deprived travel of its temporal aspect has likewise deprived it of the reality of space.' At the same time, we can understand that the reality of space depends essentially on the subject's ability to occupy it. It is a matter of subjectivity or subjectivization, that is, of singularity, of differentiation, to which is opposed the generalized interchangeability brought about by the economic management of space.

Vincent Kaufmann, *Guy Debord. La révolution au service de la poésie* (Paris: Fayard, 2001); trans. Robert Bononno, *Guy Debord: Revolution in the Service of Poetry* (Minneapolis: University of Minnesota Press, 2006) 101–6; 108–18. Translation © 2006 Robert Bononno.

Georges Perec
The Street//1974

I

The buildings stand one beside the other. They form a straight line. They are expected to form a line, and it's a serious defect in them when they don't do so. They are then said to be 'subject to alignment', meaning that they can by rights be demolished, so as to be rebuilt in a straight line with the others.

The parallel alignment of two series of buildings defines what is known as a street. The street is a space bordered, generally on its two longest sides, by houses; the street is what separates houses from each other, and also what enables us to get from one house to another, by going either along or across the street. In addition, the street is what enables us to identify the houses. Various systems of identification exist. The most widespread, in our own day and our part of the world, consists in giving a name to the street and numbers to the houses. The naming of streets is an extremely complex, often even thorny, topic, about which several books might be written. And numbering isn't that much

simpler. It was decided, first, that even numbers would be put on one side and odd numbers on the other (but, as a character in Raymond Queneau's *The Flight of Icarus* very rightly asks himself, 'Is 13A an even or an odd number?'); secondly, that the even numbers would be on the right (and odd numbers on the left) relative to the direction of the street; and thirdly, that the said direction of the street would be determined generally (but we know of many exceptions) by the position of the said street in relation to a fixed axis, in the event the River Seine. Streets parallel with the Seine are numbered starting upstream, perpendicular streets starting from the Seine and going away from it (these explanations apply to Paris obviously; one might reasonably suppose that analogous solutions have been thought up for other towns).

Contrary to the buildings, which almost always belong to someone, the streets in principle belong to no one. They are divided up, fairly equitably, into a zone reserved for motor vehicles, known as the roadway, and two zones, narrower obviously, reserved for pedestrians, which are called pavements. A certain number of streets are reserved exclusively for pedestrians, either permanently, or else on particular occasions. The zones of contact between the roadway and the pavements enable motorists who don't wish to go on driving to park. The number of motor vehicles not wishing to go on driving being much greater than the number of spaces available, the possibilities of parking have been restricted, either, within certain perimeters known as 'blue zones', by limiting the amount of parking time, or else, more generally, by installing paid parking.

Only infrequently are there trees in the streets. When there are, they have railings round them. On the other hand, most streets are equipped with specific amenities corresponding to various services. Thus there are street-lights which go on automatically as soon as the daylight begins to decline to any significant degree; stopping places at which passengers can wait for buses or taxis; telephone kiosks, public benches; boxes into which citizens may put letters which the postal services will come to collect at set times; clockwork mechanisms intended to receive the money necessary for a limited amount of parking time; baskets reserved for waste paper and other detritus, into which numbers of people compulsively cast a furtive glance as they pass; traffic lights. There are likewise traffic signs indicating, for example, that it is appropriate to park on this side of the street or that according to whether we are in the first or second fortnight of the month (what is known as 'alternate side parking'), or that silence is to be observed in the vicinity of a hospital, or, finally and especially, that the street is one-way. Such is the density of motor traffic indeed that movement would be almost impossible if it had not become customary, in the last few years, in a majority of built up areas, to force motorists to circulate in one direction only, which, obviously, sometimes obliges them to make long detours.

At certain road junctions deemed especially dangerous, communication between the pavements and the roadway, normally free, has been prevented by means of metal posts linked by chains. Identical posts, set into the pavement themselves, serve sometimes to stop motor vehicles from coming and parking on the pavements, which they would frequently tend to do if they weren't prevented. In certain circumstances, finally – military parades, Heads of State driving past, etc. – entire sections of the roadway may be put out of bounds by means of light metal barriers that fit one inside the other.

At certain points in the pavement, curved indentations, familiarly known as 'bateaux'¹ indicate that there may be motor vehicles parked inside the buildings themselves which should always be able to get out. At other points, small earthenware tiles set into the edge of the pavement indicate that this section of the pavement is reserved for the parking of hire vehicles.

The junction of the roadway and the pavements is known as the gutter. This area has a very slight incline, thanks to which rain water can flow off into the drainage system underneath the street, instead of spreading right across the roadway, which would be a considerable impediment to the traffic. For several centuries, there was only one gutter, to be found in the middle of the roadway, but the current system is thought to be better suited. Should there be a shortage of rainwater, the upkeep of the roadway and pavements can be effected thanks to hydrants installed at almost every intersection; these can be opened with the help of the T-shaped keys with which the council employees responsible for cleaning the streets are provided.

In principle, it is always possible to pass from one side of the street to the other by using the pedestrian crossings that motor vehicles must only drive over with extreme caution. These crossings are signalled, either by two parallel rows of metal studs, perpendicular to the axis of the street, whose heads have a diameter of about twelve centimetres, or else by broad bands of white paint running at an angle across the whole width of the street. This system of studded or painted crossings no longer seems as effective as it no doubt was in the old days, and it is often necessary to duplicate it by a system of traffic lights of three colours (red, amber and green) which, as they have multiplied, have ended up causing extraordinarily complex problems of synchronization that certain of the world's largest computers and certain of what are held to be the age's most brilliant mathematical brains are working tirelessly to resolve.

At various points, remote-controlled cameras keep an eye on what is going on. There is one on top of the Chambre des Députés, just underneath the big tricolour; another in the Place Edmond-Rostand, in continuation of the Boulevard Saint-Michel; others still at Alésia, the Place Clichy, the Châtelet, the Place de la Bastille, etc.

II

I saw two blind people in the Rue Linné. They were walking holding one another by the arm. They both had long, exceedingly flexible sticks. One of the two was a woman of about fifty, the other quite a young man. The woman was feeling all the vertical obstacles that stood along the pavement with the tip of her stick, and guiding the young man's stick so that he, too, touched them, indicating to him, very quickly and without ever being mistaken, what the obstacles consisted of: a street light, a bus stop, a telephone kiosk, a waste-paper bin, a post box, a road sign (she wasn't able to specify what the sign said obviously), a red light ...

III

Practical exercises

Observe the street, from time to time, with some concern for system perhaps.

Apply yourself. Take your time.

Note down the place: the terrace of a café near the junction of

the Rue de Bac and the Boulevard Saint-Germain

the time: seven o' clock in the evening

the date: 15 May 1975

the weather: set fair

Note down what you can see. Anything worthy of note going on.

Do you know how to see what's worthy of note?

Is there anything that strikes you?

Nothing strikes you. You don't know how to see.

You must set about it more slowly, almost stupidly.

Force yourself to write down what is of no interest, what is most obvious, most common, most colourless.

The street: try to describe the street, what it's made of, what it's used for. The people in the street. The cars. What sort of cars? The buildings: note that they're on the comfortable, well-heeled side. Distinguish residential from official buildings. The shops. What do they sell in the shops? There are no food shops. Oh yes, there's a baker's. Ask yourself where the locals do their shopping.

The cafes. How many cafes are there? One, two, three, four. Why did you choose this one? Because you know it, because it's in the sun, because it sells cigarettes. The other shops: antique shops, clothes, hi-fi, etc. Don't say, don't write 'etc.'. Make an effort to exhaust the subject, even if that seems grotesque, or pointless, or stupid. You still haven't looked at anything, you've merely picked out what you've long ago picked out.

Detect a rhythm: the passing of cars. The cars arrive in clumps because they've been stopped by a red light further up or down the street.

Count the cars.

Look at the number plates. Distinguish between the cars registered in Paris and the rest.

Note the absence of taxis precisely when there seem to be a lot of people waiting for them.

Read what's written in the street: Morris columns,[2] newspaper kiosks, posters, traffic signs, graffiti, discarded handouts, shop signs.

Beauty of the women.

The fashion is for heels that are too high.

Decipher a bit of the town, deduce the obvious facts: the obsession with ownership, for example. Describe the number of operations the driver of a vehicle is subjected to when he parks merely in order to go and buy a hundred grams of fruit jelly:

– parks by means of a certain amount of toing and froing
– switches off the engine
– withdraws the key, setting off a first anti-theft device
– extricates himself from the vehicle
– winds up the left-hand front window
– locks it
– checks that the left-hand rear door is locked;
if not:
– opens it
– raises the handle inside
– slams the door
– checks it's locked securely
– circles the car; if need be, checks that the boot is locked properly
– checks that the right-hand rear door is locked; if not, recommences the sequence of operations already carried out on the left-hand rear door
– winds up the right-hand front window
– shuts the right-hand front door
– locks it
– before walking away, looks all around him as if to make sure the car is still there and that no one will come and take it away.

Decipher a bit of the town. Its circuits: why do the buses go from this place to that? Who chooses the routes, and by what criteria? Remember that the trajectory of a Paris bus *intra muros* is defined by a two-figure number the first figure of which describes the central and the second the peripheral terminus. Find examples, find exceptions: all the buses whose number begins with a 2 start from the Gare St-Lazare, with a 3 from the Gare de l'Est. All the buses whose number ends in a 2 terminate roughly speaking in the sixteenth arrondissement or in Boulogne. (Before, they used letters: the S, which was Queneau's favourite,

has become the 84. Wax sentimental over the memory of buses that had a platform at the back, the shape of the tickets, the ticket collector with his little machine hooked on to his belt.)

The people in the streets: where are they coming from? Where are they going to? Who are they?

People in a hurry. People going slowly. Parcels. Prudent people who've taken their macs. Dogs: they're the only animals to be seen. You can't see any birds – yet you know there are birds – and can't hear them either. You might see a cat slip underneath a car, but it doesn't happen.

Nothing is happening, in fact.

Try to classify the people: those who live locally and those who don't live locally. There don't seem to be any tourists. The season doesn't lend itself to it, and anyway the area isn't especially touristy. What are the local attractions? Salomon Bernard's house? The church of St Thomas Aquinas? No 5, Rue Sebastien-Bottin?[3]

Time passes. Drink your beer. Wait.

Note that the trees are a long way off (on the Boulevard Saint-Germain and the Boulevard Raspail), that there are no cinemas or theatres, that there are no building sites to be seen, that most of the houses seem to have obeyed the regulations so far as renovation is concerned.

A dog, of an uncommon breed (Afghan hound? saluki?).

A Land Rover that seems to be equipped for crossing the Sahara (in spite of yourself, you're only noting the untoward, the peculiar, the wretched exceptions; the opposite is what you should be doing).

Carry on

Until the scene becomes improbable, until you have the impression, for the briefest of moments, that you are in a strange town or, better still, until you can no longer understand what is happening or is not happening, until the whole place becomes strange, and you no longer even know that this is what is called a town, a street, buildings, pavements ...

Make torrential rain fall, smash everything, make grass grow, replace the people by cows and, where the Rue de Bac meets the Boulevard Saint-Germain, make King Kong appear, or Tex Avery's herculean mouse, towering a hundred metres above the roofs of the buildings!

Or again: strive to picture to yourself, with the greatest possible precision, beneath the network of streets, the tangle of sewers, the lines of the Métro, the invisible underground proliferation of conduits (electricity, gas, telephone lines, water mains, express letter tubes), without which no life would be possible on the surface.

Underneath, just underneath, resuscitate the eocene: the limestone, the marl

and the soft chalk, the gypsum, the lacustrian Saint-Ouen limestone, the Beauchamp sands, the rough limestone, the Soissons sands and lignites, the plastic clay, the hard chalk. [...]

1 Called 'boats' because of their shape.

2 The sturdy columns that carry posters advertising theatrical and other entertainments.

3 The address of the largest and most glamorous of French publishing houses, Éditions Gallimard, by whom Perec would like to have been published, though he never was.

Georges Perec, extracts from 'La rue', in *Espèces d'espaces* (Paris: Galilée, 1974); trans. John Sturrock, *Species of Spaces and Other Pieces* (London and New York: Penguin, 1997) 46–56.

Paul Virilio
On Georges Perec//2001

[...] The journal *Cause commune* attempted to decipher events. But instead of looking at the political scene, we looked at facts – facts of various kinds. We looked at films, at works of art, at consumer goods. In other words, we looked at the world through its new symptoms. We had emerged from the events of May 1968 with a deep sense of disappointment – I had been very much personally involved, particularly in the storming of the Théâtre de l'Odéon – and consequently we set out to create a journal that had what we might call a 'post-1968' agenda. We were aware that we could not simply follow the predominant discourses, ideologies that had just failed before our very eyes. We had witnessed the collapse and abandonment of the leftist vision. It was not yet the implosion of communism, but it was the implosion of leftism. And it was precisely our experience of the post-1968 period that made the journal extraordinary. To some extent we represented the idea that May 1968 was a literary rather than a political revolution: Cohn Bendit and all the rest were just play-acting – political play-acting. That is to say, it had all ended up being a farce. In 1968 nothing changed in political terms, but everything changed in cultural terms. (The stress has too often been put on the political aspect.) It is not by chance that writers such as Lyotard, Deleuze and Guattari appeared immediately after 1968. They embody the poetics of post-1968 man. And so did our work at *Cause commune.* Hence our approach to the city, for instance, no longer connected to traditional notions of urban geography (cadastral survey, social

classes, concentration, density and other phenomena); rather, it connected to what we termed the 'infra-ordinary', i.e. what we do when we do nothing, what we hear when we hear nothing, what happens when nothing happens. Outside of the city nothingness can perhaps exist [...] but it certainly does not exist in the city. In the city there is never a void. There is always background noise, there is always a symptom, a sign, a scent. So we were interested precisely in those things which are the opposite of the extraordinary yet which are not the ordinary either – things which are 'infra'. [...]

Espèces d'espaces [Species of Spaces] was the first book of my collection L'Espace critique, and was actually commissioned by me. I invited Perec to write a text by asking him to do with space what he had earlier (when he wrote Les Choses [Things]) done with objects, because 'things' take place, just as events do. The question of space was of course central to my collection, so Perec produced a 'bestiary of spaces', as he first termed it. And he planned to give me a sequel in which he would carry out a similar project, but with mathematical spaces. Lieux [Places] was a rather personal project – Perec did not talk much about it to us. He mentioned it, showed us two or three things, but did not really share it with us at all. But I would say that his project aimed at exhausting time. Perec would periodically return to these places in order to see what would change, to see whether he could see time grow in space just as we see it grow in the images of Painlevé (those pictures of the accelerated sprouting of a plant, for instance). He wanted to unveil, through a periodical survey of each of the twelve different places he had chosen, what we might term the 'growing of the real'. That is, to see the 'real' (réel) grow out of the 'present' (actuel). Each return to the site would set the present in motion and make it become another 'real'. It was an attempt at a new kind of voyeurism, one in which what was at stake for Perec was actually the chance to see himself age. Tentative d'épuisement d'un lieu parisien [attempt to be exhaustive about a Parisian location] was different – there he was trying to exhaust a place rather than time. He would not return to it, so he took three consecutive days to grasp everything that passed through the range of his perception. (You may know I appear in the text as I passed by place Saint-Sulpice while Perec, was carrying out this project.) So he attempted to record everything, as would a surveillance camera: to record the ordinary, the banal, the habitual. That is, the signs of an event to which we may not have paid any attention, that we may not even have perceived. What interested Perec was the potential of the banal to become remarkable, how an ordinary sign can become extraordinary. At the time we were rediscovering the values of observation – the fact that looking is not self-evident. We look but we do not see; so how must we look in order to see? (Which means not just to see but actually to penetrate things.) We were very much aware that there are unknown

things concealed by what is visible, things that are hidden not in the obscure, but in the obvious. At the time there was actually a much more broad-based rediscovery of the visual, which was influenced by photography and the cinema in particular. The cinema, for example, was then inventing a new hand-held camera – the steadycam. And the steadycam had emerged from the Vietnam war: a device that was used to support American machine guns that were too heavy to hold unaided was now being used to support a camera. Cinema culture would, in turn, make us all cameramen. So there was an emerging cinematic and sequential vision that would open up for literature a new way of writing. The *nouveau roman* had already sketched this out, but in a purely literary way. This time, however, it was much more visual; in fact, literature would become more and more visual. This also explains our interest in drifting. For me – and I would say for Perec too, in his own way – the city is a film, one in a state of continuous metamorphosis, one in which not only is everything animated but everything is also incessantly accelerated. Everything passes by, everything is always in the process of unreeling. And you cannot see this film if you stand still – walking is the *tête de lecture* of this film. [...]

Paul Virilio, extract from 'On Georges Perec', *AA Files*, no. 45/46 (London: Architectural Association School of Architecture, 2001) 15-18.

Alison and Peter Smithson
The 'As Found' and the 'Found'//1989

[...] The 'as found', where the art is in the picking up, turning over and putting-with ... and the 'found', where the art is in the process and the watchful eye ...

In architecture, the 'as found' aesthetic was something we thought we named in the early 1950s when we first knew Nigel Henderson and saw in his photographs a perceptive recognition of the actuality around his house in Bethnal Green: children's pavement play-graphics; repetition of 'kind' in doors used as site hoardings; the items in the detritus on bombed sites, such as the old boot, heaps of nails, fragments of sack or mesh, and so on. Setting ourselves the task of rethinking architecture in the early 1950s, we meant by the 'as found' not only adjacent buildings but all those marks that constitute remembrances in a place and that are to be read through finding out how the existing built fabric of the

place had come to be as it was. Hence our respect for the mature trees as the existing 'structuring' of a site on which the building was to be the incomer. ... As soon as architecture begins to be thought about its ideogram should be so touched by the 'as found' as to make it specific-to-place.

Thus the 'as found' was a new seeing of the ordinary, an openness as to how prosaic 'things' could re-energize our inventive activity. A confronting recognition of what the postwar world actually was like. In a society that had nothing. You reached for what there was, previously unthought-of things. ... In turn this impressed forcibly – seen in the coat of white paint that 'renewed' the ship in 1907 – how the new could re-energize the existing fabric.

We were concerned with seeing materials for what they were: the woodness of wood; the sandiness of sand. With this came a distaste of the simulated, such as the new plastics of the period – printed, coloured to imitate a previous product in 'natural' materials. Dislike for certain mixes, particularly with technology, such as the walnut dashboard in a car. We were interested in how things could be with technology touching everything and everyone. We foresaw a general reappraisal of values would occur, as we 'read' through the aspiration-images on offer in the magazines, the approach of the acquisitive society.

Our reaction to the 1940s – for us 'design' was a dirty word – tried never to be negative. By 'taking position' we rejected the then fashionable, but for us too simple, literal and literary attitudes, represented for socialist-minded intellectuals by the writings of Herbert Read. We were the generation stepping aside from politics as no longer appropriate to our needs. All this was an intellectual activity, extending to a care for 'literacy' in the language of architecture. We worked with a belief in the gradual revealing by a building-in-formation of its own rules for its required form. [...]

Alison and Peter Smithson, extract from 'The "As Found" and the "Found"', retrospective statement in *The Independent Group: Postwar Britain and the Aesthetics of Plenty*, ed. David Robbins (Hanover, New Haven: Hood Museum of Art/London: Institute of Contemporary Arts/Los Angeles: The Museum of Contemporary Art/Berkeley: University Art Museum/Cambridge, Massachusetts: The MIT Press, 1989–90) 201–2.

Daniel Spoerri, with Robert Filliou, Emmett Williams, Dieter Roth
An Anecdoted Topography of Chance//1962–68

57. Stopper[a] from Vin des Rochers, tricoloured, this time red-white-yellow. [3, 25, 34L, 49, 67][1]

a. Crossing the Pont Neuf accompanied by ROBERT and probably MARIANNE and KICHKA, we all noticed at the same time a truck whose tyre bolts were decorated with multicoloured stoppers, which excited us and incited us to take down the licence number and name of the firm, to be able to include it here:

RUFÈRE & Co.
Pigs[b]
8356 GL 75[d]

b. Sometimes one person says to the other: 'Stupid pig!' And if it so happens that the other person believes the first, the other often says to himself: 'Hmph, that's clipped my wings that has!' because he had said to himself that pigs have short legs. And And then before long he feels he's a despondent old boar and asks himself: 'What if someone were now to slaughter me?' Finally he says: 'What a silly sausage I am!' Yes, that's the way it goes when people believe the nasty things that are said to them – regardless of whether it's someone else or themselves that say it. (DR [Dieter Roth] 1968)

c. A paraphrase of the German proverb 'lies have short legs'. (MG 1995)[2]

d. Eight minus five is three is five less two is eight minus six plus two is a G plus and L equals eight minus one the first equals seven with five behind or back to front five with seven behind like the numbers of the paragraph one more than the sum of the last two digits of the first group as well as one less than the first two of the first ones and one less than the last ones as many as the spaces half as many as the digits of the first ones. (DR 1968)

1 [Other numbered references to bottle stoppers in the *Topography*.]
2 [From Spoerri's conversation with Malcolm Green, translator of the 1995 re-anecdoted edition.]

Daniel Spoerri, from *La Topographie anecdotée du hasard* (Paris: Éditions Galerie Lawrence, 1962); revised ed., *An Anecdoted Topography of Chance*, trans. Emmett Williams (New York: Something Else Press, 1966); German revised edition, 1968; re-anecdoted edition (London: Atlas Press, 1995) n.p.

Yoko Ono
City Piece//1963

Step in all the puddles in the city.

Yoko Ono, 'City Piece', autumn 1963, in *Grapefruit* (Tokyo: Wunternaum Press, 1964); second edition (New York: Simon and Schuster, 1970); reprinted (London: Sphere Books Limited, 1971) n.p.

Sally Banes
Equality Celebrates the Ordinary//1993

The recuperation of the ordinary was crucial to the 1960s ethos. The way had been prepared in the 1950s and earlier by the incorporation of mundane sounds, sights, objects, words and actions by artists like John Cage in music, Robert Rauschenberg and Jasper Johns in visual art, Jack Kerouac and Allen Ginsberg in literature, Merce Cunningham and Paul Taylor in dance, Samuel Beckett in theatre and Joseph Cornell in film and visual art. These artists, in turn, had been inspired by earlier artists like Erik Satie, Marcel Duchamp, Gertrude Stein and Kurt Schwitters. By the 1960s, however, attention to the everyday had been democratized. It had become a symbol of egalitarianism, and it was the standard stuff of avant-garde artworks and performances.

John Cage's precepts in this regard were seminal for the 1960s generation of artists. As early as 1940 with *Living Room Music*, Cage had used as instrumentation 'objects to be found in a living room', and, in other works, flowerpots, beer bottles, tin cans and his well-known pianos prepared with bolts, screws and rubber bands. *Imaginary Landscape no. 4* (1951) called for twelve radios. *With 4'33"* (1952), his legendary piece written for the pianist David Tudor, in which 'no sounds are intentionally produced', Cage opened the way for a music made entirely of ambient sound. For Cage, this piece stated a moral-political position: all sounds should have equal opportunity to be heard and appreciated. Moreover, Cage's embrace, in the 1950s, of Zen Buddhism, led to a non-hierarchical, non-judgmental appreciation of dailiness and the commonplace.

In 'Lecture on Nothing', Cage accounts for his adoption of inclusiveness and ordinariness in specifically political terms. 'I found that I liked noises even more

than I liked intervals. I liked noises just as much as I had liked single sounds. Noises, too had been discriminated against; and being American, having been trained to be sentimental, I fought for noises.'[1] In extending the concept of human rights to nonhuman elements, Cage set the stage for a quintessentially 1960s attitude toward what might or might not be represented in art, that is, that political justice should be served in representing what had hitherto been excluded – in this case, the ordinary.

Two artists who influenced Cage in the direction of ordinariness also influenced the 1960s avant-garde. These were Erik Satie and Marcel Duchamp. For Cage, Satie's work accorded with Zen tenets of renunciation and the acceptance of the world-as-it-is. Cage admired Satie's statement that *L'Esprit nouveau* 'teaches us to tend towards an absence (*simplicité*) of emotion and an inactivity (*fermeté*) … , conceived in a spirit of humility and renunciation.'[2] Cage felt that Satie's music, like the works of Duchamp and Robert Rauschenberg, was salutary in introducing emptiness, the banal and the found object into artistic structure.

As Calvin Tomkins points out, Robert Lebel's 1959 volume on Duchamp, published simultaneously in French and English, introduced a younger generation of artists and scholars to the artist's work and thought. As a result, a veritable Duchamp boom broke out in the art world, culminating in 1963 when the first major retrospective of his work was organized by Walter Hopps at the Pasadena Art Museum. Tomkins credits the Duchamp boom with stimulating the use of banal subject matter by Pop artists.[3]

Samuel Beckett's influence on the European Theatre of the Absurd and its American offshoots Off-Broadway, like Edward Albee's plays, may be obvious. But perhaps Beckett is also a source for the staging of the banal in this group of artists as well, not only in dramatic theatre (the Living Theatre's production of Gelber's *The Connection* clearly echoes *Waiting for Godot*), but in the non-literary theatre of Happenings and Fluxus. Beckett completed the step begun by the realists in the nineteenth century. That is, everyday life had long before been introduced on the stage by writers like Zola, Ibsen and Hauptmann. But that everyday life was still written as noble tragedy. As Susan Sontag recently pointed out, Beckett's radical gesture was to portray the 'microstructure', the triviality of the way we in fact experience everyday life from moment to moment – bereft of any playwright's grand designs and momentous themes:

> Beckett has actually discovered a new dramatic subject. Normally people on the stage reflect on the macrostructure of action. What am I going to do this year? Tomorrow? Tonight? They ask: Am I going mad? Will I ever get to Moscow? Should I leave my husband? Do I have to murder my uncle? My mother? These are the sorts of large projects which have traditionally concerned a play's leading

characters. Beckett is the first writer to dramatize the microstructure of the action. What am I going to do one minute from now? In the next second? Weep? Take out my comb? Stand up? Sigh? Sit? Be silent? Tell a joke? Understand something?[4]

For the 1960s artists who came after Beckett, to concern themselves with microstructure now seemed a project quite large enough. For microstructure is the form that organizes the commonplace; microstructure, hitherto considered inconsequential, in the 1960s took on political meaning and seemed synonymous with the *demos*. That is, if the elite are concerned with macrostructure, then microstructure is the biography of the world's rank and file whose lives are usually unsung.

The use of the ordinary in Joseph Cornell's surrealist boxes and collages and his montage films was different from Beckett or Cage's practice. Such use assumed a lyrical, symbolic bent. Rather than employing the familiar as a Cageian window through which to see more of life-as-it-is, Cornell's framing and juxtaposition of mundane objects and actions released a sense of mystery, of imagination, of transcendent beauty – a surrealist technique that was influential on several members of the 1960s generation.

Jonas Mekas, writing about Cornell in 1963, calls him 'the real poet of dailiness, of the unpretentious, of the anti-art film'. 'He makes these insignificant little movies. Most people do not even think they are movies: They are so artless. And ah, how much love there is in Cornell's movies! Love for people, for flowers, for the summer girls, for the little tree leaning in the dark corner without sun, for the birds in the sad park trees. Saint Francis would have been a friend of Joseph Cornell.'[5]

Another influence was the Beat film *Pull My Daisy* (1959), about a day in the domestic life of a group of poets.[6] An encomium to dailiness and spontaneity, in its time *Pull My Daisy* was celebrated by the avant-garde (and criticized by the mainstream) as an improvised documentary on Beat life.[7] The ease, wit, informality and aimlessness of *Pull My Daisy* was a revelation to many. Mekas wrote of it in an early column: 'I don't see how I can review any film after *Pull My Daisy* without using it as a signpost. ... [It] clearly point[s] toward new directions, new ways out of the frozen officialdom and mid-century senility of our arts, towards new themes, a new sensibility. ... *Pull My Daisy* reminds us again of that sense of reality and immediacy that is cinema's first property. ... I consider *Pull My Daisy*, in all its inconsequentiality, the most alive and the most truthful of films.'[8]

These, then, were some of the 'poets of dailiness' of the previous generations of the avant-garde. It was partly because of their teachings and examples that the appreciation of the ordinary reached a new level in the 1960s. But there were

other reasons that the artworks of the 1960s abounded in prosaic actions and objects, that the quotidian as style and subject matter threaded through every art form, as well as through inter-media genres. In the political context of the rhetoric of equal rights, what had been an aspect of avant-garde style took on centrality and significance.

The embrace of the ordinary was not a monolithic project. It encompassed various styles, programmes and projects – from an almost biblical, mystical injunction humbly to love the world around one to an irreverent, transgressive embrace of schlock culture; from a lyrical appreciation of the small, simple and ephemeral things in life to a deliberate strategy of boredom; from a desire to expand perception to a refusal of Aristotelian catharsis. Additionally, the mundane itself might be defined differently according to each artist – from the untrained voice, the unpolished pace, and the sounds and sights of unsullied nature to the images and goods disseminated by radios, television, movies, advertising and other media of mass consumer culture. So to accept the ordinary might require a monkish, ascetic attitude, or it might mean being fully engaged in the brash, material here and now. But for all of these diverse ways of arriving at it, this simplicity of source and outlook – which in the 1950s had often still been contained within the high art frame – now fused with the political exuberance of the Kennedy era, burst through the gallery walls and the theatre proscenium, and demanded equal rights.

The ordinary stood for many things, but, given the political tenor of the period, it stood, above all, for the populist aims of accessibility and equality – for both artists and audiences. The activity of art-making had been opened wide by the artists' assertion that anyone could make art. They were living proof. They were ordinary people, some of whom had gone to college for free on the GI Bill, some of whom had not gone to college at all. Many were from working-class families, and some were the children of immigrant parents. Their own experiences, as well as their attitudes toward art, were clearly different from those whose families could afford both the training and the post-training support typical of artists in previous generations. For the first time, the postwar economy supported American artists without independent means, and postwar art history taught them that European bohemias had supported people like them in the past.

These artists were ordinary people, and, in turn, they made art that putatively anyone could understand. To watch people walk, run, work, eat, sleep, make love, tell stories and smile, and to see objects that closely resembled food, clothing, furniture, games, bathroom fixtures and other familiar items – or that actually were food, clothing, furniture, games and so on – now seemed the most worthwhile thing an artist could help a spectator to do.[9]

One no longer made plays or dances or films about people falling hopelessly in love or falling from power, or even people unable to fall in love. Instead, people in Happenings, Fluxus, new dances, Off-Off-Broadway theatre, Pop art and underground films ironed clothing, combed or shampooed their hair and shaved their legs. They smiled, slept, smoked cigarettes, went to the movies, sent their audiences to the movies, played cards, read newspapers, got haircuts, played hopscotch, played ball and roller-skated. They made love and they made lunch. In their very banality, these activities became charged with meaning. For in examining them – activities which everyone engages in, but does differently – the simultaneous variety and unity of human life seemed evident. And this in itself seemed a form of equal representation.

Judith Dunn's dance *Acapulco* was a collage of commonplace activities in which a woman ironed a dress she was wearing, two women played cards and a woman combed the hair of another, who said 'ouch'. The use of slow motion in parts of the piece transformed these banal events into dance movement.[10]

In his soft sculptures, Claes Oldenburg took a decidedly comic/erotic turn by changing these things' scales as well as their textures. He had used mundane objects in *The Store*, but unlike those earlier lumpy, painted plaster flags, clothing and food items, these large, sometimes unnaturally shiny objects bulged and sagged and were often soft and stiff at the same time. They seemed to make not only themselves, but the human body they so uncannily resembled grotesquely alien – very much in the manner of Swift's story of Gulliver's encounter with the Brobdingnagians and their queen whom Gulliver, while buried in her cleavage, has an opportunity to examine in microscopic detail.[11]

Andy Warhol's Brillo boxes were perhaps the most famous example of appropriating the banal.[12] The boxes do not so much awaken us to the unappreciated colours, textures or shapes in ordinary objects (although they are satisfyingly bright and succinct); instead, like Roy Lichtenstein's comic-book images, they force us to think about artistic conventions, which historically segregated the ordinary from the extraordinary. Arthur Danto argues that the point of these perplexing artworks, like the point of Duchamp's *Fountain*, was not to engage the spectator's aesthetic sense – to call attention to the sensuous values of the carton (or the urinal) – but to propose a theory about art.

Danto suggests that thinking about the Brillo boxes' right of entry into the gallery is equivalent to thinking about everyone, rich or poor, drinking Coke. Seen from another perspective, this is not so much a story about levelling downward (bums on the corner may drink Coke, but they could not afford a Warhol soup can), but about the cherished American myth of success – the possibility of meteoric success in a land of social mobility and equal opportunity. The Brillo boxes' triumph was no more or less of an American Cinderella story

than that of Warhol himself, born near Pittsburgh, the son of Czech immigrants.

Jonas Mekas, writing about Warhol's 1963 film *Eat*, which was 45 minutes long and showed Robert Indiana eating a mushroom, advances another motivation for authorizing the banal – to attack what was seen as pretentiousness in the grand themes and the grand forms of the previous generation's art.

A man is eating a mushroom (or a piece of orange or an apple perhaps; it doesn't matter). He does nothing else, and why should he? He just eats. There are thoughts and reveries appearing on his face, and disappearing again, as he continues eating. No hurry, nowhere to hurry. He likes what he is eating, and his eating could last one million years. His unpretentiousness amazes us. Why doesn't he think of something else to do; why doesn't he want anything else? Doesn't he seek anything important?... We are not – or are no longer – familiar with such humility of existence. ...What pompous asses we are![13]

Warhol himself implies that Pop art trained one to return to everyday life with a new appreciation for the familiar, and it made that experience available to all. Describing his trip to California with Gerard Malanga, Wynn Chamberlain and Taylor Mead in the fall of 1963 for an opening of Warhol's Liz and Elvis paintings at the Ferus Gallery in Los Angeles, Warhol remembers:

The farther West we drove, the more Pop everything looked on the highways. Suddenly *we all felt like insiders* because even though Pop was everywhere – that was the thing about it, most people still took it for granted, whereas we were dazzled by it – to us, it was the new Art. Once you 'got' Pop, you could never see a sign the same way again. And once you thought Pop, you could never see America the same way again. The moment you label something, you take a step – I mean, you can never go back again to seeing it unlabelled. ... The mystery was gone, but the amazement was just starting. [author's emphasis][14]

It was on this trip that Warhol saw the Duchamp retrospective in Pasadena. So perhaps it is not surprising that in his fantasy that Pop art has appropriated all of life, Warhol seems to echo Cage's observation about Duchamp: 'Therefore, everything seen – every object, that is, plus the process of looking at it – is a Duchamp. Turn it over and it is.'[15]

1 [footnote 23 in source] John Cage, 'Lecture on Nothing', *Silence* (Middletown, Conn.: Wesleyan University Press, 1961; 2nd ed., Cambridge, Mass.: MIT Press, 1966) 115–17.

2 [24] John Cage, 'Erik Satie', *Art News Annual*, 1958; reprinted in *Silence*, 82.

3 [25] Calvin Tomkins, *The Bride and the Bachelors: Five Masters of the Avant Garde* (New York: Viking, 1965).

4 [26] 'Interview: Susan Sontag: On Art and Consciousness', *Performing Arts Journal*, 2 (Fall 1977) 28.

5 [27] Jonas Mekas, 'Movie Journal: Joseph Cornell, the Poet of the Unpretentious', *Village Voice*, 5 December 1963; reprinted in Mekas, *Movie Journal*, 110.

6 [28] *Pull My Daisy* was directed by photographer Robert Frank and painter Alfred Leslie, scripted and narrated by Jack Kerouac, and featured the poets Allen Ginsberg, Gregory Corso and Peter Orlovsky as themselves, as well as the painters Larry Rivers and Alice Neel, the composer David Amram, the dancer Sally Gross, and the actress Delphine Seyrig all playing fictional roles.

7 [29] As J. Hoberman has pointed out, Alfred Leslie later debunked this notion when he published an article on the film's production that showed how it was carefully designed, scripted, planned, rehearsed and edited. (J. Hoberman, 'Pull My Daisy/The Queen of Sheba Meets the Atom Man', in Ward and Jenkins, eds., *American New Wave: 1958–1967*, 34–9.

8 [30] Jonas Mekas, 'Movie Journal: Pull My Daisy and the Truth of Cinema', *Village Voice*, 18 November 1959; reprinted in Mekas, *Movie Journal*, 5–6.

9 [31] In thinking about the different uses of the prosaic in the 1960s, the Russian Formalist concept of 'defamiliarization' (*ostranenie*) is useful. As outlined by Victor Shklovsky in his essay 'Art as Technique', defamiliarization (or 'making things strange') is a strategy used by writers for reinvigorating perception, which becomes dulled by the habitual quality of daily life. I have applied an expanded notion of defamiliarization to the 1960s avant-garde in 'Making Things Strange: The Use of the Ordinary in the Sixties Avant-Garde', *Choreography and Dance*.

10 [32] The dance was first performed on *Concert no. 9*, Gramercy Arts Theater, 30 July 1963. It is described in Jill Johnston, 'The New American Modern Dance', in Richard Kostelanetz, ed., *The New American Arts* (New York: Collier Books, 1967) 184, and in Jill Johnston, 'Motorcycle', *Village Voice* (19 December 1963) 11. [...]

11 [33] Fredric Jameson uses this example in *The Prison-House of Language: A Critical Account of Structuralism and Russian Formalism* (Princeton, New Jersey: Princeton University Press, 1972) 55–6.

12 [34] The Brillo boxes were first exhibited at the Stable Gallery, 21 April 21 – 9 May 1964.

13 [35] Jonas Mekas, 'Notes on Some New Movies and Happiness', *Film Culture*, no. 37 (Summer 1965); reprinted in Sitney, ed., *Film Culture Reader*, 317–18.

14 [36] Warhol and Hackett, *POPism*, 39–40.

15 [37] Cage, '26 Statements re Duchamp', *A Year from Monday* (Middletown, Connecticut: Wesleyan University Press, 1969) 70; 72.

Sally Banes, *Greenwich Village 1963: Avant-Garde Performance and the Effervescent Body* (Durham, North Carolina: Duke University Press, 1993) 11–24.

Helena Tatay
Hans-Peter Feldmann//2002

[...] Hans-Peter Feldmann's work can be divided into two periods, separated from each other by a decade of silence. He worked and exhibited from the end of the 1970s until 1980 and then decided to withdraw. For almost ten years he kept away from the art world, until in 1989 he once again started to place his work before the public, continuing to the present.

His first and perhaps best known works, made between 1968–76, are a series of modest booklets – cardboard covers with the title stamped on them – closer in appearance to the schoolwork of his childhood than to printed books, and which he titled simply *Bilde* (image) or *Bilder* (images). Inside each, centred and without text, are images of the same type of object, for example: twelve snow-topped mountains; six football players; five unmade hotel beds; a Zeppelin; seven actresses; three landscape paintings; eleven pairs of knees. The repertoire includes several types of photograph: the family photo, the magazine photo, photos taken by the artist, and so on. They are everyday images which open a door on a world of personal intimacy, a feeling strengthened by their presentation as series inside the booklets themselves. Although Feldmann had made other pieces previously, these are considered his first work, as within them we find for the first time its defining elements. All of his later work would have the modest and simple tone of these first books, their appearance of non-art, their formal neutrality and their sober, material nature.

From the end of the 1960s, Feldmann's art abandoned all conventional and traditional means. He began to look for his themes in other sources of intellectual and social energy which were more in harmony with his own sensibility, and to use materials which he found around him, either objects or images of any kind: gum cards, postcards, family photos, film stills or photos taken from the media. He also used numerous photos of his own.

The photographic image would from then onwards be his main medium. What interested him as far as imagery was concerned in these first books and in later works was the series, the images taken together, or, rather, what appeared when they were taken together. It wasn't the image itself, but the world that opened up when they were put together. If the isolated image constituted a statement, in combination with others, linguistically speaking, it became a narrative. [...]

Feldmann's work moves in the universe of the everyday. He takes from it the material that he uses – objects and images – along with his themes. He affirms that all his work is based on personal experience, that it is a way of transforming

experiences, obsessions or intuitions into language, an attitude which is common to many artists. In Feldmann's case, the curious thing is that he limits his work to his own emotional circle, that is, he doesn't use models: the characters from his series form part of his life, he knows them. The material he uses is the everyday stuff that habitually surrounds him. The magazine photos, family snaps, postcards, books, objects, etc., come from the day to day world and do not refer to any artistic tradition. With his material and his themes, Feldmann wants to place himself on the margins of art history in order to represent the everyday.

> The human world is not defined only by that which is historical, by culture, by the whole of society, by ideological superstructures and politics. It is defined by this intermediate and mediating level: daily life. Here we can observe the most specific dialectic movements: necessity and desire, to enjoy and not to enjoy, satisfaction and privation, achievements and failures, work and non-work, the repetitive part and the creative part.[1]

Feldmann is probably not only in agreement with this statement of Henri Lefebvre's, given that he has located his artistic praxis on this mediating level, but in radical support of it when he says: 'I am not interested in the high points of life. Only five minutes of every day are interesting. I want to show the rest, normal life.' It seems obvious that what Feldmann wants to represent is daily life without idealizations, in all its glory and all its misery.

But which are the aspects of daily life that Feldmann shows? Until now we have seen that his vision picks up on various aspects by including the images and objects which inhabit daily life and the narratives that we construct with all of this. But we can also see that he describes day to day activity and the area of 'sensitive intimacy'. In these narratives, his vision becomes more contemplative.

The most extreme case of this abstracted vision are the numerous *Time* series, which he began in the 1970s. These are consecutive images of the same place or the same person in a very short space of time, similar to film stills. The themes are trivial ones: a man reading a newspaper; a couple walking down the street; a woman cleaning an office window; seagulls in the sky; the corner of a garden. Feldmann observes, contemplates small events. Nothing important or transcendent, just any moment on any given day. He captures the passing of time on the 36 images that make up a reel, with a speed close to that of a movie camera. But if in cinema it is present time which is lived, these series of photographs talk of capturing time itself, of stopping the invisible fluid which weaves our lives so that we may inspect it. These series respond to the perplexity felt before the idea of time, as if they were questioning the immanence of life.

Feldmann has converted trivial moments, the unattended moments that turn our lives into events, into something worthy of being photographed and recorded. We are dealing here with moments in which there is practically no action, in which nothing is happening. And where nothing is happening we can do nothing except be. If the collection explores the narratives which give meaning to having, then in these narratives located in temporal spaces in which nothing is happening, we are closer to being than to having. Closer to contemplative rather than active life. Hence the meditative nature of these series of such everyday images.

In other photo series, Feldmann has reproduced personal experiences. The images from *Telefonbuch* [*Telephone Book*] appear to transcribe the vision we have when we are waiting our turn in front of a busy telephone booth. The photos show an attractive girl in a miniskirt, talking on the phone inside the phone booth. One after the other, the practically identical black and white photos follow each other as do the minutes that pass while we wait. The girl has her back to us, and changes her position slightly from one photo to the next. The tripod of Feldmann's camera is projected onto the glass of the booth and is reflected between her legs and on her skirt, we don't know whether voluntarily or involuntarily. Everyday things.

In another of his 1977 series, which he would later convert into a book, *Alle Kleider einer Frau* [*All the Clothes of a Woman*], one of his most poetic works, the small black and white photos show, one by one, 71 garments in the order in which we dress (inside out). Nothing else. The woman to whom the clothes belong is veiled, an enigma. She is present only through her clothing, converted into fetishistic objects. But the setting is the antithesis of this idea of the sophisticated or perverse fetishistic object. These fetishes are domestic, humble, and provoke tenderness. Not only is the woman hidden, but so is the action, if there ever was any.

The information that is not given is considered to be given as understood; it isn't mentioned because it belongs to a common area shared between the author and the public. In this case, what is given as understood is the area of sensitive intimacy which Feldmann does not reveal. In the end, we only know for sure that somebody has taken the trouble of photographing all the pieces of clothing of a woman, one by one.

The titles of Feldmann's works, and this would be a good example, give a very clear idea of the way in which he works; they are always descriptive, as if only giving information, but they usually mark out a metaphorical space, as in this case in which there is an 'all' of 'one'.

In this series, as in other works, the impulse towards emotional implication is deferred.[2] It is based on his emotional experience, but keeps a distance

between language and the personal experience which codifies it, blurring it so as to temper the emotional power. His narratives are made up of non-hierarchical fragments and do not provide the spectator with a single reading or meaning, but rather with an open and inconclusive signification. Rather than search for a coherent discourse, Feldmann seems to explore the meaninglessness of existence.

Another aspect he finds interesting is leaving the work open, so that it not only allows but demands that the spectator recreate the works, projecting his or her own experience.

Normal life, day to day existence or vision, in which Feldmann locates his works, is defined by opposition to other levels of human activity. The everyday is associated with the small side of life, with the grey, humble and imprecise element. It is the other side of the coin of the capitalist social scene, whose image, constructed by the media, is colourful, optimistic and logical.

The scene which Feldmann shows is of another type. The book *Eine Stadt: Essen* [*A City: Essen*] feeds on the same 'information-giving' spirit as *Telefonbuch* or *Alle Kleider einer Frau*, but is a report on Essen. Feldmann made the book in 1977, commissioned by the Folkwang Museum in Essen, to accompany the exhibition of his collection of images.

The book shows views of the city which, as its title indicates, could be any German city with similar characteristics, given that the photos show nothing out of the ordinary. The photos are presented without texts or any apparent order; they are not classified by sections or chapters. All together, it is an archive of standard views of an industrial city in northern Europe, put into a formal order. They are grey photos of a grey environment, which repeat the visual experience of everyday life. Feldmann commented as a joke that the Essen Tourist Office wanted to sue him.

The book is surprising, even today, because we still persist in thinking that photography should capture special moments or places, ones that are out of the ordinary. And if these photos belong to any kind of category it is that of 'nothing special', that of the ordinary. In the field of art, in which photography now has its own field of reference and academy, the photos of *Eine Stadt: Essen* are hard to classify; and, it goes without saying, in 1977 they suggested a new way of approaching amateur photography.

But what we choose to tell and how we decide to do it mark a point of view and a framework, that is to say, they give form to a way of perceiving the world which responds to an ideology. In Feldmann's work there is no romanticism nor any ideal world nor any transcendence. Feldmann wants to show his visual landscape and daily experiences without filters, without mental constructions that redeem them.

The formal neutrality and the material austerity of his work also reaffirm this position. Feldmann considers aesthetics as 'something from another time' and his works are formalized in such a way that they appear to be simply giving information. But the style known as 'neutral' is as artificial as any other style, and like all styles responds to questions which in the last resort are ethical, social and political. For example, Feldmann's view of Essen responds to a way of looking which is different and opposed to that which the tourist office would probably give, but is just as elaborate and artificial. As far as material austerity is concerned, it is also a choice, more opulent and sophisticated, which rejects ways of giving form to the work, and responds to the same spirit of reducing means in order to highlight the essential.

The alien images he uses belong to popular culture and the media, two sources of images common to large sections of society. He does not work with elitist images, nor with those taken from high culture. Nor do images of fashion and advertising and style form part of his visual inventories. Feldmann does not seem to be interested in the values of class and money that they represent.[3] When he includes them in the middle of one of his image archives, such as *Voyeur*, the reduction in scale, the black and white and the context mean that they are read in a different fashion.

If all we know of the past is what seemed important to certain social groups, that is to say, if the stereotyped representation of history as a single main stream – questioned so much today – was constructed by the dominant classes, what Feldmann wants to show is what appears relevant to the walk-on parts in the drama of history.

Feldmann finds some forms of aristocratic art in the past obscene, 'Many of these works have been made with the blood and suffering of many people. Nonetheless, their descendants are delighted to go and look at them.'

In his *Critique de la vie quotidienne*, Henri Lefebvre points out that the level of the everyday is not reduced to alienation, but rather ceaselessly calls out to the possible in order to evaluate and achieve the present.[4] Feldmann would also appear to be in agreement with this when he affirms: 'People expect a better life. If we thought this one was the good one, that this was paradise, our entire attitude would be different. Our perceptions change according to what we think, according to our idea of how things are.'[5]

Feldmann starts with the possibility of intervening in the everyday, but introduces the idea, central in his work, of the mind's participation in the elaboration of what we perceive. With this idea as a base, he develops a series of actions in which he uses his family car. The artist painted the outside of the car in different ways, as if he belonged to a rock group, or to a striptease club, and so on, and people approached him depending on his supposed profession. When

he painted the outside of the car as if he belonged to a circus, children waved at him and smiled as he went by. On other occasions, when people visited him at home, or when he visited them, at openings and other situations involving social interaction, Feldmann distributed photocopies with an image and a word or a phrase, like a kind of print. The prints were usually given out as a souvenir of special personal situations which had been socially ritualized, such as births, first communions, marriages or deaths; that is to say, they highlighted special moments in a person's life. And that is what Feldmann does.

1 [footnote 15 in source] Henri Lefebvre, *Critique de la vie quotidienne*, vol. II (Paris: L'Arche, 1958-1981) 50.

2 [16] The work of Feldmann and Boltanski shares areas of common interest. […] But, apart from many others, the main difference between their works lies in the fact that Boltanski dramatizes sentiment whereas Feldmann neutralizes it.

3 [17] In this and in the fact that Feldmann is interested in series and not in the individual image, lie two of the main differences between his work and that of other artists who appropriated the use of images in the 1980s.

4 [18] Henri Lefebvre, op. cit., 'La critique de l'inaccomplissement et de l'aliénation ne se reduit pas au noir tableaux de la douleur et de l'accablement. Elle implique sans cesse l'appel au possible pour juger le présent et l'accompli.'

5 [19] From conversations with the artist.

Helena Tatay, retitled extract from 'When One Gets Involved in Art One Does Nothing but Move from Catalogue to Catalogue', trans. Matthew Tree, in Tatay, ed., *Hans-Peter Feldmann* (Barcelona: Fundació Antoni Tàpies, 2002) 29; 33–7.

Ian Breakwell
Diary//1964–85

17. 3. 1974, Leeds–London train, 7:25 pm

The woman in the corner seat wears a green velvet coat trimmed with imitation fur, and knee length maroon suede boots. She falls asleep sinking into the corner of the seat. Her red velvet skirt slides up around her thighs; her mouth falls open and is reflected in the window, superimposed in the night landscape outside. The trains parallel with a motorway: cars and lorries rush into her mouth, their headlights full on. She wakes up, coughing.

11. 3. 1983 London, West Smithfield, 2pm
In the foreground a newspaper placard: DEARER TEETH.
In the background a sobbing woman.
Around the corner a man with his hands in his overcoat pockets, his shoulders
shaking with mirth.

Ian Breakwell, *Diary. 1964–85* (London: Pluto Press, 1986) 21; 32.

Ivone Margulies
Nothing Happens: Time for the Everyday
in Postwar Realist Cinema//1996

'Nothing Happens': this definition of the everyday is often appended to films and
literature in which the representation's substratum of content seems at variance
with the duration accorded it. Too much celluloid, too many words, too much
time, is devoted to 'nothing of interest'. The precariousness of this extremely
relative definition is more than a matter of taste. If the word 'boring' has little
critical value, after World War II the phrase 'Nothing happens' becomes
increasingly charged with a substantive, polemical valence. [...] My interest is in
the way some filmmakers negotiate the link between the banal or quotidian and
the political, and in the shifts in discursive ground that allow for such different
approaches to everyday life. Akerman's *Jeanne Dielman, 23 Quai du Commerce,
1080 Bruxelles*,[1] of course, figures as a major text in any consideration of the
modernist approach to the quotidian. The label 'Nothing Happens', often applied
to Akerman's work, is key in defining that work's specificity – its equation of
extension and intensity, of description and drama. [...]

In *Jeanne Dielman*, Akerman disables romantic connotations by giving to the
mundane its proper, and heavy, weight and by channelling the disturbing effect of
a minimal-hyperrealist style into a narrative with definite political resonances.
Her attention to a subject-matter of social interest is literal – fixed frame,
extended take – and so stylized as almost to be stilted. In this way, she denotes
the idea of display itself; her cinema focuses hyperbolically on what Cesare
Zavattini claimed as the main requirement of neorealist cinema – 'social
attention'.[2] Indeed, in *Jeanne Dielman* this focus is quite extreme. Hans Jürgen
Syberberg, Godard, Rossellini, and Jean-Marie Straub and Daniélle Huillet, among
others, have all interpreted the demand for 'social attention' as interchangeable

with temporal filmic focus on a single scene, situation, problem; but the relentless frontality of Akerman's display of 'social attention' still surprises. [...]

Both Warhol and Akerman choose the literal approach rather than the 'iterative' representation (the deduction of a recurrent series through the presentation of a single event). But there is a crucial difference between, on the one hand, Akerman's and Warhol's excesses, both a form of minimal hyperrealism, and, on the other, the expansive thrust of neo-realist narrative, which, for example, may try to signify all unemployed Italians through a single character such as Umberto D. The minimal-hyperrealist rendition undoes any idea of symbolic transcendence. Besides injecting representation with the effect of a surplus of reality, literal time robs it of the possibility of standing for something other than that concrete instance.

For Zavattini, 'no other medium of expression has cinema's original and innate capacity for showing things that we believe worth showing, as they happen day by day — in what we might call their "dailiness", their longest and truest duration'.[3] This duration that he proposes as innately cinematic is more appropriately seen as another figure of the excess required in the unending search for truth, an excess of the same order as the ability Margaret Mead imagines a 360-degree camera might have to register a vanishing tribe, or of the fixed camera she mentions in her discussion of film's potential for objectivity: 'The camera or tape recorder that stays in one spot, that is not tuned, wound, refocused, or visibly loaded, does become part of the background scene, and what it records did happen'.[4] Mead could not have known that she was advocating for her objective record the same basic cinematic framing — the long fixed take — that would reveal the amazing performances in Warhol's films, and would create the rigid, distanced, albeit subjective perspective in Akerman's.

In Warhol, for instance, the issue of the degree of objectivity in representation is moot. With an ethnographic sensibility (his films show the interactions of a very specific 'tribe'), Warhol undermines observational and direct cinema by hyperbolizing, to the point of caricature, the very basis of their existence: the notion of non-interference. He trades their positive indexing of the ethic of non-interference for the equally ethical, and in his case actively political, stance of indifference. Merely by enhancing duration, the fixity of the frame, and the intrusion of chance, he undermines the belief underlying observational cinema and American direct cinema that a measured closeness between subject and object guarantees objectivity. [...]

Warhol exposes the limits of the humanist perspective in cinema. He defies it initially by suggesting a radical lack of empathy among filmmaker, object, and spectator: the cinematic and the profilmic are purposefully at odds, resulting either in a busy – *The Chelsea Girls, Vinyl* (1965) – or a simplified – *Sleep, Blow*

Job (1963) – arbitrariness that never caters to the spectator. Warhol's forty-five-minute *Eat*, six-hour *Sleep*, and eight-hour *Empire* (1964) resemble exaggerated responses to Zavattini's plea for a film that would follow someone to whom nothing happens for ninety minutes. After Warhol's attack on spectatorial comfort, Zavattini's assertion, once bold in its privileging of 'nothingness', seems too careful a compromise: ninety minutes, after all, is the normal length of a commercial feature. Warhol's films mock and subvert all the basic values associated with neorealist 'nothingness'. Warhol's extended renditions of cliché images create a different register through which to read neorealism's narrativized phenomenology of the quotidian. His gaze allows no space for the heroic. The changing backgrounds that, in neorealism, throw the constancy of the hero into perspective is dropped. In place of a narrative in which the humanist hero is outlined against a tokenistic surface of varying sites and situations, Warhol proposes an antinarrative in which variety issues from any object looked at long enough. Instead of cashing in on the neglected and 'irrelevant' – the neorealist strategy – Warhol doubles the banality of his objects by promoting an overvisibility where it is superfluous. In overdoing his reductions (single themes filmed for extended periods of time), Warhol excludes even the limited suggestiveness of neorealism's policy of variegation and tokenism.

André Bazin more than anyone sees realism to be at its best when it pursues ideas of non-interference and the integrity of reality so as to enlarge the perceptual field of representation. Hence he puts a moral value on the use of the long take and depth of field at the expense of montage; for him, these devices forgo artifice. Discontinuity and gaps constitute the main threats to the flawless homogeneity of a cinema intended as an analogue to an equally full reality. Taking this idea one step further, what matters is no longer the actual physical integrity of representation – its lack of cuts – but that it appear to be physically integral (as in *Umberto D* [Vittorio de Sica, 1952]).[5] Despite Bazin's theories (but in accord with his aesthetic inclinations), from Jean Renoir to Roberto Rossellini, the textural integrity provided through the long take has been less an assurance of homogeneity than the counterpoint to a *mise-en-scène* intended to resist harmony. The long take here is meant not as an analogue for reality but as one more element in a subtle weave of artifice and spontaneity, of theatricality and realistic detail. Modern cinema's appropriation of the long take is to be understood as the background for the emergence of an 'effect of reality', in Barthes' sense. The 'irrelevant detail' (Rossellini's term) appears best when set in an unfractured shot.

Warhol's literal representations foreclose on the differential play between depth and surface that constitutes the truth of modernist cinema. Rossellini, Renoir, Akerman and other modernist realists use the qualities of cinema to set up

material clashes with idealized versions of reality. Warhol establishes a forceful and arbitrary entropy of registers. One could say that with Warhol, the materiality and concreteness that pop up in these directors' films are drastically amplified as pure (and passive) resistance. Warhol undoes the main knot underwriting their visions of a truer cinema. Where they invoke intention, he seems indifferent. His cinematic choices are aprioristic, and provoke randomness of performance (in his scripted films) and perceptual arbitrariness (in his early work). At the base of any *cinema engagé* is human interest. In Warhol, interest is challenged on all fronts: the filmmaker is absent, the object is banal, the spectator is bored. The spectator's confrontation with his or her own physical and mental endurance delineates a cinema that has given up on the notions of truth that sustain other alternative cinema (Akerman's included). But interest is not simply traded for indifference, for the Warhol strategy puts forth a politics of indifferentiation: identity wavers between representation and reality, between acting and being, flickering constantly and unstably.

By contrast with Warhol's politics of indifference neorealism's and *cinema verité*'s search for authenticity in reenacting events seems hampered by its desire to find a truth lying always beyond materiality, beyond the body. As suggested, Warhol's undermining of search, effort and intention makes any cinematic approach seem lame before it even gets close to its object. So his cinema never does get close: Warhol does not intend to 'get inside' the objects of his cinema (as Rouch would have it). Yet neither does it search for a feeling of being 'outside' – for an alienation effect, of the kind that might give rise to a sudden empathy (as in Jean-Luc Godard, Robert Bresson and Rossellini). The literalness of Warhol's cinema qualifies these two approaches. On the one hand, the event's radical duration on screen disallows the equation of fissures in the illusion with truth. His work provokes such a random surfacing of fissures – mistakes in performance (*The Chelsea Girls*), shifts in address (*Beauty no. 2*, 1965), mixings of genres (*Lonesome Cowboys*) – that a gap or error cannot be taken as more true than articulated speech. On the other hand, his enhancement of cinematic materiality is so pervasive as to defy the pedagogic thrust of a modernist cinema intent on the disclosure of materiality (Godard and Jean-Marie Straub & Danièle Huillet being the main examples). Moreover, it is precisely through an apparently unfissured surface, in a Bazinian sense, that Warhol shifts discontinuity from the text onto the spectator's perception.

Neither Bazin's concept of an unfissured realist representation nor Warhol's overturning of such a notion, however, responds fully to the neorealist desire for totality. This essentialist conception leans on metonymic expansion, which might dissect for us, for instance, the bedroom where Umberto D sleeps, but might also create a physical and moral geography that suggests a totality. In this respect, the

attention to details, and the presentation of sites and events as illustrative tokens, operates in neorealist film in much the same way as the display of iconographic images works to shape allegorical meanings in conventional cinema. In de Sica's *Bicycle Thieves* (1948) all of Rome (or rather all of Italy and of the postwar world) is meant to be represented by the syncretically woven neighbourhoods and sites that the protagonist Antonio Ricci traverses. The wanderings of the characters in *Umberto D* or *Bicycle Thieves* signify a solely 'physical' coverage of reality only superficially: here multiplicity – of spaces, of people – always reconvenes on a centre, sucked back to it by a human perspective that is represented in the films by a human body, a hero. It is this heroic body, the generic postwar individual, that Akerman's *Jeanne Dielman* takes to task. While Warhol substitutes the character's body for the filmic body, transforming the one-to-one nature of literal representation in an ultimate decentring of humanism, Akerman proves how a body can flicker in and out of character (through a kind of oscillating perception made possible by literal representation) and still further a narrative.

Akerman's minimal hyperrealism, in so many ways similar to Warhol's, makes a positive claim to tell a story; her equation of drama and everydayness is made from within narrative. Moreover, it is in instituting another sort of hero(ine) that she mounts her blows on essentialist humanism. The singularity of Akerman's Jeanne defies the generic humanism of Umberto D or Antonio. The historical grounding of this sort of heroine is represented at its best in Akerman's fusion of a minimalist hyperrealist sensibility with an acute awareness of seventies micro-politics, and of feminism in particular. It is this awareness of the singularity of a woman's everydayness that forms the backbone of Akerman's corporeal cinema, a cinema whose split concern with referentiality and cinematic materiality can be examined in the context of other contemporaneous artistic practices.

1 [*Jeanne Dielman, 23 Quai du commerce, 1080 Bruxelles* (1975, 210 min, colour) fictively documents in minute detail three days in the home life of a widowed Belgian mother.]

2 [footnote 4 in source] Cesare Zavattini, 'Some Ideas on the Cinema', in *Film: A Montage of Theories*, ed. Richard Dyer MacCann (New York E.P. Dutton, 1966) 219.

3 [53] Ibid., 220.

4 [54] Margaret Mead, 'Visual Anthropology in a Discourse of Words', in Paul Hockings, ed., Principles of Visual Anthropology (The Hague and Paris: Mouton, 1973) 9.

5 [56] See Marsha Kinder, 'The Subversive Potential of the Pseudo-iterative', *Film Quarterly*, vol. 43, no. 2 (Winter 1989–90) 8. [...]

Ivone Margulies, extract from *Nothing Happens: Chantal Akerman's Hyperrealist Everyday* (Durham: Duke University Press, 1996) 38–41.

Patrick Frey
Outings in the Visible World//1995

The piece [*Visible World*, a continuous project from 1987 onwards] consists [at the time of writing] of some ninety video sequences ranging from twenty minutes to just short of two hours, yielding a panoptical archive of over eighty hours in length, and shown on a number of monitors so that the entire eighty hours last exactly the length of one day's exhibition. [...]

Outings generally take place on a day off; they are small trips with one or several, more or less clearly defined goals, but actually the trip itself – the ride or the hike and the events on the way – is as important as the destination. So Fischli and Weiss went out into the world day after day to capture it in their own special way with a Handycam, panoptically of course, like an overview, but with tiny, inconsequent details. They have done this before, even on film – in their second film, to be precise, where they wander through a primal landscape wearing rat and bear costumes. But the first such attempt of 1982, *Suddenly This Overview* (*Plötzlich diese Übersicht*), consisted of 250 unfired clay sculptures. Here for the first time, we see prefigured the specific interests and familiar, often popular *topoi* with typical moods that later played a central role in sculptures and photographic series, and now in these video films. The clay sculptures did not communicate a discursive narrative but materialized, as it were, out of rapidly modelled clay, which lends them something of the character of profane, earthly epiphanies.

'Waiting for the Elevator', 'Modern Development', 'Work and Play', 'Autumn' (a few leaves), and 'Native Forest', 'At the Dentist's', 'Cutting through the Gotthard Tunnel', 'Scrap Heap' or 'Indoor Cross' are just a few of the programmatic titles of the sculptures in *Suddenly This Overview*. They indicate that the oeuvre of Fischli/Weiss consists of something like a steadily expanding and varied collection, indeed a system of general subjects. Correspondingly, in their most recent videos Fischli/Weiss wander through the working world, through the worlds of recreation and entertainment; they spend hours in real world situations with mostly banal architecture and in nature with all its ordinary, idyllic, picturesque and archaic grandeur. They look long and hard at huge buildings in construction, at industrial operations, at people doing what they always do – on the job, working out, enjoying their free time, dancing.

They observe judges examining paws at a cat show, and in another film, an operation at a veterinary hospital – how a terrier is anaesthetized, how they do surgery on its meniscus, how the dog recovers from anaesthesia, and finally, how it takes its first limping steps to recovery (guided by Fischli who is also filming).

On all of their outings, they drive through big and small tunnels, even through the Gotthard Tunnel in an almost eight-minute sequence; in three of the films we join them watching the construction of a new tunnel through the Alps; we see one day's progress of about nine sequential feet, how drilled holes are dynamited and the rubble cleared away, how Gunite is sprayed to reinforce the walls, and then how new holes are drilled.

They take the train from Zurich to Paris and there ride the Métro from station to station; they drive via the throughway from Zurich to Frankfurt and stop for a while to watch work at a construction site before going out to visit the airport; then they drive to the Rhine, look at gravel pits, sluices and steamers, drive on to Alsace, then Strasbourg; in three films they show a flight to the United States, from check-in to security check to a look at the cockpit. Once there they record utterly unspectacular events, like the squirrels in Gramercy Park. They visit a traditional Swiss Alpine farmer for a day, keeping an unobtrusive eye on him like a team of anthropologists documenting a curious ritual. They show him milking his cows, making cheese, walking his cattle down from the mountain pastures; they also visit a modern Alpine farm where the milking is semi-automatic and a pipeline transports the milk down into the valley. [...]

Given the rampant nature of their project, Fischli and Weiss have to proceed with inventive efficiency. Thus, the beautiful (making the films) is sometimes linked up with the useful and the necessary (things that have to get done anyway). This is most persuasively demonstrated when they have their snow tires mounted before driving up into the mountains. In the evening, we drive to the garage through the rain listening to the strains of Dvořák's beautiful New World Symphony. At the garage, the hit parade is playing and we watch the mechanics take the old tires off the rims, mount the new ones, fill them with air, balance them, and put them on the car again. [...]

The camera seems to be waiting for an event, like alert or passive observers, sitting on a bench or strolling around somewhere, watching the world go by, and since they have no particular aim, easily distracted by all kinds of sensations large and small, even micro-sensations and zero events that enter their active or passive field of vision. Many sequences consists almost exclusively of inspired and patiently anticipated, lucky coincidences that often make their appearance when they are least expected. For instance, an early morning ride on the trolley in darkness and rain through a perfectly ordinary suburb turns into an incredibly glamorous array of sparkling lights and reflections because the camera peers shamelessly out of the window, and delights in the exciting play on the rain-washed windows of reflections and double exposures of passengers, passing cars, buildings and lights – a spectacle that comes to a dramatic climax in the wet window panes of two passing trolleys. [...]

'Things that passively cross our path, that happen by accident, mean the most to us. They seem to be even more authentic than planned activities to show what actually happens in reality – and besides they relieve us of having to justify or explain why we are shooting this thing and not something else.'

This conscious, inspired waiting for something, an event, an appearance, in any case something phenomenal that might just happen by itself if we wait long enough, with enough curiosity and patience – this is the attitude that underlies the entire project. Closely related in several respects to both documentary and amateur camera work, the attentive camera, biding its time, backgrounds narrative, sequential perception to the benefit of imaginative, simultaneous perception. Filmed sequences of a basically narrative structure are transformed into 'stills' that we look at contemplatively, that no longer appear in some kind of temporal order but as pure images in a spatial structure, as if in a space capsule where time no longer passes, or only very, very slowly, almost suspended. [...]

Fischli/Weiss do not make such generous use of time in order to tell us about their travels in lengthy detail, like amateur film-makers. Nor do they want to make a statement about video art's frequent exploration of processes in real time. Their complicated detours down untold side streets are simply the archest and most beautiful means of transporting viewers into a phenomenal kingdom in which conventional cinematic narrative has been abandoned apart from the rare hint of reproduction.

Such primal images, which are basically the objective of these day trips, must be approached slowly, cautiously, indirectly. That is perhaps why we so often join Fischli/Weiss on the way to and from their destinations. This is not a narrative device. But, as in real life, we almost forget whether the act of travelling is a means or an end in itself, so that all of a sudden we are no longer peering ahead through the rainy windscreen, focusing on some goal out there in front of us, but are instead completely detached and engrossed in the previously 'invisible' pattern of drops travelling down the windshield. We have drifted off, have been immersed in an entirely different 'visible world'

Patrick Frey, 'Outings in the Visible World', in *Peter Fischli and David Weiss* (Venice: Swiss Pavilion, XLVI Venice Biennale/Bern: Bundesamt für Kultur, 1995) 39–49 [footnotes not included].

Gabriel Orozco
On Recent Films//1998

What I'm after is the liquidity of things, how one thing leads you on to the next. These films [*From Green Glass to Federal Express*; *From Container to Don't Walk*; *From Cap in Car to Atlas*; *From Dog Shit to Irma Vep*; *From Flat Tire to Airplane*, all 1997] take place in very ordinary urban settings. I'm not concerned with spectacular events or frantic rhythms. The works are about concentration, intention and paths of thought: the flow of totality in our perception, the fragmentation of the 'river of phenomena', which takes place all the time.

I avoid all postproduction because I want to keep the clumsiness, insecurity and ambiguity of the actual shooting. It's really the awareness involved in the shooting itself that is important to me, not what one can do with images afterwards. The tension between my intentions and reality itself is what drives the films. I devote a day to creating a kind of 'story'. Walking down, say, Sixth Avenue, I'll suddenly see something that intrigues me – a plastic bag, a green umbrella, an aeroplane tracing a line in the sky. That's how I get started.

One can't really see the films as entries in a diary, because they're not at all private. I'm very conscious of the fact that they'll be viewed by somebody else. I think about the viewer all along. The presence of the viewer makes me want to be more precise. But more important, the fact that the thoughts of the spectator are with me as I shoot the film short-circuits all ideas of privacy. There's nothing private about the process of creation.

The metaphoric links between things are not something I plan but something that just happens. The kind of connection that intrigues me is contiguity. I move from one thing to another, and in the film they'll be situated next to each other or happen right after one another, although there may be ten or twenty minutes between them in reality.

The connections themselves are real, not metaphoric. Borges wrote somewhere that all these things that are next to each other, we call the universe. It's this 'being next to each other' that appeals to me. In the films things are related, but through proximity rather than narrative. Therefore you can begin in one place and wind up in another that doesn't seem related to the starting point. For example, the tape I like the most, *From Dog Shit to Irma Vep*, traces a series of connections between two things: a piece of dog shit I saw in the street at 10:45 a.m. and this beautiful Chinese actress whose face I found on a poster at 4:45 p.m. Between these two events there's an entire day of walking, now condensed into forty minutes of recording on a tape.

There could be some kind of resemblance between what I'm doing and John Cage's recordings, but Cage's work has so much to do with chance, whereas I'm really focusing on concentration and intention. The same goes for the automatic writing of Surrealism. That's all about losing control, whereas the flow of images in my work is extremely controlled. I trace certain intentions with the camera, and then suddenly the tension between my intentions and reality becomes too great and the whole thing breaks down.

I wake up in the morning. The light has to be okay. I have breakfast and then start walking down some street until something catches my attention. That's when the movie starts. When I begin recording something, I don't know how long it's going to last, maybe thirty seconds, maybe five minutes, so I improvise, watching and walking at the same time. I always hope to be able to stop filming at the right moment, not before something great happens or after my finger and future viewers get *calambres*[1] of boredom.

Sometimes I focus and just wait. I like the sounds in the video to connect in the same way as the images. I'm actually amazed by how 'normal' my video sounds, just like real life – collapsing sounds and noises that overlap and connect without logic. I move the camera, I walk with it, I take stills, I use the zoom a lot and play with scale and distance. Sometimes I intervene in reality, like at this bar in Amsterdam, where I turned all the beer coasters upside down on a table and taped them. Sometimes I follow a dog, sometimes I follow a backpack.

These are the things I normally look at when walking down the street. They wouldn't be interesting in photographs, but perhaps they are in a movie. After a day of walking I have twenty to forty minutes' worth of tape. I like to sit at a bar and have a beer while going through it. It's nice to see all the fragments of a day condensed. The narrative is like a series of punctums – focal points of attention. There's no postproduction – it's all left as it is: a day of awareness. I think that if I were to edit these films and try to make sense out of them, the final result would still be the same: '*Las partes son el todo, el todo son las partes*' [The parts are the whole, the whole are the parts].

1 *Calambres* – twitching in limbs, cramps, listlessness …

Gabriel Orozco, 'Gabriel Orozco Talks About His Recent Films', *Artforum* (New York, June 1998) 115.

Ilya and Emilia Kabakov
Night Journey//1998

1. Take or build a desk (it's best to take an old wooden one, dark brown with age, a simple wooden table with a long 'history') 70 x 130 x 72 cm in size.
2. Buy a glass dome 28-30 cm in diameter and 20 cm high and place it in the upper right corner of the desk.
3. Take a few small objects which can usually be found on a desk: a box of paper-clips, erasers, pens, pencils, an ink bottle, a piece of cookie, a sheet of paper, etc. Place all of this under the dome.
4. Place an electric desk-lamp next to the dome, turn it on and direct the light on the objects under the dome. The lamp should be 75 watts. The lamp should be simple, black, office-like.
5. On the rest of the table, place objects which are usually found there: notepads, pens, paper clips, a telephone book, a water glass, a bottle of glue, etc.
Place all of this in the same way, in the same 'disorder' as the items under the dome so that – and this is very important – it gives the impression that the dome covered the corner of the desk and the objects there completely accidentally and not selectively, the objects under it are just like the ones nearby.
6. The circle of light from the lamp should illuminate only what has wound up under the dome, it should coincide almost exactly with the rim of the dome.

W. Petrov, Pensioner, Kiev
1. How can you escape far-far away, to set off on a boundless journey, where everything around you will be new, unexpected, where everything is surrounded by the unfamiliar and interesting, you encounter things which don't have names, their purposes and reason for existing are incomprehensible, where your every step is accompanied by the risk of falling under the feet of a strange being, and at the same time you will be surrounded on all sides by symbols and signs addressing you but in a language that is foreign to you? It is not at all mandatory for such a journey to buy a ticket for a train, plane or boat, or even to leave one's own apartment. When night has fallen, and you remain alone in your room, sit down at your desk, turn out the light, and turn your desk lamp so that it illuminates only one small part of the desk, it can be one of its corners (but this circle of light shouldn't be too wide, not more than 20–25 cm in diameter). And you will quickly see how suddenly a new mysterious world emerges, which you couldn't have anticipated before. Ordinary things – a note pad, a pen, a ruler, a box of paper clips, an eraser – which during the day were lying on your desk, will

**A NOTE PAD, A PEN,
A RULER, A BOX OF
PAPER CLIPS, AN ERASER**
WHICH DURING THE DAY
WERE LYING ON YOUR
DESK, WILL ACQUIRE
ROLES IN THIS MAGICAL
CIRCLE OF LIGHT THAT
ARE UNEXPECTED AND
UNFAMILIAR TO YOU.
BUT MOST OF ALL, YOU
YOURSELF WILL CHANGE.
IN A STRANGE WAY
AND WITHOUT ANY
PARTICULAR EFFORT,
YOU WILL BEGIN TO
SHRINK, AND SOON
YOU WILL BECOME VERY
TINY AMIDST THESE
ENORMOUS, STRANGE
AND INCOMPREHENSIBLE
OBJECTS

Ilya and Emilia Kabakov, *Night Journey*, 1998

acquire roles in this magical circle of light that are unexpected and unfamiliar to you. But most of all, you yourself will change. In a strange way and without any particular effort, you will begin to shrink, and soon you will become very tiny amidst these enormous, strange and incomprehensible objects. This 'journey' of yours begins at that moment: very slowly, not rushing, you begin to walk around each of them, carefully examining them, concocting all kinds of guesses about the purpose of each of them and about what is written or drawn on them ...

Ilya and Emilia Kabakov, 'Night Journey', from *The Palace of Projects* (London: Artangel/Madrid: Museo Centro de Arte Reina Sofía, 1998) n.p.

Stephen Shore
Interview with Lynne Tillman//2004

Lynne Tillman Some people might think your work is entirely formal. Yet you have a tremendous interest in the multiplicity of things.

There's a tension: To be a formalist you must exclude a lot to find the image that fits your idea of what makes a picture. Another side of you wants inclusion.

Stephen Shore When you were saying that I was thinking of one of my favourite photographers, Walker Evans, who spoke about his work in the 1930s as being in documentary style. In a certain way, that makes him the first postmodernist photographer. His work is very consciously structured. He makes choices that reference a vernacular style of imagery and adopt the cultural resonances that that style calls up. The document.

Tillman In *American Surfaces*, you photographed meals, food, often.

Shore It was a visual journal of a trip across the country. When I started the trip I had many ideas about what I was going to do. I didn't want to do 'Decisive Moments'. Cartier-Bresson had used the term for a particular kind of visual coming together but I was interested more in the ordinary, of things not happening in your life, I wanted to be visually aware as I went through the day. I started photographing everyone I met, every meal, every toilet, every bed I slept in, the streets I walked on, the towns I visited. Then, when the trip was over, I just continued it.

Tillman It's similar to a writer's first novel being a *roman à clef*. But autobiographical visual images are different from what happens with words. What you're looking at is outside yourself; your autobiography necessarily includes what you see as pictures: others, objects, houses, meals.

Shore Maybe related to it is that the following year, 1973, when I did the first pictures for *Uncommon Places* I actually kept a journal. None of it is introspective at all, though there's some writing. It's photographic too. I'm choosing certain facts. How many miles I drove. Postcards I collected.

Tillman Did you feel at the time that it was important for you to remember everything?

Shore It was more a fascination with how certain kinds of facts and materials from the external world can describe a day or an activity. The journal had its root in *American Surfaces*, when I was recording my life.

Tillman That kind of journal is similar to displaying the contents of a refrigerator. The question occurs: who would have this refrigerator? The journal's not a psychological portrait. Not how you're feeling, but how activity defines character, with an attitude or approach to character and place. Not psychological ideas about inferiority, but a commentary about your place in the world. Your portraits aren't about individual psychology. They seem more about how people pose for the camera, how they live or fit inside their environments.

Shore Yes. But they also have to do with what people look like. And what the backgrounds are, what kind of rooms they're in.

Tillman In *Uncommon Places*, when I look at the photograph of your wife, Ginger, against an orange wall, I think about her hair, skin, the tones of orange and red. She's looking away. You could be presenting a young woman or a meal. The photograph of your friend, Michael Marsh, on the couch, with the woman lying on him: you represent a relationship – two bodies in an embrace – but we don't see the woman's face, her expression. It's about the embrace. The man is looking impassively at the camera. We see the couch, the rug ...

Shore The TV stand. [...]

Stephen Shore, extract from interview with Lynne Tillman, in 2004 revised edition of *Uncommon Places* (Millerton: Aperture, 1982) 173–83.

Francis Alÿs
Interview with James Lingwood//2006

James Lingwood Does your interest in railings come from a childhood memory, from growing up in Belgium?

Francis Alÿs Maybe as a kid's game, you know, picking up a stick and running it along the railings. A lot of the walks have had that kind of echo, like kicking a bottle along the pavements, or dragging a magnet through the streets at the end of a string. I tried something similar in Mexico City – not on railings but on the metal shutters of shops in the old centre of the city. [...] Now if I go back to the chronology of how the projects in London developed, the simple act of touching the railings, of feeling the architecture with the drumstick acting as a kind of catalyst, was a way of making contact, of connecting to the physicality of the place. As the drumming piece developed, a number of variations happened. The first moment was just walking with a stick bouncing on the architecture; there was no interaction, the architecture was entirely dictating the sound patterns, but the melody was generated by the motion of the walker.

Lingwood Architecture has been called 'frozen music'.

Alÿs The city is a kind of interlocutor. It was just about listening to the music of the city. The second stage was to build some kind of archive of all the different sonorities that the railings and architectural patterns could offer, a kind of repertoire. Once that had been done, the logical step was to start playing with the instrument, to improvise, to see how far this could get me. [...]

Lingwood The London project is called *Seven Walks*. Could we say that walking is a medium for you?

Alÿs Walking happens to be a very immediate way of unfolding these stories.

Lingwood Walking generates a particular conception of time, of a human body moving at a pace when the legs can move easily. The writer Rebecca Solnit suggests the mind moves at three miles an hour.
 Is walking, for you, a tool for thinking?

Alÿs It's a perfect space to process thoughts. You can function at multiple levels

simultaneously. [...] Also, when you are walking, you are aware of, or awake to, everything that happens in your peripheral vision: the little incidents, smells, images, sounds. Walking brings a rich state of consciousness. In our digital age, it's also one of the last private spaces. [...]

Francis Alÿs and James Lingwood, extract from interview edited from two conversations in London on 11 and 20 July 2005, in Francis Alÿs, *Seven Walks* (London: Artangel, 2006).

Michael Sheringham
Configuring the Everyday//2007

Should we pay attention to the everyday? If so, how should we do it? [...] First, while many things are commonly identified with the *quotidien* – eating, phoning, shopping, objects and gadgets – everydayness is not a property or aggregate of these things; it inheres rather in the way they are part of manifold lived experience. Secondly, the ensemble in which we are immersed comprises other people: *quotidienneté* implies community. Thirdly, while the everyday is not the place of the event (always exceptional), and is therefore in tension with history, it has a historicity that is embodied, shared and ever-changing (repetition does not have to be stale). Fourthly, *quotidienneté* dissolves (into statistics, properties, data) when the everyday is made an object of scrutiny. Everydayness lies in practices that weave contexts together; only practices make it visible. Overall, this summary points to two lines of approach that rise to the challenge of the everyday. Both are implicit in the evolution of thinking on the *quotidien*, and in the works in different media which, as we have noted, bear the imprint of such thought. One approach centres on the *figure*, the other on the *project*. In practice they intertwine, as will be seen when we consider three areas: the day, the street and the project itself.

If the everyday is the site of a struggle between alienation and appropriation, critical reflection is inevitably involved in a similar dynamic. The factors that make the everyday alien to us are themselves bound up with the project of rationality. The foreclosure induced by most ways of thinking about the everyday is of a piece with the alienation wrought in the sphere of the everyday through its 'colonization' (Guy Debord) by abstract and technocratic reason. Attempts to theorize the everyday that use the methods of individual 'sciences parcellaires' (Lefebvre) are in complicity with the segmentation and

rationalization that threaten the everyday in the first place. Thus the ways of rethinking the everyday with which [we are concerned here] – Lefebvre, Debord, Blanchot, Barthes, Certeau, Perec, Marc Augé, Stanley Cavell – acknowledge its resistance to thought, the indeterminacy that makes for its paradoxical strength.

The everyday cannot be reduced to its content. It is not just repetition that makes daily activities part of everydayness, but the endless variation and sedimentation which, according to Jacques Réda or Certeau, turn the *quotidien* into a sphere of invention. Driving to work, getting the groceries, talking to friends are all objective phenomena – instances of which can be analysed in a wide variety of ways – but the everyday invokes something that holds these things together, their continuity and rhythm, or lack of it, something that is adverbial, modal, and ultimately therefore ethical, because it has to do with individual and collective *art de vivre.* […]

Projects of Attention

It is easier to talk about a special *journée* – Virgil's *summa dies* or the 'Perfect Day' of Lou Reed's hit song – than about an ordinary, everyday sort of day, and easier to make the street a symbol or microcosm than see it simply as a street. Think all day, observes Raymond Queneau, and you may convince yourself that a street is a cavern; think for a year and you may decide it is a grotto; just give it the odd thought from time to time and you will no doubt recognize that 'toute rue est une rue'.[1] What needs 'factoring in' if one is to apprehend the everyday street is not something extra – aesthetic, subjective or intellectual – added from the outside, but our lived experience of it, our participation and immersion in its fields, the ways in which we make it part of our world and recognize it as such. For Certeau this is the dimension of *pratique*. The difference between a *lieu* and an *espace* is that 'un espace est un lieu pratiqué' (a space is a place appropriated by practices). Practice makes a difference through vectors, velocities and timing.[2] The everyday exists through the practices that constitute it, the ways in which times and spaces are appropriated by human subjects and converted into physical traces, narratives and histories (of the kinds François Maspero encounters in the Paris suburbs, or Perec invents for his apartment block). Thus, in Foucault's Roman letter-writers, in Benjamin and Jacques Roubaud, we encounter practices – of the day and the street. The figural dimension of the day, the street, the conversation, the gadget, the *fait divers*, which connects with everydayness as *sens*, over and above (or prior to) *significations* that can be objectified, stems from practice.

Yet surely, one may object, the activities of Maspero and Queneau, like the '*exercices pratiques*' Perec advocated in *Espèces d'espaces*, and executed in *Lieux*, are self-conscious, artificial and experimental. How may they relate to

what we actually do in our everyday lives? In the terms of Pierre Bourdieu's account of *pratique* the difference would be radical. For Bourdieu, 'C'est parce que les sujets ne savent pas, à proprement parler, ce qu'ils font, que ce qu'ils font a plus de sens qu'ils ne savent' (It is because subjects do not, strictly speaking, know what they are doing, that what they do means more than they know).[3] Bourdieu's theory of practice does link *pratique* with a synthesizing *sens* that exceeds objectified significations (in fact he placed a dictionary entry for the word '*sens*' as the epigraph to the ethnographic studies that accompany the *Esquisse*), and with 'strategies'. But in Bourdieu the subject of 'le sens pratique' is debarred from self-knowledge and volition. Ultimately, as Certeau points out, the logic of practice in Bourdieu ferishizes *habitus* and unconscious reproduction rather than creation.[4]

Certeau rebuts this view of *pratique*. For him, people know more than we imagine: doing is a kind of thinking. In his logic of practice,[5] what makes *pratiques* operative and efficacious is the level and context of their application. It is not a matter of knowledge or power but of local, pragmatic flair. In Certeau *pratique* does not possess its own content or space: it is a secondary production that exists only through the way it uses what is already in place, but it does thereby have a projective, dynamic aspect: it produces by reusing rather than reproducing. And this creative, indigent, ludic dimension is what gives Certeau's *pratique* an affinity with the more deliberate ruses of André Breton, Queneau, Perec, Annie Ernaux or Roubaud. For Certeau, we invent our own unofficial everyday through the improvised ways in which we go about our daily activities (inhabiting, shopping, reading, conversing) – 'le quotidien s'invente avec mille manières de braconner' (the everyday is invented in a thousand ways of poaching).[6] 'Whether we recognize it as such or not, everydayness is what we invent through the way we conduct our activities: 'art de faire' pertains to 'art de vivre' (Certeau's emphasis on style chimes with Foucault's 'art of existence'). Hence the possibility that if we want to draw attention to and acknowledge the everyday we need to simulate and thus stimulate the dynamic creativity that is inherent in the practices that constitute it, yet are generally hidden in the 'opacity' of gestures and local contexts. If the explorer of the everyday – Louis Aragon, Certeau, Perec, Augé, Ernaux or Sophie Calle – seeks to grasp a dynamism that springs from *pratique* it makes sense that it should be by inventing practices of his or her own.

Outlining *Lieux* and many other enterprises in his 1969 letter to Maurice Nadeau, Perec repeatedly uses the word *projet*,[7] an appropriate general term for the types of activity through which he and other explorers make themselves – at a second degree – what Certeau calls practitioners of the everyday. Semantically, the difference between *project* and such cognates as plan, scheme,

undertaking, task or endeavour is that, although it points towards an end, a project makes the end less defined, more hypothetical. Compared to a plan, a project is less determined by a specific goal that is known in advance and is to be achieved in a set way. Although it has a 'projected' outcome, on the horizon, the notion of the project focuses on steps to be taken during a stretch of future time. In a project the relation between the activities in the foreground or midterm and any eventual issue is uncertain: to talk of a project is to invoke the hazards of that relationship. To outline a project is not so much to focus on an achievement as to invoke, on the one hand an idea, a mental postulation, and on the other hand a range of actions conducive – in theory – to its realization. A project – a commitment to midterm actions – implies a preoccupation with the domain of practice.

As many developments in twentieth century culture attest, the notion of the project has come to occupy a central place in aesthetic and broadly cultural activities, shifting attention from outcomes (for instance, a finished artwork) to processes, practices, constraints, and durations.[8] Dada and Surrealism played a key role in favouring these developments. Of central importance in this cultural appropriation of the project is the way it accentuates the gap between action and result, menial and physical, the theoretical and the practical, whilst underlining their inextricability. Here the hatching of a project generally involves an ironic attitude to both systematic knowledge and utilitarian attitudes. Under the aegis of the project, the product of cultural practice is, on the one hand, a report on the conduct of the project itself (as we see clearly in Perec) and on the other hand a redirection of attention and a change in awareness brought about by the progressive implementation (or non-implementation) of the project. Projects are about practices and the differences they make, but also about the limits of orthodox, abstract thought: hence the strong affinity between the project and the everyday. The agency of practices in the constitution of the everyday – the projective dimension through which practices 'invent' the *quotidien*, not as an objective statistical reality but as lived experience that has its own bearings – finds its counterpart in the project. What the project figures is the active, performative dimension of the everyday, the way it inheres in 'arts de faire'. Thus I would like to probe further how the everyday finds its articulation in *ad hoc* grass-roots projects, involving both a marked practical dimension and an ample pinch of salt. [...]

Embarking on a project means avoiding the limitations of particular frames of understanding: a set of *ad hoc*, provisional, yet rule-bound actions and procedures provides a neutral framework within which experience can be freely addressed and received (constraints help regulate the balance between activity and passivity). Three examples may briefly be added to the list of projects

already encountered in previous chapters. In May 1982 Julio Cortázar and Carol Dunlop devoted a month to travelling from Paris to Marseilles on the Autoroute du Soleil in a Volkswagen camper van.[9] The key rule was that they would stop in service areas (two per day), eat and sleep there, but never leave the immediate environs of the motorway. Accompanied by numerous photographs and a logbook of their daily activities (including details of what they ate and the flora and fauna of various car parks), the narrative of their 'voyage intemporel' (timeless journey) – as the book's subtitle puts it – pays particular attention to the progressive 'mutation' of their awareness as they floated free of customary purposes and preoccupations. Cortázar's project influenced Maspero's *Les Passagers du Roissy-Express*,[10] which was in turn emulated by Jean Rolin. Rolin's *Zones* (1995) – a title evoking existential as well as geographic terrain – reports on three journeys, each of approximately two weeks' duration, round the fringe areas of Paris (either side of the Périphérique). Leaving on a Sunday in June 1994 (he will strive throughout to be a 'Sunday' traveller) Rolin took the metro towards Pont de Sèvres, alighted at the Marcel-Sembat station and checked in to the modest Hotel Phénix (signalling rebirth?), the first of many establishments, similar to those frequented by Maspero and Frantz, where he will rest fitfully over the next two weeks, often ruminating 'la lancinante question de ce que je pourrais bien faire, en voyage à Paris, qui ne soit pas du journalisme pittoresque ou de la sociologie de comptoir' (the pressing question of what I was up to, travelling round Paris, if not picturesque journalism or bar-room sociology).[11]

Like Maspero, Rolin frequently insists that his aim was to look, not to carry out a survey: everyday projects are interrogative rather than assertive. Jacques Réda's *Le Meridien de Paris* (1997) logs the author's attempt to follow the line of the Paris meridian, established by the scientist Arago (1786–1853) when he was director of the Bureau des Longitudes, then superseded when Greenwich was adopted. Armed with a brochure giving approximate directions, Réda tries to 'walk' the line, even though it 'traverses' boulevards, parks and buildings of all kinds, and even 'crosses' the Seine (Réda wonders if, in keeping with the logic of his project, he should swim across!). Although the activity involved is simple and physical, the hypothetical nature of the meridian locates the project at the interface of the abstract and the concrete, the material and the intangible, testing the parameters of different kinds of understanding or participation. Réda's account of his forced deviations makes his narrative comically digressive and rich in speculation, nuance and variation, thereby communicating the experience of Paris in arresting and unfamiliar ways.

In the sphere of everyday life, the project 'allows for' everydayness by suspending abstract definition and creating a breathing space, a gap or hiatus that enables the *quotidien* to be apprehended as a medium in which we are

immersed rather than as a category to be analysed. Projects (like Aragon's, Roubaud's, Maspero's or Rolin's) often originate in curiosity or anxiety about something in the field of everyday experience. An impulse grows into a project when it hatches a possible *modus operandi*, a sequence of thoughts or actions that generally consist in putting oneself (or someone else) into a particular concrete situation: cruising round the Buttes-Chaumont park at night (Aragon), visiting twelve chosen places once a year (Perec), following a stranger to Venice (Calle). Once under way, the project highlights the conditions of the experiment, the rules of the game, the practical steps to be taken. At the core of the experimental situation are factors designed to maintain openness and avoid pre-judgement. If there is a gap between mental impulse and practical execution, there is a further gap between the activities that thematize or concretize the project and any outcomes or conclusions. These must wait on events, they 'remain to be seen'. The deviation into practice is designed precisely to suspend judgement and 'see what happens'.

How does the project's practical dimension enact this suspension? When Perec spends three days in the Place Saint-Sulpice, or Sophie Calle works as a hotel chambermaid and photographs the guests' possessions,[12] or Christian Boltanski assembles photographs of missing children, we note an insistence on the hands-on, grass-roots level, on practical steps geared to the accumulation of data. One of the defining features of the everyday project is that it neutralizes purpose by displacement from the long-term macro-level, to the short-term micro-level, through a proliferation of rules, constraints, provisos and methodological niceties. In most projects the specifications (usually self-imposed ordinances) bear on both space (location, itinerary) and time (duration, frequency), as well as on mental and physical 'acts' to be performed. Codified as a set of instructions, such specifications are often ironic because their precision accompanies a strong sense of the gratuitous. The elements of irony or play suggest that the project involves parodic simulation, that 'scientificity' is being debunked to some degree, that collecting data is less important than the process of gathering. Yet the gratuitousness that neutralizes scientific enquiry also redirects attention.

There is a characteristic myopia of the project. Repetition of a sequence of actions according to a set procedure is often central and one of its effects is to neutralize the teleology of continuous narrative. But repetition has its positive aspects as it focuses attention on minute variations. This allies the project to a kind of knowledge linked to process – Perec's '*émergence*' (emergence).[13] Repetition fosters a different sort of attention by numbing customary activities. Its temporality is that of progressive 'tuning in' to a particular level of existence, a new mode of attention that is responsive to the uneventful, to what is initially

hidden by habit. Projects often succeed in making visible what is already there, not hidden but lying on the surface. By diverting attention from a goal to the carrying out of a repeated, preordained programme, the project creates its own intermediate spatio-temporal zone. In so doing, it generates attention to the present, to the unresolved matter of what is still in process (the process may be the spectator's current flow of awareness). The project is a frame, but nothing that comes to fill that frame can be said to complete or realize the project, which always remains open and unfinished. Yet within its framework a shift, essentially a shift of attention, takes place. The project brings us into proximity with something that might have seemed familiar, but which we now acknowledge more fully. In this sense we can see at work in the project the interface of alienation and appropriation that is central to thinking about the everyday.

1 [footnote 78 in source] Queneau, 'Une Facilité de Pensée', *Oeuvres complètes*, I (Paris: Gallimard, 1989) 422.

2 [79] Certeau, *L'Invention du quotidien*, I (Paris: Union générale d'éditions, 1980; revised edition, Paris: Gallimard, 1990) 173.

3 [80] Bourdieu, *Esquisse d'une théorie de la pratique* (Paris: Éditions Seuil, 2000) 273.

4 [81] Certeau, *L'Invention du quotidien*, I, 96.

5 [82] Ibid., I, xl.

6 [83] Ibid., I, xxxvi.

7 [84] Perec, *Je suis né* (Paris: Seuil, 1990) 51–66, *passim*.

8 [85] Cf. Gratton and Sheringham, Introduction, *The Art of the Project* (Oxford: Berghahn Books, 2005).

9 [86] Julio Cortázar and Carol Dunlop, *Les Autoroutes de la cosmoroute, ou un voyage intemporel Paris–Marseille* (Paris: Gallimard, 1983).

10 [87] Cf. Maspero's 'Postface 1993' in the English translation of *Les Passagers*. For a discussion of Maspero and Cortázar see Charles Forsdick, 'Projected Journeys: Exploring the Limits of Travel', in Gratton and Sheringham, eds, *The Art of the Project*, op. cit., 51–65.

11 Rolin, *Zones*, 37. On Rolin see Catherine Poisson, 'Terrains vagues: *Zones* de Jean Rolin', *Nottingham French Studies*, vol. 39, no. 1 (Spring 2000).

12 See Michael Sheringham, 'Checking Out: Sophie Calle's *L'Hôtel* and the Investigation of the Everyday', *Contemporary French and Francophone Studies*, vol. 10, no. 4 (December 2006) 415–24.

13 Perec, *Penser/Classer* (Paris: Hachette, 1985) 23.

Michael Sheringham, extract from 'Configuring the Everyday', *Everyday Life: Theories and Practices from Surrealism to the Present* (Oxford: Oxford University Press, 2007) 386–91.

I clean the room and start to read his diary. His handwriting is poor, heavy, irregular. I re-read his remarks about Venice: 'Sunday 15 February 1981. We arrived in Venice this morning. We took the train. It is really spectacular. No cars, just pretty little streets and small bridges over the canals. We sat outside and had drinks of various strange things. We went back to the hotel. I am in a tiny room by myself. Ran out and bought a kilo of oranges and apples and put them on my windowsill. We went out and had a very good walk. I ate a good soup, noodles with tomato sauce, and drank a lot of white wine. Went to Piazza San Marco, had a grappa. Made me feel not too good. Went back to Hotel C. I slept a bit. Rob and I went strolling. Stayed at a bar and had a beer. Came back. Rob went up. Got a postcard from the desk and went to hotel bar and had a beer + cig. I wrote a long postcard to Ol. Up to my room, had a bath, ate some oranges and apples, and will crash. I have told the desk to wake me up at 8:30 ...' Sounds in the hallway. I close the diary. As I put it down, someone enters the room. I pick up my rags, my bucket (where my camera and tape recorder are hidden), lower my gaze and leave.

DOCUMENTARY STYLE AND ETHNOGRAPHY

Stanley Brouwn
This Way Brouwn//1961

Stanley Brouwn is standing somewhere on earth. He asks a random pedestrian to show on paper the way to another point in the city. The next pedestrian showns him the way. The 24th, the 11,000th pedestrian shows him the way. This Way Brouwn.

A This Way Brouwn is produced in the time it takes the pedestrian to give his explanation. No second thoughts, no polishing and touching up the result.

The fleet of streets, squares, lanes, etc., is sinking deeper and deeper in a network of This Way Brouwns. All direction is being drained from it. They are leading nowhere. They are already involved, captured in my work. I am concentrating the direction of all possible ways in my work. I am the only way, the only direction. I have become direction.

Stanley Brouwn, statement in *This Way Brouwn. 25.2.61–26.2.61. Zeichnungen 1* (Cologne/New York: Verlag Gebr. König Koln, 1971) n.p.

Tom McDonough
Calling from the Inside: Filmic Topologies
of the Everyday//2007

We must, however, not forget that language has other functions than that of ensuring mutual understanding.
– André Martinet, *Éléments de linguistique générale* (1960)

A small notice appeared in the arts and theatre section of Parisian daily *Le Monde* on Thursday, October 19,1961, announcing the opening of a new film, *Chronique d'un été* (*Chronicle of a Summer*), at the Agriculteurs cinema on the rue d'Athènes, just behind the Gare Saint-Lazare: 'Jean Rouch – author of *Moi, un noir* and *Pyramide humaine* – and Edgar Morin have tried an experiment in '*cinema-verité*' with some Parisians who talk without pretence about their professional and private life. This film won the Critics Award at the last Cannes Festival.'[1] Behind this rather laconic notice lay one of the most widely discussed and influential documentary films of the decade. Ethnologist Jean Rouch, who had gained a

significant reputation over the previous decade for his ever more ambitious films of African life (including the aforementioned *Me, a Black Man* of 1957 and *Human Pyramid* of 1959), joined sociologist Edgar Morin to produce a study of what he called 'this strange tribe living in Paris', turning the ethnographic gaze back upon the metropole at the moment of decolonization. Filmgoers at the Agriculteurs would have seen images shot on the boulevards of Paris, not so different from those in the neighbourhood where they now were sitting, images of other Parisians like themselves, stopped on the street and asked a curiously inchoate question: 'Tell us, are you happy?' *Chronique d'un été* was a film, then, whose subject was everyday life itself, that rather unformed, amorphous daily existence and its imbrication with (or disjunction from) the broader world and the forces of history. As such, it was by no means unique: at the same moment that *Chronique* was being filmed in Paris, Guy Debord was shooting his short film, *Critique de la separation* (*Critique of Separation*), a project he himself described as an 'experimental documentary'[2] He, too, was concerned with investigating everyday life at the ambiguous opening of this new decade, and his film also at least implicitly revolved around the question insistently posed in Rouch and Morin's documentary: Are you happy? But the meaning of this question, and how it ultimately might be answered, differed profoundly from one film to the next; here, in close proximity one with the other, we find two radically differing conceptions of the documentary form, of the possibilities for open dialogue and communication between its subjects, and finally of everyday life itself.

This conjunction of concerns was by no means coincidental: Debord's film was undoubtedly, among other things, a response to *Chronique d'un été*. We can be sure that he was aware of the project, since Morin had originally hoped to enlist Debord's Situationist colleague Asger Jorn in the filming early in October 1960. (The majority of the film had been shot that summer, but Morin evidently wished to include a segment of Jorn in his Paris studio.) This was a wildly naïve request on Morin's part, because at that time the Situationists were engaged in a heated campaign of calumny against *Arguments*, the revisionist journal Morin co-edited along with several other colleagues; given that Debord was derisive of the entire milieu, there was no chance of Jorn accepting the offer. The latter's curt refusal led to a brief but bitter campaign of accusation and counteraccusation between the two groups (revolving, as always, around claims of plagiarism), but what is most significant is the certainty that Debord, at the time he was shooting his *Critique*, was informed of Rouch and Morin's ambition to create, as he described it, 'a film on the everyday life of the French'.[3] And despite his disdain for the latter, one imagines that Debord could not help but have been curious about the planned film, not least because of Rouch's involvement. Although our knowledge of Debord's filmic interests is at best imprecise, his admiration for the

anthropologist-filmmaker is undeniable: next to the films of his Lettrist colleagues, Rouch's cinematic work was the *only* one of the 1950s singled out for praise by the Situationists.[4] [...]

My claim is not merely that Debord knew of *Chronique d'un été*, but that his own 'experimental documentary' can be understood only if we see it as a refutation of this other film and the entire project of which it was a part – as, that is, a radically different vision of documentary and a radically different analysis of 'the everyday life of the French'. Now the idea of a new documentary form was much in the air at the time, not least thanks to the publication in January 1960 of Morin's article 'For a New *Cinema-Verité*', a report on the International Festival of Ethnographic Film held in Florence. Both Morin and Rouch had been members of the jury, and the former's essay seems to have been a development from conversations held at that time. Here the sociologist called for a documentary cinema that would capture 'the authenticity of life as it is lived', or 'the depth of everyday life as it is really lived'.[5] In the past, Morin contended, documentary had ceded these realms to the more sensitive explorations of fictional film, contenting itself with the examination of the individual's milieu, his or her external relations within industrial or agricultural labour, the role of modern technology, the experience of the mass. But now he demanded that documentary 'reinterrogate man [sic] by means of cinema' via the integration of an ethnographic model of participant observation, the filmmaker united in the closest possible contact with his or her subjects. His exemplar of this new *cinema-verité* was Rouch who, 'equipped only with a 16mm camera and a tape recorder slung across his shoulders', had abandoned the heavy appurtenances of the film director and could immerse himself in a given community like a scuba diver exploring some exotic undersea world.[6] It only remained for future explorers to turn this ethnographic eye from African society to the contemporary West, to 'workers, the petite bourgeoisie, the petty bureaucrats ... the men and women of our enormous cities'. What was the aim of this new documentary that wished, as Morin wrote, 'to penetrate beyond appearances, beyond defences, to enter the unknown world of everyday life?' Nothing less than the abolition of separation, 'breaking the membrane that isolates each of us from others in the metro, on the street, or on the stairway of the apartment building'. Documentary would become 'a "cinema of brotherhood"'.[7]

Chronique d'un été was meant to be the realization of this manifesto, what Morin called a 'sociological fresco' of Paris during the summer of 1960, when the Algerian War was believed to be in its final chapter. (The war would, in fact, drag on for two more years.) For its creators the film began as a desire to elucidate the unexplored 'depths' of private life of which Morin had spoken in his *cinema-verité* essay; they would enquire after not only the sociological bases of the private

sphere (housing, work, leisure), but also its existential profundities, 'the style of life, the attitude people have towards themselves and towards others, their means of conceiving their most profound problems and the solutions to those problems', as Morin later described it.[8] The echoes between this programme and that of Henri Lefebvre, the greatest theorist of everyday life as a philosophical category and Morin's close colleague at *Arguments*, are unmistakable. What they both shared was an awareness of the very obscurity of the subject in question; when Lefebvre had returned to write the lengthy foreword to the second edition of his *Critique of Everyday Life* in 1958, he was compelled to confess 'a certain obscurity in the very concept of everyday life. Where is it to be found?' he wrote:

> In work or in leisure? In family life and in moments 'lived' outside of culture? Initially the answer seems obvious. Everyday life involves all three elements, all three aspects. It is their unity and their totality, and it determines the concrete individual. And yet this answer is not entirely satisfactory.[9]

Indeed, Lefebvre's recognition that 'for the historian of a specific period, for the ethnographer, for the sociologist studying a society or a group, the fundamental question would be to grasp a certain quality, difficult to define and yet essential and concrete', could well stand as the coda to *Chronique*, this film which was made precisely through the collaboration of a sociologist and an ethnographer.[10]

Rouch and Morin would evolve certain procedures in order to penetrate that obscurity and access the difficult-to-define quality of everyday life. Notably they sought 'psychoanalytic stimulants' that might enable participants to talk about subjects they would normally be unwilling or unable to discuss. Morin had already broached this question in his 1960 essay, in which he wrote of participants in this new documentary form playing out their lives before the filmmaker in a game that 'has the value of psychoanalytic truth, that is to say, precisely that which is hidden or repressed comes to the surface in these roles'.[11] In *Chronique* both he and Rouch were avowed participants, provocateurs really, challenging their subjects with questions, hoping to precipitate a crisis – sometimes with startling success. The camera acted as a 'catalyst', an 'accelerator', provoking its subjects to reveal themselves under circumstances that, while entirely artificial, were supposed to have the paradoxical effect of bringing hidden truths to the surface. Even contemporary viewers recognized the innovative quality of this approach; *Le Monde*'s film critic noted how the central figures in *Chronique* managed thereby to tackle 'some of the key problems of our time':

> Disgust with an occupational universe become inhuman, and nostalgia for a job 'you could take an interest in'; obsessive fear (in the Jewish woman) of certain

memories; difficulty in accepting a complete sexual freedom; temptation of a peace of mind without responsibility or rebellion in the student; a casual '*difficulté d'être*'; fear of loneliness; a confused wish for love and brotherhood: such are the main themes that can be drawn from this succession of 'spontaneous' confessions.[12]

In the intervening decades, this inscription of the camera into the film text has become banal (if not sinister), but at the time of *Chronique*'s release in 1961 it was nothing short of astonishing (the same reviewer in *Le Monde* spoke repeatedly of the 'shamelessness' of the film and its subjects) and appeared to offer an unprecedented window into the otherwise opaque daily lives of those filmed. The camera became a sort of surrogate analyst or father-confessor, coaxing and sometimes forcing a discourse of truth from its subjects, a technology of vision become a technology of self.

Defenders of Rouch's work have often returned to this conception of the camera as provocateur, as an assertive presence in the filmic event whose role was stressed and which in fact ceased to be a mere technical obstacle (as it was thought to be in most ethnographic filmmaking, which had attempted to hide the work of the camera and microphone) and became instead the primary pretext for the subject's revelation of self.[13] But the status of the technological apparatus in Rouch's film is notably unstable. One of the great myths that grew around *Chronique d'un été* was that of its experimentation with new camera technology: shooting had begun with Raoul Coutard (Godard's cameraman for *À bout de souffle*, 1959, and subsequent films) using a standard Arriflex, but when even this relatively portable 16mm camera proved too bulky, Rouch brought in the Quebecois documentarist Michel Brault, who had extensive experience with handheld camera technology. With the help of a technician at the Eclair camera factory, they were able to use an experimental piece of equipment that was light, silent, highly portable, and outfitted with synch sound (a prototype of the KMT Coutant-Mathot Eclair, originally developed for satellite and military surveillance use). This camera allowed the film crew to operate freely on the streets of Paris, to move about while filming and capture its subjects in the midst of their daily activities: it was the technological basis of this new *cinema-verité*. But this technology, this camera-work, had a paradoxical effect: if the visible presence of the camera had a provocative effect on participants in the film, it was also at the same time curiously invisible. Miniaturization, portability and the like was a means of hiding the work of the camera and microphone, of seeming to restitute the lived in a raw manner and eliminating any intervention of the filmmaker and his technique. Viewers are subject to what has been called a 'natural language' of cinema, in which film is figured as a duplicate of a profilmic 'reality'. This entailed precisely a repression of the work of signification, in favour of 'the preservation of

the homogeneous nature of reality which can be easily and unproblematically rendered visible'.[14] *Chronique d'un été* occupied an uneasy ground between this conception of film as evidence and a recognition of film as text, as in other words a semiotic activity that produced and not merely reflected meaning.

Something of Rouch's ambivalence can be sensed in his attitude toward Dziga Vertov. The term *cinema-verité* was itself an homage to the Soviet filmmaker, a translation of his term *kino-pravda* (film-truth), and discussions of *Chronique* often refer to his *Man with a Movie Camera* (1929) and its reflexive documentary practice as a precedent for the later film.[15] But the alignment of these practices cannot hold: at the most basic level, Vertov's practice had depended crucially on experiments with montage, while Rouch's valorization of the direct transcription of reality could only conceive of montage as a formalist distortion, a dead end. [...]

But just what was this reality that Rouch and Morin set out to 'explore' with the help of their novel documentary techniques, their noiseless mobile cameras and convivial interview style? Perhaps the question is best answered by saying that they conceived reality in essentially Freudian terms. We will recall that Freud had presupposed the existence of two real and unknown worlds – one exterior, the other psychic, interior – and, relying upon Kant, had rejoiced at the conclusion that, of the two, only interior reality stood a chance of being understood.[16] Even if Freud, at the end of his life, would arrive at a rather different conception of this partition of interior-exterior (whereby the psychic apparatus extended into space, and space in its turn was the projection of this apparatus),[17] his work and that of his followers remained encumbered by this ineradicable intuition that psychic life was an inside delimited by a surface (the skin) turned towards exterior reality. Rouch and Morin would adopt an identical perspective, in that *Chronique d'un été* superimposed the topography of the Freudian unconscious on that of the Lefebvrian everyday. Like analysts before their patient, they hoped to coax out the mysteries of this peculiarly social unconscious – the lived experience of Parisians circa 1960. And in fact the difficulties encountered in this project seem to stem from the fact that in order to grasp this fundamentally elusive unconscious, one needed a device that, while external to it, was simultaneously dependent upon and responsive to the conditions of that very internal realm. For Freud this had of course been the psychoanalytic experience itself; for the filmmakers it was the technique of *cinema verité*, with its various 'stimulants' to revelation. Here, in their interviewing methods as in the analytic relation, the two apparently separate worlds interpenetrated in the crossed form of a chiasma joining the subject's desire to that of Rouch and Morin themselves: 'the border is so large that it absorbs the two worlds that it separates.'[18]

The filmstrip marked the frontier of those two worlds: that, on the one hand, of the supposedly neutral scientific researchers behind the camera; and that, on

the other hand, of their subjects, *loci* of everydayness, who are filmed. But as in the analytic experience, that clear topography of interior/exterior was continually troubled by Rouch and Morin's filmic *dispositif*, by their need precisely to break down the boundaries separating investigator from object. Indeed the techniques they pioneered in *Chronique d'un été* unavoidably constructed a filmstrip/border broad enough to encompass both the worlds that the camera had of necessity to separate. But *cinema verité* both summoned forth that confusion, that mutual desire of analyst and analysand, and simultaneously disavowed it: *Chronique*, symptomatically, concluded with a scene of the two filmmakers walking through the Musée de l'Homme and discussing the outcome of the project, reinscribing its authors' status as dispassionate observers and a stable topography of the division of worlds. But to this duality of Freudian realities we might counterpose a Lacanian topology that brings into play rather more precise relations. As J.-D. Nasio has written, 'in place of two realities, it is a question of one alone, uniform, without partition', and it is this psychoanalytic reality that topology tries to take into account.[19]

So Freud's conception of a clash and interference between two worlds and their respective languages is abandoned. That which replaces it is suggested in Lacan's extension and alteration of Plato's allegory of the cave: The place in question is the entrance to the cave, towards the exit of which Plato guides us, while one imagines seeing the psychoanalyst entering there. But things are not that easy, as it is an entrance one can only reach just as it closes (the place will never be popular with tourists), and the only way for it to open up a bit is by calling from the inside.[20]

In other words, it is always closing time at the cave of the unconscious, and the only way of gaining access is to be inside already. In contrast to the clear borderline dividing interior from exterior in Freudian topography, Lacanian topology proposes a cave mouth that more closely resembles a Möbius strip, which has only one side and one surface. Interior and exterior no longer evoke heterogeneous surfaces; rather the opposition between these two 'worlds' has become internal to the circular structure of the topological object itself. Any analysis of the unconscious/everyday must position itself both within and outside this cave, eschewing the simplifying fictions of inclusion/exclusion that govern an earlier Freudian topography. To pursue Lacan's analogy, the representation of the everyday occurs precisely at the mouth of the cave, at which the philosopher/revolutionary attempting to escape meets the psychoanalyst entreating entry: the mouth of the cave, characterized by its rapid opening and shutting ('what we have to account for is a gap, beat, or alternating suction …'),[21] becomes the projector and screen onto which the everyday, the 'unconscious' of official histories, enters into visibility even as it continually

resists formalization. This would be a cinematic topology of the everyday, one that insisted on its own imbrication within the social and psychic structures it set out to represent, as against *cinema verité*'s metaphysical claim of a disinterested observation, premised on a belief in the evidential power of film.

Debord's *Critique de la séparation* opened with a trailer for itself that can only be characterized as a parody of this cinematic language. After images of a still photograph of a girl wearing a bikini [...], a text frame ('Coming soon to this screen'), and a very brief glimpse of newsreel footage of a riot in the Belgian Congo, we are given a rather long travelling shot – apparently filmed out of the window of a car – down the Boulevard Saint-Michel, past the Musée de Cluny and the intersection with the Boulevard Saint-Germain. Debord's cinematographer, André Mrugalski, here made use of camera work that directly recalled that of Raoul Coutard in *À bout de souffle* (as well as, of course, *Chronique d'un été*). [...] Exactly coinciding with this sequence was a voice-over by a woman of the following text, reciting the opening sentence of André Martinet's foreword to his *Éléments de linguistique générale* (1960): 'If we reflect how natural and advantageous it is for man to identify his language with reality, we shall appreciate how high a degree of sophistication had to be reached before he could dissociate them and make of each a separate object of study.'[22] The same voice went on to narrate the credits for the film,, which she described as a 'documentary', while a text frame exclaimed 'REAL characters! An AUTHENTIC story!', before the screen returned to another short segment from the Congo newsreel. This brief introductory sequence to Debord's film was nothing if not a highly condensed critique of the premises of *cinéma vérité* (with all its pretensions to spontaneity, rawness, instinctiveness, sincerity) and of any assumption of film as a 'natural language' with a privileged, indexical relation to reality. The Martinet quote was deployed as an epigraph precisely to indicate the critical relation to be developed here between the film-text and pro-filmic 'reality'. Each would become an object of study in this film in which any notion of the 'real' or the 'authentic' would be thrown into radical doubt through, above all else, the volatilization of the meaning of images and text in its use of montage.

If Rouch and Morin had assumed a sort of transparency between their cinematic language and reality, *Chronique d'un été* was underpinned to an even greater degree by the status accorded spoken language, which became its guarantor of truth. Indeed the advances in synch sound technology of which they had taken advantage had allowed the film to be 'about' nothing more than people talking. Yet what struck contemporary viewers was less the dialogue so much desired by the film's two directors – less, that is the moments in which communication might serve, as Martinet put it, 'to establish contact', to allow people 'to enter into relations with one another'[23] – than those points in which

communication broke down and gave way to incomprehension and inexpressibility in 'certain gestures, certain tics, certain stammerings, and above all certain silences'. This same reviewer remarked that 'silences play a large role in *Chronique d'un été*. That of the two Black men learning the reason for the young Jewish woman's tattoo, that of the secretary driven to the point of hysteria, are overwhelming'.[24] It was just these moments of confusion, however, the groping formulations, awkwardnesses and silences of many of the participants in *Chronique*, that – within the economy of *vérité* filmmaking – functioned to anchor the film all the more tenaciously in an objective reality and that attested to its spontaneous, unmediated relation to this truth. For stammering and uncertainty here always operated as a prelude to enlightenment, to the arrival at knowledge, whether of the external world or of oneself; it was always a spur to further speech on the subject's part in an ongoing quest for an objective view. *Critique de la séparation* went further, placing in doubt the authority of its own subject of enunciation, the directorial commentary provided over the image track by the voice of Debord himself. He in fact opened with a confession of his own confusion, 'we don't know what to say', an uncertainty that threatened to leave one mute and that hung, as it were, over the entire film.[25]

This sentiment would be reiterated, the film compared with 'a blurry, drunken vision' (Debord, *Complete Cinematic Works*, 36); at another point Debord admitted on his voice-over that 'none of this is very clear. It is a completely typical drunken monologue, with its incomprehensible allusions and its tiresome delivery. With its vain phrases that do not await response and its sententious explanations. And its silences.' (*CCW*, 35.) A subtitle in the closing moments seemed to capture the exasperation of the viewer subjected to this drunkard's rant: 'I didn't understand all of it.' (*CCW*, 39.) Drunkenness, physical fatigue, the inability to 'find the the right word', all were moments in which the communicative role of language broke down, as Martinet had pointed out in his book on linguistics.[26] Yet this incomprehension, and the silences of *Critique*, differed fundamentally from those of the participants in *Chronique*. If in the latter they had served as evidence for subjects' unconscious (and unself-conscious) display of what they felt, of a kind of emotional truth that appeared unconcerned with the reactions of the film viewers, the structure of Debord's film seemed purposely to foster this sense of bewilderment. A simultaneous use of images, voice-over narration and subtitling throughout the film made it particularly difficult to follow, made any straightforward understanding elusive. And this was hardly inadvertent on Debord's part; such a refusal of transparency has been described by Tom Levin as part of a double-edged '*mimesis of incoherence*', the deliberate staging of confusion as both a refusal of a false and

reductive pseudo-coherence of (narrative) spectacle and as a reflection of the fundamental *incoherence* of the reality of late capitalism.[27] Or, as Debord stated within the film itself, 'the poverty of means is charged with expressing plainly the scandalous poverty of the subject' (*CCW*, 35, translation modified). [...]

1 'Les films nouveaux', *Le Monde* (19 October 1961) 13.

2 [...] [described in] Letter of 10 October 1960 to Patrick Straram; Guy Debord, *Correspondance*, vol. 2 (Paris: Librairie Arthème Fayard, 2001) 24.

3 [...] [described in] Letter of 1 October 1960 to Maurice Wyckaert; Guy Debord, *Correspondance*, vol. 2, 16. See also the account provided in 'Renseignetaents situationnistes', *Internationale situationniste*, 5 (December 1960) 13.

4 See the favourable mention of 'experiments that have remained on the fringe of cinema, like certain films by Jean Rouch, as regards content'. 'Le cinema après Alain Resnais', *Internationale situationniste*, 3 (December 1959) 8. [...]

5 [footnote 6 in source] Edgar Morin, 'Chronicle of a Film', in Jean Rouch, *Ciné-Ethnography*, ed. and translated by Steven Feld (Minneapolis: University of Minnesota Press, 2003) 229; 230 (translation modified).
 Morin's essay 'Pour un nouveau cinema-verité' originally appeared in *France-Observateur*, no. 506 (14 January 1960).

6 [7] Morin, 'Chronicle of a Film', 230.

7 [8] Ibid., 231 (trans. modified).

8 [9] Ibid., 232–3.

9 [10] Henri Lefebvre, Foreword (1958), *Critique of Everyday Life*, vol. 1; trans. John Moore (London and New York: Verso, 1991) 31.

10 [11] Ibid., 7.

11 [12] Morin, 'Chronicle of a Film', 232.

12 [13] Jean de Baroncelli, 'Le cinema: *Chronique d'un été*, *Le Monde* (27 October 1961) 13.

13 [14] [See] Jean-André Fieschi, 'Slippages of Fiction', trans. Tom Milne, in *Anthropology-Reality-Cinema*, ed. Mick Eaton (London: British Film Institute, 1979) 67–77.

14 [15] Mick Eaton, 'The Production of Cinematic Reality', in *Anthropology-Reality-Cinema*, 42.

15 [16] See Jean Rouch, 'Cinq regards sur Vertov', in Georges Sadoul, *Dziga Vertov* (Paris: Éditions Champ Libre, 1971) 11–14. [...]

16 [19] 'We shall be glad to learn, however, that the correction of internal perception will turn out not to offer such great difficulties as the correction of external perception – that internal objects are less unknowable than the external world.' Sigmund Freud, 'The Unconscious' (1915), [...]

17 [20] See in particular his remarks in 'An Outline of Psycho-Analysis' (1940) ('the hypothesis we have adopted of a psychical apparatus extended into space ...') and in 'Findings, Ideas, Problems' (1941) ('Space maybe the projection of the extension of the psychical apparatus. No other derivation is probable. Instead of Kant's *a priori* determinants of our psychical apparatus. Psyche

is extended; knows nothing about it.'). Both in *The Standard Edition* ..., vol. 23, 196; 300.

18 [21] To follow the formulation of J.-D. Nasio, *Les yeux de Laure* (Paris: Aubier, collection 'La psychanalyse prise au mot', 1987) 153.

19 [22] Ibid., 153–4.

20 [23] Jacques Lacan, 'Position of the Unconscious' (1960, rewritten 1964), in *Écrits*, trans. Bruce Fink (London and New York: W.W. Norton, 2005) 711.

21 [24] Ibid., 711.

22 [27] André Martinet, Elements of General Linguistics (1960), trans. Elisabeth Palmer (Chicago: University of Chicago Press, 1964) 11.

23 [28] Ibid., 18.

24 [29] Jean de Baroncelli, 'Le Cinéma: Chronique d'un été', 13.

25 [30] Guy Debord, 'Critique of Separation' (1961) in *Complete Cinematographic Works*, trans. Ken Knabb (Oakland, California: AK Press, 2003) 29.

26 [31] See Martinet, op. cit., 169

27 [32] Thomas Y. Levin, 'Dismantling the Spectacle: The Cinema of Guy Debord', in *Guy Debord and the Situationist International*, ed. Tom McDonough (Cambridge, Massachusetts: The MIT Press, 2002) 358.

Tom McDonough, extract from 'Calling from the Inside: Filmic Topologies of the Everyday', *Grey Room*, no. 26 (Cambridge, Massachusetts: The MIT Press, Winter 2007) 7–14.

Annette Messager
Album//1972–73

The Approaches
At 4 pm on the street, I am always surprised by the indifference of the people crossing each other's paths. Nobody talks to anyone they don't know, to whom they haven't been introduced; only a catastrophe or some incident on the street can momentarily shatter this isolation.

I am attracted to these men who walk past me because I know I will never see them again. From a hiding place, I take some pictures of these strangers passing by, and at home I amass a good deal of enlargements of a single detail, always the same one: the front of the trousers where the zipper closes; but this quite enlarged detail turns strangely indistinct and blurry, even when I very carefully draw over it while pressing down hard on the photo with my pencil.

MY JULIE ...
MY DUCK ...
MY BEAUTY ...
MY SLUT ...
MY PRINCESS ...
MY RAT ...
MY LION ...
MY DOLL ...
MY IDIOT ...
MY WOMAN ...
MY SAUSAGE ...
MY CHICK ...
MY PET ...
MY BELOVED ...
MY LITTLE CHICKIE ...
MY GODDESS ...
MY QUEEN ...
MY JOIE DE VIVRE ...
MY SNORING BITCH ...
MY SUN ...
MY WHORE ...
MY ISLAND BIRD ...
MY LITTLE MADAM ...
MY LIGHT ...
MY DARLING ...
MY ROSE ...
MY GIRLFRIEND ...
MY HOLE ...
MY RABBIT ...
MY HEART ...
MY BOURGEOISE ...
MY CHOUCHOU ...
MY CHICK ...
MY LITTLE URCHIN ...
MY LITTLE LAMB ...
MY CONQUEST ...
MY YOUNG MADAM ...
MY HEART ...
MY DAMSEL ...
MY BEAN POLE ...
MY TART ...
MY ADORED ONE ...
MY DOG ...
MY LITTLE DEVIL ...
MY KITTEN ...
MY JEWEL ...
MY MECHANIC ...

MY SWEET ...
MY WHORE ...
MY PIECE ...
MY GRANNY ...
MY KIKI ...
MY TENDER LITTLE GIRL ...
MY DEAR ...
MY DEMON ...
MY DARLING ...
MY DOE ...
MY TEASE ...
MY GRASSHOPPER ...
MY WILY WOMAN ...
MY OTHER HALF ...
MY WENCH ...
MY OLD LADY ...
MY GIRL ...
MY BEGUINE ...
MY BEAST ...
MY MOMMY ...
MY BITCH ...
MY FLAME ...
MY CREATURE ...
MY MOUSE ...
MY DAMSEL ...
MY STRUMPET ...
MY FEMALE GIGOLO ...
MY SIREN ...
MY PLANT ...
MY CUTIE-PIE ...
MY CHILD ...
MY HEN ...
MY TINY ONE ...
MY HOT BODY ...
MY CHICK ...
MY HOOKER ...
MY HAG ...
MY WITCH ...
MY VIRAGO ...
MY METER ...
MY KID ...
MY SWEETIE
MY GIGOLO
MY BIRD
MY HOLE
MY KID
MY MECHANIC

MY RABBIT
MY CHICK
MY WINCH
MY HEART
MY ADORED-ONE
MY LOVELY
MY URCHIN
MY WHORE
MY SUN
MY DEMON
MY BEGUINE
MY LOVE
MY LOVED-ONE
MY TENDERNESS
MY JEWEL
MY BABY
MY DARLING
MY CAPRICE
MY FLIRT
MY FRIEND,
MY CUPID
MY LAMB
MY LITTLE RAT
MY CUTIE-PIE
MY TEDDY BEAR
MY SWINE ...
CONVOLVULUS
DOUDOU
MY SUNFLOWER
VOLCANO,
MY ELF
WOLF
MY CROCODILE
MY VIOLIN
LOULOU
MY SUN
MY TREASURE
MY FIRST
CANNIBAL
KITTEN
YOUYOU
MY FLAME
BLUE BUTTERFLY
KITTY
KIKI
TOMCAT
BIRD ...

Annette Messager, 'Terms Used for Women', from *Album*, 1972–73

The 45-Year Old Man
She's had it with keeping quiet
today

she would tell him to wear the
grey checked trousers
that she prefers to those he wore yesterday
but that she also likes the ones he was wearing on Tuesday

that, by the way, she found some similar swatches
and that she likes to look at them and touch them sometimes

but that perhaps they can
see each other again tomorrow at
the same time because he seems to be in quite a hurry

that's exactly what she would have told him
if she had spoken to him [...]

The Man with the Striped Sweater
She's had it with keeping quiet
today she would tell him that she has rarely seen eyes
as light as his, with such dark hair

that it gives him a half-child-like
half-serious quite surprising air

that's exactly what she would have told him
if she had spoken to him.

Means of Protection
Tonight I am assembling an entire set of documentation on how to protect
oneself, defend oneself from others:

Alarm bells; numerous, very sophisticated locks; weapons; different
methods to use against people with bad intentions towards me; fire, health and
car insurances.

All alone at home, safe from harm, I am attempting to appropriate the world, and
therefore protect myself from it, by using a ball-point pen, glue, scissors and
some different newspapers and magazines.

The different brochures are titled:
Never fear anyone again
Beware of theft and aggression
Protect yourself from people with bad intentions
Defend yourself
Be the strongest
Never be attacked again
Overcome your fear
Become invincible

Thanks to my file no. 28 I am no longer afraid

Handbook of Everyday Magic during the Month of May 1973
Every morning of the month of May 1973, I write down my first name Annette in black ink and I quickly fold the paper in fours onto my name. I try to discover how my day will turn out through the stain that formed when I unfolded the sheet of paper ...

Tuesday 1 May
Today there is something hanging over me – my name is illegible – like a large dark mass, a bird perhaps. I shouldn't board a plane, I shouldn't walk along pavements.

Wednesday 2 May
Today will be a happy, uneventful day. I can feel confident, no enemies.

Thursday 3 May
Today something or someone new will enter my life. At the top in the centre, a bizarre form. It may be the telephone, it looks like it. News for me.

Friday 4 May
Today the thing at the top: the telephone. Bad news: dark perspectives.

Saturday 5 May
Today, the upside-down bird, the telephone, or the mailman. Good news? Not exactly. 4 horns at the top, 2 ears at the two ends: I don't really understand; beware of everything.

Sunday 6 May
Today I have to wash my hair. This figure with the dark black eyes and the very

elaborate hair is me. I have to put on make-up and take good physical care of myself or else my brain, my head will burst. Bad and dark thoughts. Vacant and joyless gaze.

Monday 7 May
This stain represents my father's brown jacket, he is calling me. The 2 spots on each side tell me that nothing else but this matters today.

Annette Messager, texts from *The Approaches* (1972), *Collection Album no. 8*; *Means of Protection* (1972–73), *Collection Album no. 28*; *Handbook of Everyday Magic during the Month of May 1973* (1973), *Collection Album no. 47*; reprinted in Messager, *Word for Word: Texts, Writings and Interviews*, ed. Marie-Laure Bernadac, trans. Vivian Rehberg (London: Violette Editions/Dijon: Les presses du réel, 2006) 62–3; 104; 140.

Rebecca J. DeRoo
Annette Messager's Images of the Everyday//2006

From 1971 to 1974, Annette Messager created over one hundred notebooks and collection albums in which she pretended to document her daily life. Inside the notebooks, which constituted her first major series, Messager claimed to describe her daily activities and chores, such as caring for children, cooking, shopping and knitting. She drew diagrams with pen and ink and coloured pencils, sometimes pasting in clippings from magazines that she labelled in pen. Beginning in 1973, Messager exhibited her notebooks in horizontal display cases or hung their individual pages on walls of museums. [...]

The notebooks [...] did not emerge from her own private experience or represent an 'individual mythology' of her own creation. Instead, these works had their sources in the home economics and childcare lessons taught to girls in the 1950s and 1960s when they attended primary and secondary school – lessons that have since largely been relegated to the national education archives after decades of struggle by feminist critics of education. [...]

Indeed, Messager's notebooks directly engaged contemporary feminist debates over the teaching of women's domestic tasks, an engagement that explored the problems and possibilities represented by both sides. For example, the page titled *'Le Lavage'* ('Laundry') from her 1974 notebook *Ma Vie pratique* (*My Practical Life)* repeated detailed and didactic textbook instructions on doing

laundry properly. It read: 'To wash a wool garment, I use warm water and a bit of soap. I squeeze the wool but don't scrub it. I rinse it several times, always with water the same temperature. I squeeze the wool and ring it out by hand and lay it flat to dry.' Messager's mechanical repetition of the tasks implied utter immersion in daily routine and clearly related to the strand of feminist thinking that denounced the ways the curriculum trained women into domestic roles. At the same time, the elaboration of the detailed skills and processes learned made visible the value – the intensity of the labour, the care and skill – of the domestic aspects of many women's daily life.

In its more critical mode, Messager's repetition of tasks from the home economics curriculum can be compared to ideas being explored concurrently by the sociologist Luc Boltanski [brother of her partner, the artist Christian Boltanski].[1] Luc Boltanski, like his contemporaries Michel Foucault and Louis Althusser, saw the curriculum as a means for dominant social classes to structure and control students' lives by regulating daily practices.[2] I want to examine this connection at some length here, for it helps to make clearer how her work formed a critique of the ways the curriculum regulated students' daily activities.

Since its inception in the 1880s, the housekeeping curriculum had been promoted by the state as a means for bringing happiness and health to all homes. In his 1969 study, *Prime Education et morale de classe*, Boltanski sought to expose the ideology underlying this codification of housekeeping practices. He argued that the housekeeping curriculum had formed part of a systematic project to regulate the habits of the working classes. In the late nineteenth century, popular opinion characterized the working class as immoral, disorderly and free from collective constraints. In response, educational programmes were organized to teach moral lessons, housekeeping and hygiene, in order to acculturate the working class to the middle-class values of order, work and economy. The schools instilled *enseignement ménager* and *puériculture*, housekeeping and childcare lessons, by teaching rationalized attitudes and practices to be adopted in daily life. Because the familial sphere was considered 'women's domain', these housekeeping courses for girls supplied a means to control the private life of the working classes. The factory and office workday had been timed, organized and rationalized since the nineteenth century, and the housekeeping classes provided a corresponding way to structure the private life of the working classes by regulating domestic labours:

> Not public life which occurs in factories, offices and administration, which for a long time, since the beginning or middle of the [nineteenth] century, has been made uniform, standardized, constricted in space and time, confined in workplaces, delimited by work schedules. What needed to be regulated

henceforth was private life, the multiple activities that are done in the privacy of the home, done behind the walls of individual houses. The 'habitual manners of behaving', [which were] governed by custom, passed on by tradition, had to be replaced by rules.[3]

This structuring of private life was manifest in home economic textbooks, which provided rationally organized chronologies of daily activities, with precise amounts of time allotted for each child-rearing and housekeeping task. Beyond teaching rules of housekeeping, hygiene and childcare, the lessons encouraged students to adopt methods of order and discipline in their daily life. Most importantly, the lessons compelled students to regulate their own behaviour, accomplishing what Boltanski called 'a total transformation of spirit, a peaceful and internal revolution.'[4]

Boltanski's analysis of the home economics and childcare curriculum provides an important perspective on the class-component of education, yet his analysis of women's role in the curriculum is limited. For him, women as homemakers enter into his model simply as the means for transmitting middle-class values to the working class. He does not consider how the home economics classes – because they were taught to and carried out by women – shaped the subjectivity of women in particular.

Messager's work, in contrast, not only enacted the 'rationalization of behaviour' that Boltanski noted, but also showed how women's training shaped their subjectivity. Messager represented the ways in which the behaviours taught in school were internalized at the level of the individual woman and, despite the reality of class differences, became common to some degree to all French women.

Messager's notebook *Ma Vie pratique* (1974) evoked the systematization of daily behaviours that Boltanski observed. [...]

In line with feminists who saw the teaching of home economics as a means of preparing girls for menial roles, *Ma Vie pratique* and *Mes Travaux d'aiguille* enacted ways that the social order was incorporated into individual behaviour. By selecting statements such as 'I must take a shower each day' or labels such as 'my needlework', Messager isolated the moments at which educational directives were absorbed and expressed in the behaviour of the individual. From this perspective, it appeared that women across social classes shared, though unevenly, quotidian experiences that had been perpetuated through the education system for their subjection. At the same time though, grouping together these documents of women's daily hygiene practices, household labours and domestic arts, could be seen to produce a detailed catalogue of

women's work and traditional skills that gave them dignity and respect. Both readings are possible, and in the mid-1970s, both readings would be advanced.

The dual modes of forming a critique and displaying attachment in Messager's work seem particularly crucial coming at a time when traditions were changing due to feminist challenges, and equally significantly, the encroachments of consumer culture. These changes were particularly noteworthy in relation to women's housework. Messager documented this separate and currently modernizing women's culture, which stood in opposition to the promotion of standards of national culture that had been the aim of the education system and the museum. [...]

In contrast to the 'artisanship' and 'culture' of traditional feminine household arts, the contemporary housekeeping techniques promoted by women's magazines were based on acquiring housekeeping gadgets that required no specific skills to operate.

The critic Pascal Lainé's description of feminine culture as a 'local culture' (ironically, one created and perpetuated in part by the national school system) that was in the process of being liquidated by Western modernism, echoed the ethnographic approach to modernizing traditional cultures exemplified by Claude Lévi-Strauss in *Tristes Tropiques*.[5] And like Lévi-Strauss and the ethnographers, anthropologists and museum curators influenced by him, Lainé saw this local culture as a feature to be preserved. Within this framework, Messager's albums can be seen as constructing the kind of archive that would preserve a vanishing women's civilization, making visible the skilled and detailed labour in household work that had frequently gone unnoticed. [...]

One of her albums, *Ma Vie pratique*, for instance, was an encyclopaedic inventory of home economics lessons from the 1950s and 1960s. In the various notebook entries, Messager pretended to document her rigorous methods of housekeeping, health and hygiene, analysing her daily chores in handwritten instructions, and including textbook passages and textbook-style illustrations with bright, diagrammatic colours. For example, 'La Cuisson des aliments', one page from the album, described how to use a pressure cooker and how to cook meat, fish, dried and fresh fruits and vegetables, and represented each method schematically in diagrams. The notes described the health benefits of certain methods. For example: 'Boiled meat is easy to digest. The heat makes the food either softer or harder, and it becomes more savoury and easier to digest, and further, it's sterilized.' In contrast, *Mon Livre de cuisine* (*My Cookery Book*), was filled with *fiches cuisine*, recipe cards published in women's magazines such as Elle in the 1960s and 1970s. These clipped-out cards had a picture of the prepared dish on one side and the simple recipe on the back. Both *Ma Vie*

pratique and *Mon Livre de cuisine* were based on the idea of women as housekeepers and cooks. Yet unlike *Ma Vie pratique*, the recipe cards in *Mon Livre de cuisine* did not promote principles of cooking in careful diagrams, but were simple recipes – often called 'grandma's recipes' in an effort to lend them the aura of tradition – clipped out of magazines and glued into notebooks or copied over word for word. Whereas '*La Cuisson des aliments*' illustrated the steps involved in each task, emphasizing the tradition and science of housekeeping, the recipe cards merely showed the final product, displaying the finished dish in an effort to entice the reader into purchasing the merchandise whose ads appeared on the pages of the magazine. The learning, the detail and the labour represented in *Ma Vie pratique* all vanished into a vision of a ready-to-be-consumed meal. Whereas '*La Cuisson des aliments*' described a number of techniques to be used at the discretion of the housekeeper, the *fiches cuisine* provided a simple, generic model leaving little room for the housekeeper's discrimination, and thus little recognition of her skill. Viewed in this light, Messager's albums would seem to reinforce Lainé's comment that homemaking skills were being effaced and transformed. Where the domestic arts had gained dignity from the rhetoric of health, order and moralistic progress that surrounded their skills, now, it seemed, 'All that remains are "grandma's recipes", produced by the major food companies' – mere publicity for brand-name products.[6] [...]

The role of women's magazines and their advertising in saturating the everyday existence of their readers was not lost on Lefebvre, who noted the rapid influx of American-style commodities in the 1960s in *Everyday Life in the Modern World*.[7] He believed that women's magazines were the perfect object through which to study this transformation of the everyday, because of their intense focus on the new domestic commodities and their promulgation of the step-by-step behaviours needed to use them. The increased repetition and mechanization of household gestures that they displayed, Lefebvre believed, were a quintessential image of the broader restructuring of the everyday in which work and leisure had been so quantified and structured that no room remained for individual creativity, turning people into passive consumers. The consumerist ethic that Lefebvre noted would have profound effects on not only women's practices in the home but also their subjectivities and bodies.

As an example of the influence of this consumer society on subjectivity, Lefebvre described how one day his wife brought home a new laundry detergent and exclaimed, 'This is an excellent product', with her speech and behaviour unconsciously imitating the advertising for the product.[8] The force of this unconscious immersion was a striking example of the difficulty women would

have in attaining a critical perspective on the everyday. Like Lefebvre, Messager explored the way women emulated everyday gestures from the media, but also took the idea further, in *Mes Collections d'expressions et d'attitudes diverses (My Collection of Various Expressions and Attitudes)* to show how even women's emotions had become saturated with these representations. In this series, Messager collected mass-media representations of women and catalogued them by activities or emotional states – 'on the telephone', 'at the beach', 'fatigue', 'sadness', 'fear', 'jealousy', 'happiness', and so forth. The series 'tears', for example, contains highly staged representations of women in distress: one woman holds her head in her hands, another leans her head on folded arms, and another covers her face. In the centre of the page, Messager drew herself in a similarly cliché pose – with her eyes closed, her head thrust back, and one hand held to her forehead. Another series of her '*expressions diverses*' presented photographs of couples embracing, which surrounded various sketches of Messager embracing a man, being kissed by him, and leaning against his shoulder. By portraying herself within these stereotypes, Messager acted out how advertising had influenced her.[9] Yet her drawn activities appear exaggerated and highly unnatural, providing a parody of the stereotypes and rising above the media immersion, signalling a critical perspective that Lefebvre would have thought women could not attain. [...]

1 [footnote 16 in source] Luc Boltanski, *Prime Education et morale de classe* (Paris: Ecole Pratique des Hautes Etudes and Mouton, 1969). Luc Boltanski's book formed part of a larger study directed by Pierre Bourdieu and carried out by the Centre de Sociologie Européenne. Boltanski's approach to the educational establishment as a means of social control was indebted to Michel Foucault's *Birth of the Clinic*. See Michel Foucault, *Naissance de la clinique* (Paris: Presses Universitaires de France, 1963). [...]

2 [17] The other renowned contemporary work on this subject was, of course, that of Louis Althusser, who saw school as one of the ideological state apparatuses that perpetuated the dominant ideology and class divisions; through forming the students' subjectivities, school also accomplished their subjection. Louis Althusser, *Lenin and Philosophy and Other Essays* (New York: Monthly Review Press, 1971 [orig. 1969]).

3 [18] Boltanski, *Prime Education et morale de classe*, 21–2. [...]

4 [19] Ibid., 26. [...]

5 [25] See Claude Lévi-Strauss, *Tristes Tropiques* (1955), trans. John and Doreen Weightman (New York: Modern Library, 1997).

6 [27] Pascal Lainé, *La Femme et ses images*, 23. [...]

7 [30] Henri Lefebvre, *Everyday Life in the Modern World*, 67, 72–4, 85–8.

8 [31] Henri Lefebvre, *Le Temps des méprises* (Paris: Stock, 1975) 34.

9 [32] Whereas Messager's references to the French school curriculum remain more nationally

specific, her explorations of the way mass media representations were internalized by women may be compared more broadly with the work of international artists active in the mid-1970s, such as Cindy Sherman's *Untitled Film Stills*. For an account that emphasizes the similarities of French and American artwork of the 1970s, see Thomasine Haynes Bradford, 'The Relations of American and French Feminism as Seen in the Art of Annette Messager', dissertation, State University of New York at Stony Brook, 2000.

Rebecca J. De Roo, extracts from 'Annette Messager's Images of the Everyday: The Feminist Recasting of '68', in *The Museum Establishment and Contemporary Art: The Politics of Artistic Display in France after 1968* (Cambridge, England: Cambridge University Press 2006) 125; 130; 131–4; 140–2; 144–5; 146–50.

Helen Molesworth
House Work and Art Work//2000

[…] In *Feminism and Philosophy*, Moira Gatens has staged the feminist debate in terms of those who privilege a model of equality and those who think in terms of difference.[1] These terms are analogous to the essentialism/theory split and Gatens astutely problematizes both positions. First, she sets out to dismantle the idea of equality. She argues that the problem with the model of 'equality in the public sphere' is that '… the public sphere is dependent upon and developed around a male subject who acts in the public sphere but is maintained in the private sphere traditionally by women'.[2] […]

These [unpaid domestic] services have become so naturalized that 'clearly, part of the privilege accorded to members of a political body is that their needs, desires and powers are converted into rights and virtues'.[3] In other words, Gatens suggests that the political realm within which women struggle for forms of equality, such as democracy, must be disarticulated, not presumed *a priori* to be a 'neutral' system, except for its inability to grant women equality. The system is founded on inequality; hence 'equality in this context can involve only the abstract opportunity to become men'.[4]

Democracy's dependence upon inequality has been naturalized as the public and private spheres have been used to shore up distinctions and inequities between men and women, particularly in that the private sphere has been 'intricate[ly] and extensive[ly] cross-reference[d] … with the body, passions, and nature'.[5] This critique of equality (as found in much Anglo-American feminist

theory) reveals the wry notion of equality and its symbolic representation in the public sphere to be historically dependent on the unacknowledged (and unequal) labour of the private sphere.[6]

Gatens is also suspicious of the discursive move from equality to difference. Noting that feminist writing and art practice, after freeing itself from the tyranny of nature, took up explorations of female sexuality, she cautions that such a move runs the risk of reducing women's subjectivity to their sexuality. [...] One effect of Gatens' critique is to register the extent to which *both* groups of feminist work explored issues of sexuality to the exclusion of other attributes of subjectivity and also to the exclusion of political philosophy's critique of the role of the private sphere in the democracy-capitalism covenant.

As Gatens problematizes the equality/difference dichotomy through a feminist analysis of political philosophy, so too a similar operation can be performed on the iconic pairing of Mary Kelly's *Post Partum Document* and Judy Chicago's *The Dinner Party*, by considering them in conjunction with Mierle Laderman Ukeles' *Maintenance Art Performances* (1973–74) and Martha Rosler's videos *Semiotics of the Kitchen* (1975) and *Domination and the Everyday* (1978) – works produced around the same time and under similar cultural pressures. Ukeles' and Rosler's work is explicitly concerned with how 'ideologically appropriate subjects' are created, in part, through the naturalizing of unpaid and underpaid domestic labour. By placing the *PPD* and *The Dinner Party* within this expanded interpretive field, labour, particularly domestic or maintenance labour, emerges as a thematic shared by these four artists (as well as many others of the period). The introduction of the problem of such labour leads in turn to a consideration of the relation between public and private, which emerges as a defining issue in the discussion of 1970s art and the legacy of feminism's intervention in it. The problematic of public and private spheres is, of course, present in both *The Dinner Party* and *Post Partum Document*, but the essentialism/theory debate has occluded its importance, disallowing the debate to be framed in terms of a political economy as well as a bodily or psychic one.[7]

In her 1969 'Maintenance Art Manifesto' Ukeles divided human labour into two categories: development and maintenance. She writes:

Development: pure individual creation; the new; change; progress; advance; excitement; flight or fleeing. Maintenance: Keep the dual off the pure individual creation; preserve the new; sustain the change; protect progress; defend and prolong the advance: renew the excitement; repeat the flight.[8]

Ukeles' manifesto insists that ideals of modernity (progress, change, individual creation) are dependent on the denigrated and boring labour of maintenance

(activities that make things possible – cooking, cleaning, shopping, child rearing, and so forth). Incisively, Ukeles does not refer to maintenance as domestic labour, or housework, for it is evident that such labour is not confined solely to the spaces of domesticity. Included in this manifesto was a proposal that Ukeles live in the museum and perform her maintenance activities; while the gallery might look 'empty', she explained that her labour would indeed be the 'work'.[9] Her offer went unaccepted.

In 1973, however, the Wadsworth Athenaeum agreed to the *Maintenance Art Performances*. In *Hartford Wash: Washing Tracks, Maintenance Inside*, Ukeles scrubbed and mopped the floor of the museum for four hours. In *Hartford Wash: Washing Tracks, Maintenance Outside*, she cleaned the exterior plaza and steps of the museum. She referred to these activities as 'floor paintings'. In *Transfer: The Maintenance of the Art Object*, she designated her cleaning of a protective display case as an art work – a 'dust painting'. Normally this vitrine was cleaned by the janitor; however, once Ukeles' cleaning of the case was designated as 'art' the responsibility of the cleaning and maintenance of this case became the job of the conservator. The fourth performance, *The Keeping of the Keys*, consisted of Ukeles taking the museum guards' keys and locking and unlocking galleries and offices, which when locked were subsequently deemed to be works of 'maintenance art'. In each performance Ukeles' role as 'artist' allowed her to reconfigure the value bestowed upon these otherwise unobtrusive maintenance operations, and to explore the ramifications of making maintenance labour visible in public.

Martha Rosler's videos *Semiotics of the Kitchen* and *Domination and the Everyday* also critically engaged the problem of housewifery. In the relatively new medium of video, *Semiotics of the Kitchen* humorously skewered both the mass-media image of the smiling, middle-class, white housewife and theories of semiotics, suggesting that neither was able to provide an adequate account of the role of wife/mother/maintenance provider. Informed by Marxist and feminist critique, *Domination and the Everyday* considers the everyday household labours of women in tandem with global politics. Like the *Maintenance Art Performances*, *Domination* suggests that the domestic chores of cooking and child rearing are not exclusively private but instead that such labours are intimately connected to public events, and furthermore that unpaid and underpaid maintenance labour needs to be thought of as equivalent to other forms of oppression.

What happens if the *Maintenance Art Performance* and Rosler's early video work are insinuated into *The Dinner Party* and *Post Partum Document* binarism, creating a four-way compare-and-contrast? Might such an expanded field allow us to see previously unacknowledged aspects of each of the works? For instance, as well as seeing the stark contrast between Chicago's cunt-based central core imagery and Kelly's pointed refusal to represent the female body, we might also

see that all four artists deal in varying degrees with putatively 'private' aspects of women's lives and experience: motherhood, cleaning, cooking and entertaining. Similarly, as opposed to the intractable contrast between the lush tactile quality of *The Dinner Party* and the diagrammatic aspect of the *Post Partum Document*, we might see the importance of text in each of the works. The women's names that cover the floor and place settings mean that reading is also integral to viewing *The Dinner Party*. Rosler's *Domination and the Everyday* contains a running text at the bottom of the screen and Ukeles' works contain charts, posted announcements, and the 'Maintenance Art' verification stamp. Each artist participated in the assault on the privileged role of vision in aesthetics, as did so many of their 1970s contemporaries. When the binarism is undone we can see that these works were directly engaged with the most 'advanced' artistic practices of the day – Minimalism, performance and conceptual art – and that they were also in the process of forming the practice of institutional critique.[10] This is, again, to insist on the linkages between art informed by feminism and most of the advanced or critical artistic practices of the 1960s and 70s that took as part of their inquiry the institutions within which art is encountered. The artists who worked in this manner – whose work's content was bound up with domesticity or maintenance and its structural relation to the public sphere – have been by and large neglected by the historians and archivists of Minimalism, conceptual art and institutional critique.[11] Their omission was caused not by active suppression but rather a fundamental misrecognition of the terms and strategies they employed. The overtly domestic/maintenance content of such works was read as being equivalent to their meaning. Therefore, little or no attention was paid to these works' engagement with the Duchampian legacy of art's investigation of its own meaning, value and institutionality. What has not been fully appreciated are the ways in which this usually 'degraded' content actually permits an engagement with questions of value and institutioniality that form a critique of the conditions of everyday life as well as art. Hence, when we compare *The Dinner Party, Semiotics of the Kitchen* and *Domination and the Everyday*, and the *Post Partum Document* with Ukeles' explicit feminist address of the museum, we are able to reframe them in such a manner as to see that they were each bound up with a critique of the institutional conditions of art. Among the four artists this critique manifested itself in varying degrees and was shaped by different concerns. There is no denying that Chicago's work may seem to us now the most problematic of the four, in that her work supports a notion of genius and 'artist' in keeping with the ideal model of bourgeois subjectivity offered by the Western art museum. Yet, despite the differences between the works (or because of them), the feminist critique of the institutions of art should no longer be

misrecognized, for its understanding of the relations between 'private' acts and public institutions will reframe the work of contemporaneous figures in the field. Such a comparison will ultimately expand our notion of institutional critique, precisely because the feminist critique differs so markedly from the paradigmatic works of figures such as Marcel Broodthaers, Daniel Buren or Hans Haacke. For as we will see, it insisted on the reciprocity and mutual dependence of the categories of private and public.

Ukeles' performances, by establishing domestic (read private, natural) labour as 'maintenance', help to articulate the structural conditions of the relations between the public and private sphere. It is the 'hidden' and unrecognized nature of this labour that permits the myth that the public sphere functions as a self-contained and independent site, a site devoid of interest (in classic Habermasian terms). However, by staging such labours in the museum, a traditional institution of the bourgeois public sphere, Ukeles' work establishes maintenance labour as a subject for public discussion. [...] But when Ukeles renames domestic labour 'maintenance', she uses ideas and processes usually deemed 'private' to open institutions and ideas usually deemed 'public'. This gesture is in obvious sympathy with the 1970s feminist slogan 'the personal is political' but, more incisively, it supports political philosopher Carole Pateman's contention that 'the public sphere is always assumed to throw light onto the private sphere, rather than vice versa. On the contrary, an understanding of modern patriarchy requires that the employment contract is illuminated by the structure of domestic relations.'[12] In other words, one legacy of feminist criticism is to establish that it is the private sphere that can help us to rearticulate the public sphere, as opposed to the other way around. Ukeles' exposure of this problematic animates the content of labour in both *The Dinner Party* and the *Post Partum Document*, pulling these works away from their more familiar interpretations. [...]

Reading *The Dinner Party* through a hermeneutics of maintenance suggests that the logic of repetition is not exclusively bound to industrial production but exists as well – although with vastly different effects – in the perpetual labours of cooking, eating and cleaning up: the women's work that is never done; work that is conspicuously absent in *The Dinner Party*, effaced as it was by its Minimalist counterparts.[13] And if Minimalism asked its viewers to distinguish what in the room was not sculpture, what in the room constituted institutional space, then *The Dinner Party* potentially asked viewers to articulate what in the room existed in the realm of the private and what belonged in the realm of the public.[14] [...]

It would be *Post Partum Document*, however, that would launch a more thorough critique of conceptual art. Following on Minimalism's investigation of

the public quality of art, much conceptual art sought to replace a spatial and visual experience with a linguistic one, or what has been called 'the work as analytic proposition'.[15] This meant that the art object could be radically de-skilled, potentially democratizing art's production. However, Frazer Ward has argued that while conceptual art 'sought to demystify aesthetic experience and mastery ("Anybody can do that"), [it] maintained the abstraction of content crucial to high modernist art', hence, 'if modernist painting was just about painting, conceptual art was just about art'.[16] Just as Chicago exposed Minimalism's abstract viewer, similarly the explicit content of the *Post Partum Document* complicated conceptual art's hermeticism.[17]

The *Document*'s numerous graphs and charts, in their standardized frames (a repetition that rhymes with Chicago's), represent the labour of child care, labour normally obscured in Western capitalist culture. One effect of the category of the mother as essential and biological is to naturalize this labour, placing it outside of social conditions. (It is telling that the *PPD* emerges around the time of the idea of the 'working mother', as if mothering weren't already a form of work.) Kelly's refusal to image the mother impedes the naturalization of the labour of motherhood (in Gatens' words, 'cross-referenced with the private'). By submitting this labour to the public and social languages of work and science, the *Document* countermands conceptual art's maintenance of abstract relations between public and private realms, revealing its continuation of a modernist paradigm of art for art's sake. (Indeed, if one of the primary responses to modernist painting is 'My kid could do that' or 'What is that crap on the walls?' then Kelly's inclusion of her son's soiled diapers could be seen as a joke at the expense of both conceptual art and modernist painting.) Kelly's inclusion of maintenance labour also functions as an address to the institution of the museum. She has said of the work: 'As an installation within a traditional gallery space, the work subscribes to certain modes of presentation; the framing, for example, parodies a familiar type of museum display in so far as it allows my archaeology of the everyday to slip unannounced into the great hall and ask impertinent questions of its keepers.[18] This 'archaeology of the everyday' permitted Kelly to represent two forms of labour – artistic and domestic – both of which debunk the myths of non-work that surround both forms of reproduction (artist as genius, mother as natural). *PPD* stages the relations between artistic and human creation as analogous, and by doing so interrogates the boundaries between public and private realms of experience. And if one premise of conceptual art is that 'anyone can do it', then Kelly's work suggests that the same is true of the labour of mothering, for to denaturalize such labour is to make it non-gender-specific.

While Chicago and Kelly were extensively engaged with the public discursive

fields of Minimalism and conceptual art, Ukeles' explicit address of the museum makes her work an early instance of institutional critique.[19] By taking the normally hidden labour of the private sphere and submitting it to public scrutiny in the institutions of art, *Maintenance Art* explored the fictional quality of the distinction between public and private. The performances demonstrated that the work of maintenance is neither exclusively public nor private; it is the realm of human activities that serves to bind the two. Ukeles' use of performance – her insistence that her 'private' body perform 'private' activities in public space – seems to suggest that maintenance is a key component of subjectivity. Yet it is one that often goes unrecognized, and instead is naturalized through repetition into the status of 'habit' as opposed to being constitutive of identity. So one effect of Ukeles' performances is to show how institutions such as the museum unconsciously help to maintain 'the category of artistic individuality that emblematizes bourgeois subjectivity' through its suppression of its dependence on the labours that keep the white cube clean.[20] [...]

Rosler is perhaps best known for her two influential conceptual pieces, *The Bowery in Two Inadequate Descriptive Systems* (1974–75) and *Vital Statistics of a Citizen, Simply Obtained* (1977), both of which exposed the limits of representation and imported charged political content into the field of conceptual art. Her early collages and video works are less familiar. Many of these works focused on various aspects of cooking: the disparity between starvation and gourmet meals; the cultural value placed on cooking, and the complicated hierarchies of who cooks and who serves what food. Several works transpose the language of cooking and the language of art, forming a composite that alludes to the similarity between the terms 'artwork' and 'housework'. In all of these early works – be they videos, film scripts or postcard pieces – Rosler frames the conviviality of food as a bodily necessity and pleasure that binds all human beings. Yet lest such commonality give rise to humanist myths (as is the case with Chicago's work) she also casts the production of food as a form of maintenance labour, and hence subject to the inequities of race, class and gender, that cannot be merely swept away under the guise of things 'private' or 'domestic'. Similar to Ukeles' performances in both their rejection of traditional artistic media and their focus on various aspects of maintenance labour, video works such as *Semiotics of the Kitchen* and *Domination and the Everyday* turn a critical eye towards the relations between public and private that shape our daily lives.

Both videos employ various strategies of distanciation, yet, as in Ukeles' performances, such strategies are combined with a sometimes caustic, sometimes slapstick sense of humour. In *Semiotics of the Kitchen*, Rosler stands in a kitchen and names various cooking utensils in alphabetical order and then

mimes their uses ('bowl', she declares, and stirs an imaginary substance). Rosler 'performs' the role of cook as if the stage directions were written by Bertolt Brecht; straight-faced and purged of emotion, she discourages any identification on the part of the viewer. (However, in the background we can see a large book whose binding reads 'MOTHER', suggesting a possible root cause for the character's bizarre behaviour.) The tape also lacks a plot, offering a list instead of a story, further blocking 'normative' identification. A broadly drawn spoof on television cooking shows, the tape further discourages identification in that there is nothing to cook, no recipe to complete, we are not asked to follow along with her activities. Yet Rosler's deadpan delivery is held in humorous relation to her slapstick-like performance of non-existent activities (recalling Charlie Chaplin's *Gold Rush*, Rosler ladles an imaginary liquid and then tosses it over her shoulder; instead of 'slicing' or 'cutting' with the knife, she aggressively stabs at the air). The exaggerated sense of physical labour means that her everyday kitchen gestures border on the calisthenic. The work's humour and deliberate foiling of the maintenance labour of cooking (if the kitchen had any actual food in it the set would have resembled the aftermath of a food fight) recalls Ukeles' slapstick aesthetic. Indeed, to think of the two works in tandem is to heighten the way in which the works are designed in part to provoke an extremely ambivalent response on the part of the viewer. Should we giggle or shudder at the trapped quality of Rosler's slightly maniacal home cook? Do we laugh knowingly at Ukeles' 'door paintings', with their explicit evocation of the grand painterly gestures of Jackson Pollock, or do we feel a tinge of shame at the public display of a woman who cleans up after us? Responses are rendered ambivalent, in part because both Rosler and Ukeles have combined an aesthetic of identification (traditionally associated with second-wave feminism) with one of distanciation (usually affiliated with poststructuralist feminism); and they have done so, in large measure, by showing us the fault line between things considered private and things considered public.

Rosler deals with this problematic even more rigorously in *Domination and the Everyday*. Self-described as an 'artist-mother's *This is Your Life*',[21] the tape begins with an image of Chilean dictator Augusto Pinochet. The image track quickly becomes layered, as a steady stream of disparate pictures – family snapshots, mass-media advertising, photographs of political leaders and artists – fills the screen. Scrolling along the bottom of the screen is a dense theoretical text analysing the problem of class domination and the relation between those who make culture and those with political power, arguing that 'the controlling class also controls culture'. Deploying a classic strategy of filmic distanciation, the sound and image track are separate. Accompanying this already dense visual field is a similarly doubled soundtrack, as we hear, simultaneously, the real-time

conversation between Rosler and her young son as she readies him for bed, and a radio interview with the famous art dealer Irving Blum.

Here the everyday labour of mothering, of feeding, bedtime stories and cleaning, is laid down next to humanist art discourse, Marxist analysis and the cruel facts of political domination; their polyvalence renders them, if not entirely equivalent, at least impossible to hierarchize. As one track among many, it is hard to privilege the everyday labour of Rosler's mothering, as hard as it is to keep any one of the tracks in focus above the others, as each interrupts, overlaps, synchronizes, and seems incommensurate with the others. To this end *Domination and the Everyday* does something slightly different from the *Maintenance Art Performances*. Rosler does not isolate the labour in order to show it, nor does she engage the literal public spaces of the museum. Rather, by placing maintenance labour as one competing factor among many, one ingredient among many that blend together to form the everyday, she shows it to be as structuring of our lives as other, seemingly invisible structures – political domination, for instance. For Rosler the question is how to make the connection between the brutal regime of Pinochet and the ideology of first world bedtime stories; how to understand the relays between Irving Blum's blather about the genius of Jasper Johns and the laconic address of mother to child, as she slowly persuades the boy to get ready for bed. What do all these things have to do with one another? The tape insinuates that they are related in our inability not only to recognize them (they are too layered; they compete too steadily for our individuated attention), but further, to draw any meaningful connections between them. A sentence scrolls by: 'We understand that we have no control over big events; we do not understand HOW and WHY the "small" events that make up our own lives are controlled as well.' [...]

While Chicago, Kelly and Ukeles are explicit in their address of more traditionally defined public space. Rosler's work is an early instanciation of the changing parameters of such space, the very de-spatialization of public space. However, while notions of what constitutes the public may shift, the society of the spectacle hardly operates without the structural role of maintenance labour. And Rosler's works make clear that we not only have to value that labour as such, but that one way we might be able to do that is to articulate the relations among and between different forms of dailiness: the everyday for her being an ineluctable mixture of politics, culture and maintenance activities. (This is one way Rosler refuses a fetishization of the everyday as a retreat from politics.) To perform this articulation is to be willing to tear away at the layers and veils of ideology that not only separate people from one another but also render various aspects of daily life radically disjointed. And it is here that the function of maintenance as an activity that forms a bond between public and private realms becomes so important.

Rosler's work refutes the either unknowing or unwilling acquiescence of people to systems of domination, be they ideological, cultural or political. Yet such refusals do not operate strictly in the negative, as *Domination and the Everyday* ends on a decidedly utopian note: 'It is in the marketplace alone that we are replaceable, because interchangeable, and until we take control we will always be owned by the culture that imagines us to be replaceable. The truth, of course, is that NO ONE can be replaced ... but there will always be more of us, more and more of us, willing to struggle to take control of our lives, our culture, our world ... which to be fully human, we must do and we will.'[22]

I have been arguing that the aspect that binds these works together is their concern with the problems of labour and political economy and their address to the public institutions of art. By imposing explicitly domestic or private content (Chicago and Kelly) or by substituting the notion of domestic labour with maintenance labour (Ukeles), or by insisting on the equivalence between maintenance labour and other forms of domination (Rosler), all four artists explore the interpenetration between public and private institutions. [...]

Another aspect that binds these works is that each participates in what Fredric Jameson calls the 'laboratory situation' of art.[23] All four works submit various 'givens' about the way the world works to a type of laboratory experimentation. For instance, the body and perception are questioned by Minimalism; the status of the art object is queried by conceptual art; the medium of video places a strain on both art institutions (in terms of distribution) and the viewer (in terms of expectation); and the regimes of power embedded in the museum are articulated by institutional critique. Yet I would contend that these artists add yet another layer to these 'laboratory experiments', for embodied in each work is a proposition about how the world might be differently organized. Woven into the fabric of each work is the utopian question, 'What if the world worked like this?' Chicago offers us the old parlour game of the ideal dinner party, and suggests that the museum could be a site for conviviality, social exchange and the pleasures of the flesh. Kelly's work intimates the desire for a culture that would bestow equal value on the work of mothering and the labour of the artist; so, too, the work's very existence points towards a different model of the 'working mother'. Rosler images a polyvalent and dialectical world where the demands of work and pleasure, and the seeming separation between culture and domination, are held in a constant tensile relation to one another. Ukeles' work, again, may be the most explicit in its utopian dimension, its literalness a demand beyond 'equal time equal pay' or the 'personal is political', for hers is a world where maintenance labour is equal in value to artistic labour – a proposition that

would require a radically different organization of the public and private spheres.

Feminism has long operated with the power (and limitations) of utopian thought. It is telling, then, that these artists have dovetailed the 'what if' potential of both art and feminism. Yet they have not collapsed the distinction between art and life; rather, they have used art as a form of legitimated public discourse, a conduit through which to enter ideas into public discussion. So while all of the works expose the porosity between public and private spheres, none calls for the dismantling of these formations. Fictional as the division might be, the myth of a private sphere is too dear to relinquish,[24] and the public sphere as a site of discourse and debate is too important a fiction for democracy to disavow. [...]

In *At the Heart of Freedom*, Drucilla Cornell writes: 'There is a necessary aesthetic dimension to a feminist practice of freedom. Feminism is invariably a symbolic project.'[25] It is within the tradition of art as a laboratory experiment that Chicago, Kelly, Rosler and Ukeles engage in speculative feminist utopian thought, each attempting to rearticulate the terms of public and private in ways that might fashion new possibilities for both spheres and the labour they entail. But this is not a call for a utopian field in which all parties agree on the terms of the discourse, decidedly not. While all four artists are bound by their interest in labour, their address to questions of public and private, and their pointed complications of the (now) standard narratives of postwar advanced art practice, they clearly differ in contentious and important ways. While this essay has valorized a moment of obscured affinity, this is not to say that such affinities should be privileged as such. Difference is crucial for utopian thought, in that utopia (like democracy) has the potential to offer discourses marked precisely by disagreement and contestation. [...]

1 [footnote 11 in source] Moira Gatens, *Feminism and Philosophy: Perspectives on Difference and Equality* (Bloomington: Indiana University Press, 1991).

2 [12] Moira Gatens, 'Powers, Bodies and Difference', in *Destabilizing Theory: Contemporary Feminist Debates*, ed. Michelle Barret and Anne Phillips (Stanford University Press, 1992).

3 [13] Gatens, *Feminism and Philosophy*, 138.

4 [14] Ibid., 124–5.

5 [15] Ibid., 122–3.

6 [16] For an elaboration of this argument see Carole Pateman's *The Sexual Contract* (Stanford: Stanford University Press, 1988). [...]

7 [20] Additionally, the essentialism/theory debate may also have restricted feminist discourse to notions of the subject that reside (rhetorically) outside of the dominant structure of capitalism, hence further marginalizing the political potential of feminism, and art that operates within its concerns.

8 [21] For a reprint of Ukeles' *Maintenance Art Manifesto* in full see 'Artist Project: Mierle

Laderman Ukeles Maintenance Art Activity (1973) with responses from Miwon Kwon and Helen Molesworth', *Documents*, 10 (Fall 1997).

9 [22] It is Ukeles' insistence on the structural aspects of everyday maintenance labour, as opposed to a fetishized notion of the 'everyday', that distinguishes her performances from recent practices that merely represent or stage the everyday [...]

10 [23] Griselda Pollock has argued that the 'radical reconceptualization of the function of artistic activity – its procedures, personnel and institutional sites – is the major legacy of feminist interventions in culture since the late sixties.' see Griselda Pollock, 'Painting, Feminism, History', in *Destabilizing Theory*, 155.

11 [24] For instance, no women are discussed in Benjamin Buchloh's 'Conceptual Art 1962–1969: From the Aesthetic of Administration to the Critique of Institutions', *October*, 55 (Winter 1990), although Hilla Becher and Hanne Darboven are mentioned in passing. More recently, Ann Goldstein and Anne Rorimer, in *Reconsidering the Object of Art 1965–1975* (Cambridge, Massachusetts: The MIT Press, 1995) included only eight women out of a total of fifty-six artists. More recently, however, this seems to have changed. For example, Peter Wollen included numerous women artists in the North American section of the 'Global Conceptualism' exhibition.

12 [26] Pateman, *The Sexual Contract*, 144.

13 [28] *The Dinner Party*, it should be noted, is always exhibited accompanied by documentary photographs of the massive groups and collectives of women who worked on the project. In this regard the labour of making *The Dinner Party* is always registered, but in a peripheral, supporting role. *The Dinner Party* effaces the marks of labour within its boundaries, and in so doing presents itself like a traditional museum-oriented art object: the result of creative genius as opposed to manual labour (a distinction that perpetuates the power relations between the artist and those who work in his or her atelier), and, furthermore, the result of *artistic* labour only, not the maintenance labour that supports such labour.

14 [29] See Rosalind Krauss, 'Sculpture in the Expanded Field', *October*, March 1979; reprinted in Krauss, *The Originality of the Avant-Garde and Other Modernist Myths* (Cambridge, Massachusetts: The MIT Press, 1985).

15 [31] Benjamin H.D. Buchloh, 'Conceptual Art 1962–1969', op. cit., 107.

16 [32] Frazer Ward, 'Some Relations between Conceptual and Performance Art', *Art Journal*, 56, no. 4 (Winter 1997).

17 [33] In this light Kelly's *Post Partum Document* can be seen as a direct attack against the conceptual art of someone like Joseph Kosuth, for instance, but not, say, the work of Hans Haacke. However, Kelly's work also does serve to problematize the dominant reception of conceptual art as defined by male artists. For more on the historical context of the *Post Partum Document* see Juli Carson, '(Re)Viewing Mary Kelly's *Post Partum Document*', *Documents*, 13 (Fall 1998).

18 [34] Mary Kelly, *Post Partum Document* (London: Routledge & Kegan Paul, 1985) xvi.

19 [35] I do not want to place these artists so firmly within specific categories that their work is seen to be either only an instance of that 'style' of work, nor do I want to suggest that these 'styles' are in any way internally coherent. Rather, I want to emphasize the ways in which these works are in

conscious and explicit dialogue with the predominant movements of critical art of their period.

conscious and explicit dialogue with the predominant movements of critical art of their period.

conscious and explicit dialogue with the predominant movements of critical art of their period.

20 [36] Frazer Ward, 'The Haunted Museum: Institutional Critique and Publicity', *October*, 73 (Summer 1995) 83.

21 [38] The tape is called this in the descriptive list of Rosler's works found in *Martha Rosler: Positions in the Life World*, ed. Catherine de Zegher (Birmingham, England: Ikon Gallery/Vienna: Generali Foundation, 1998).

22 [40] Rosler in *Martha Rosler: Positions in the Life World*, 31.

23 [44] Fredric Jameson, 'Periodizing the 1960s', in *The Sixties without Apology* (Minneapolis: University of Minnesota Press, 1984) 79. Additionally, Martha Rosler has said of her own work: 'Everything I have ever done I've thought of "as if": Every single thing I have offered to the public has been offered as a suggestion of a work ... which is that my work is a sketch, a line of thinking, a possibility.' ('a Conversation with Martha Rosler', in *Martha Rosler: Positions in the Life World*, 31).

24 [45] For more on the importance of privacy, see Drucilla Cornell, *At the Heart of Freedom: Feminism, Sex and Equality* (Princeton: Princeton University Press, 1998). [...]

25 [47] Drucilla Cornell, *At the Heart of Freedom*, op. cit., 24.

Helen Molesworth, extracts from 'House Work and Art Work', *October*, no. 92 (Winter 2000) 75–88; 90–6.

Joseph Kosuth
The Artist as Anthropologist//1975

Part II. Theory as Praxis: A Role for an 'Anthropologized Art'
'The highest wisdom would be to understand that every fact is already a theory.'
– Goethe

1. The artist perpetuates his culture by maintaining certain features of it by 'using' them. The artist is a model of the anthropologist *engaged*. It is the implosion Mel Ramsden speaks of, an implosion of a reconstituted socio-culturally mediated overview.[1] In the sense that it is a theory, it is an overview; yet because it is not a detached overview but rather a socially mediating activity, it is engaged, and it is praxis. It is in this sense that one speaks of the artist-as-anthropologist's *theory* as praxis. There obviously are structural similarities between an 'anthropologized art' and philosophy in their relationship with society (they both depict it – making the social reality conceivable) yet art is manifested in praxis; it 'depicts' *while* it alters society.[2] And its growth as a

cultural reality is necessitated by a dialectical relationship with the activity's historicity (cultural memory) and the social fabric of present-day reality. [...]

7. Because the anthropologist is outside of the culture which he studies he is not a part of the community. This means whatever effect he has on the people he is studying is similar to the effect of an act of nature. He is not part of the social matrix. Whereas the artist, as anthropologist, is operating within the same socio-cultural context from which he evolved. He is totally immersed, and has a social impact. His activities embody the culture. Now one might ask, why not have the anthropologist, as a professional, 'anthropologize' his own society? Precisely because he is an anthropologist. Anthropology, as it is popularly conceived, is a science. The scientist, as a professional, is *dis*-engaged.[3] Thus it is the nature of anthropology that makes anthropologizing one's own society difficult and probably impossible in terms of the task I am suggesting here. The role I am suggesting for art in this context is based on the difference between the very basis of the two activities – what they mean as human activities. It is the pervasiveness of 'artistic-like' activity in human society – past or present, primitive or modern, which forces us to consider closely the nature of art. [...]

9. Artistic activity consists of cultural fluency. When one talks of the artist as an anthropologist one is talking of acquiring the kinds of tools that the anthropologist has acquired – in so far as the anthropologist is concerned with trying to obtain fluency in another culture. But the artist attempts to obtain fluency in his *own* culture. For the artist, obtaining cultural fluency is a dialectical process which, simply put, consists of attempting to affect the culture while he is simultaneously learning from (and seeking the acceptance of) that same culture which is affecting him. The artist's success is understood in terms of his praxis. Art *means* praxis, so any art activity, including 'theoretical art' activity, is praxiological. The reason why one has traditionally not considered the art historian or critic as artist is that because of Modernism (Scientism) the critic and art historian have always maintained a position outside of praxis (the attempt to find objectivity has necessitated that) but in so doing they made culture *nature*. This is one reason why artists have always felt alienated from art historians and critics. Anthropologists have always attempted to discuss other cultures (that is, become fluent in other cultures) and translate that understanding into sensical forms which are understandable to the culture in which they are located (the 'ethnic' problem). As we said, the anthropologist has always had the problem of being outside of the culture which he is studying. Now what may be interesting about the artist-as-anthropologist is that the artist's activity is not *outside*, but a mapping of an internalizing cultural activity in his own society. The artist-as-

anthropologist may be able to accomplish what the anthropologist has always failed at. A non-static 'depiction' of art's (and thereby culture's) operational infrastructure is the aim of an anthropologized art. The hope for this understanding of the human condition is not in the search for a religio-scientific 'truth', but rather to utilize the state of our constituted interaction. [...]

1 The term 'implosion' was originally introduced into our conversation by Michael Baldwin. I refer here to its use by Mel Ramsden in 'On Practice', this issue.

2 This notion of an 'anthropologized art' is one I began working on over three years ago – a point at which I had been studying anthropology for only a year, and my model of an anthropologist was a fairly academic one.
 That model has continually changed, but not as much as it has in the past year through my studies with Bob Scholte and Stanley Diamond (at the Graduate Faculty of the New School for Social Research). While their influence is strongly felt, I obviously take full responsibility for the use (or misuse) of their material within my discussion here.

3 [footnote 5 in source] I must point out here that the Marxist anthropology of Diamond and Scholte is not included in this generalization. Indeed, due to the alternative anthropological tradition in which they see themselves, their role as anthropologists *necessitates* that they be 'engaged'. It is a consideration of their work, and what it has to say about the *limits* of anthropology (and the study of culture) which has allowed me a further elucidation of my notion of the 'artist-as-anthropologist'.

Joseph Kosuth, extract from 'The Artist as Anthropologist', *The Fox*, no. 1 (New York, 1975); reprinted in Kosuth, *Art after Philosophy and After: Selected Writings 1966–1990* (Cambridge, Massachusetts: The MIT Press, 1991) 117–24.

Stephen Willats
The Lurky Place//1978

Not far from the busy shopping centre of Hayes in West London, there exists a large, seemingly abandoned, area of land known to the residents of surrounding housing estates as the 'Lurky Place'. Completely hemmed in by various manifestations of institutional society, the Lurky Place is a waste land, isolated and contained. It is this symbolic separation from an institutionalized society that gives the Lurky Place its value for local inhabitants. While the Lurky Place is, of course, actually dependent on society for its existence, the local inhabitants

view it as being outside the norms and stereotypes of everyday life. It has become a territory for pursuits which cannot be undertaken within institutional society, and, as such, is a symbol of a consciousness counter to the dominant authoritative consciousness.

In the work *The Lurky Place*, the waste land is seen as a vehicle for a 'counter-consciousness', which takes the form of self-determined behaviours. The determinism of the dominant culture is inferred in the work by the objects transported into the 'Lurky Place' by people engaging in various pursuits. I photographed these items in situ and used them as triggers for making connections back into the institutionalized society from which they originated and from which they have been freed. The manufacture of an item, and its decomposition in the Lurky Place represent two totally different value structures which – while existing in a state of alienation from each other – are nevertheless linked by a linear path of events through time. The movement of an item from location to location represents a point of change in the way that item's function is perceived. In the linear system: A. Factory, B. Home, C. Lurky Place, three points are represented which transform the perception of an item's function. There can therefore be quite a clear distinction between an item's assumed function in manufacture and its subsequent function in the Lurky Place. The transportation of an item into the Lurky Place represents a fundamental point of transformation. Two types of transformation occur: 1. an article is given a use other than that intended at its manufacture; and 2. the intended use of certain items can only be fulfilled by being freed from the constraining conventions of everyday life. In both cases, the transformation of the item also frees the persons who vest in it changes of function. For these persons, the article becomes an agent for manifesting a consciousness counter to that of the institutional society from which they are escaping. The mundane routines of the day are relieved by pursuits in the Lurky Place, the key to which lies in the transportation of items.

The work is divided into a sequence of four interrelated areas, each of which centres on a point of transformation in the reality of an individual, symbolically represented. This sequence is as follows: education, home, work, culture.

Each state is divided into two parts. The top relates the transported items back to institutional society, represented in the work by such manifestations as a school, tower block, factory and car dump, all located on the edge of the Lurky Place. The bottom part presents the viewer with a problem question in the form of a text relating to the different ways the symbolic individual is involved in various behaviours. A concept frame in both areas of each state holds various representations of the symbolic individual and transported items as variables or cues, related to the problem question. Thus the viewer is presented with a puzzle which can only be solved by entering into the encoded structure of The Lurky

Place and relating cues from both top and bottom together. The action of so doing involves the construction of the consciousness found there. It is the viewers who transport their own references into The Lurky Place in order to attach meaning to the cues in the 'concept frames', thus giving the work its analagous connection to all such contexts which keep alive a counter-consciousness.

Stephen Willats, Statement on *The Lurky Place* (1977–78), in *Stephen Willats: Concerning Our Present Way of Living* (London: Whitechapel Art Gallery/Eindhoven: Stedelijk Van Abbemuseum, 1979) 41.

Susan Hiller
Collaborative Meaning: Art as Experience//1982

[...] *Monument* (1980–81)[1] is an installation. In one sense, this means it is part of the sculpture category. But my work has never been considered part of British sculpture, which does not include installations, unless they are by Richard Long. In England we have this idea about something called 'third area' work, perhaps a way of excluding installations from the 'real' art catagories of painting and sculpture ... What I mean by an installation is something that occupies a site in such a way that objects, spaces, light, distances, sounds – everything that inhabits the site – everything is defined by its relationship to all the other things. So nothing in an installation means anything much except in relationship. It's not that the photographs in *Monument* mean x, the park bench means y, the sound tape means z. It's that the park bench in relationship to the photographs in relationship to the sound tape in relationship to the viewer mean something. I will say, again, that my talking here about this work is about intention, about process as I am aware of it, not about interpretation or meaning, which come along later, and in this sense, as well as its starting-point in a specific set of cultural artefacts, *Monument* is collaborative and collective, as are all art works at the points of reception and origination. All my work points to this, which may be what's distinct about it.

One legitimate way for me to talk about this piece would be anecdotally or autobiographically. So let me point out that the photographs are of ceramic memorial plaques I came across in a park in East London, and that when I returned the next day to take photographs there were people sitting on park benches in front of the plaques eating their lunches, who turned round over

their shoulders to look, as if for the first time, at what I was photographing. And when they had seen the plaques they said things like, 'Oh, isn't it sad. Isn't it dreadful.' But what struck me was that they had sat in front of these things every day having lunch for years and years and the things had been, literally, invisible to them. Only my act of noticing, of photographing, had made them visible. These plaques, like war memorials or tombstones, were designed to address the public, but they don't. Maybe because the ideology they represent is archaic or maybe because our culture simply can't handle being reminded of death in any way; but certainly they were not saying much when I came across them.

It's been pointed out to me often that I take as starting points items of British origin that the British themselves perhaps trivialize or overlook. That's because I am a foreigner, but not so foreign that British culture is unreadable or antagonistic. I probably misunderstand British things quite often, and maybe these misunderstandings provide the why and how of much of my work. On the other hand, I deeply feel that I am doing something like 'writing home' when I work, that I am showing something or telling something to the folks at home at the same time as to the folks in my adopted country. After I had lived in Europe for a few years, much of the time in England, I realized that all the statues and monuments were commemorating people of noble and exalted birth, viscounts, lords, noble generals, etc. Coming from a country that wished in its origins to overthrow all that, and that is replete with monuments to ordinary people who became great, rather than to people born great, I suppose I began to feel very alienated from the urban furniture in England, which as you know is memorials to generals and nobles, statues, park benches with inscriptions.

And these pieces of urban furniture began to become things I simply ignored, or deliberately paid no attention to, since what they obviously commemorated, as a group, was a system of social inequality which located me very negatively, as a woman and a commoner. Of course there is one category or kind of obvious exception to these memorials, and that is the war memorials commemorating soldiers who died in wars, long, long lists of names usually underneath a statue of Victory or Peace or something similar. This is a kind of memorial that one finds in the United States or Canada, of course, and so it was familiar and yet different in the English setting. For a start, these dead soldiers are only names, they are never depicted as individuals, there are no statues of specific ordinary soldiers, though there are a few statues of generic ordinary soldiers. No, this kind of dead hero is only a name, no sculpture depicts what he looked like as an individual. Commemoration in a list seems curiously modest, and doesn't take up much space, compared to all the statues of generals and nobles.

Of course, I wasn't thinking any of this consciously when I came across the memorial plaques in an East London park that commemorated a different kind

of dead hero, heroes who were non-military, civilian, ordinary and local, being all Londoners, ordinary people who had died heroically, men and women. And so I found these plaques riveting, stunning, fascinating. And the next day I returned with a camera to photograph them, not with any specific piece of work in mind, only wanting to have the images as reference points. But the reactions of the people sitting on the park benches became part of my understanding of the memorial plaques, and eventually led to this piece of work called *Monument*, which began for me with discoveries and with contradictions.

The plaques were colourful in themselves, turquoise, blue and green, sometimes stained and beautifully discoloured. They were made of ceramic tiles that had originally been composed on a regular grid, but this had often shifted or become disturbed over the years. They were organized in a long, thin row set into a dark brown stucco wall, a tidy but unfocused arrangement, and it seemed as though more examples could have been added in. As it was, the plaques covered a very specific historical period, and came to an end around World War I. Later I found out the history of the plaques, who had put them up, and why, but in making *Monument* I quite consciously avoided doing any art-historical or social research, and I limited myself to looking at my photographs of the plaques and thinking about them, just as one might work from sketches of a landscape or of a fruit, without knowing the map reference points or the particular type of apple or pear.

Of course, the most obvious appeal was that each plaque sums up an individual act of heroism in a concise and vivid, maybe picturesque way. The turn of phrase is adroit in conjuring up a picture – words are used to evoke images in the mind very clearly. We all feel we can know these people, that is, we can almost see them. I found the little stories sad, bizarre, odd. There was something I didn't understand, but whether it was the materials or my relationship to them wasn't clear. It was at this point that I began to think about making a piece of work, in order to find out something. As always, I had no idea what form the work would finally take.

The steps in making *Monument* seem to me to have followed on from my initial decision to photograph the plaques and from properties in the plaques, in their context, and in photography as a mode of representing. The first act was to organize the photographs on a large piece of paper as though making a study for something, perhaps a painting. I mused a bit about history painting as a genre. From playing with the photographs in various configurations, I arrived at this open cross formation, which I liked because of its symmetry (there were two stylistically distinct sorts of plaques at the site, and I wanted to find a way to incorporate them both), and its other connotations which seemed suitable for the materials. Also, it was a shape made of segments, organized on a rough grid,

like each of the original plaques. It was somewhat irregular, as they had become through time. The stepped edges seemed to suggest that additional units could be added – the shape was not smoothly framed and contained; it was dynamic and open. It was orderly but nonhierarchical. And it was visually very strong. I imagined it big, built up like a wall, each small segment making up units, units making a wall. It would have an almost physical impact, because the photographs would be so illusionistic they would look 'real' … I would make them bigger than the originals, to make them more emphatic. At that stage, I counted the number of photographs I would be able to fit into my configuration, and discovered that there was one for each year of my life. *Monument* was already beginning to be about a kind of self-representation through art, as well as all the other obvious themes enunciated by the material itself.

To be true to the materials as I had found them, I felt it would be appropriate to use words, not as explanation, but as part of the texture of the work. My words, a response to the plaques and to the presentation of them as photographs, would emphasize their words by means of contrast. I began to incorporate my own notes and musings into a kind of meditation on death, heroism, gender and representation – themes immediately evoked by the plaques as I saw them. Class, history, religion, consciousness and definitions of 'life' seemed inevitable detours. What I produced was a non-linear, open-ended series of thoughts, as incomplete and non-hierarchical as the arrangements of individual units in my wall of photographs. My text was left as fragmented and unbounded as the subject-matter, and it was presented as a sound tape to be listened to, privately, on headphones, while sitting on a park bench positioned in front of the wall of photographs. You would, as a viewer, decide whether or not to participate in this closer involvement with the work. You would first look at the photographs, decide whether to accept the invitation to sit down and listen, decide whether or not to engage in a private act of contemplation in public, and even decide whether or not to listen to the entire tape or whether to abandon it at any stage or possibly to rewind and listen to bits over again. When you listened to the tape, you would become temporarily part of the installation, part of the work. You would be very aware of this. You would be seen against a backdrop of representations of dead heroes. You would become aware of the different ways you experienced 'seeing' and 'listening', as well as 'looking at' and 'being looked at'. You would 'see' that you are not a unified subject, and maybe you would see what I saw, which is the unspoken content of the work …

I myself like the discursive, dispersed, non-unified nature of the experience *Monument* provides, in its initial impact. This was quite deliberate on my part, and makes it almost impossible to document. On one level the diffuse construction was a statement against archaic notions of aesthetics, but the piece

certainly doesn't disdain to set the stage on which a non-cognitive, non-discursive, even aesthetic experience might become available.

Reality is provisional. Art is contingent. The self is in fragments. 'I' am not a container for 'consciousness'. By taking these things seriously, I believe it is possible, both ironically and in all sincerity, to approach the viewer with a proposal about the possibility of collaboratively arriving at meanings — by which I mean experiences – that aren't themselves entirely contingent, provisional or fragmented.

1 *Monument* (1980–81). 41 C-type photographic panels, park bench, audio soundtrack, overall
 size (in first British installation) 557 x 670.5 cm.

Susan Hiller, extract from 'Collaborative Meaning: Art as Experience', edited transcript of an improvised lecture, 18 January 1982, in the 'Art Now' series at Nova Scotia College of Art and Design, Halifax, Nova Scotia; reprinted in *Thinking about Art: Conversations with Susan Hiller*, ed. Barbara Einzig (Manchester: Manchester University Press, 1996) 185–92.

Sophie Calle
The Hotel//1984

On Monday 16 February 1981 I was hired as a temporary chambermaid for three weeks in a Venetian hotel.

I was assigned twelve bedrooms on the fourth floor.

In the course of my cleaning duties, I examined the personal belongings of the hotel guests and observed through details lives which remained unknown to me. On Friday 6 March the job came to an end.

Room 25
16–19 February

Monday 16 February, 9 am. I go into Room 25. The only room on the floor with a single bed, and the first one I enter. The sight of the crumpled navy pajamas with the light blue piping left on the bed and the brown leather slippers does something to me. The occupant is a man. There are a few clues by the washbasin: a dirty comb with missing teeth, a toothbrush, toothpaste, and Mennen deodorant. On the table: lime, the *International Herald Tribune*, and a book, *The*

Moon and Sixpence, by W Somerset Maugham, with a marker at page 198. On the windowsill outside are apples and oranges in two paper bags. On the night table I find a hardcover notebook, his travel log. I go through it. 'Friday: Rome … Tuesday: Florence …' and under yesterday's date, these lines: '… arrived in Venice this morning … up to my room, had a bath, a couple of oranges + apples + will crash. I have told the desk to wake me up at 8:30 + will go to the market which Rob says is ex …'. I also find two Paris addresses: Count and Countess M, and Ambassador O. I stop reading. I don't want to take it all in today. I make the bed and leave. It is 9:15 am.

Tuesday 17th, 9:30 am. Today I open the closet. Few clothes, but good-quality ones. Tweeds, woollens … subdued colours: grey, navy, brown. A pair of large white underpants lines the bottom of the drawer. In the corner of the closet, a nearly empty toilet kit. It contains some night cream for pimples, needles and thread inside a lipstick case – I see there is no razor – and a list of clothes he is traveling with. By elimination, that tells me that today he is wearing blue trousers, a blue t-shirt and a windbreaker. I clean the room and start to read his diary. His handwriting is poor, heavy, irregular. I re-read his remarks about Venice: 'Sunday 15 February 1981. We arrived in Venice this morning. We took the train. It is really spectacular. No cars, just pretty little streets and small bridges over the canals. We sat outside and had drinks of various strange things. We went back to the hotel. I am in a tiny room by myself. Ran out and bought a kilo of oranges and apples and put them on my windowsill. We went out and had a very good walk. I ate a good soup, noodles with tomato sauce, and drank a lot of white wine. Went to Piazza San Marco, had a grappa. Made me feel not too good. Went back to Hotel C. I slept a bit. Rob and I went strolling. Stayed at a bar and had a beer. Came back. Rob went up. Got a postcard from the desk and went to hotel bar and had a beer + cig. I wrote a long postcard to Ol. Up to my room, had a bath, ate some oranges and apples, and will crash. I have told the desk to wake me up at 8:30 …' Sounds in the hallway. I close the diary. As I put it down, someone enters the room. I pick up my rags, my bucket (where my camera and tape recorder are hidden), lower my gaze and leave. He is dressed the way I thought; he is about twenty-eight, with a weak face. I will try to forget him.

Wednesday 18th, 9:40 am. He has finished the apples and oranges. The wastebasket is full of peel. He's still on page 198 of Somerset Maugham's book. Nothing has changed in the room. So I have a look inside the bag of dirty laundry hanging on the door, and empty it on the bed. I go back to the diary. Nothing for the 16th. But for the 17th there are these lines: 'Yesterday I walked around. Went to restaurant. Had excellent lasagne. Today we went and had lunch at Harry's Bar

which is supposed to be the best restaurant in the world. And it was good. I had good green noodles with excellent sauce. In the afternoon, went to see Steve McQueen in Italian. I had a beer in a square. Then some guy tried to pick me up. I think I will have a bad dream about it tonight.' And that's it. I also find a postcard addressed to someone named Olivier R (no address). In it the occupant of Room 25 describes in detail the menu of his latest meal.

Thursday 19th, noon. He is gone. He has left his orange peel in the wastebasket, three fresh eggs on the windowsill and the remains of a croissant which I polish off. I shall miss him.

Sophie Calle, extract from *L'Hôtel* (1981); reprinted in Sophie Calle, *L'Hôtel* (Paris: Éditions de l'Étoile, 1984); second edition (Arles: Actes Sud, 1998); trans. in Calle, *M'as-tu vue* (Munich, Berlin, London, New York: Prestel, 2003) n.p.

Paul Auster and Sophie Calle
Double Game//1999

The Rules of the Game (from *Double Game* by Sophie Calle)

In his novel *Leviathan*, Paul Auster thanks me for having authorized him to mingle fact with fiction. And indeed, on pages 60 to 67 of his book, he uses a number of episodes from my life to create a fictive character named Maria. Intrigued by this double, I decided to turn Paul Auster's novel into a game and to make my own particular mixture of reality and fiction.

I. *The life of Maria and how it influenced the life of Sophie.*
In *Leviathan*, Maria puts herself through the same rituals as I did. But Paul Auster has slipped some rules of his own inventing into his portrait of Maria. In order to bring Maria and myself closer together, I decided to go by the book.

II. *The life of Sophie and how it influenced the life of Maria.*
The rituals that Auster 'borrowed' from me to shape Maria are: *The Wardrobe, The Striptease, To Follow …, Suite venitienne, The Detective, The Hotel, The Address Book,* and *The Birthday Ceremony. Leviathan* gives me the opportunity to present these artistic projects that inspired the author and which Maria and I now share.

III. *One of the many ways of mingling fact with fiction, or how to try to become a character out of a novel.*

Since, in *Leviathan*, Auster has taken me as a subject, I imagined swapping roles and taking him as the author of my actions. I asked him to invent a fictive character which I would attempt to resemble. Instead, Auster preferred to send me 'Personal Instructions for SC on How to Improve Life in New York City (Because she asked ...)'. I followed his directives. This project is entitled *Gotham Handbook*.

Gotham Handbook (Paul Auster)

Smiling
Smile when the situation doesn't call for it.

Smile when you're feeling angry, when you're feeling miserable, when you're feeling most crushed by the world – and see if it makes any difference.

Smile at strangers in the street. New York can be dangerous, so you must be careful. If you prefer, smile only at female strangers. (Men are beasts, and they must not be given the wrong idea.)

Nevertheless, smile as often as possible at people you don't know. Smile at the bank teller who gives you your money, at the waitress who gives you your food, at the person sitting across from you on the IRT.

See if anyone smiles back at you.

Keep track of the number of smiles you are given each day.

Don't be disappointed when people don't smile back at you.

Consider each smile you receive a precious gift. [...]

Beggars and Homeless People
I'm not asking you to reinvent the world.

I just want you to pay attention to it, to think about the things around you more than you think about yourself. At least while you're outside, walking down the street on your way from here to there.

Don't ignore the miserable ones. They are everywhere, and a person can grow so accustomed to seeing them that he begins to forget they are there. Don't forget.

I'm not asking you to give all your money to the poor. Even if you did, poverty would still exist (and have one more member among its ranks). At the same time, it's our responsibility as human beings not to harden our hearts. Action is necessary, no matter how small or hopeless our gestures might seem to be.

Stock up on bread and cheese. Every time you leave the house, make three or four sandwiches and put them in your pocket. Every time you see a hungry person, give him a sandwich.

Stock up on cigarettes as well. Common wisdom says that cigarettes are bad

for your health, but what common wisdom neglects to say is that they also give great comfort to the people who smoke them.

Don't just give one or two. Give away whole packs.

If you find your pockets can't hold enough sandwiches, go to the nearest McDonald's and buy as many meal coupons as you can afford. Give these coupons away when you're out of cheese sandwiches. You might not like the food at McDonald's, but most people do. Considering the alternatives, they give pretty good value for money. These coupons will be especially helpful on cold days. Not only will the hungry person be able to fill his stomach, he'll be able to go inside somewhere and get warm.

If you can't think of anything to say when you give the coupon to the hungry person, talk about the weather.

Cultivating a Spot

People are not the only ones neglected in New York.

Things are neglected as well. I don't just mean big things like bridges and subway tracks, I mean the small, barely noticeable things standing right in front of our eyes: patches of sidewalk, walls, park benches. Look closely at the things around you and you'll see that nearly everything is falling apart.

Pick one spot in the city and begin to think of it as yours. It doesn't matter where, and it doesn't matter what. A street corner, a subway entrance, a tree in the park. Take on this place as your responsibility. Keep it clean. Beautify it. Think of it as an extension of who you are, as a part of your identity. Take as much pride in it as you would in your own home.

Go to your spot every day at the same time. Spend an hour watching everything that happens to it, keeping track of everyone who passes by or stops or does anything there. Take notes, take photographs. Make a record of these daily observations, and see if you learn anything about the people, or the place, or yourself.

Smile at the people who come there. Whenever possible, talk to them. If you can't think of anything to say, begin by talking about the weather.

Paul Auster, 'Gotham Handbook. Personal instructions for S.C. on how to improve life in New York City (because she asked)', in Sophie Calle, *Double Game* (London: Violette Editions, 1999); texts reprinted in Paul Auster, *Collected Prose* (London: Faber and Faber, 2003) 285–7.

Abigail Solomon-Godeau
Inside/Out//1994

In her withering critique of the work of Diane Arbus – itself part of a larger thesis about the baleful effects of the photographic colonization of the world and its objects – Susan Sontag argued that certain forms of photographic depiction were especially complicit with processes of objectification that precluded either empathy or identification with the subjects in Arbus' photographs. In producing a photographic oeuvre largely featuring subjects who were physically deviant (e.g., freaks) or those deemed socially deviant (e.g., transvestites, nudists) or even those who through Arbus' singular lens merely looked deviant (e.g., crying babies) and by photographing them in ways that defiantly renounced either compassion or sympathetic engagement, Arbus was indicted as a voyeuristic and deeply morbid connoisseur of the horrible:

> The camera is a kind of passport that annihilates moral boundaries and social inhibitions, freeing the photographer from any responsibility toward the people photographed. The whole point of photographing people is that you are not intervening in their lives, only visiting them. The photographer is supertourist, an extension of the anthropologist, visiting natives and bringing back news of their exotic doings and strange gear. The photographer is always trying to colonize new experiences or find new ways to look at familiar subjects – to fight against boredom. For boredom is just the reverse side of fascination: both depend on being outside rather than inside a situation, and one leads to the other.[1]

Sontag's critique of the touristic and anomic sensibility informing the work of Arbus (a critique that was clearly meant to encompass many other comparable practices) turns, among other things, on the binary couple inside/outside. Sontag in fact closes the paragraph cited above by remarking of Arbus that 'her view is always from the outside'. This binarism, which is but one of a series that underpins much photography theory and criticism, characterizes – in a manner that appears virtually self-evident – two possible positions for the photographer. The insider position – in this particular context, the 'good' position – is thus understood to imply a position of engagement, participation and privileged knowledge, whereas the second, the outsider's position, is taken to produce an alienated and voyeuristic relationship that heightens the distance between subject and object. Along the lines of this binarism hinges much of the debate concerned with either the ethics or the politics of certain forms of photographic

practice. In this respect, Sontag's critique is best characterized as an investigation of the ethics of photographic seeing, whereas Martha Rosler's no less uncompromising critique of traditional documentary practice – I refer here to her 1981 essay 'In, Around and Afterthoughts (On Documentary Photography)' – was structured around an explicitly politicized analysis of how such photography actually functions. 'Imperialism', she wrote, 'breeds an imperialist sensibility in all phases of cultural life',[2] a comment that contrasts interestingly with Sontag's 'Like sexual voyeurism, [taking photographs] is a way of at least tacitly, often explicitly, encouraging whatever is going on to keep on happening.'[3] Thus, where Rosler sees the issue of photographic voyeurism and objectification as a synecdoche of a larger political/cultural totality, Sontag tends to locate the problem in photography itself. Nevertheless, and despite the important difference between the nature of an ethical and a political critique, both Sontag and Rosler are equally aware of the problematic nature of the photographic representation of the other, whether that other is incarnated by the deviant, the freak, the wino, the poor, the racial or ethnic other – the list is obviously endless. And although the inside/outside dichotomy for Sontag pivots on the possibility (or lack) of empathy and identification, and where for Rosler it devolves on issues of power and powerlessness, it is nonetheless significant that from either a humanist or a left perspective, the inside/outside couple is a central theme. Among other things, such a distinction operates to differentiate the kind of practice Rosler calls 'victim photography' and at least one possible alternative – the putative empowerment of self-representation. In other words, where the inside/outside pairing is mobilized with respect to the representation of the other, the operative assumption is that the vantage point of the photographer who comes from outside – the quintessential documentarian, the ethnographer or anthropologist, the tourist armed with Leica, etc. – is not only itself an act of violence and expropriation but is virtually by definition a partial if not distorted view of the subject to be represented.

Without necessarily disagreeing with this characterization I would nevertheless suggest that the terms of this binarism are in fact more complicated, indeed far more ambiguous than they might initially appear. And while there is a perfectly commonsensical way in which we all grasp what is meant by Sontag's description of a photographer being 'outside rather than inside a situation', and the implications thereof, there is yet a stubborn resistance in photography, even a logical incompatibility with these terms. On the one hand, we frequently assume authenticity and truth to be located on the inside (the truth of the subject), and, at the same time, we routinely – culturally – locate and define objectivity (as in reportorial, journalistic or juridical objectivity) in conditions of exteriority, of non-implication.

It is in this context therefore significant that one of the recurring tropes of photography criticism is an acknowledgment of the medium's brute exteriority, its depthlessness, perceived as a kind of ontological limitation rendering it incapable of registering anything more than the accident of appearances. 'Less than ever does a simple reproduction of reality express something about reality', wrote Walter Benjamin (citing Brecht) on a photograph of a Krupp munitions factory.[4] 'Only that which narrates can make us understand', cautions Sontag nearly forty years later. 'The knowledge gained through still photographs will always be some kind of sentimentalism, whether cynical or humanist.'[5]

But if the medium is itself understood – in this virtually ontological sense – to be limited to the superficiality of surface appearance, how then does one gauge the difference between the photographic image made with an insider's knowledge or investment from the one made from a position of total exteriority? If the inside or outside position is taken to constitute a difference, we need to determine where that difference lies. In other words, is the implication (from the Latin, *implicare* – to be folded within) of the photographer in the world he or she represents visually manifest in the pictures that are taken, and if so, how? Are the terms of reception – or, for that matter, presentation – in any way determined by the position – inside or out – of the photographer making the exposure? Does the personal involvement of the photographer in a milieu, a place, a culture, in fact dislodge the subject/object distinction that is thought to foster a *flâneur*-like sensibility? And what exactly is meant by the notion of 'inside' in relation to an activity that is by definition about the capture – with greater or lesser fidelity – of appearance? [...]

In this respect, Ed Ruscha's photographic book works such as *Every Building on the Sunset Strip* (1966) or Dan Graham's *Homes for America* (1965–70) might be considered the degree zero of photographic exteriority, for not only are the photographs themselves exterior views, but they model themselves directly on the impersonality, anonymity and banality of the purely instrumental image. In so far as the former work is structured as an arbitrary inventory, providing nothing other than the external signs of its own parameters, it can be said to thematize the perfect solipsism of the instrumental photograph. In fact, it is precisely this evacuation of subjectivity, the refusal of personality, style – in short, the rejection of all the hallmarks of photographic authorship, no less than the nature of the subject matter itself – that would seem to situate such work logically at the 'outside' pole of photographic practice. It was, furthermore, these very qualities of vernacular photography – its depthlessness, anonymity, banality, and of course mechanical reproducibility – that fostered its widespread use by artists like Ruscha in the first place, and indeed by so many of the artistic generation that succeeded Abstract Expressionism, including Warhol and Richter.

At the other pole of photographic representation is the 'confessional' mode represented by Larry Clark and Nan Goldin, who deploy a photographic rhetoric of lived experience, privileged knowledge, and who declare both rhetorically and visually the photographers' personal stake in the substance of the representations. Such work descends ultimately from art photography to the degree that it affirms the medium's capacity to render subjectivity, whether that of the photographer or that of his or her subjects. Putting aside for the moment discussion of the viability of this claim, it is nevertheless the case that the work of Clark and Goldin raises some of the same issues posed by the work of Diane Arbus, for the subjects of these works are variously outlaws, hustlers, drug addicts, marginals, transvestites, and so forth. However their photographic representations were originally intended or used, they exist now in a nether zone between art and spectacle, on view for the gallery and museum goer, the purchaser of photography books.[6] In contrast, however, to Arbus' manifestly outsider position vis-a-vis many if not most of her chosen subjects, Nan Goldin's *Ballad of Sexual Dependency* (1986) or, more recently, *The Other Side* (1992) are the product of an insider's position:

> People in the pictures say my camera is as much a part of being with me as any other aspect of knowing me. It's as if my hand were a camera. If it were possible, I'd want no mechanism between me and the moment of photographing. The camera is as much a part of my everyday life as talking or eating or sex. The instance of photographing, instead of creating distance, is a moment of clarity and emotional connection for me. There is a popular notion that the photographer is by nature a voyeur, the last one to be invited to the party. But I'm not crashing; this is my party. This is my family, my history.[7]

In both of Goldin's photographic projects we are therefore presented with the residents of her own social and sexual world, and in *The Ballad of Sexual Dependency*, with several images of Goldin herself. She appears, for example, in the jacket photograph, lying in bed and looking at her boyfriend, smoking and seen from the back. She appears in another picture, with battered face and blackened eye, having been beaten by her boyfriend, and in two other instances, photographed in explicitly sexual situations. Although she is not represented in the photographs that constitute *The Other Side*, in her introductory essay she acknowledges her emotional and indeed romantic investment in the drag queens, transsexuals and transvestites who are the work's subject. For all these reasons both *The Ballad of Sexual Dependency* and *The Other Side* can be considered as exemplary of the insider position, one further established by what I have termed the confessional mode – *le coeur mis à nu* (the heart laid bare – Baudelaire).

In the case of the latter project, and by way of examining the terms by which insiderness comes into play, the viewer can readily assume from the content of the images that the photographer is in a position of intimate proximity with her subjects. This is suggested by the depiction of the conventionally private activities of dressing and undressing, bathing, putting on make-up, the apparent physical closeness of the camera itself to its subjects in many of the pictures, and lastly, towards the end of the book, three images of one of the transvestites and a lover in bed together.

But having said this, how does the insider position – in this instance, that of someone who has lived with the subjects (i.e., the pictures from the 1970s, taken in Boston); who loves and admires them; who shares their world – determine the reception of these images or even the nature of the content? The dressing/undressing images, for example, which could be said to signify effectively the intimacy of the relation between photographer and subject, have a specific valency with respect to cross-dressing and transvestism. In other words, whether or not one considers these to be indicative of identities, roles, masquerades, or 'third genders', the very nature of the entity 'drag queen' or 'transvestite' is predicated on the transforming act of dressing up. To photograph different moments in that transformation from biological male into extravagant fantasy of made-in-Hollywood femininity and glamour is to document a ritual that is itself about exteriority, appearance, performance. For it is, after all, on the level of appearance that drag queens stage their subversive theatre of gender.

In the first grouping of photographs that opens *The Other Side* (those pictures shot in Boston in the 1970s), the intention seems to be to produce – actually to re-produce – the desired personae of the subjects. In this sense, Goldin's insider relationship facilitates her ability to produce the image of the subject's desire – but this is not structurally different from any other photographic collaboration between photographer and model. In fact, certain of the Boston pictures (which are black and white) resemble nothing so much as arty fashion photographs, very much in the style of the period. One would not necessarily think that certain of the portraits – particularly those of the person called 'roommate' – represented anything other than a fragile looking, fine-boned woman. But this too subverts the privilege and authority of the inside position in so far as one confronts what is itself a perfection of simulation. Later in the book (and later chronologically) the style changes – the photographs are now in colour, more informal, more spontaneous looking. It is as though the stylistic referent shifts from art photography to *cinema verité*, and, analogously, the images of the subjects become more revealing, pictured often in various in-between states of physical transformation. Still later in the book, after New York, Paris and Berlin, the action, as it were, moves to Manila and Bangkok, where the

drag queens, transvestites and transsexuals are portrayed in the bars they work at, the revues they perform in, or, in a few instances, *en famille*. Insiderness here, as elsewhere, can thus be seen to be about access and proximity, but whether one can argue a non-voyeuristic relationship in consequence of the photographer's position is another matter entirely.

As with Arbus' photographs of freaks and deviants, the risk is that the subject – irrespective of the photographer's intent – becomes object and spectacle. Where the subjects are in reality so often victimized, marginalized, discriminated against, or even physically attacked – as is the case with drag queens – the political and ethical terms of their representation are inseparable. Goldin may well claim her devotion to and investment in her subjects, but does this mitigate the prurience, or indeed the phobic distaste, so often manifested towards her subjects by the straight world? Does a photographic representation, however sympathetic, of drag queens and transsexuals constitute an effective intervention against the political and ethical problem of homophobia? In any event, it would be naïve to disclaim the nature of most people's interest in photographs of drag queens, and surely part of the fascination of these photographs lies in the uncanniness of gender masquerade itself. Thus, on the one hand, the drag queens who so astonishingly simulate female beauty as to destabilize the very nature of the divide; on the other hand, those who retain – disturbingly – the signs of both sexes, both genders. To the degree, therefore, that the photographer produces a seamless illusion of the subject's successful 'femininity' we are not so far from the photo studio; to the degree that the masquerade is revealed as such, we are in the province of the exposé. In neither case does the camera transcend the exteriority of appearance, nor, for that matter, does it provide an interiorized truth of the subject.

Moreover, to the extent that the very concept of voyeurism entails a sexual stake – in its original, clinical meaning it refers to sexual pleasure derived from looking – the privileged 'look' at subjects who are in fact defined by their sexuality is doubly charged. Although Goldin's lived relationships with her subjects are based on emotional intimacy and personal knowledge, the very presence of a camera as they dress or undress, make love or bathe – instates a third term, even as the photographer wishes to disavow it. ('If it were possible, I'd want no mechanism between me and the moment of photographing. The camera is as much a part of my everyday life as talking or eating or sex.') The desire for transparency, immediacy, the wish that the viewer might see the other with the photographer's own eyes, is inevitably frustrated by the very mechanisms of the camera, which, despite the best intentions of the photographer, cannot penetrate beyond that which is simply, stupidly there. [...]

In considering the ambiguities and contradictions attendant on the insider

position as exemplifed in the work of Goldin [...] we need reckon with the fact that to the extent that such work is 'about' sexual lives or sexual activities it necessarily intersects with the sexuality of the viewer. Indeed, it may well be the case that all photography that deals with sexuality, of whatever stripe, can be located within the workings of the inside, in so far as there is, in fact, no outside of sexuality, no Archimedean point from which either photographer, subject or viewer is disinterestedly positioned. Alternatively, one could as well argue that it is inevitably the case with photography, especially photography that attempts to make visible the operations of subjectivity and sexuality, that it remains fixated on the outside, that it cannot tell what the photographer knows, it cannot reveal a truth of the subject.

Inside or out, one remains confronted with the ethical and political issues posed by Sontag and Rosler, where it is a question of the representation of the other, where the analysis depends on notions of voyeurism and objectification, tourism or imperialism. Certain alternative strategies have in fact emerged within photographic practice, albeit those are found for the most part in galleries and art spaces. One strategy might be described as a form of radical iconoclasm that Rosler herself pioneered (in her photo-text work *The Bowery in two inadequate descriptive systems*). There, the crucial intervention consisted in precisely not representing the men of the Bowery, substituting instead the textual – the verbal lexicon of drunkenness – and photographing the storefronts and doorways of the Bowery strip pointedly evacuated of their resident winos. In refusing to spectacularize the more-than-familiar image of the wino, the Bowery bum, Rosler could be said to have displaced this particular 'social problem' from the register of the visual – the register of appearance – which is mindlessly consumed, to that of the politics of representation. Jeff Wall's use of illuminated Cibachrome light-box installations constitutes another explicitly political practice that takes serious cognisance of the inside/outside problematic. For all their deceptive visual realism, Wall's tableaux are entirely theatrical; calculated *mise-en-scènes* that use actors, locations and directorial strategies.

But where faux realism, simulation or iconoclasm function more or less effectively to counter or obviate the problematics of inside/outside, it is perhaps more to the point to question the validity of the binarism itself. For what is really at issue is the fundamentally unanswerable question of how reality is in fact to be known, and in this respect, the truth claims of photography – always disputed – are now for the most part rejected. In any case, the nature of the debate that turns on the capacity of photography to represent truth or reality obviously depends on the notion that truth or reality are in fact representable. While photographic representation retains its evidentiary or juridical status for purposes of individual identification, police procedure, the courtroom and the

racetrack, the truth status of photography has not fared well in the epoch of postmodernity Thus, if *pace* Althusser, no less than Baudrillard, we are given to understand that reality is always mediated through representational systems, is always in the final instance a question of representation itself, on what basis is photography found less capable of rendering, however imperfectly, the real?

The debate that turns on the adequacy of photographic representation to the demands of the real therefore has several modalities, depending on whether the discursive object is 'photography' – itself an abstraction – or a particular subset – practice – within it. But the binarism of inside/outside only has meaning within the context of particular practices, not as an ontological given. If we are then to consider the possibility that a photographic practice ostensibly premised on insiderness ultimately reveals the very impossibility of such a position in the realm of the visual, might it conversely be the case that a photographic practice that affirms its own implacable exteriority yields a certain truth of its own? [...]

Chantal Akerman's *D'Est* (From the East) is a filmic journey that makes of outsiderness its very structuring principle. Travelling through Eastern Europe in 1991, without linguistic access or, for that matter, any specialized knowledge, Akerman made a film constructed as a series of long looks – pans – at people (mostly women) in their interior spaces; of peasants in the fields; of people in a railroad waiting room; but mostly, seemingly endless tracking shots of people on the street, in queues, in the midst of a snowy Moscow winter. The camera observes, mutely; there is no text, no narration, no explanation, no commentary. There is no sound other than ambient sound, merely this seemingly nonselective and passive outsider's look, scanning landscapes, faces, bodies, postures, gestures. Like Ed Ruscha's laconic photo books, *D'Est* seems to occupy the degree zero of exteriority, but there is produced, nonetheless, a kind of knowledge, a certain kind of truth. It is a truth that is perhaps best characterized as a truth of appearance, which with a sort of principled modesty and discretion refuses 'interpretation' altogether. Akerman's notes, written before and during the making of the film, evidence the same combination of obliqueness and transparency as does the film itself:

> The film would begin in the flowering of summer, in East Germany, then in Poland. Just the look of someone who passes by, someone who does not have total access to this reality.
>
> Little by little, as one presses forward into the country, the summer fades to give way to autumn. An autumn muffled and white, overcast by fog.
>
> In the countryside, men and women nearly lying on the black earth of Ukraine, merging with it, picking the beets. Not far from them, the road rutted by the continuous passage of ramshackle trucks from which escape black fumes.

It is winter and in Moscow, where the film constricts its focus. It will hopefully allow one to perceive something of this directionless world with its postwar atmosphere, where each day gotten through resembles a victory

This may seem terrible and insubstantial, but in the middle of all this, I will show faces, which when they are isolated from the mass, express something yet untouched and often the opposite of this uniformity which sometimes strikes us in the movement of crowds, the opposite of our own uniformity

Without being too sentimental, I would say that these are unspoiled faces which offer themselves; they present themselves as they are, and sometimes erase the sentiment of loss, the world at the edge of the abyss which sometimes seizes us when we cross the East, as I have just done.[8]

This cinematic looking cannot logically be distinguished from the more negative concept of cinematic tourism, and yet, for all that, one does not particularly have the sensation of intrusion and expropriation, the imperialism of representation. What Akerman's film suggests, as do the photographs of Robert Frank, the soul-chilling suburban-scapes of Dan Graham, the neutral inventories of Ed Ruscha, is a way to think about a truth of appearance that without prodding reveals itself to the camera and totally escapes the binary of inside/outside. This runs counter to a cultural bias that maintains a truth behind appearance, a truth always veiled that reflects the philosophical divide between seeming and being. But as Walter Benjamin observed, 'it is a different nature that speaks to the camera than speaks to the eye.'[9] It may well be that the nature that speaks to our eyes can be plotted neither on the side of inside nor outside but in some liminal and as yet unplotted space between perception and cognition, projection and identification.

1 Susan Sontag, *On Photography* (New York: Farrar, Straus & Giroux, 1977) 41–2.

2 Martha Rosler, 'In, Around and Afterthoughts (On Documentary Photography)', in Rosler, *3 Works* (Halifax: Nova Scotia College of Art and Design Press, 1981) 78.

3 Sontag, *On Photography*, 12.

4 Walter Benjamin, 'A Short History of Photography', in *Classic Essays on Photography*, ed. Alan Trachtenberg (New Haven: Leete's Island Books, 1980) 206.

5 Sontag, *On Photography*, 23–4.

6 It is, however, important to signal that the original format of *The Ballad of Sexual Dependency* – the form in which it will be seen at SFMOMA ['Public Information', 1995] – is a slide/audio work involving more than seven hundred images. The specific nature of this format, the sound track that organizes, accompanies, and counterpoints the images, the darkness in which the work is viewed by the spectator, the speed with which the images flash by, its temporal, evanescent structure, and lastly, its intentionally 'spectacularizing' form, all decisively distinguish it from the book version of the same project. Nevertheless, in exploring the

modalities of inside/outside, and given my emphasis on the medium of still photography, I have based my discussion of Goldin on the book versions of her projects.

7 Nan Goldin, *The Ballad of Sexual Dependency* (New York: Aperture, 1986) 6.

8 [footnote 12 in source] My translation of unpublished film notes by Chantal Akerman. [...]

9 [13] Benjamin, 'A Short History of Photography', 213.

Abigail Solomon Godeau, extract from 'Inside/Out' in *Public Information: Desire, Disaster, Document* (San Francisco: San Francisco Museum of Modern Art, 1994) 49–55; 58–61.

John Roberts
Mad for It! Philistinism, the Everyday and the New British Art//1996

We all thought we knew what titles of exhibitions should sound like: serious, vaguely poetic, intellectually authoritative. There would be no doubt then that we were in the presence of something significant. Jokes, facetiousness, face-pulling and goofiness were tolerable so long as the act of curatorship and the demands of critical categorisation were not put in jeopardy. Throughout the 1990s, though, we have become familiar with the contra or anti-exhibition title, the title that mocks the assiduousness of theory-led curatorship. These are titles that know no decorum or circumspection, 'in-yer-face' displays of rudery and the pleasures of popular culture and speech. Unembarrassed by a lack of intellectual propriety, they are avowedly anti-professional and disputatious. Those who devised the titles of recent shows such as 'Minky Manky', 'Sick', 'Gang Warfare' and 'Brilliant!' certainly don't want to be thought of as earnest and well-intentioned – this is for art nonces who have spent too much time in the eighties reading Baudrillard and Virilio and 'getting into the critique of identity'. To organize a show today entitled 'Identity, Representation and the Dialogic' would seem as smart and vital a move as Tachism's existential gibberings did to many seventies conceptualists.

The truth is, playing dumb, shouting 'ARSE' and taking your knickers down has become an attractive move in the face of the institutionalization of critical theory in art in the 1980s. The new generation of British artists have perhaps been the first to recognise this, given, I would argue, their privileged exposure in the eighties to the systematic incorporation of contemporary art theory and philosophy into art education, particularly at post-graduate level. This has

created in certain metropolitan centres (specifically London) a crucial awareness of what was needed to move art forward generationally, to take it beyond the radical expectations and conformities of the critical postmodernisms emanating from New York and cultural studies departments of British universities. A younger generation has had to find a way through these congealing radicalisms. For some this has meant the chance to free-wheel and play the *idiot savant*, for others the liberating turn from critical virtue has allowed them to refocus on the theory's underlying social and political realities from a more formally open position. This is why it would be mistaken to identify the new art and its fuck-you attitudinising with anything so simple-minded as the 'depoliticization' of art, as if this generation had hitched itself gleefully to the brutal inanities of the new Lottery Culture. Despite much of the new art's unqualified regard for the voluptuous pleasures of popular culture (drug references and experiences and the arcana of tabloid TV being common denominators), it does not seek to assimilate itself to popular culture in fazed admiration, as if its only ambition was an anti-intellectual release of libidinal energy. Rather, it treats the aesthetically despised categories and pleasures of popular culture – the pornographic, sleazy, abject and trivial – as things that are first nature and commonplace and mutually defining of subjectivity and therefore needing no intellectual introduction into art. This is not a generation of artists who, in utilizing the stereotypes, archetypes, signs and product-images of popular and mass culture, employ them as a means to revivify the content of fine art. After postmodernism, the bridging of the 'great divide' between popular culture and high culture is formally, at least, a dead issue for these artists.

The 'bad behaviour', the journalistic and demotic voicing in the new art, is a way of saying that, as the shared and unexceptional conditions of modern subjectivity, these categories and pleasures do not need to be incorporated into art in order to validate them. From this perspective, the decisive change brought about by this work is a loss of guilt in front of popular culture. In this, the conceptual categories and strategies of critical postmodernism (the spectacle, simulation, the deconstruction of representation and identity) are perceived to have distanced artists from the pleasures and contradictions of the everyday. If all visual experience is subject to the law of 'reification' and all representation is suspect, the representation of the everyday is always being judged as a problem in need of a critique, rather than a site where ideology and its resistance are lived out in all their messy contingency. The critical act of deconstruction makes it difficult for artists to take the truth of their own experience seriously, for it always appears to be invented somewhere else.

There is a way of reading the new art, then, as a generation moving the critique of representation out of the domain of academic reference onto the

'street'. By this I don't mean that artists now are only interested in producing posters or t-shirts or showing in shops – although some notoriously have – but that the culture of art has come to overlap and interfuse with the forms and values of popular culture as a shared culture in new and extended ways. It is as if art has begun to live out its disenchantment with its institutionalization by treating the value of its activities as indistinguishable from the pursuit of everyday pleasures and activities. As with that moment in the late sixties and early seventies when art took itself to be the performative extension of daily living, the new art occupies a 'way of life' within the culture. It is understandable, therefore, why the 'professional' critique of representation pursued by the likes of Victor Burgin, Mary Kelly and Hans Haacke in the seventies and eighties began to appear so censorious to this generation. Such moral strenuousness and the intellectualization of pleasure looked bathetic, gruesome even, the work of bodies at war with themselves despite the sophisticated critique of identity. To note this, in terms of the links between the new art in London and the informal arrangements of the new club culture, is hardly novel, but it is nonetheless pertinent for all that. For what is particularly noticeable about the presentation of much of the new work is how it has set out to transform radically art's forms of attention. If, in the 1970s, the dominant form of art's presentation was the sociological display (Haacke, Kelly), and in the 1980s was the shopping mall or bank foyer (Jeff Koons, Neo-Geo), today artists have looked to a more informal aesthetic that owes something to the domestic and something to the club chill-out zone. In many instances the gallery becomes a kind of 'play-area' in which the work on the walls and floor form part of a kitschy installation or cheesy spectacle. Of course, this informal treatment of the gallery space is nothing new (Fluxus, Jonathan Borofsky, Group Material). But in this case what counts is the maximum entertainment value, the fact that the 'private' moment of encounter with the discrete, individual artwork is disturbed and exposed to a non-aestheticizing milieu. [...]

The working-class philistine may be the excluded disaffirmative presence of art's professional self-ratification, but this does not mean that working-class refusal of art's ratification is the excluded truth of art. This sociological formalism is what is wrong with the post-aesthetic followers of Pierre Bourdieu who take the truth of art to lie solely with its class-exclusions. To denounce the categories of art in the name of a philistine common sense judgement is merely to substitute the non-cognitive realities of the exclusion for the cognitive problems that the realities create. The philistine as proletarian may haunt the conditions of art's production and spectatorship, but the philistine is also necessarily an intra and inter art voice of the excluded. For there are obviously

power relations internal to the institutions and categories of art which make it imperative that art continually judges what passes for dominant critical taste. The philistine, therefore, is also the voice of art's bid for critical autonomy, the voice that recognises the congealing power of dominant academic and aesthetic positions in the name of art's critical renewal and self-definition. As such, the 'philistine' possesses a dialectical identity across the borders of the empirical and discursive. It may be employed to describe a person or persons who exhibit certain insensitivities to art as such, but at the same time it can function differentially, its position shifting depending on what constitutes 'proper' or 'correct' aesthetic behaviour. This is why it is not reducible to an essentialist class position, and at times is forced to take up arms against those who fail to acknowledge the academicization of their own radical self-image.

In these terms, it is very short-sighted to talk about the anti-intellectualism of this new generation of artists just because they are not writing mountains of texts and quoting Fredric Jameson. For there is the unthinking stupidity of the philistine who sees his or her rejection of the dominant discourses of modern art as univocally true and the thinking stupidity of the philistine who sees the rejection of the dominant discourses of art as a matter of ethical positioning. The latter, in my view, underscores the work of Bank and a number of other young British artists (Gavin Turk, Dave Beech, David Burrows). Yet this is not to deny that anti-intellectualism and the celebration of inanity haven't found a sympathetic voice in the new art culture, but that in the hands of some, the dumb-routines, behaving badly and cheesiness have a specific aim: to unsettle the bureaucratic smoothness of critical postmodernism, particularly now it has become the official ideology of our wider digital culture. As the voice of interruption and disaffirmation, the 'philistine' is the parasite on theory and practice and not theory's enemy. This is why the 'philistine' can as easily take on the voice of the intellectual as it can its ventriloquized opposite, as in the case of conceptualism in the early 1970s and neo-conceptualism in the early 1980s.

Is the category of the 'philistine', then, just another way of talking about the positional politics of the avant-garde? At a formal level, perhaps, but if some of the new art adopts a positional cultural politics, it stakes no wider claim on the avant-garde as the bearer of advanced taste outside of a common popular culture. This is why the notion of the philistine has a content today that distinguishes it in important ways from the art of the seventies and eighties. As I touched on, many of the younger British artists do not appropriate the forms, emblems and themes of popular culture in order to intellectualize the pleasures and follies of the popular. This makes the claims of the work very different from, say, John Stezaker's paintings of the late 1970s, and those artists close to the magazine *ZG* in the early eighties. Although Stezaker remains a compelling

figure for Bank — he was included in [their exhibition/installations] 'Cocaine Orgasm' as well as 'Zombie Golf' – Stezaker's critique of modernism via an identification with popular culture has lost its critical tension. Stezaker's appropriation of stills from familiar 1950s films as a commentary on popular culture as the site of Romantic longings has simply become incorporated into what artists know to be true, and not an issue to be foregrounded theoretically. As such, this generation of artists no longer feels it has to justify its illicit pleasures, they no longer feel embarrassed or theoretically self-conscious about incorporating their everyday cultural obsessions and observations into their art. The pleasures and brutalities of the encounter between the body and commodity culture are something they inhabit and work from as a matter of course.

There are two primary causes behind this. The waning of the institutional and intellectual force of modernism, which in the seventies and eighties defined what an art of the 'everyday' should distinguish itself from, and the transformation of popular culture itself as a space of radically expanded subjectivities, pleasures and alternative forms. For example, the cross-over of musics, popular visual traditions, non-traditional kinds of political activism and fashion in contemporary dance culture. As a result, what defines the attitude of the most interesting of the new British artists, particularly some of those working around Bank, is that art and the 'everyday' are two mutually defining components of something bigger: *the ordinariness of culture*. Indicative of this is Gavin Turk's sculptural self-portrait as Sid Vicious and Elvis, an iconic interfusion of the categories of the 'everyday' and the categories of art. In the process, there may be artists who want to ride the bandwagon and assimilate themselves to a passive, post-critical view of the popular, but there are others who see the definition of art as 'ordinary' as an ethical and political challenge. This is why we shouldn't treat the widespread adoption of the pornographic, vulgar and profane in the new art as the coat-tailing of media-sensationalism, but a refusal on the part of artists to feel shame about engaging with the categories of the everyday through the abject. The general effect has not only been a new sensitivity to the brutalizing rituals and tropes of late capitalist mass culture, but also a greater tolerance for the profane and vulgar as forms of working-class dissidence.

It has to be said that this is one of the aspects of the new philistinism that has come in for the strongest amount of criticism: namely, that artists, particularly middle-class artists, are slumming it for egregious effect. Gillian Wearing, for example, has been accused of patronising her subjects in her street-snapshots and videos of popular practices such as air-guitar playing. These criticisms have also been levelled at Sarah Lucas, who, in one well publicized sculpture, invokes the working-class slang of the playground (two fried eggs and

a kebab exhibited on a table) as the basis for an unambiguous take on the gendering of subjectivity, and, in another work, lists in her own hand a non-PC catalogue of popular synonyms for homosexuals. Whatever the truth of the accusation of slumming in the case of Wearing and Lucas, it nevertheless has to be said that there is a great deal of art around that does embrace the pleasures of the philistine for easy effect. But there is nothing wrong with that. For whatever the class origins or critical intentions of the new British artists, there is a refreshing sense that certain modes of critical decorum are being tested, even pulverised into submission. This has acted to release a new candidness about the representation of the quotidian, particularly in the work of women artists. In fact, the increased tolerance amongst women artists for the profane and illicit is perhaps where the voice of the dissonant philistine is at its strongest at the moment. Talking dirty – literally – and showing your bottom for the sheer delight of it has become a proletarian-philistine reflex against eighties feminist propriety about the body. Reinstating the word 'cunt' as a mark of linguistic pride and embracing the overtly pornographic and confessional, have become a means of releasing women's sexuality from the comforts of a 'progressive eroticism' into an angry voluptuousness. A good indication of this is Tracy Emin's unphased presentation of her own sexual history, *Everybody I've Ever Slept With: 1963–1995*. Today this breakdown of bodily rectitude is increasingly evident, as younger artists feel no intellectual insecurity about addressing the spectator as embodied. The title of Bank's 1995 Christmas spectacle 'Cocaine Orgasm' flags this with abandon, even if in logical terms the title is self-contradictory, and there was little evidence of sexual disclosure. But a spirit of bodily excess, intoxication and disordered reason was clearly implied in the snow/cocaine setting (mounds of polystyrene chips) and in some of the better works, particularly Dave Beech's *I'll Teach You Difference*. In a reprise of the proletarian body theme of 'Zombie Golf', Beech photographs himself in a monster mask — at home and in various external locations. Flicking through the slide-projected images, we are presented with a narrative of pleasures taken, fantasies enacted (in one image we see Beech peering from behind a pillar waving a red card, as if sending someone off) and pain suffered.

This takes us onto one of the key areas that unites much of the new art. Although I have singled out mostly three-dimensional work, it is in fact the return to the lens-based document which distinguishes much of the new art's commitment to the ordinariness of culture and the philistine pleasures of the everyday. Beech is one of a number of well known and not so well known artists (Gillian Wearing, Lucy Gunning, Maria Cook, Deborah Holland and Graham Ramsay) who have turned to the photographic document to take their distance from the theoretical categories of critical postmodernism. In the 1980s, under

the impact of psychoanalytic and semiotic critiques of representation, the photographic document was laid to rest as 'primitive', 'objectifying' or worse. Many artists who used photography as a way out of modernism, such as Stezaker and Burgin, also saw documentary photography as an enemy. The result was either a return to some form of montage or the embracing of the studio image. This move against the photographic document produced much interesting work. However, its theoretical claims were based on shaky assumptions. Naturalistic photographs do not just inscribe the voice of the photographer, that is, the power of the photographer to determine the meaning of the image, but also the voices of those who are represented. The theory of photographic objectification fails to recognize the fact that representational positions are locked together in the image; photographs also contain the 'reported speech' of others. In this respect naturalistic photography has an important part to play in sustaining an archival knowledge of the appearance of things and their dialectical relations. Failure to acknowledge this turns photography over to what has been a recurring tendency in modern western culture: iconophobia, or the fear of representation.

A good deal of recent art using photography (whether naturalistically derived staged-images like Beech's or naturalistic imagery itself) has resisted this, seeing the photographic document as an indispensable means of opening up the categories of the everyday. There are, of course, recent precedents for this. Jo Spence and Nan Goldin in the eighties relocated the critical function of the photographic document in art by extending the archival boundaries of domestic photography and the family album. Both Spence and Goldin used the naturalistic domestic image and self-representation as narrative resources for the recovery of the value of their own bodily and emotional experiences. This generation occupy a similar 'story-telling' space. But in this instance they have embraced the document as part of a common culture of domestic representation itself (family snapshots, home videos). There is a sense, then, that the distance this work establishes from the overarching categories of critical postmodernism rests on a familiar and simple move: the turn to what is at hand as a means of reasserting control of the production and distribution of art and the use of photography as a means of documenting and defining an emergent culture. In this, the naturalistic image allows the artist to re-establish his or her place in the spaces of the everyday.

This clearly has echoes of a number of moments within the long narrative of photography and the everyday this century. The turn to 'lived experience' underwrites the very conceptual delineation of the everyday in art. But this does not thereby make the return to the everyday a series of iterations. The everyday is tropological or discursive, not ontological. In this, the social and political

location of the term in the new art not only makes it very different from its use in critical postmodernism, but also very different from its use in Walter Benjamin and Henri Lefebvre, despite the fact that the new art shares an identity with its previous uses as source of art's modernity and critical identity. This is to say that the 'profane illuminations', unofficial truths and deconstructive strategies of photography are neither used nor experienced in the new art in the same kind of way as previously. Thus the return to the document may take its distance from the hypostatization of allegory in critical postmodernism, but it doesn't do this by assuming, as Lefebvre did and many others subsequently, that naturalism is somehow politically progressive. Just as its emphasis on humour and the pleasures of the flesh as well as the abject moves it away from the traumas of the everyday in Spence and Goldin. There are, therefore, broader social and political considerations at stake. The new British art may inhabit the same set of expectations and ideals for an 'art of the everyday' as those before it, but at the same time the work has been produced in a culture where the theoretical validation of such a project is now academically institutionalized, and where the commodification of critical practice as such is now an established fact. When I say this work takes its distance from the categories of critical postmodernism it is also taking its distance from critical postmodernism's bureaucraticization of art's critique of itself. Furthermore this is the first period since before the Russian revolution where the promise of socialism or radical social change has become purely utopian. Whether artists acknowledge this openly or not, the end of 'actually existing communism' in Europe, and the implementation of a new world order has had a profound effect on how the everyday is narrativized. [...]

Is the new art, then, yet another neo-Dada disruption of art's official and academic identity in the name of the anti-aesthetic? Or does it participate in a wider process of change in the culture of art? In so far as the new art takes a certain pride in being gratuitous and facetious, the former appears the most plausible. But the new art is not out to denounce art in the name of the ordinary and everyday; this is not a rerun of the anti-art snobbery of Fluxus for instance. On the contrary, what the new art reflects and participates in is what I would call the increasing popular enculturalization of art, that is, the incorporation of art's production and its forms of attention into a culture of art not immediately governed by professional academic criteria of success. And this essentially is what people identify as the clubby nature of the new London-based art scene. The making of a show or event is part of an informal social network of artists who see the social relations involved in attending to art as being as important as its making. Much of the new work is of course finding its way into normal

circuits of exchange, and as a consequence suffering from the wretched nationalistic trumpet-blowing that attends it. But most of the work still continues to be produced for a localized audience. In itself there is naturally nothing virtuous in this. But it does point to what is one of the determining characteristics of the new culture, fed as it has been by financial necessity: people make and show art in contingent response to circumstances and not out of any idealized or pre-ordered sense of career or abstract sense of struggle. The financial and institutional success of a Damien Hirst remains utterly anomalous for most artists. In fact, it is the widespread reaction against the traditional artistic identity of self-sacrifice and oppositional exclusion that underwrites the informal character of the new art's relations of production and distribution. The net effect of this is the further discrediting of the idea of the Great Artist; this is a culture of the committed but occasional artist. Thus artists move from medium to medium, voice to voice, without worry. In short, what this work reveals is the increasing subsumption of art under the category of the practical. As Sean Cubitt puts it, art today is an 'accumulation of cultural acts, made by thousands', and not the embattled activity of a handful of marginals. With the popular enculturalization of art, therefore, it is inevitable that a distance should open up between the new art and the theoretical strenuousness of the 1980s. For, in many respects, what continues to have theoretical value has been sorted out from what is redundant in a process of cultural assimilation. The theory, so to speak, has been given sensual form.

John Roberts, extract from 'Mad for it: Philistinism, the Everyday and the New British Art', *Third Text*, no. 35 (Summer 1996) 29–31; 34–42 [footnotes not included].

Alison Marchant
Living Room//1998

[...] I simply stood in Holly Street and asked people passing by if they would be interested in giving me their views on the redevelopment [of the housing estate]. I spent a week doing this. I made appointments with interested people and interviewed them in their own homes or in the estate office. Of course, some people walked past thinking I was one of those market research people. But it was the best approach because only two people had responded to the advert I placed in an estate mail-out. [...] Most of the residents I spoke to were not involved in

resident participation committees, only a few were, and so I felt I engaged a diverse group. [...] After the transcription of the cassette tapes, I passed them back to the residents to add and edit as they wished. I had done this before with the oral history parts of the installations: *Shadows* (1988), *Tying the Threads* (1992) and *Turning Keys* (1994). This is an important aspect of all the work I've shown which has included oral history. It's crucial to enable the residents to go over the transcription, alone, for some time, giving them the chance to contemplate what has been said in a private situation, to compare it to that which they wish to be placed in a public situation. The printed word gives realization to that situation, and the fact that they only need to put in print what they want. [...]

Fundamentally my work has been concerned with mapping, excavating and tracking half-forgotten histories. When working-class voices are embodied in the large physical space of installations this enables a huge presence for the viewers to encounter, learn from, or identify with ... depending on their position. The installations become monumental works for hidden histories. Similarly, *Living Room* is small-scale, but also large-scale through its distribution, accessibility and potential audience. The recorded voices are also fixed in print, and have claimed the power of the printed word ... a place which is often denied. [...]

Alison Marchant, extracts from *Living Room* (London: Working Press, 1997) 122; 128.

Richard Wentworth
Statement//2007

[...] I grew up in a world held together with string and brown paper and sealing wax, and that's how it was. I slowly realized that this is the underlying condition of the world, and there's nothing I like more than when, for example, there's been a near-disaster at NASA and they say: 'If it hadn't been for the chewing gum ...' It's not because I want to fetishize chewing gum or the aesthetics of gum pressed over some break or membrane; it's because we have the intelligence to think: 'Hey, there's a malleable, mastic material and we can use that.' A large part of our lives is spent using that very edgy bit of our intelligence [...]

Richard Wentworth, extract from interview with Kevin Henry in Henry, 'Parallel Universes: Making Do and Getting By + Thoughtless Acts (Mapping the Quotidian from Two Perspectives), 2007. http://www.core77.com/reactor/03.07_parallel.asp

Geoff Dyer
Les mots et les choses: Eugène Atget and Richard Wentworth//2001

Artists are always in dialogue with each other-across decades, across centuries. Contemporary artists allude to and are influenced by those that have gone before. Some of the earlier artists no longer have much to say by way of reply but most answer back; some scarcely let you get a word in edgeways, but the best ones are good listeners too. So what kind of conversation is going on here ['Faux Amis' exhibition, 2001] between Eugène Atget and Richard Wentworth? What kinds of things are being said?

The answer to the first question is suggested by the second: this is a conversation about things. Wentworth likes things that don't work. We tend to be oblivious to efficiency so maybe we notice things more when they don't work than when they do. By stopping working a thing becomes – is reincarnated as – something else. This *when is a door not a door?* quality animates a lot of Wentworth's work and thought. It also provides a link with Atget whose pictures were taken up by the Surrealists. Atget himself was famously indifferent to his proximity to the avant-garde, insisting that the photograph on the cover of *La Revolution surréaliste* was used anonymously, explaining to Man Ray that what he made were 'simply documents'. (It is, nevertheless, the 'endless plasticity' of Atget's world that strikes his most perceptive commentator, John Szarkowski.) Wentworth's London might be riddled with the surreal but it's as ordinary as the boots in Atget's shop, hung out like a string of French onions. Perhaps, then, it's best to avoid the word surreal and think in terms of the accidental miraculous, the *when it's ajar* mundane.

A shoe stops being an item of footwear and becomes something to keep a window at bay. We speak of a foot in the door, so why not a shoe in the window? Visual puns and reversals of function and intent hold Wentworth's world together. A cushion lies on the hard shoulder. A bar stool gets all tipsy – but is not as far gone as the chair crashed out in a doorway. This seems to be one of what might be called Wentworth's *object lessons*: when all else fails, things – at the very least – can still get in the way.

Atget and Wentworth would both agree with Joseph Brodsky: 'There's no life without furniture.' Wentworth – who speaks fondly of the 'tired sofa school of English culture' – likes furniture at the end of its life, when it's removed from shop or home and put out to the urban equivalent of grass, i.e., the pavement. Szarkowski considers Atget's picture of the *Intérieur de Mr F., Négociant, Rue Montaigne* to be the 'the best picture of an empty bed made to date'. It is, he

says, a bed 'in which all the world has slept badly'. Maybe so, but it could rest easy in the knowledge that it had a roof over its head. Wentworth caught up with the offspring of this mattress – and others like it – when it was down on its uppers on the Caledonian Road. When people throw stuff out some things fare better in their newly straitened circumstances than others. Used to a life of indolence, a mattress does not have a long shelf life and looks set to get the stuffing knocked out of it. After that it will go quickly to pieces. Not that the bathtub is going to lose any sleep over this. Accustomed to the wet, at home with showers, its own prospects of finding a new position are far more optimistic. As are those of the washbasin standing proud outside a house, unemployed but willing to work (has experience in plumbing).

And then there are the chairs, of course, the empty chairs which – as Szarkowski points out – virtually every photographer after Atget has had a bash at. Wentworth's chairs make the Caledonian Road seem like the promenade of a seaside town so out-of-season they've turned their backs on the view (such as it is). One can only imagine the dismal quality of conversations that were had – and the number of mugs of tea drunk, the Woodbines smoked – in them. Having said that, you could probably have sat out the Blitz on chairs like these. They have a specifically British, stoic quality about them, of people waiting patiently on a doctor whose freedom to dispense spare pairs of spectacles to all and sundry survives as a fading memory of the heyday of the welfare state. [...]

The goods on Wentworth's streets – whether bad or ugly, on display or discarded (displayed, in fact, even when discarded) – are like prophecies in reverse, a part-work story of manufacture, consumption, breakdown and obsolescence. A pile of household cast-offs is a discarded – and, until Wentworth came along, disregarded – history of British manufacturing. These inventories are tilted all the time in the direction of Wentworth's distinctive sensibility. Aesthetically, what he calls an 'involuntary geometry' (it has to rhyme) holds sway More broadly, it is the 'manners' of the street that interest him. Maybe that's why the work in this show feels like an ongoing comedy of manners with things standing in for people. Workers' overalls hang out on a street corner, railing – so to speak – against their redundancy. Or are they peering ghoulishly down at the basement, pondering how things got so slack, how the bottom fell out of the building industry? Or perhaps they're resigned to the fact that, how ever much overtime they put in, it will never add up to what artists like to call a body of work. If Wentworth proceeded in a more rigorous, Atget-like fashion he might have filed this picture in a series called 'Railings'. Viewed in this documentary light, a portion of his work comprises an incidental taxonomy of London's railings. Intended to keep people out, they are, I suppose, domestic equivalents of Atget's *fortifications militaire*. But a familiar Wentworthian

transformation means that they are also a species of spiky Classifieds: Lost, Found, *Un*Wanted. [...]

Wentworth may not photograph people but his world is human, all the more human, for being uninhabited. Szarkowski notes that 'Atget made relatively few pictures of people'. Perhaps only two of Atget's pictures in a hundred feature people as 'significant players'. The number of people with walk-on or drive-by parts in Atget's Paris is further reduced for technical reasons.

I still think that the most interesting thing I ever learnt about photography is that the streets in early photographs of cities are empty because the slow shutter speeds of cameras eliminated moving objects. I've known this for years but it is only now, looking at Atget's traffic- and pedestrian-free zones that the corollary of this makes itself felt: anything that doesn't get 'disappeared' is granted a permanence that is intransigent, palpable, immortal. Atget was deliberately preserving – and catering, partly, to a market that was nostalgic for a Paris poised to disappear in the wake of Haussmannization. Benjamin was right: 'Atget almost always passed by the "great sights and so-called landmarks"; what he did not pass by was a long row of boot lasts.' But-partly due to the exposure times – the things he did photograph become solid, unmoveable, monumental. Clothes become like homes: people don't just wear them, they live in them. Atget's are the opposite of motion pictures. The carts he photographed are going nowhere slowly. The ragpicker in one of his most famous images can strain every muscle of his being and he is never going to drag his load beyond the edge of the frame. Old Paris might be on the way out but Atget's pictures are, so to speak, built to last. To adapt a phrase of Truman Capote's: when Atget photographed something it stayed photographed. It's a very simple, even banal point I want to make: *Atget's baguettes can never look fresh.* Hence their timeless quality.

The only timeless picture, in this sense, that Wentworth has made is of a clock – look, no hands! – in London. Like people who do not wear a watch and thereby get used to telling the time from the city's clocks, shop windows and cash registers, many of his pictures offer oblique visual records of the time, the seasons. He is a diary photographer, jotting down the way things change – and his pictures partake, stylistically, in the transitoriness they depict. The question they ask again and again is 'How long will this be here?' Or, to reduce the exposure time of that sentence: 'Still here, then?' You feel this especially powerfully in the one of a dog leashed not to a railing but to a shoulder bag (which, in London, is synonymous with 'possible bomb'). Everything is provisional, temporary; Or usually it is, anyway. Here today, possibly here tomorrow. From the moment they were made Atget's pictures had about them something of the weight of eternity (unlike the real things, his baguettes will never go stale). Wentworth's pictures, by contrast, have a different kind of

permanence, that of shops which insist that today is 'Last Day of Sale' and, because of that, never close.

This hints also at a difference in their respective attitudes to photography and at the way it has changed over time. Once Atget had settled on photography, it became a vocation, one might almost say his *raison d'être*. In Europe and America at the same time other photographers were also investigating the medium for all it was worth, engaged in a practical and polemical scramble to establish photography as an art. For Wentworth photography is something he does *en route* to somewhere else (the tube station, his studio, his sculptures). It's incidental, something done, quite literally, in passing. Nor does he seem particularly interested in exploring the medium. He's an artist, the camera's been around even longer than Atget's baguettes: of course he knows how to use one.

It goes without saying that the photographs are all the better for this. Modest in outlook, courting neither controversy nor VIP (where P equals photographs) privileges, these are photographs you or I could take.

Except we couldn't, of course. We don't notice the stuff that Wentworth does. We do not, as they used to say – or maybe they still do – have his eye. Robert Musil thought that there was nothing more invisible than a monument.

Oh, but there is: the street you walk down every day. Especially if you live in London with its abundance of bus lanes and chronic shortage of street life. Especially if that street's the Caledonian Road. Wentworth's vision – refined and thoroughly democratised – makes us aware of all the stuff we not only fail to notice but actually edit out in the hurried course of our daily lives. And so, in the spirit of the man who declined the blandishments of the avant-garde – 'These are simply documents I make' – let's end by saying of Wentworth that he makes the Caledonian Road look *interesting*. It could almost be twinned with a street in Paris, ideally one that no longer exists – except in Atget's photographs. [...]

Geoff Dyer, extracts from '*Les Mots et les choses*: Eugène Atget and Richard Wentworth', in *Faux Amis: Eugène Atget/Richard Wentworth*, ed. Kate Bush (London: The Photographers' Gallery, 2001) 9–21.

Aleksandra Mir
Living and Loving # 1: The Biography
of Donald Cappy//2002

[...] I've been working here for a few weeks now, researching this other project for the CCAC Institute, and I've just met this young man, Donald Cappy.

Donald is the Manager of Public Safety here on the CCAC campus where I am staying: we got talking about his life after my first night in town when I thought I was being harassed and my place broken into. Donald grew up in various foster homes: was a punk in his teens; went into the marines; saw 47 nations; had 50 girlfriends; was married; had a child; found the love of his life. She dumped him the day he got a divorce from his wife (Why? 'Because she is a woman'): came back to go to college; dropped out; went into security and bouncing; works the nightclubs where he meets all the stars and manages security at the school where he is buddy with all the staff and the students. Donald is 28 years old. He showed me all his meticulously well kept photo albums and broke everything down for me in detail: The reasons why people take in foster kids and what is expected of you in return; the destroy-and-create economy of punk: the torturous aspects of love and friendship; the logic between swinging when you are married, cheating when you are not; the rituals of the marines and the intimacy between men; the fine line between violence and safety.

Donald's life hinges on everyone else's but this story is his only; the public dissemination of one ordinary man's extraordinary life. I am coming back here at the end of January and will take the opportunity to spend more time with him; record our conversations and scan his photos. I have promised Donald I will make a book about his life one day, so thus extend this opportunity to you. [...]

Aleksandra Mir, extract from the work *Living and Loving #1: The Biography of Donald Cappy* (London: Cubitt Gallery, 2002) n.p.

Roman Ondák
Interview with Hans Ulrich Obrist//2005

Roman Ondák These are all different projects. They're notes of lots of situations – I don't know whether they'll be important for me or not. I do them every day. As I'm reading newspapers or books, I'm making notes or doing small drawings absolutely anywhere and recording experiences in this way. Sometimes I can generate a piece of work from such notes, but I always try to make it something immaterial. For example, I did a project with Slovak Skoda cars, called *SK Parking*.

Hans Ulrich Obrist That was the project for the Secession?

Ondák Yes, it was a collaboration with some of my friends and the owners of the cars. I borrowed a number of them and asked my friends to drive them to the car park behind the Secession in Vienna. We parked the cars and left them there for two months.

Obrist So the cars belonged to your friends, in fact?

Ondák No, the cars were mainly from other people, sometimes from relatives of my friends and so on. The people I borrowed them from were still using them quite often, although they bought them 15 or 20 years ago. These Skodas from the late seventies are still visually very present in Bratislava, but almost completely absent from Viennese streets. It's not easy to cross the border between Slovakia and Austria with this kind of car, and if it reaches the centre of Vienna, it immediately becomes the object of suspicion because everyone associates it with poverty. That's one of the offset prints from an edition I made: twelve postcards called *Antinomads*.

Obrist I remember seeing these cards at Apex in New York.

Ondák Yes, that's right, they were on show there. They also appeared later, along with the cars, in the show (*Ausgetraumt …*) at the Secession. For this project I interviewed all my friends and relatives, perhaps all the people I have some relationship with, asking them questions about their attitudes to travelling in general. All these twelve people had a negative attitude toward travel.

Obrist All of them?

Ondák All of them! I called them 'antinomads' and they agreed to have their photos taken and put on postcards. So I asked them to select a place where they wanted to be photographed, and then I had the shots made into postcards that were given away free to visitors during the exhibition.

Obrist Would you say that notions of speed and slowness play a role in your work? The parked cars piece certainly suggests that slowness might be a factor.

Ondák Yes, that's true. The project was definitely concerned with motion, action and exchange of spaces over time. It was about the potential of space in general: for me the constellation of these cars was like a snapshot of the 'found situation' in Bratislava. Since I physically displaced this snapshot to Vienna, it then led people to think differently about the effects of the action. From time to time other cars would park next to them or behind them, and it was only the Skodas that didn't move, so they also reflected this fixed, motionless situation.

Obrist The other cars moved.

Ondák The cars moved but these didn't, and this was something that passers-by might notice without them necessarily knowing that this was a work of art.

Obrist That's a bit like the time capsule thing, I mean the thing we observed this morning with the guy who operates the lift. It's a similar phenomenon, perhaps.

Ondák Right, this guy in the lift takes you up to the cafe that's in one of the symbols of our utopian architecture of the seventies, a UFO-shaped disc built on two pylons over the Danube bridge, and this elevator is inside one of these pylons. Absolutely nothing about this place has changed since the seventies. So you go up, but at the same time you're going back to the seventies as well. I've often thought about this tiny elevator having the ability to transform time, and especially when I always saw the same old man operating it for years. With cars I was interested in the fact that they sense the potency of time that I experience myself all the time in Bratislava. Like when every day you go past a car that is parked on the pavement, and if it's been there too long you ask yourself: 'Who's the owner of this car? Why has it been here for so long?' So you activate your own awareness of time. This situation of stationary cars was for me something that might activate the potential awareness of passers-by.

Roman Ondák, Interview with Hans Ulrich Obrist, in *Roman Ondák* (Cologne: Kölnischer Kunstverein/Verlag der Buchhandlung Walter König, 2005) 114–16.

Vladimir Arkhipov
Home-Made: Contemporary Russian
Folk Artefacts//2006

[*Home-Made: Contemporary Russian Folk Artefacts*] makes no claims to being a piece of serious research, although, it goes without saying, it did not come about as a result of nothing. The folk phenomenon of the home-made production of functional everyday items is widescale, spontaneous and largely unknown. Such things have always been with us, and can be found today in any country in the world. This book, however, deals only with the Russian part of this phenomenon.

In 1994 I saw, at an acquaintance's dacha, an unusual hook on which clothes were hanging. It was made from an old toothbrush, without bristles, and had been obviously bent over a fire. There was something strange in that moment of recognition. I immediately saw the light, as it were, and recalled similar things that I knew, belonging to my relatives, friends, acquaintances or acquaintances of acquaintances. Before then I hadn't really noticed them. Now it seemed to me that it would be an interesting task to gather them all together and see them in large numbers – a gathering of equals. The first on the list of candidates to approach was my father who, I remembered, had several strange 'thingamyjigs'. I started my collection with them. Then I set to work on my cousins, aunts and uncles. Then it was the turn of friends, acquaintances and non-acquaintances. After that things started to seek me out themselves. People who liked the idea called me, and continue to call, in order to inform me when, what, and where they had seen something similar. It's clear that the process of searching for things has its own momentum, its own internal logic, and is of a highly accidental nature. It is for this reason that the discovery of each item is listed randomly in this book.

Here you will only get acquainted with a fraction of my collection. In almost all cases, my interest in some or other item led to the spontaneous desire of the author of that item to begin to tell me how it had all come about. I realized that it would be a good idea to record all of this, so I bought myself a dictaphone and a camera and began to document these stories and processes. Sometimes they gave me old photographs of themselves – where they, of course, looked a lot younger. Because of this, the styles of the authors' or witnesses' photographs vary. In some cases there are no photos because, like many people, they didn't want to have their photos published. Apart from this a few people refused to give, or asked me not to publish their names, surnames, professions, work places or places of residence. The interviews which I recorded with the authors of the objects appear in an edited form. My questions have been omitted in order to

print monologues from the authors, which, in my opinion, have more value. [...]

There are over a thousand items in my collection today, and they all have three characteristics in common: functionality; a visual uniqueness; and the testimony of the author, who is both the creator and the user. They represent an astonishing part of modern folk material culture but, unfortunately, are under the constant threat of ruin, because I do not have the means at my disposal for their proper storage.

Vladimir Arkhipov, extract from Introduction, *Home Made: Contemporary Russian Folk Artefacts* (London: Fuel Publishing 2006) 5; 7.

Martha Rosler
The Garage Sale is a Metaphor for the Mind//2005

[...] Garage sales are vernacular forms in which suburbanites, primarily, set out a number of cast-off items in or in front of their garages, put up signs, and hope that people will browse and buy. As a city dweller I had never heard of these until I moved to Southern California, where where they are a highly popular, even beloved, pastime. Coming from a culture in which one donates unwanted items to charity or sets them on the street, I saw the garage sale as a brief portrait of suburban society, in which the hope of cashing-in on cast-offs, so that one might go out and consume again,, led people unabashedly to expose their material lives to the scrutiny of others. I saw it as an art form of contemporary American society and determined to create such a sale in an art gallery. The first one I organized took place in the gallery of the University of San Diego in 1973. My sale included unlikely items, such as empty boxes and welfare-commodity containers, private letters and photos, cast-off underwear, girlie magazines, dead landscaping materials, broken household items and a notebook listing the names of men. The gallery was arranged so that the brightest lighting and the best items were at the front, and the questionable, less saleable, more personal, and even salacious items were located further back as the lighting progressively diminished, leading finally to the empty containers and other abject items. A tape recorder played a 'meditation' by the garage sale 'persona' I had adopted – dressed in a long-skirted hippie costume – wondering aloud what the *Garage Sale* represents and quoting Marx on the commodity form. A projector showed images of blonde middle-class families, at home and on trips, on slides bought at a local garage sale of the effects of a dead man. A blackboard bore the phrase,

'Maybe the Garage Sale is a metaphor for the mind.' I advertised the sale in the local art community but, more importantly, in the free *Pennysaver* newspaper,, which brought a mixed audience to the week-long sale. Restaging this sale in various countries, and in New York in conjunction with my retrospective [2000], I hypothesized, correctly, that in the presence of a bargain, most people, including those who came to visit an artwork, would ignore the quite audible tape recording and the slides. [...]

The piece has become less organized by the original principles of ordering, and there is much less 'sentimental' material such as old personal letters and iconic baby items (partly because the culture of the throw-away is much less likely to sentimentalize baby shoes). The audience in the earliest days was divided: the ordinary shoppers were intrigued at such a sale in a gallery but not overly troubled or driven to philosophizing, and the art shoppers felt they were in a great conspiracy to tweak the noses of those who found such ordinary things as garage sales to be too low for an art gallery. Today, the ordinary people have the same reaction as ever, but the art public is jubilant and unapologetic, because ART is now supposed to be FUN! The only surprise seems to be that things really are available at bargain prices, so they don't even have to pay extra to share in the joke. [...]

By its nature the *Garage Sale* cannot be a historical work because commerce is always located in the present. [...]

Garage Sale Timeline

1973	Art Gallery of the University of California at San Diego
1977	La Mamelle Gallery, San Francisco
1999	Institut d'Art Contemporain, Villeurbanne
	Generali Foundation, Vienna
2000	Museu d'Art Contemporani de Barcelona
	Nederlands Foto-Instituut, Rotterdam
	New Museum of Contemporary Art, New York
2004	Project Arts Centre, Dublin
	Sprengel Museum, Hannover
2005	Institute of Contemporary Arts, London

Martha Rosler, excerpts from 'The Garage Sale is a Metaphor for the Mind: A Conversation between Martha Rosler and Jens Hoffmann', in *Martha Rosler, London Garage Sale* (London: Institute of Contemporary Arts, 2005) 5–6.

Biographical Notes

Francis Alÿs is a Belgian-born artist who has lived and worked in Mexico City since the late 1980s. Among his projects which have involved walks in urban environments are *The Collector* (1991–92), *The Leak* (1995) and *Paradox of Praxis* (1997). Solo exhibitions include Museo de Arte Moderno, Mexico City (1997), Kunstmuseum Wolfsburg (2005), MALBA, Buenos Aires (2006).

Vladimir Arkhipov is a Russian artist based in Moscow. Self-taught, he trained and worked as an engineer, a doctor and in the construction business before he began exhibiting in 1990. Solo exhibitions include 'Post-Folk Archive', MXM Gallery, Prague (1996) and 'Folk Sculpture', Kunstverein Rosenheim, Germany (2004).

Paul Auster is a New York-based novelist, poet, translator and writer. His writings on art have included a text in the catalogue *Edward Hopper and the American Imagination* (1997) and his collaboration with Sophie Calle, *Double Game & Gotham Handbook* (2000).

Sally Banes is a historian of modern and contemporary dance. Her books include *Democracy's Body: Judson Dance Theater 1962–1964* (1983) and *Greenwich Village 1963: Avant-Garde Performance and the Effervescent Body* (1993). She is Marian Hannah Winter Professor of Theatre and Dance Studies, University of Wisconsin-Madison.

Maurice Blanchot (1907–2003) was a French philosopher, novelist and literary critic. His writing on the everyday is included in *L'Entretien infini* (1969); trans. *The Infinite Conversation* (1992). His key texts are collected in *The Blanchot Reader*, ed. Michael Holland (1995).

Ian Breakwell (1943–2005) was a British artist whose work encompassed painting, photography, film, collage and performance. His works observing everyday life include *Estate* (1971–76) *Diary* (1964–85), and *Seeing in the Dark* (1990). His *Diary* was published in 1986, broadcast in TV slots on Channel 4 in the late 1980s, serialized on BBC Radio 3 in 1990, and exhibited in 'Live in Your Head: Concept and Experiment in Britain 1965–75', Whitechapel Gallery (2000).

Stanley Brouwn is a Suriname-born Dutch conceptual artist based in Amsterdam. Between 1960–64 he asked passers-by to sketch for him on paper the way from A to B, which he certificated with the stamp *This Way Brouwn*. Continuations of this work include the division of 1m and 1 wari (Kenya) according to the golden section (1994) and proposing short walks in the direction of world cities (2005). Retrospectives include Stedelijk Van Abbemuseum, Eindhoven (2005).

Sophie Calle is a French artist whose works include photography and text, artist's books and installation. Her works involving her undercover observation of everyday situations include *Suite venitienne* (1979), *L'Hôtel* (1983), *Cash Machine* (1991) and in collaboration with the writer Paul Auster, *Gotham Handbook* (1998), a participatory installation in a New York phone booth. Solo exhibitions include 'à suivre', ARC Musée d'art moderne de la Ville de Paris (1990) and retrospective, Centre Georges Pompidou, Paris (2005).

Gregory Crewdson is an American photographer whose staged photographs have combined traditions of observing the everyday in American photography, art and film, with the representation of the Gothic and uncanny. His projects are documented in the books *Hover* (1995), *Twilight* (2000) and *Gregory Crewdson 1985–2005* (2005).

Rebecca J. DeRoo is an American art historian whose research and teaching encompasses postwar art, photography, film, theory and gender studies. She is the author of *The Museum Establishment and Contemporary Art: The Politics of Artistic Display in France after 1968* (2006). DeRoo is Assistant Professor of Art History, Washington University, St. Louis.

Marcel Duchamp (1887–1968) was an independent French artist and chess player, associated with Dada and Surrealism. From 1913 his readymades and from *c.* 1945 his concepts such as the 'infra-slim' were a major influence in the turn of Fluxus, Pop, performance and conceptual art towards the everyday. Retrospectives include Pasadena Museum of Art (1963) and Philadelphia Museum of Art (1987).

Geoff Dyer is a British author and essayist based in London. His books include *Paris Trance* (1998) and *What Was True: The Photographs and Notebooks of William Gedney*, ed., with Margaret Sartor (2000).

Patrick Frey is a Swiss art critic, performance artist and publisher based in Zurich, home of his publishing house, Editions Patrick Frey. He has been a longtime friend of the artists Fischli and Weiss and has written extensively on their work.

Ben Highmore is a British writer and researcher on the culture of everyday life. His books include *The Everyday Life Reader* (2002), *Everyday Life and Cultural Theory: An Introduction* (2002), *Cityscapes: Cultural Readings in the Material and Symbolic City* (2005) and *Michel de Certeau: Analysing Culture* (2006). He is Reader in Media Studies at the University of Sussex.

Susan Hiller is an American-born artist, writer and curator based in England since 1969. Originally an anthropologist, she investigates cultural processes of classification and their manifestations in everyday culture. Solo exhibitions include Tate Liverpool (1996), Museu Serralves, Porto (2004) and Wexner Center for the Arts, Columbus, Ohio (2005). Her books include *Thinking about Art: Conversations with Susan Hiller* (1996) and *The J Street Project* (2004).

Ilya & Emilia Kabakov are Russian artists based in New York since 1992. Ilya Kabakov worked as an underground artist in Moscow from the early 1970s, making books, paintings and installations which reflect upon the conditions of communal life in the Soviet Union, such as '10 Characters', exhibited at Ronald Feldman Fine Arts, New York (1988) and 'The Communal Kitchen', Musée Maillol, Paris (1994).

Vincent Kaufmann is a Swiss cultural historian and literary critic whose work on the Situationists includes *Guy Debord. La révolution au service de la poésie* (2001); *Guy Debord: Revolution in the Service of Poetry* (2006). He is Professor of the History of Ideas and French Literature at the École des hautes études économiques, juridiques et sociales, Saint-Gallen, Switzerland.

Stephen Koch is an American novelist and essayist whose book *Stargazer: The Life, World and Films of Andy Warhol* (1973) is among the definitive expositions of Warhol's fusion of his life and art. From 1977 to 1998 Koch taught in the Graduate Writing Program at Columbia University.

Joseph Kosuth is an American artist who was a founding figure of New York conceptualism in the mid-1960s, an American affiliate of Art & Language from 1969–70 and co-editor of *The Fox* (1975–76). Retrospectives include Kunstmuseum Luzern (1973) and Staatsgalerie Stuttgart (1981). His writings are collected in *Art After Philosophy and After* (1991).

Henri Lefebvre (1901–1991) was a French philosopher and Marxist sociologist. His pioneering studies of the everyday include *Critique de la vie quotidienne II* (1961); *Critique of Everyday Life, vol. II* (2002); *La Vie quotidienne dans le monde moderne* (1958); *Everyday Life in the Modern World* (1971); and *Critique de la vie quotidienne, III* (1981); *Critique of Everyday Life, vol. III* (2005).

Jean-Jacques Lévêque is a French art historian and critic. Closely associated with Nouveau Réalisme in the early 1960s, he was the founder of the journal *Sens plastique* and co-founder of *Opus International*. He is the author of numerous art-historical studies of French art and artists, and of the public spaces of Paris.

The Lettrist International was a Paris-based gathering of radical theorists and artists (1952–57), formed after a split with the Lettrist movement of Isidore Isou, and out of which emerged the Situationist International. The group published four issues of *Internationale lettriste* (1951–54) followed by eight issues of *Potlatch* (1954–57). Their work was also published in *Les Lèvres nues*.

Lucy R. Lippard is an American art historian, critic and curator who was closely associated with the emergence of conceptualism and feminism in the 1960s and seventies. Her books include *Six Years: The dematerialization of the art object from 1966 to 1972 ...* (1973; revised edition 1997).

Tom McDonough is the author of 'The Beautiful Language of My Century': Reinventing the Language of Contestation in Postwar France, 1945–1968 (2007) and editor of *Guy Debord and the Situationist International* (2004). He is Associate Professor of Modern Architecture and Urbanism in the Art History department at Binghamton University, New York.

Michel Maffesoli is a French sociologist whose works include *Au creux des apparences. Pour une éthique de l'esthétique* (1990), *La Contemplation du monde* (1993) and *Le réenchantement du monde: Morales, éthiques, déontologies* (2007). He is a Professor at the University of Paris V, and director of the journal *Sociétés*.

Alison Marchant is a British artist who lives and works in London's East End. She uses archive photographs and oral testimony to create site-specific installations, making visible working class cultural and domestic life. Her projects include *Living Room* (1994–98).

Ivone Margulies is a film theorist and historian who has taught and written extensively on neo-realism, French and feminist film, independent cinema, performance in film and video and *cinema vérité*. She is Associate Professor, Department of Film and Media Studies, Hunter College, City University of New York.

Jonas Mekas is a Lithuanian-born filmmaker, writer and curator based in New York, who was among the leaders of the American underground cinema movement. He was a founder of the Filmmakers' Cooperative (1962) and Anthology Film Archives (1970). *As I was Moving Ahead, Occasionally I Saw Brief Glimpses of Beauty* (2001) is a five-hour long diary film assembled by hand from an archive of fifty years of recordings of his life.

Annette Messager is a French artist based in Paris whose conceptual works and installations since the early 1970s have explored issues surrounding women ranging from physical abuse to obsession with appearances and the repetition of everyday actions. Solo exhibitions include Musée d'art moderne de la Ville de Paris (1974; 1995) and Los Angeles County Museum of Art; The Museum of Modern Art, New York; Art Institute of Chicago (1995–96).

Aleksandra Mir is a Polish-born artist based in Sicily who has lived and worked in Sweden and New York. Her witty, often playful works take their cue from social processes and situations, often connected with the work's location, making a space for viewers to reflect upon norms, categorizations and traditions. Solo shows include The Wrong Gallery, New York (2003), Kunsthaus Zurich (2006) and the Sicilian Pavilion, Venice Biennale (2007).

Helen Molesworth is Curator of Contemporary Art at Harvard University Art Museums. Formerly Chief Curator of Exhibitions at Wexner Center for the Arts (2003–7) and Curator of Contemporary Art at Baltimore Museum of Art (2000–3), among the exhibitions she curated at Baltimore was 'Work Ethic', based upon the research in her text published here. She was a co-founding editor of the journal *Documents*.

Roman Ondák is a Slovakian-born artist who lives and works in Bratislava. His installations, performance works or interventions are barely distinguishable from the real-life situations in which they are located, inviting viewers to question their perceptions of social codes. Solo exhibitions include Stedelijk Museum, Amsterdam (2004), Museum Ludwig, Köln (2002), Wiener Secession, Vienna, (2001).

Yoko Ono is a Japanese-born artist who has lived in New York since 1952. From the late 1950s she was associated with John Cage and the Fluxus group, first exhibiting her 'Instructions for Paintings' in Tokyo and New York in 1960–61. Her work has encompassed performance, music, film, sculpture, conceptual art and activism for world peace. Retrospectives include 'Yes. Yoko Ono', Japan Society Gallery, New York (2000).

Gabriel Orozco is a Mexican-born artist who lives and works in New York, Paris and Mexico City. His photographs, sculptures and installations propose subtle forms of political engagement with the poetry of everyday chance encounters. Retrospectives include The Museum of Contemporary Art, Los Angeles (2000) and Museo del Palacio de Bellas Artes, Mexico City (2006).

Nikos Papastergiadis is a cultural theorist and writer on contemporary art. His works include *Modernity as Exile* (1992), *The Turbulence of Migration* (2000), *Complex Entanglements* (2003), *Metaphor and Tension* (2004). He is a co-editor of *Third Text.*

Georges Perec (1936–82) was a French author, essayist and filmmaker. He was a member of the Parisian group OuLiPo (Ouvroir de Littérature Potentielle, or 'Workshop of Potential Literature'), founded in 1960 by Raymond Queneau and François LeLionnais. His works include *La Vie mode d'emploi* (1978), *Espèces d'espaces* (1974) and *Penser Classer* (1985).

John Roberts is a British art critic and theorist, and contributor to *New Left Review.* His works include *Postmodernism, Politics and Art* (1990), *The Art of Interruption: Realism, Photography and the Everyday* (1998) and *Philosophizing the Everyday: Revolutionary Praxis and the Fate of Cultural Theory* (2006). See also bibliography.

Martha Rosler is an American artist and writer on art, photography and culture, whose media have included video, photography, performance and installation. Retrospectives include 'Positions in the Life World' (1998–2000), shown in five European cities and, concurrently, at the International Center of Photography and the New Museum of Contemporary Art, New York. Rosler teaches at Rutgers University, New Jersey, and the Städelschule, Frankfurt am Main.

David A. Ross is an American curator who has been closely associated with important emerging contemporary artists since the early 1970s. He was Director of the Whitney Museum of American Art, New York (1991–98), and of the San Francisco Museum of Modern Art (1998–2001). He is Chairman of the APT Curatorial Committees and a member of the Board of Directors of the Artist Pension Trust.

Kristin Ross has written extensively on the everyday in French intellectual culture. She is the author of *The Emergence of Social Space: Rimbaud and the Paris Commune* (1988), *Fast Cars, Clean Bodies: Decolonization and the Reordering of French Culture* (1995) and *May '68 and its Afterlives* (2002). She is Professor of Comparative Literature at New York University.

Allen Ruppersberg is an American artist of the conceptual generation whose media include painting, photography, sculpture, installation and artist's books. Solo exhibitions include The Museum of Contemporary Art, Los Angeles (retrospective, 1985), Musée d'art moderne et contemporain, Geneva (2001) and Centro Andaluz de Arte Contemporáneo, Seville (2006).

Nicholas Serota is Director of the Tate galleries and collections in London, Liverpool and St. Ives. Appointed in 1988, he was formerly Director of the Whitechapel Art Gallery (1976–88) and the Museum of Modern Art, Oxford (1973–76). Major exhibitions he has curated include 'A New Spirit in Painting', with Norman Rosenthal, Royal Academy of Arts, London (1981), and retrospectives of Robert Ryman, Tate Gallery, London (1993) and Donald Judd, Tate Modern, London (2004).

Michael Sheringham is the author of *French Autobiography: Devices and Desires* (Oxford University Press, 1993), *The Art of the Project*, with Johnnie Gratton (2005) and *Everyday Life: Theories and Practices from Surrealism to the Present* (2006). He is Marshal Foch Professor of French Literature at All Souls College, Oxford.

Stephen Shore is an American photographer who in the early 1970s was among the exponents of colour in photography and the expansion of the fields of reportage and art photography in a new genre in which he recorded the banal objects and scenes of everyday life. Retrospectives include 'The Biographical Landscape', Musée du Jeu de Paume, Paris (2004), and international tour. He has been Director of the Photography department at Bard College, Annandale-on-Hudson, since 1982.

Alison and Peter Smithson (Alison Smithson 1928–93; Peter Smithson 1923–2003) were pioneering British architects who in the mid-1950s, along with their fellow Independent Group member the critic Reyner Banham, advocated a new direction for architecture, still based on International Style construction principles but arising from sensitivity to the existing conditions and needs of specific communities. Retrospectives include The Design Museum, London (2003).

Abigail Solomon-Godeau is an American art historian, critic and curator. Her curatorial projects include 'The Way We Live Now' (1982) and 'The Image of Desire; Femininity, Modernity, and the Birth of Mass Culture in Nineteenth-Century France' (1998). Her books include *Photography at the Dock: Essays on Photographic History, Institutions and Practices* (1991),

Daniel Spoerri is a Romanian-born French artist who was a central member of the Nouveau Réalisme and Fluxus movements in the early 1960s. Retrospectives include Museum Ludwig, Cologne (2002).

Helena Tatay is an independent curator based in Barcelona. Exhibitions she has curated include Hiroshi Sugimoto, Fundación 'la Caixa', Madrid and Centro Cultural de Belém, Lisbon (1998), 'Still Life', Galeria Joan Prats, Barcelona (2000) and Hans-Peter Feldmann, Fundació Antoni Tàpies, Barcelona, (2001), Centre national de la photographie, Paris; Fotomuseum Winterthur, Winterthur; Museum Ludwig, Cologne (2002).

Paul Virilio is a French philosopher and cultural theorist of urban space, architecture and technology. His books include *The Aesthetics of Disapperance* (1991), *Bunker Archaeology* (1994), *Virilio Live: Selected Interviews* (2001) and with Sylvère Lotringer, *The Accident of Art* (2005).

Jeff Wall is a Canadian artist based in Vancouver whose work since the 1970s has explored dialogues between photography and pictorial narrative in painting and cinema. Major solo exhibitions include Galerie nationale du Jeu de Paume, Paris (1995), Whitechapel Gallery, London (1998), Museum für Moderne Kunste, Frankfurt am Main (2001), Tate Modern, London (2005) and Museum of Modern Art, New York (2007).

Jonathan Watkins is Director of the Ikon Gallery, Birmingham. Appointed in 2000 he was formerly Director of the Chisenhale Gallery, London. In 1998 he was Artistic Director of 'Every Day', the 11th Sydney Biennale, and in 2003 he co-curated with Judith Nesbitt 'Days Like These', the Tate Triennial at Tate Modern, London.

Richard Wentworth is a British sculptor whose work since the 1970s has centred on the transformation of everyday objects. A series of photographs on the pavements of Caledonian Road in North London, titled *Making Do and Getting By*, which record chance appearances of objects, discarded or turned to new uses and relationships, have a parallel relation to the ideas informing his sculptures. He is Master of the Ruskin School of Drawing and Fine Art, Oxford.

Stephen Willats is a British artist based in West London whose projects, stemming from the study of cybernetics and systems theories, have since 1965 involved the participation of communities in artworks that document and explore aspects of everyday conditions in environments such as public housing, offices, or in-between urban spaces. Since the early 1970s he has worked and exhibited extensively in cities throughout Britain and Europe. Retrospectives include Musuem für Gegenwartskunst, Siegen, and Kunstwerke, Berlin (2006).

Bibliography

See also anthology bibliographic references at end of each text.

Alberro, Alexander, 'The Dialectics of Everyday Life', in *Martha Rosler: Positions in the Lifeworld*, ed. Catherine de Zegher (Cambridge, Massachusetts: The MIT Press, 1999).

Banes, Sally, *Greenwich Village 1963: Avant-Garde Performance and the Effervescent Body* (Durham, North Carolina: Duke University Press, 1993).

Blanchot, Maurice, 'L'Homme de la rue', in *Nouvelle revue française*, no. 114 (Paris, June 1962); reprinted as 'La Parole quotidienne', in Blanchot, *L'Entretien infini* (Paris: Gallimard, 1969); trans. Susan Hanson, 'Everyday Speech', in *Yale French Studies*, no. 73, special issue on Everyday Life (1987); reprinted in *The Infinite Conversation*, trans. Susan Hanson (Minneapolis: University of Minnesota Press, 1992).

Bowman Robinson, Julia, 'The Sculpture of Indeterminacy: Alison Knowles' beans and variations', *Art Journal*, vol. 63 (2004).

Certeau, Michel de, *L'invention du quotidien, I. Arts de faire* (Paris: Gallimard, 1974); trans. Stephen Rendall, *The Practice of Everyday Life* (Berkeley and Los Angeles: University of California Press, 1984).

Certeau, Michel de, and Giard, Luce, Mayol, Pierre, *L'Invention du quotidien, II. Habiter, cuisiner* (Paris: Gallimard, 1980); trans. Timothy J. Tomasik, *The Practice of Everyday Life, vol. 2. Living and Cooking* (Minneapolis: University of Minnesota Press, 1998).

Crewdson, Gregory, 'Aesthetics of Alienation', *Tate etc.*, issue 1 (Summer 2004).

Days Like These. Tate Triennial Exhibition of Contemporary British Art, curated by Judith Nesbitt and Jonathan Watkins (London: Tate/New York: Abrams, 2003).

Debord, Guy, *Oeuvres cinématographiques complètes* (Paris: Éditions Champ Libre, 1978); trans. Ken Knabb, *Complete Cinematic Works* (Oakland, California: AK Press, 2003).

Debord, Guy, 'Perspectives for Conscious Alterations in Everyday Life', *Internationale Situationniste*, 6 (August 1961), online in Situationist Library at www.nothingness.org

DeRoo, Rebecca J., *The Museum Establishment and Contemporary Art: The Politics of Artistic Display in France after 1968* (Cambridge, England: Cambridge University Press 2006).

Dezeuze, Anna, 'Thriving on Adversity: The Art of Precariousness', *Mute*, vol. 2, no. 3 (Autumn 2006).

Duchamp, Marcel, *Notes*, ed. Paul Matisse (Paris: Éditions du Centre Georges Pompidou, 1980).

Dyer, Geoff, '*Les mots et les choses*: Eugène Atget and Richard Wentworth', in *Faux Amis: Eugène Atget/Richard Wentworth*, ed. Kate Bush (London: The Photographers' Gallery, 2001).

Graham, Dan, *Two-Way Mirror Power: Selected Writings by Dan Graham on His Art*, ed. Alexander Alberro; introduction Jeff Wall (Cambridge, Massachusetts: The MIT Press, 1999).

Elden, Stuart, *Understanding Henri Lefebvre* (London: Continuum, 2004).

Epic and the Everyday, The, ed. Martin Caiger-Smith and James Lingwood (London: Hayward Gallery, 1994).

Everyday Altered, The, curated by Gabriel Orozco (Venice: 50th Venice Biennale: Dreams and Conflicts: The Dictatorship of the Viewer, cur. Francesco Bonami, 2003).

Buchloh, Benjamin H.D., Rodenbeck, Judith F., et al., *Experiments in the Everyday: Allan Kaprow and Robert Watts: Events, Objects, Documents* (New York: Wallach Art Gallery, Columbia University, 1999).

Felski, Rita, 'The Invention of Everyday Life', *New Formations*, no. 39 (Winter 1999).

Felski, Rita, Introduction, *New Literary History*, vol. 33, no. 4, special issue on Everyday Life (Autumn 2002).

Foster, Hal, 'The Artist as Ethnographer', *The Return of the Real* (Cambridge, Massachusetts: The MIT Press, 1994).

Ganguly, Keya, Introduction, *Cultural Critique*, no. 52, Everyday Life special issue (Fall 2002).

Gardner, Michael, *Critiques of Everyday Life* (London and New York: Routledge, 2000).

Global Conceptualism: Points of Origin, 1950s–1980s (New York: Queens Museum of Art, 1999).

Harris, Steven, and Berke, Deborah, *The Architecture of the Everyday* (Princeton, New Jersey: Princeton Architectural Press, 1997).

Highmore, Ben, *Everyday Life and Cultural Theory: An Introduction* (London and New York: Routledge, 2002).

Highmore, Ben, Hopscotch Modernism: On Everyday Life and the Blurring of Art and Social Science', in *Modernism and the Everyday*, special issue of *Modernist Cultures*, vol. 2, no. 1 (Summer 2006).

Highmore, Ben, ed., *The Everyday Life Reader* (London and New York: Routledge, 2002).

Hiller, Susan, *Thinking about Art: Conversations with Susan Hiller*, ed. Barbara Einzig (Manchester: Manchester University Press, 1996).

Internationale Lettriste, 'Projet d'embellissements rationnels de la ville de Paris', *Potlatch*, no. 23 (Paris, 13 October 1955); trans. Ken Knabb, in *Situationist International Anthology* (Berkeley: Bureau of Public Secrets, 2002).

Interventionists: User's Manual for the Creative Disruption of Everyday Life, The (North Adams, Massachusetts: Massachusetts Museum of Contemporary Art, 2004).

Kaplan, Alice, and Ross, Kristin, Introduction, *Yale French Studies*, Everyday Life special issue, no. 73 (Fall 1987).

Kaprow, Allan, *Essays on the Blurring of Art and Life* (Berkeley and Los Angeles: University of California Press, 1993).

Kaufmann, Vincent, *Guy Debord. La révolution au service de la poésie* (Paris: Fayard, 2001); trans. Robert Bononno, *Guy Debord: Revolution in the Service of Poetry* (Minneapolis: University of Minnesota Press, 2006).

Kosuth, Joseph, *Art after Philosophy and After: Selected Writings 1966–1990* (Cambridge, Massachusetts: The MIT Press, 1991).

Kracauer, Siegfried, 'Boredom' (1924), in *The Mass Ornament: Weimar Essays by Siegfried Kracauer* (Harvard: Harvard University Press, 1995).

Lefebvre, Henri, *Critique de la vie quotidienne II, Fondements d'une sociologie de la quotidienneté* (Paris: L'Arche, 1961); trans. John Moore, *Critique of Everyday Life, vol. 2: Foundations for a Sociology of the Everyday* (London and New York: Verso, 2002).

Lefebvre, Henri, *La Vie quotidienne dans le monde moderne* (Paris: Gallimard, 1958); trans. Sacha Rabinovitch, *Everyday Life in the Modern World* (New York: Haper & Row, 1971).

Lefebvre, Henri, *Critique de la vie quotidienne, III. De la modernité au modernisme (Pour une métaphilosophie du quotidien)* (Paris: L'Arche, 1981); trans. Gregory Elliott, *Critique of Everyday Life, vol. III. From Modernity to Modernism (Towards a Metaphilosophy of Daily Life)* (London and New York: Verso, 2005).

Lefebvre, Henri, 'The Everyday and Everydayness' in *Architecture of the Everyday* (see Harris above).

Leiris, Michel, 'Le Sacré dans la vie quotidienne', *Nouvelle revue française*, 50 (1938); trans. 'The Sacred and the Everyday', in Hollier, Denis, ed., *The College of Sociology* (Minneapolis: University of Minnesota Press, 1988).

Lévêque, Jean-Jacques, text from poster for 'Occupation des lieux', American Center for Students and Artists, Paris, December 1968, reproduced in DeRoo, see above.

Lichtenstein, Claude and Schregenberger, Thomas 'As found: A Radical Way of Taking Note of Things' in *As Found: The Discovery of the Ordinary* (Amsterdam: NAAi, 2004).

Light, Andrew, and Smith, John M., *The Aesthetics of Everyday Life* (New York: Columbia University Press, 2005).

Lippard, Lucy R., *Six Years: The Dematerialization of the Art Object from 1966 to 1972* (Berkeley and Los Angeles: University of California Press, 1997).

McDonough, Tom, 'Situationist Space', *October*, no. 67 (Winter 1994).

McDonough, Tom, 'Calling from the Inside: Filmic Topologies of the Everyday', *Grey Room*, no. 26 (Cambridge, Massachusetts: The MIT Press, Winter 2007).

Maffesoli, Michel, 'Promenades en marges', *Trottoirs – Sidewalks [Promenades en marges]* (Paris: Galerie Chantal Crousel, 2002).

Maffesoli, Michel, 'Everyday Tragedy and Creation', *Cultural Studies*, vol. 18, no. 2–3, special issue: *Rethinking Everyday Life: and then nothing turns itself inside out* (March–May 2004).

Margulies, Ivone, *Nothing Happens: Chantal Akerman's Hyperrealist Everyday* (Durham: Duke University Press, 1996).

Maspero, François, *Les Passagers du Roissy-Express* (Paris: Seuil, 1990); trans. Paul Jones, *Roissy Express: a Journey through the Paris Suburbs* (London and New York: Verso, 1994).

Micropolitics: Art and Everyday Life 2001–1968 (Valencia: Espai d'Art Contemporain de Castello, 2003).

Molesworth, Helen, 'House Work and Art Work', *October*, no. 92 (Winter 2000).

Osborne, Peter, 'Appropriation, Intervention, Everyday' sections, *Conceptual Art* (London and New York: Phaidon Press, 2001).

Papastergiadis, Nikos, 'Everything that Surrounds: Art, Politics and Theories of the Everyday', in *Every Day. 11th Biennale of Sydney* (Sydney: Biennale of Sydney, 1998).

Perec, Georges, *Espèces d'espaces* (Paris: Galilée, 1974); trans. John Sturrock, *Species of Spaces and Other Pieces* (London and New York: Penguin, 1997).

Quiet in the Land: Everyday Life, Contemporary Art and The Shakers, The (Portland, Maine: Institute of Contemporary Art, 1997). http://thequietintheland.com

Quotidiana: The Continuity of the Everyday in Twentieth-Century Art (Turin: Castello di Rivoli, Museo d'Arte Contemporanea, 2000).

Radical Scavengers: The Conceptual Vernacular in Recent American Art (Chicago: Museum of Contemporary Art, 1994).

Read, Alan, *Theatre and Everyday Life: An Ethics of Performance* (London and New York: Routledge, 1995).

Roberts, John, *The Art of Interruption: Realism, Photography and the Everyday* (Manchester: Manchester University Press 1998).

Roberts, John, *Philosophizing the Everyday: Revolutionary Praxis and the Fate of Cultural Theory* (London: Pluto Press, 2006).

Rosler, Martha, *Decoys and Disruptions: Selected Writings, 1975–2001* (Cambridge, Massachusetts: The MIT Press, 2004).

Rosler, Martha: *Martha Rosler. London Garage Sale*, introduction and interview by Jens Hoffmann, designed by APFEL (a practice for everyday life) (London: Institute of Contemporary Arts, 2005).

Ross, Kristin, 'French Quotidian', in *The Art of the Everyday: The Quotidian in Postwar French Culture*, ed. Lynn Gumpert (New York: Grey Art Gallery, 1997).

Sheringham, Michael, and Gratton, Johnnie, *The Art of the Project* (Oxford: Berghan Books, 2005).

Sheringham, Michael, *Everyday Life: Theories and Practices from Surrealism to the Present* (Oxford: Oxford University Press, 2007).

Shields, Rob, *Lefebvre, Love and Struggle: Spatial Dialectics* (London and New York: Routledge, 1999).

Silva, Elizabeth B., and Bennett, Tony, *Contemporary Culture and Everyday Life* (Oxford: Blackwell, 2004).

Shore, Stephen, *American Surfaces* (London and New York: Phaidon Press, 2005).

Solomon-Godeau, Abigail, 'Inside/Out', in *Public Information: Desire, Disaster, Document* (San Francisco: San Francisco Museum of Modern Art, 1994).

Ukeles, Mierle Laderman, *MANIFESTO FOR MAINTENANCE ART 1969! Proposal for an exhibition 'CARE'* (1969); scan and transcript on Ukeles page at www.feldmangallery.com

Vaneigem, Raoul, *The Revolution of Everyday Life*, at www.nothingness.org

Virilio, Paul, 'On Georges Perec', *AA Files*, no. 45/46 (London: Architectural Association School of Architecture, 2001).

Wall, Jeff, 'Dan Graham's Kammerspiel', in *Real Life Magazine*, no. 15 (Winter 1985/86); reprinted in *Jeff Wall, Selected Essays and Interviews* (New York: The Museum of Modern Art, 2007).

Watkins, Jonathan, Introduction, *Every Day. 11th Biennale of Sydney* (Sydney: Biennale of Sydney, 1998).

Willats, Stephen, *Art and Social Function* (London: Latimer New Dimensions, 1976); revised edition (London: Ellipsis, 2000).

Wollen, Peter, 'Mappings: Situationists and/or Conceptualists', in Newman, Michael and Bird, Jon, eds, *Rewriting Conceptual Art* (London: Reaktion Books, 1999).

Index

ACKNOWLEDGEMENTS

Editor's acknowledgements

With sincere thanks to Richard Noble, Graham Ellard, Anne Caron-Delion, Iwona Blazwick, Ian Farr, Hannah Vaughan and Stuart Smith.

Publisher's acknowledgements

Whitechapel is grateful to all those who gave their generous permission to reproduce the listed material. Every effort has been made to secure all permissions and we apologize for any inadvertent errors or ommissions. If notified, we will endeavour to correct these at the earliest opportunity.

We would like to express our thanks to all who contributed to the making of this volume, especially: Francis Alÿs, APFEL (A Practice for Everyday Life), Vladimir Arkhipov, Stanley Brouwn, Sophie Calle, Gregory Crewdson, Thomas Cuckle, Patrick Frey, Ben Highmore, Susan Hiller, Jens Hoffmann, Ilya and Emilia Kabakov, Vincent Kaufmann, Ken Knabb, Laura Knowles, Joseph Kosuth Studio, James Lingwood, Lucy R. Lippard, Alison Marchant, Thomas F. McDonough, Annette Messager, Aleksandra Mir, Helen Molesworth, Roman Ondák, Yoko Ono, Gabriel Orozco, Nikos Papastergiadis, Alan Read, John Roberts, Rebecca J. DeRoo, Martha Rosler, David A. Ross, Kristin Ross, Allen Ruppersberg, Nicholas Serota, Michael Sheringham, Stephen Shore, Serena Smithson, Abigail Solomon-Godeau, Felicity Sparrow, Daniel Spoerri, Jeff Wall, Jonathan Watkins, Richard Wentworth, Stephen Willats. We also gratefully acknowledge the cooperation of: Aperture Foundation; Artangel, London; Artforum; Marion Boyars; Galerie Chantal Crousel; Estate of Marcel Duchamp/ADAGP; Duke University Press; Éditions Galilée; Guggenheim Image Archive; Institute of Contemporary Arts, London; Sean Kelly Gallery; University of Minnesota Press; Simon & Schuster; Verso; Visiting Arts, London; Yale French Studies.

Whitechapel Gallery is supported by
Arts Council England